Being Marc Márquez

This Is How I Win My Race

With Werner Jessner

gestalten

PANTAURO

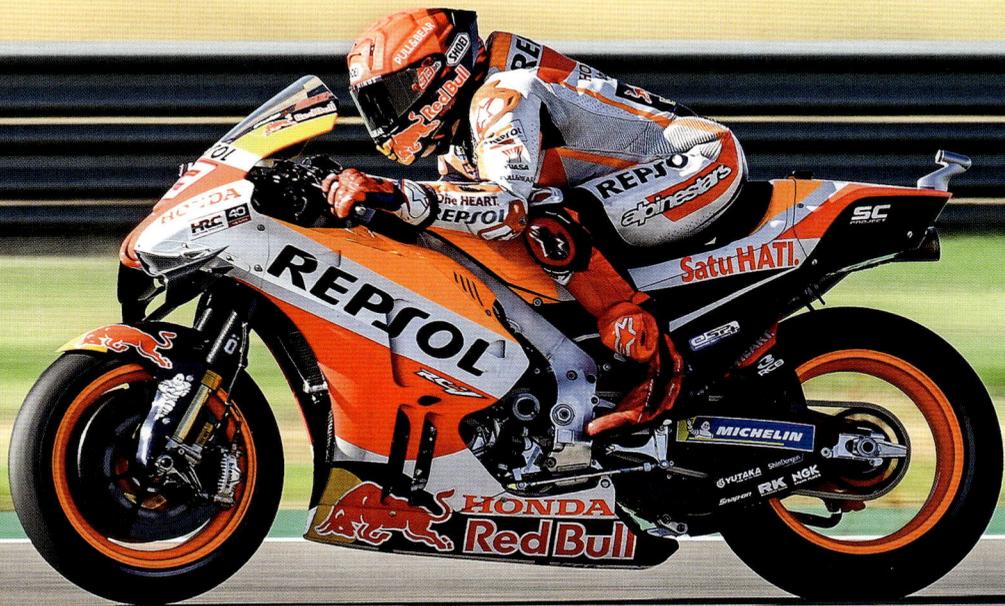

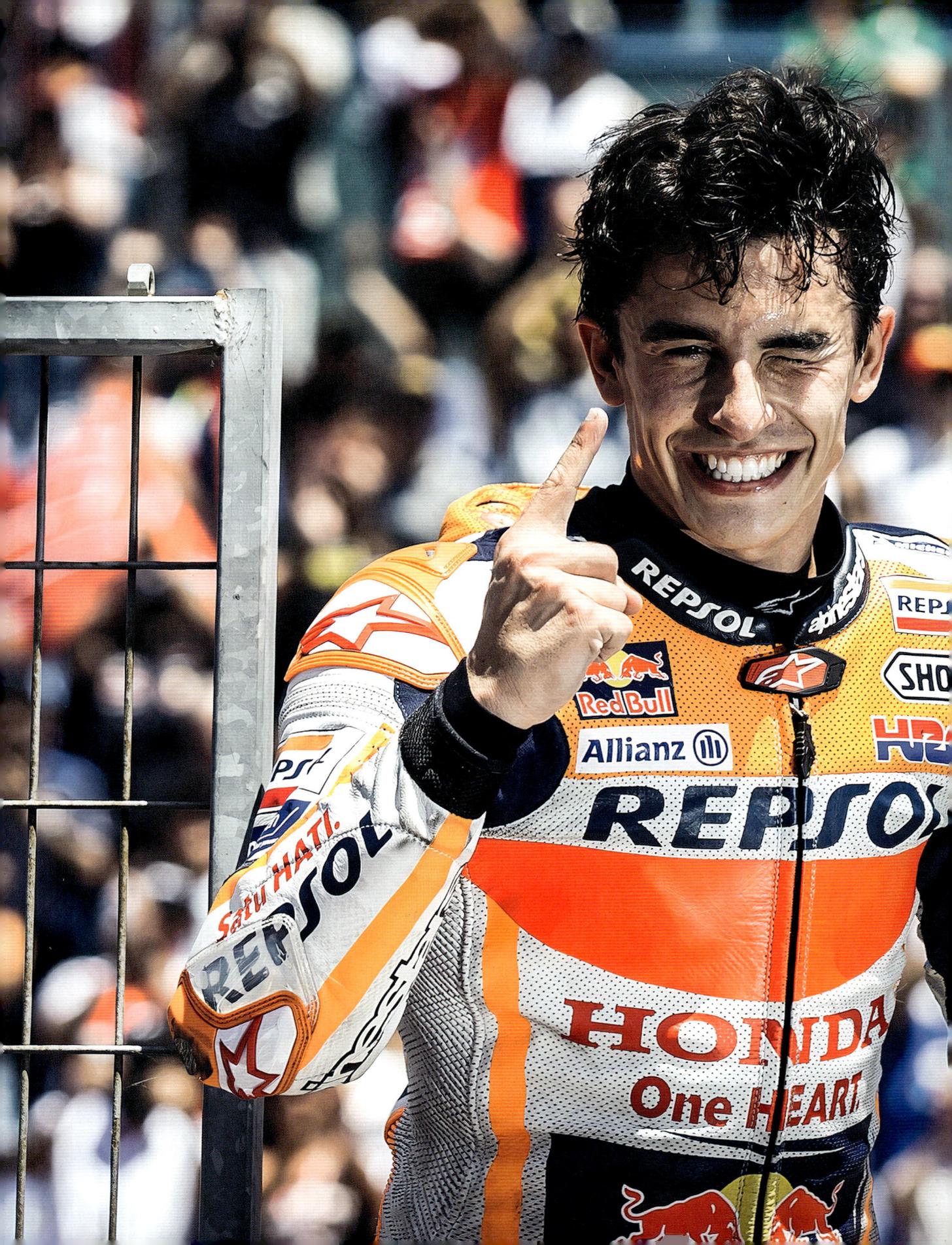

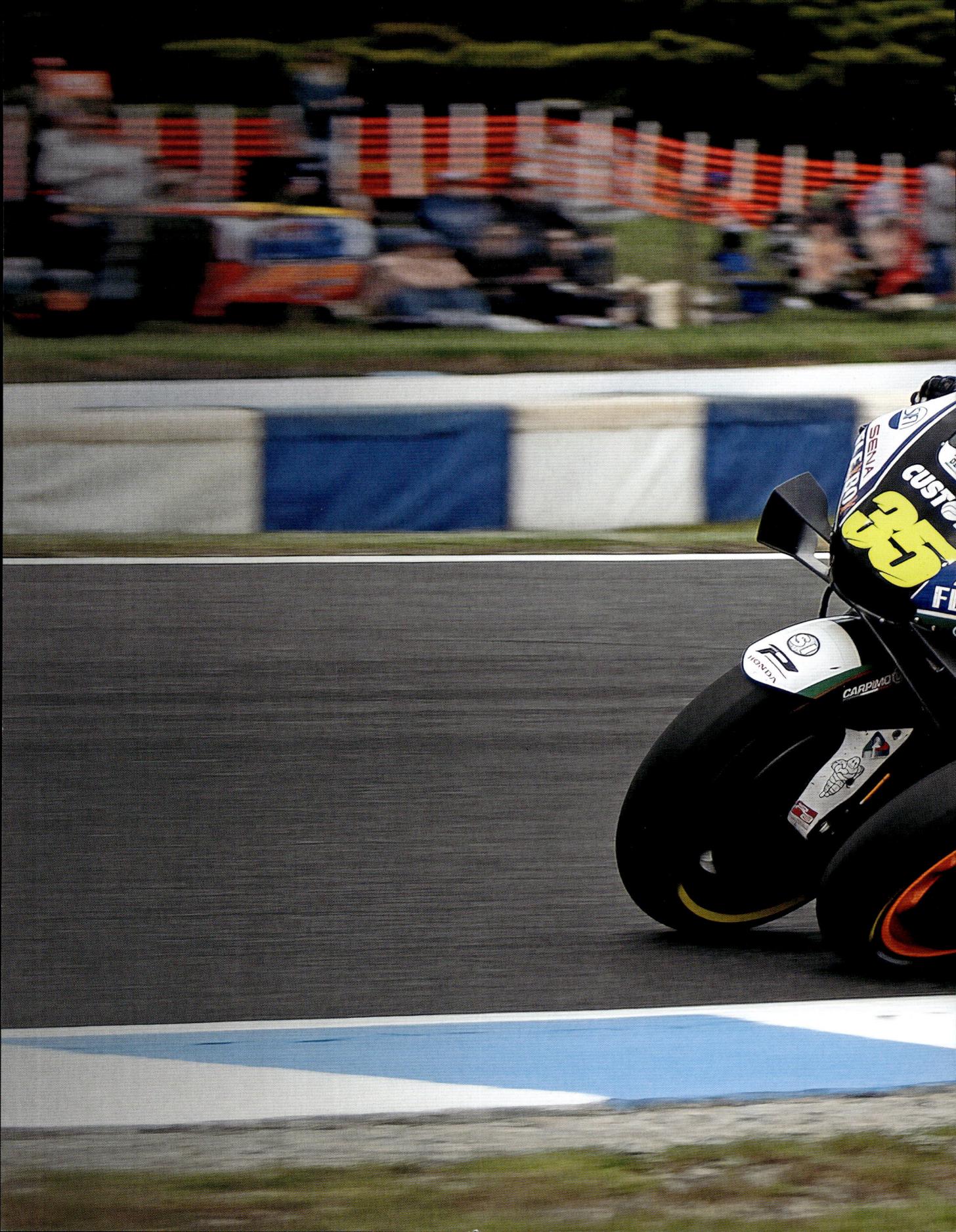

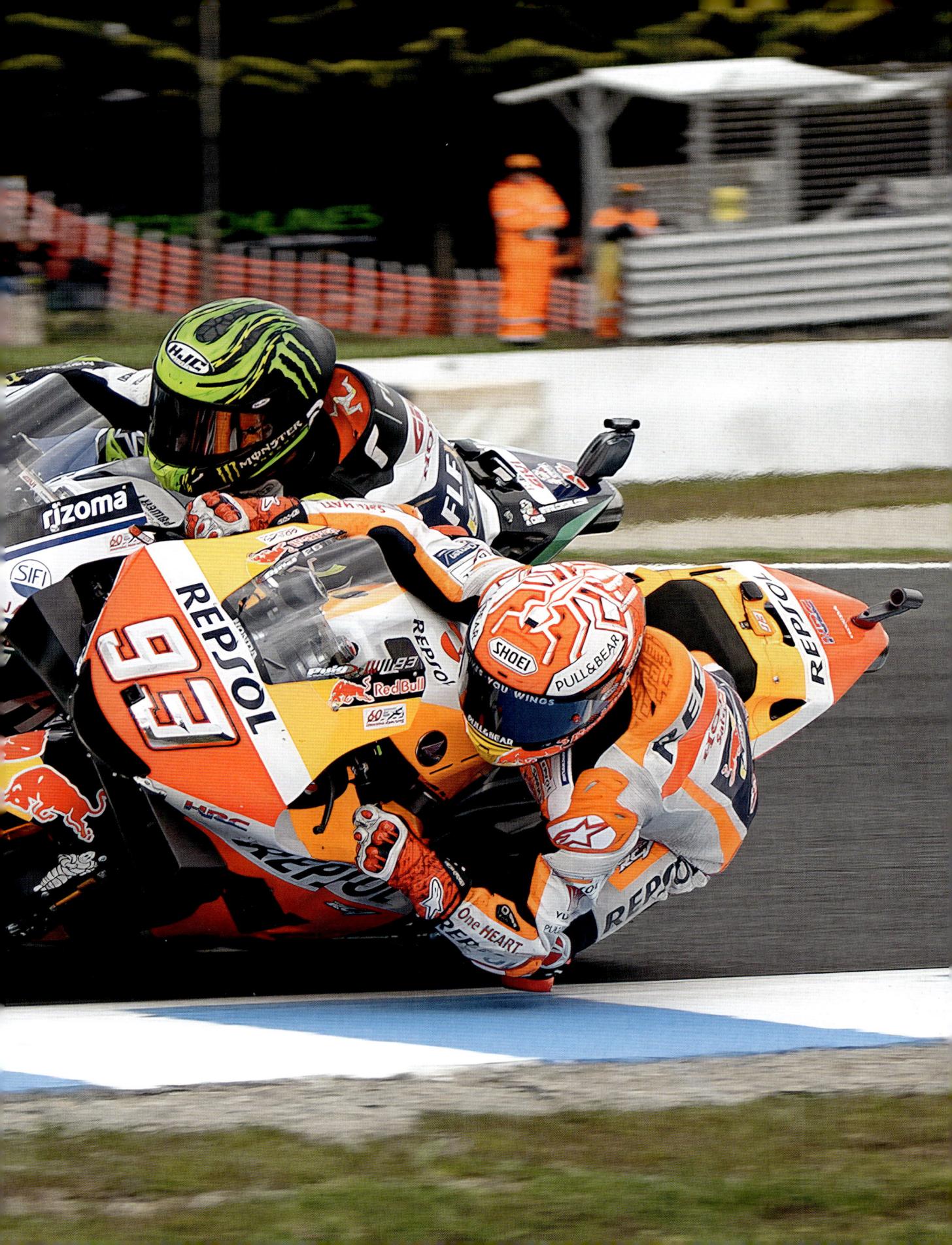

Contents
Inside the Superstar's Head in Eight Sections

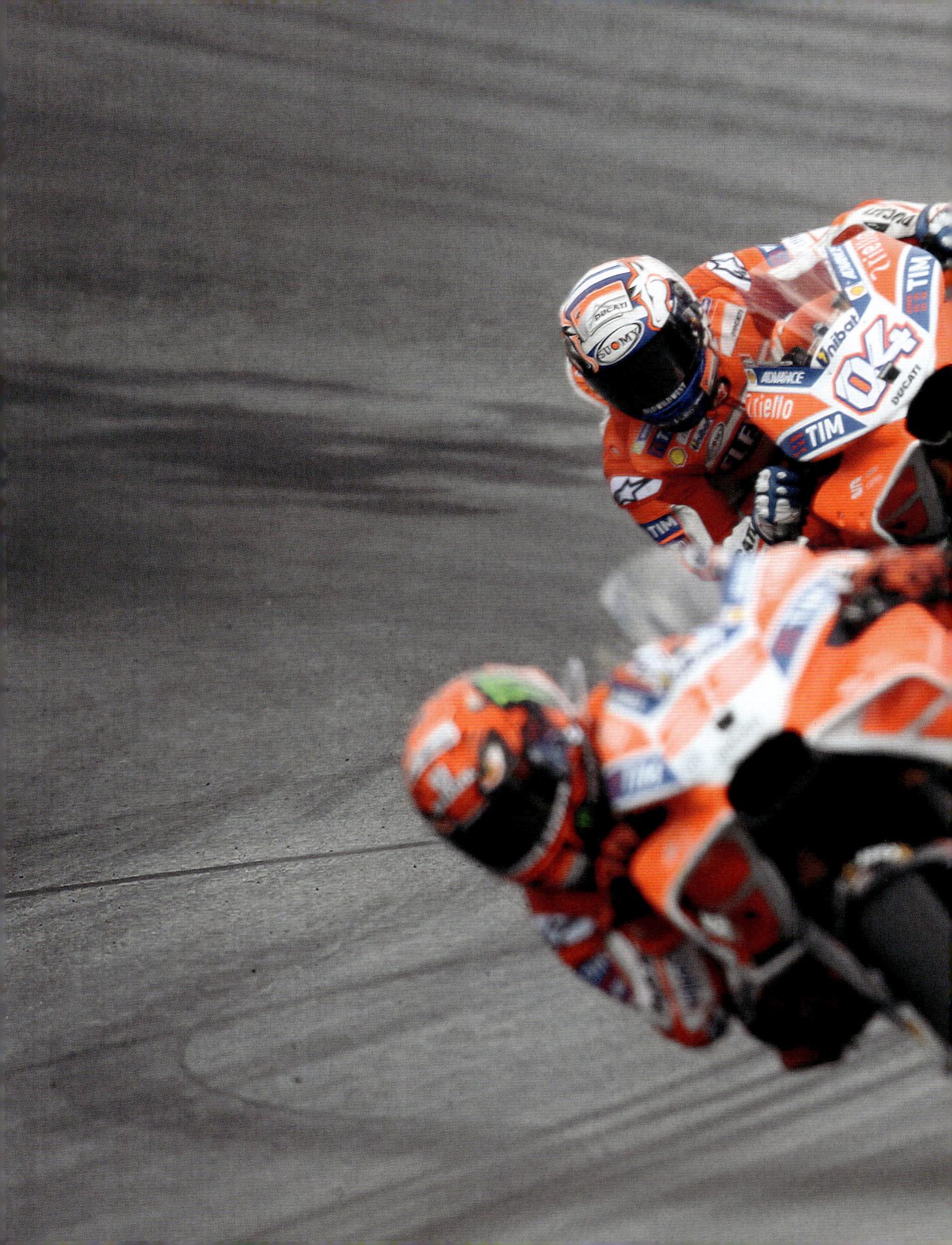

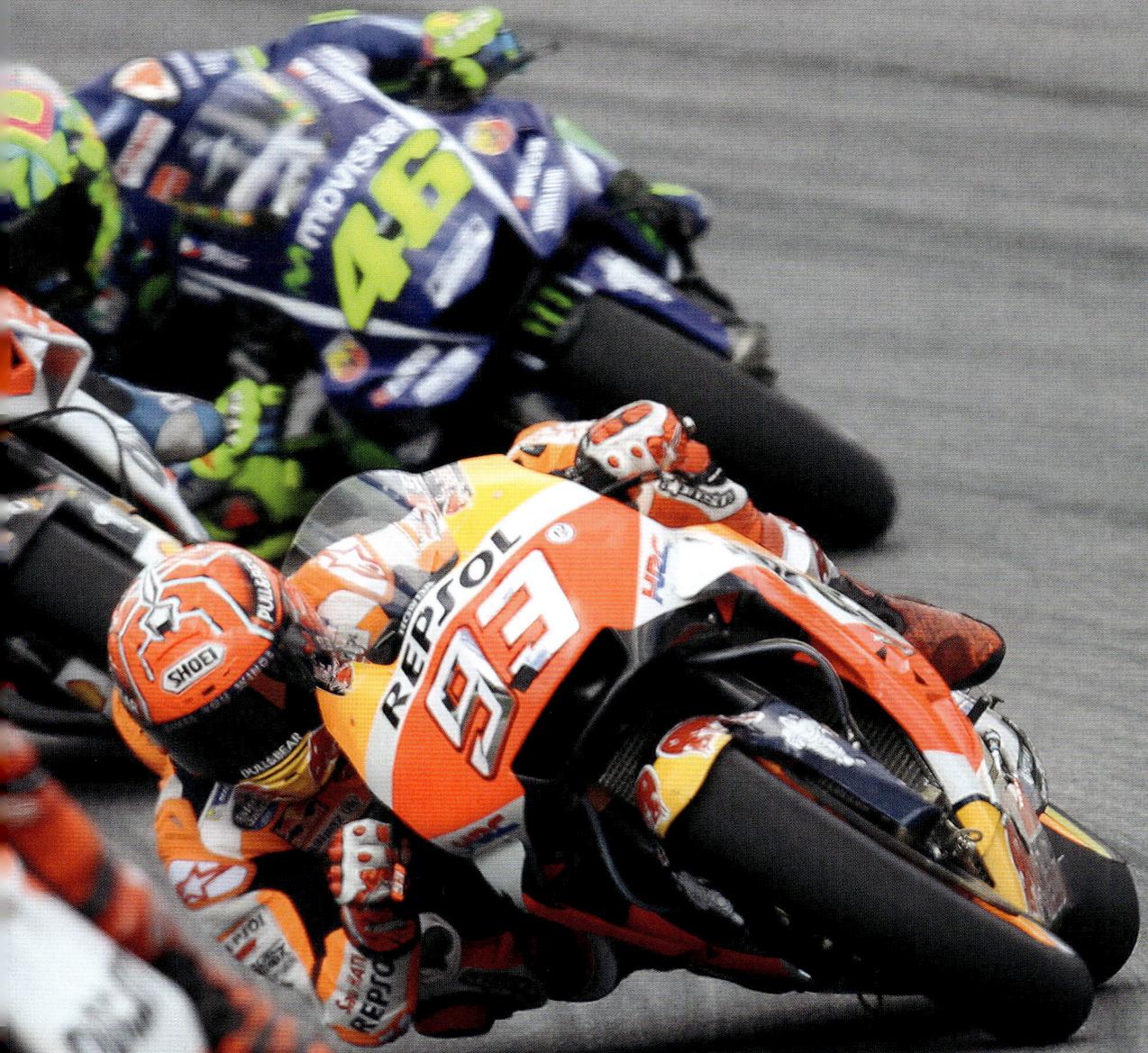

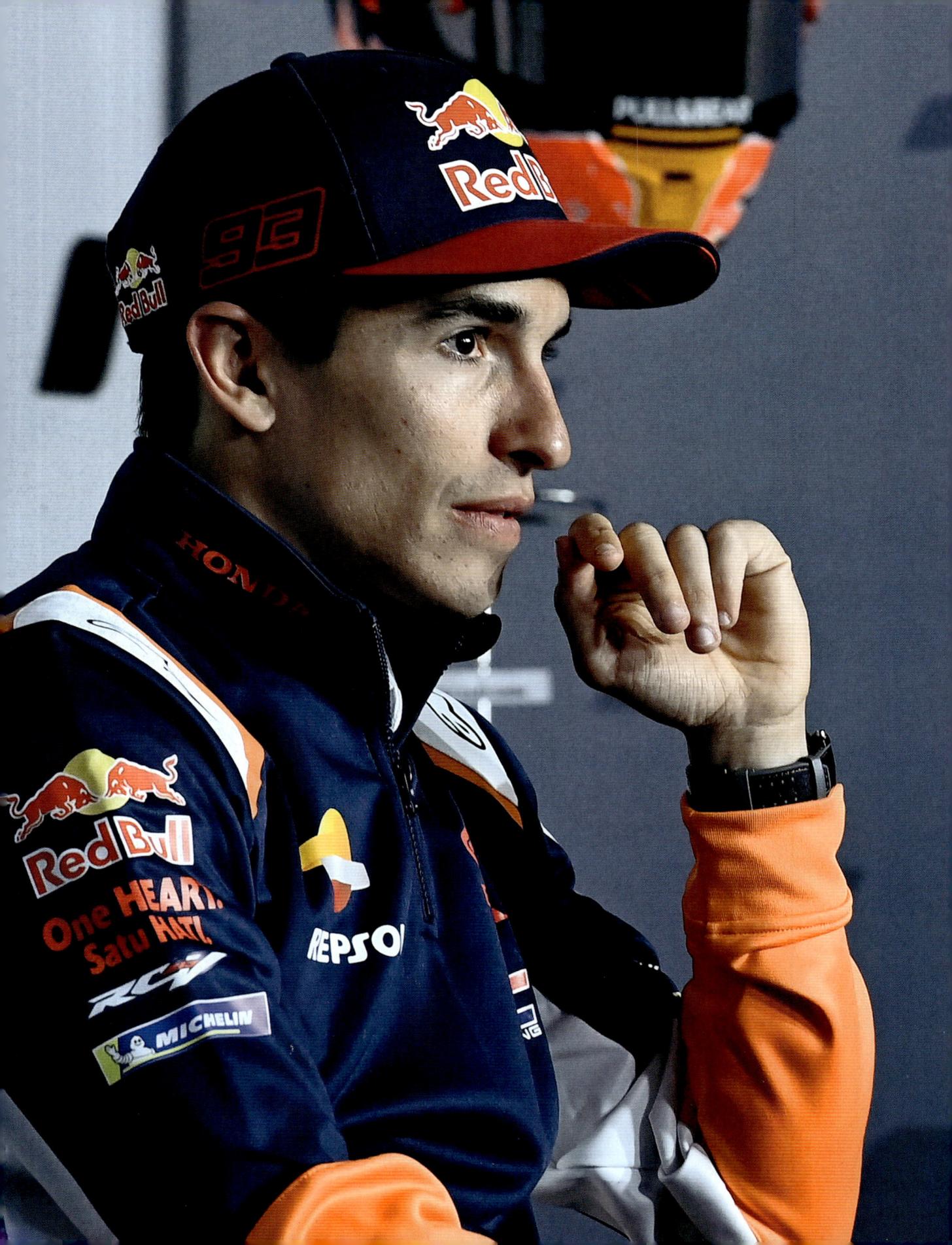

Technology

①

How it feels to ride a MotoGP bike at full throttle

The most powerful commercial super-bikes today are nudging towards the 200-200 mark, i.e. 200bhp and 200kg with a full tank. This is just about at the limit of what passes for "exciting" among talented motorcyclists on the racetrack. Secretly, the ambitious amateur is only too happy for power to be tamed by smart electronics. In MotoGP, the power-to-weight ratio shifts dramatically given the same engine size (1000cc). A MotoGP bike must weigh at least 157kg and it generates around 300bhp. The power-to-weight ratio is therefore roughly twice as high as with the best motorcycles currently available on the market. Furthermore, the actual performance values of the six manufacturers – Honda, Yamaha, Ducati, Aprilia, KTM and the identical GasGas – are firstly confidential and in practice irrelevant: the riders can only accelerate for a few seconds in the highest gear on very few tracks. Top speed is over 360kph. The huge carbon brakes reach temperatures of 750°C in the braking zones. The real challenge for the riders is to control the constant excess of power so that they don't just go flying off their bikes. From a physical point of view, a motorcycle is incredibly complex. There is the chassis itself, which wants to go straight ahead because of the rotating wheels. Then there is the stabilising effect of the engine, which is installed transversely on all bikes and whose crankshaft rotates counter to the direction of travel. So far, so simple. But then there are turns where the rider leans over and uses the handlebars. The bike tilts, and an entity that once had a single centre of gravity now has two: the motorcycle has one, and the rider, loosely connected to it via his arms and legs, has his own. And just to make things a bit more complicated, wheel pressure and speed also change. Depending on style, riders brake at different stages of a turn, putting different loads on the front wheel. For the rear wheel, that means the

→
A workplace like no other: Marc on his RC213V.

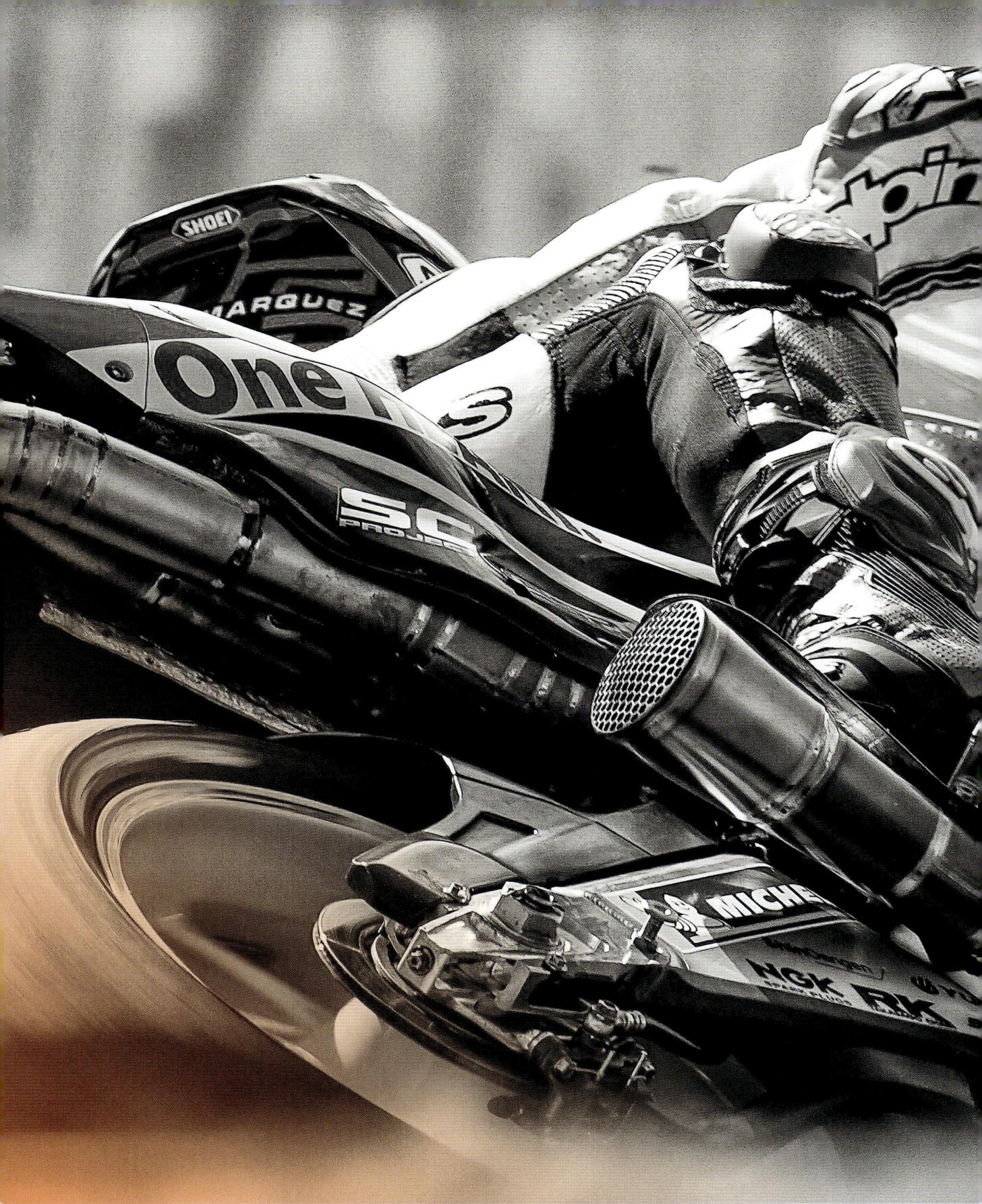

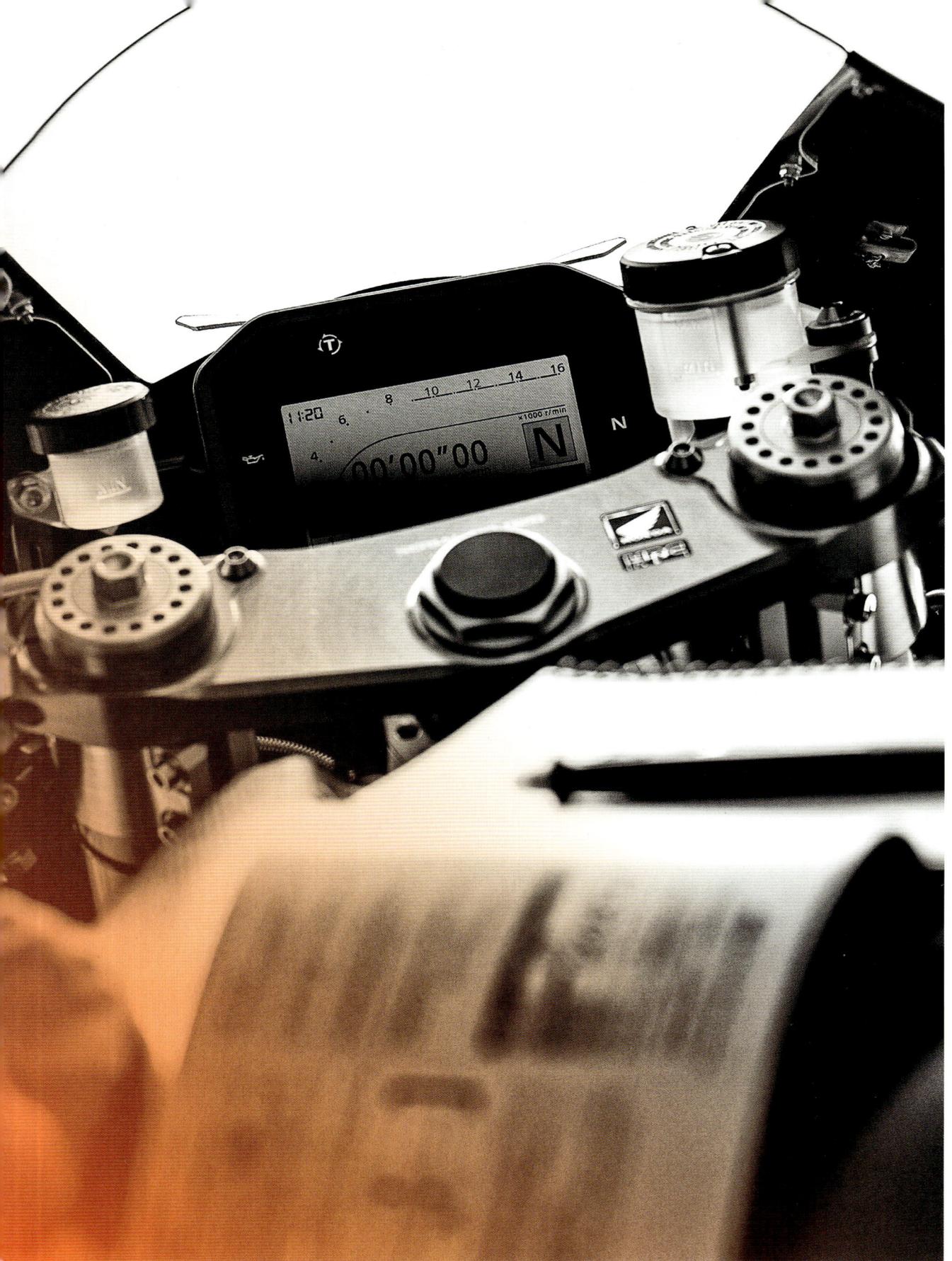

power it can transmit also changes. Conversely, the same applies to acceleration, and the electronics can help, provided the rider is perfectly positioned on the motorcycle and all the digital parameters between the rider and his data engineers have been fine-tuned to general satisfaction. Does that sound complicated enough? There's a couple more things to keep in mind. A MotoGP bike can consume up to 22 litres of fuel during a race. The petrol is cooled to 15° before the start, at which point it weighs 16.5kg. That's how much lighter the bike will become during a race. It reacts more nimbly and is easier on the tyres (which, by contrast, are now more worn down). In order to make things even more challenging for the riders, a new phenomenon has emerged in recent years that eclipses all of the above, and that's aerodynamics. It's what ensures the bike stays on the ground. It helps riders avoid wheelies while accelerating, stoppies on the ground when braking and remain stable in the turns, provided the technicians have done their job well. In the swirling air behind another bike, the system changes completely, however, because the flow on the spoilers, flaps and other attachments no longer behaves as it does in the wind tunnel. And speaking of the wind tunnel, you'd be wrong to assume that smaller riders have an advantage over taller ones. The Márquez brothers did a motorcycle test in the wind tunnel when they both rode for Honda. The result was that Álex, who is 15cm taller, was more aerodynamic because the air could flow backwards more easily due to his longer back. Larger riders have disadvantages in terms of weight, but then they also have more mass that they can use to play with the bike. They can brake later and accelerate harder than smaller, lighter riders. Height and weight have a different effect depending on the circuit and level of grip. What is even more astonishing is that the

←
The rider's essential information: start in neutral, revs, lap-timer. The pit crew can also send messages relevant for the race.

full line-up of MotoGP riders achieve very similar results. There is almost no other category of racing where the gap between first and second, but also between first and last, is so small. And we haven't even touched on the fact that the riders don't perform their physical magic in a secure environment, but rather in the midst of a herd of adrenaline-soaked, full-throttle sportsmen who are particularly bad at one thing: being behind others. The man who is the very worst at that takes us behind the fairing of his Honda RC213V, and suddenly you can hear a pin drop, even with the engine roaring at up to 128 decibels.

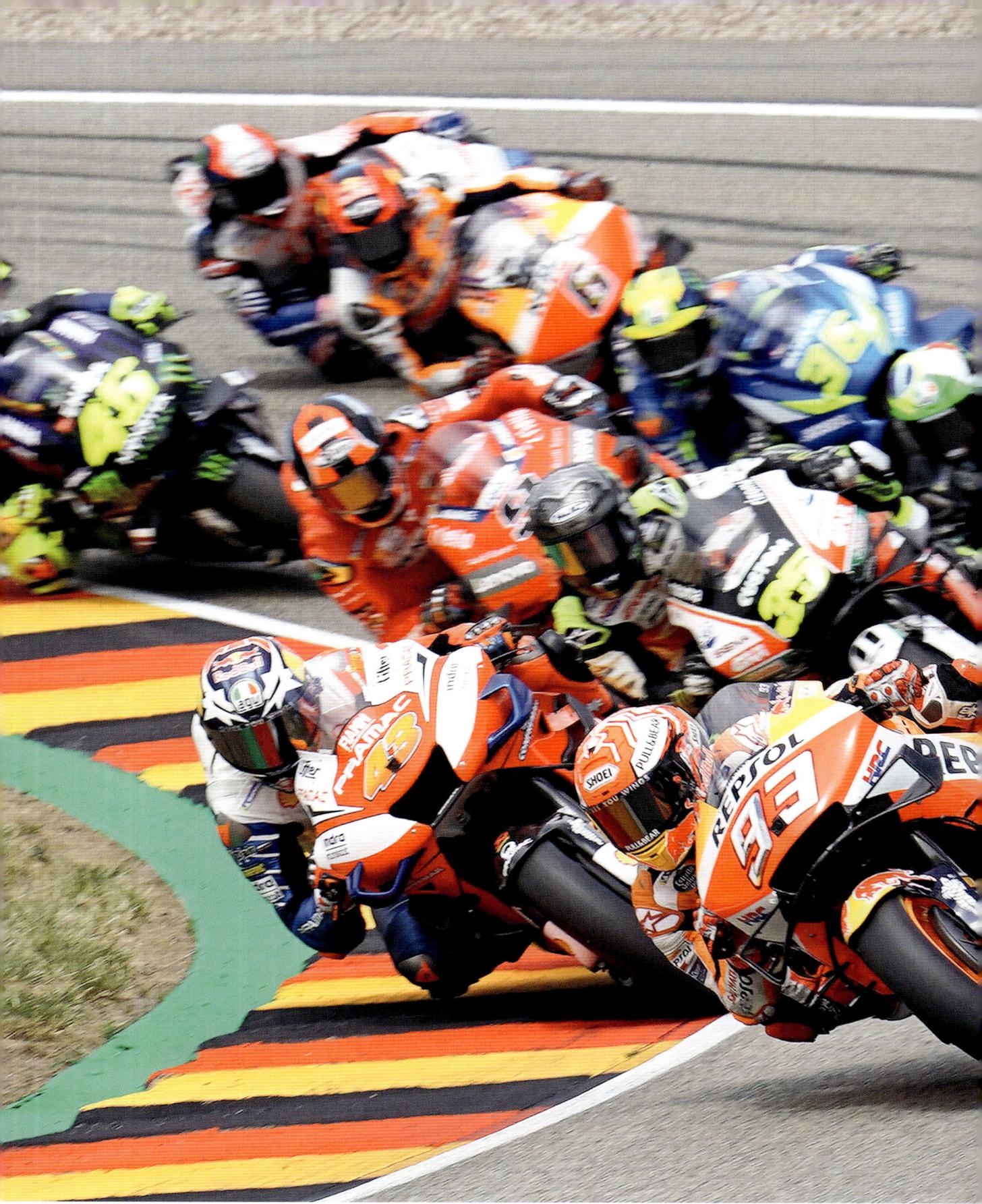

Curve 1

←
They call him King of the Ring: Marc has won every time he's raced at the Sachsenring in Germany, except when he was injured (2020 and 2022). Here he is ahead of Miller, Viñales and co. in 2019.

You have a lot of moments of breathlessness on a MotoGP bike without your realising it. It certainly happens when you're just starting out, but after a decade of racing these bikes, even I sometimes forget to breathe. There's the acceleration, on the one hand, but it's really the brakes that take your breath away. Braking well is the most difficult thing to do on a MotoGP bike, but I'll come to that in a minute. Everyone is basically equally quick on the straight. Where you make the difference as a rider is in the braking zone. You can push hard there but you need to know how. And that's when it gets complicated.

I can't even imagine what it would be like for a novice to be put on a MotoGP bike. I'm pretty sure most would be disappointed because they wouldn't be able to ride it. The slower you are, the more difficult it gets. If the bike is going too slowly, there's an increased tendency to

wheelie, and it will want to rear up while accelerating. This doesn't happen with us professionals as we come out of the turns faster. That continues down the entire straight because there is so much power. Then the next turn comes, and the game starts all over again. No, I can't imagine that an average skilled biker, even one with track experience, would enjoy my Honda.

Amazingly, my first MotoGP test in 2012 went pretty well. That was because my Moto2 bike that year wasn't good to ride. Yes, I did win the world championship pretty commandingly on it, but the stupid thing was rarely really fun to ride. What you need to know is we were using commercial engines and didn't have much in the way of electronics. Plus I had a nasty problem with chatter, which we just couldn't get under control. On some circuits the problem was more noticeable, on others less, but it was always there.

Chatter. It's what engineers call a phenomenon that has not yet been fully understood. Subtle, very fast vibrations usually build up at the front of the bike, making it impossible for the rider to steer the way he wants to. The more you steer, the stronger the chatter. So you have to wait a moment for the front of the bike to calm down before you can make the decisive move. If you're not patient, you normally end up flat on your face. Chatter is barely visible to the onlooker. Riders describe every tiny movement as feeling big, and the movements you do notice on TV are almost inevitably a prelude to a crash. Marc Márquez had his own way of dealing with this problem...

I just had to live with the chatter on my Moto2 bike. It was clear the engineers couldn't just conjure up a magic solution.

We analysed which turns the problem was worst at. I held back at those. In turns where there was less or sometimes even no chatter, I increased my lead. I couldn't stand up and say, sorry I didn't win because I had chatter! No, in our job, the rider has to deal with what the engineers produce to the best of their ability.

When I finally got to test the MotoGP Honda, it was a different world. After the first few laps, I rolled back into the box with a huge grin on my face and told the technicians, "Wow, that's a real racing bike!" Of course it helped that Honda had the best bike at the time. That isn't the case today. I was obviously overwhelmed by this experience at the same time and didn't have a moment to think because everything happened way too quickly for me as the newbie from Moto2. But I understood how smooth the whole package was, from turning to changing gear, in an instant. Then came the complicated bit: understanding how to move that kind of rocket quickly, in all conditions, on all circuits.

Why was I fast so quickly? I don't know. Why could I do the things I could? Why was I able to rely on my instincts? Why was I so cocky? I ended up flat on my face four times at one of my first tests, in Malaysia. Then a senior Honda employee took me aside and explained to me that I couldn't ride like that. Twenty years old at the time, I looked him in the eye and said, "Please don't worry about me. Take care of the bike instead. If I hurt myself, the doctors will know how to fix me." I would never say that now, but that's what I was like back then. And it worked.

I'm not an engineer. But I do want to know what my crew has put onto my bike. When I report a problem, I want to know what the solution looks like, because that influences the way I ride. However, this evolution took time – three or four years. In my first MotoGP season – which, sensationally, I finished as world champion – I just rode. I didn't care what the techni-

cians put under my backside. My approach was completely naive, yet success proved me right.

To start with, I rode purely on instinct. I just wanted the same set-up as my then team-mate, Dani Pedrosa, and that made me happy. I did the rest based on my gut feeling. Dani was definitely the best team-mate I've had at any point in my career. He's the person I learnt most from. I've become more and more engaged in the technological side of things in recent years, especially since Honda has fallen behind the competition compared to when I started out with the team. But I'm not one for suggesting solutions to my engineers. I describe the problem and say what I need in order to ride faster. It includes my observations from the track. Which turns am I losing ground to the other riders on? Where does the bike feel odd? What do I want to be different? Then we work out a plan A, and if I propose another solution, we also work out a plan B. Then we implement plan A and keep my plan B on the back burner in case plan A doesn't work. Before I put the helmet on, I want to know exactly how my technicians went about tackling the problem. For example, you have to ride a bike with a sharper steer angle and shorter wheelbase differently from a longer one with a flatter angle. It rides more aggressively.

Knowing about technology is a matter of safety. As soon as I get on the track, I'm looking to take things to the limit. OK, so I tend to crash a lot, but knowing the exact set-up helps me avoid the odd unnecessary crash here and there. It also helps you understand crashes. This may sound strange to an outsider, but not knowing why you crashed is often worse than the crash itself. It is about cause and effect, as so often in life.

The deeper you get into the nitty-gritty, the more obvious it becomes just how difficult it is to take a MotoGP bike to the limit. Another example: just giving it more

"When I finally got to test the MotoGP Honda, it was a different world. After the first few laps, I rolled back into the box with a huge grin on my face and told the technicians, 'Wow, that's a real racing bike!'"

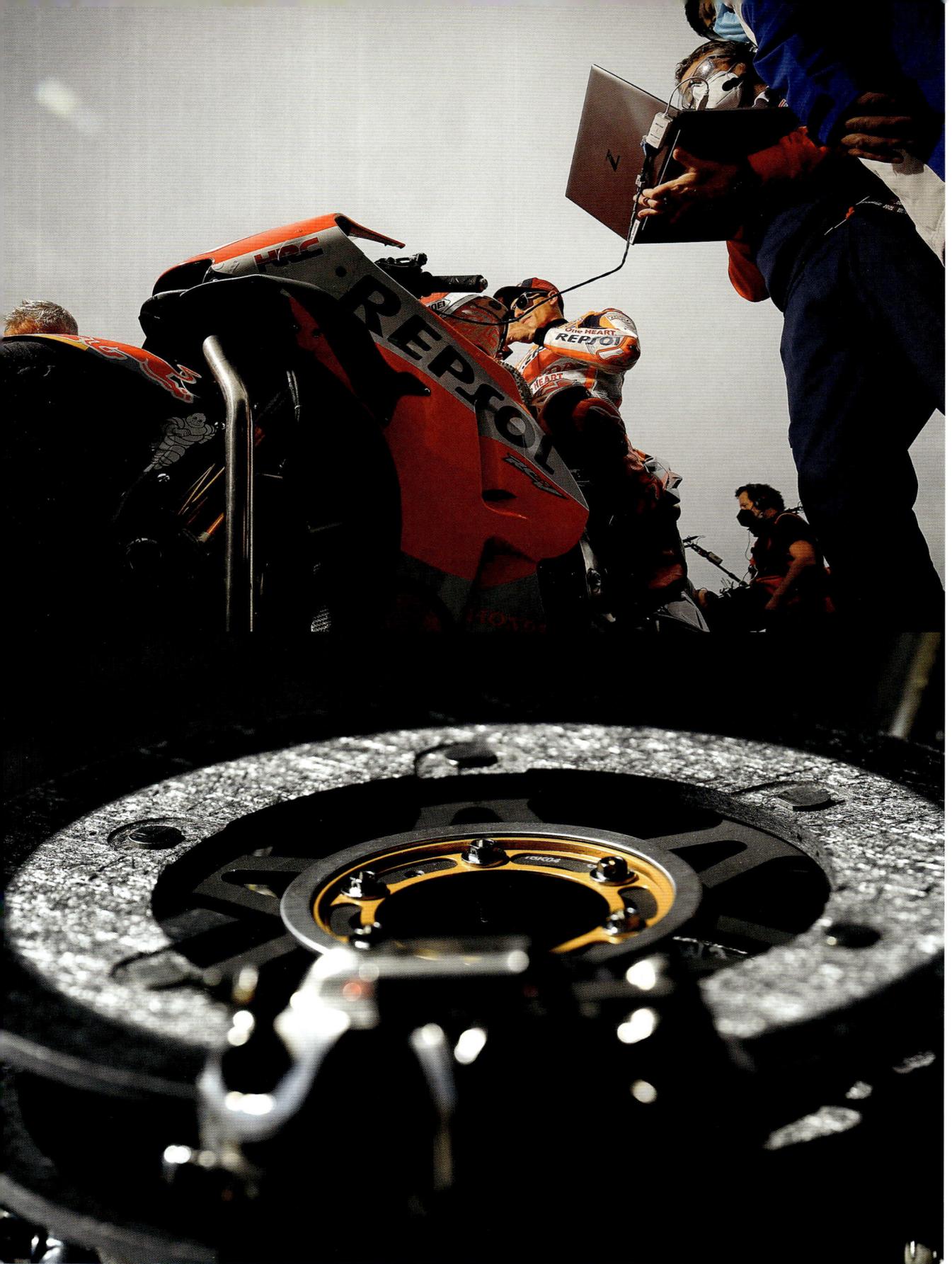

throttle and hoping that will make you faster doesn't work. On the contrary, it will be completely counter-productive. We have so many sensors on board that instantly stop you making stupid mistakes, like your hands going numb on the throttle and reducing performance. Relatively speaking, it's easiest to be quick at the pre-season tests; the conditions are perfect and the track has good grip, because we – and it's just us, no one else – do laps there for a couple of days. The conditions are consistent and they are consistently good. For that reason, all the riders' times are usually similar. But on a race weekend, it's a different matter altogether.

Race time. A Grand Prix weekend features the smaller categories – Moto3, Moto2, and the electric competition, MotoE – in addition to MotoGP. Each category uses different lines, which means different levels of tyre abrasion on different sections of the track. Throw in changeable weather, fluctuating temperatures and maybe some wind on top of that or, at some tracks, sand and dust settling on the tarmac, and you can guess how hard it is to push yourself to the limit from session to session. And, last but not least, the track undergoes its greatest change during the race itself: it gets faster due to the tyre abrasion from the 22 – usually – 300hp bikes, which themselves slow down during the 45-minute race due to their tyres degrading. The bikes also get lighter as they use up their petrol, which in turn affects the way they ride, as mentioned above. All these micro-adjustments need to be made by the riders constantly as they go elbow-to-elbow with their opponents for every tenth of a second.

Yes, we have traction control on board. It helps, of course, but the rider is still

← Thanks to the electronics, a MotoGP bike knows pretty much exactly where on the track it is. Aweinspiring: the front carbon brake discs.

Spielberg, 8th August 2021

completely on his own when it comes to finding those last three or four tenths. To make this comprehensible, I need to go into some detail. We mainly use traction control for two reasons: firstly, to spare the tyres and secondly, to lessen the power spikes that would otherwise lead to a highside. That's one of those spectacular crashes where the bike kicks you in the backside and shoots you over the outer – "high" – side of the bike to what feels like the moon and back, and you usually hit the ground very painfully.

If you use traction control too much, it's hard to ride the bike exactly as you want. You can no longer create "transfer", as we riders call targeting the load at a certain part of the bike in order to achieve the desired ride, e.g. maximum load on the rear wheel for optimal acceleration. Even if we riders now have to operate on the boundary between the benefits of traction control and its disadvantages, the bottom line is that it is a good thing, especially over the course of a whole race; it helps you avoid mistakes and maintains tyre performance over the distance better than sensitive use of the throttle alone.

You can normally tell if you're quick. You don't need a clock or signals from the box to know. You're in the flow. Your movements and thos of your bike are in sync. Strange as it may sound, when you're really fast, riding doesn't feel like much of an effort. And then there are those other days when the clock says you're slow. So you try to push. You brake later. Give it your all. Throw yourself into it. But the clock says, "Sorry, mate. You were slower." If you override the bike, as just described, you miss apexes, hit the throttle later, take less speed into the straight. It's the perfect vicious cycle.

Flow-riding is a wonderful feeling. The last time I managed that was at Jerez in 2020, just before my injury odyssey. Yes, I've won races since then and been on the podium, but the last time I felt flow was in

Jerez. In the 2019 season, which I consider the best of my career, I was able to generate this feeling of flow on a regular basis. That season, I knew that if I didn't make up time on one turn, I would on the next. There were phases when I could have done 60 laps with exactly the same lap time to within a tenth of a second. It might not always have looked that way from the outside, but trust me, 2019 was what you want as a racer, and not only because I was crowned world champion with a record-breaking leading margin of 151 points. My nearest rival would have had to win six more races and I still could have had my feet up, preparing to celebrate my world championship. In that flow year, my worst result when finishing a race was second.

I had a pretty good win at the Sachsenring in Germany in 2021 but it still wasn't flow. It was a win. Nothing more, nothing less. To be as one with your bike, it has to play along too, and in 2019, unlike the following years, it did. If there's no support from the bike, you are powerless as a rider, even if you have a significantly higher impact on overall performance, as a human being, in MotoGP than you do in Formula 1, for example.

If you are not at one with your equipment, things get difficult. At moments like those, my team advises me to study the data to see where I'm losing time. But I know instinctively when studying the data will slow me down, not make me faster. I can feel when to trust the numbers and when to trust my gut.

There are days when I can't find the limit. I can feel when I have a mental knot that makes it impossible for me to reach my potential. This is how it went down at the official MotoGP test in Malaysia: I was slow and I knew it. I asked the team for a two-hour break. Then I did two runs with new tyres, just like that, almost for fun, on the same bike I had been so slow on in the morning, with no adjustments.

"I can feel when to trust the numbers and when to trust my gut. There are days when I can't find the limit. I can feel when I have a knot in my brain that makes it impossible for me to reach my potential."

That way, I was able to reboot my system and the lap times came. But you don't have that luxury on a race weekend. There, it's much more difficult to get back into the zone if things aren't working. That's why I try never to get out of it.

On race weekends, I work to my own rhythm. FP1: five laps on the bike, stop. [FP1 is the first free practice session on the Friday] FP2: five laps on the bike, stop. Qualifying: the same thing. Boredom is hard for me, having two hours on the bike where I can pretty much do whatever I want. Tests, for example: after three laps, I'm fourth but after two hours I'm tenth, because the others have improved compared to me. The ability to improve during a session is definitely where I am weaker. If I was competing in endurance races, marathons like the Dakar, I'd have zero motivation. I need the maximum amount of adrenaline in the shortest possible time. And I have to be at the limit.

I didn't sit on a motorcycle after the 2022 Grand Prix in Valencia for a single second for over two months to give my arm time to fully recover after surgery. My brother Álex and my sparring partner José are really good motocross riders, and they're bloody quick. I first got back on a bike with those two after the long enforced break. The first two laps were still a bit sluggish, but then it all came flooding back. I might not have been inch-perfect, but I was straight back up to speed again. Or take the MotoGP test in Misano in 2022, after my injury, with a completely crooked upper arm and a shoulder like the Grinch: I clocked the fastest time by a Honda rider, by far, just like that on a track that all the other riders knew perfectly well from the previous race, and with the same set-up as my team-mate, Pol Espargaró! After three whole months without getting on a motorcycle. I'd immediately found my limit again, because I couldn't improve my time after that. That is what sets me apart from many other riders; they improve

from session to session, whereas I hit my personal limit straight away. It's easy for me to find it.

Maybe I should correct that. There is no limit. OK, I've put together some pretty good laps in my life. Qualifying in Malaysia in 2022 was one of those laps where I didn't know where the time had come from: Pecco Bagnaia had crashed right in front of me, and I had had an odd crazy moment or two of my own on a track where I wasn't expecting all that much, and yet I managed to get my Honda on the front row of the grid. Was it a perfect lap? No, because it wasn't without its mistakes. But the time was good. I get annoyed when other riders say in interviews, "I had the perfect lap." NO, you really didn't. Maybe you had a bloody good lap, maybe even the best lap possible under the current conditions, but perfect? There is no such thing in our sport. Pole position only tells us who was able to make the most of the current conditions. From a pure riding point of view, the guy in sixth might have been better, but no one noticed because his bike was slower.

What probably does exist is the perfect race. That doesn't mean leading from start to finish, but rather the fact that you chose the right strategy. Sometimes that means going easy on the tyres to be able to attack towards the end; sometimes it means creating a lead right at the beginning and then controlling the race, or attacking your opponents here and there and then moving in for the kill. Unlike the best possible lap, you can tell a perfect race from the result when the number 1 lights up at the end. That's what it's all about: winning races. Everything else is just a warm-up exercise, a means to an end. You've done a good job if you won. Who cares about fifth place?

Whether you win also depends on your rivals. Why do I train like a lunatic in the winter? Because I know how hard my competitors are working on themselves. In order to be able to train properly, I need

points of reference. For example, I've been practising karting a lot lately. I was on the track by myself recently without so much as a lap-time monitor to check myself against. Man, was that boring! My thoughts began to wander, and although I really wasn't slow out there, the training session was a waste of time. I need someone or something to compete with. Always.

That's why the first and last three laps of a Grand Prix are the most interesting, especially if I'm caught in traffic. That's the best feeling ever! As a five-, six-, seven-year-old child, I rode in motocross and enduro at the same time. Even back then I told my father I didn't want to do enduro any more because it's just you against the clock and not against direct competitors. I need the adrenaline, and I only get that from battling it out against other riders. For that reason, I never train alone, but always with my brother or José Luis Martínez, who was a Spanish motocross champion. His job in my entourage is to be so fast and so fit that I struggle to keep up with him. He is a real benchmark off-road. Riding around a track alone feels like a chore to me. The fun comes in competing directly against others. And everything is easier when you're having fun.

How can I describe what a fast lap on my bike feels like, with all the hustle and bustle that comes with it? Right after the start, with all the other bikes around me, the noise, the adrenaline, all the action, it's like being in a tunnel. I can't even hear my bike when I'm in a group – and that's almost always the case at the start – and that's not because I'm wearing earplugs. I always protect my ears when I ride, otherwise I can't concentrate. And there's a psychological component to it too; the louder the bike, the faster and closer to the limit you feel. When you protect your ears, though, everything is fine, straightforward. It's also easier for me to understand my bike if it isn't roaring at me, such as when traction control kicks in, how the engine

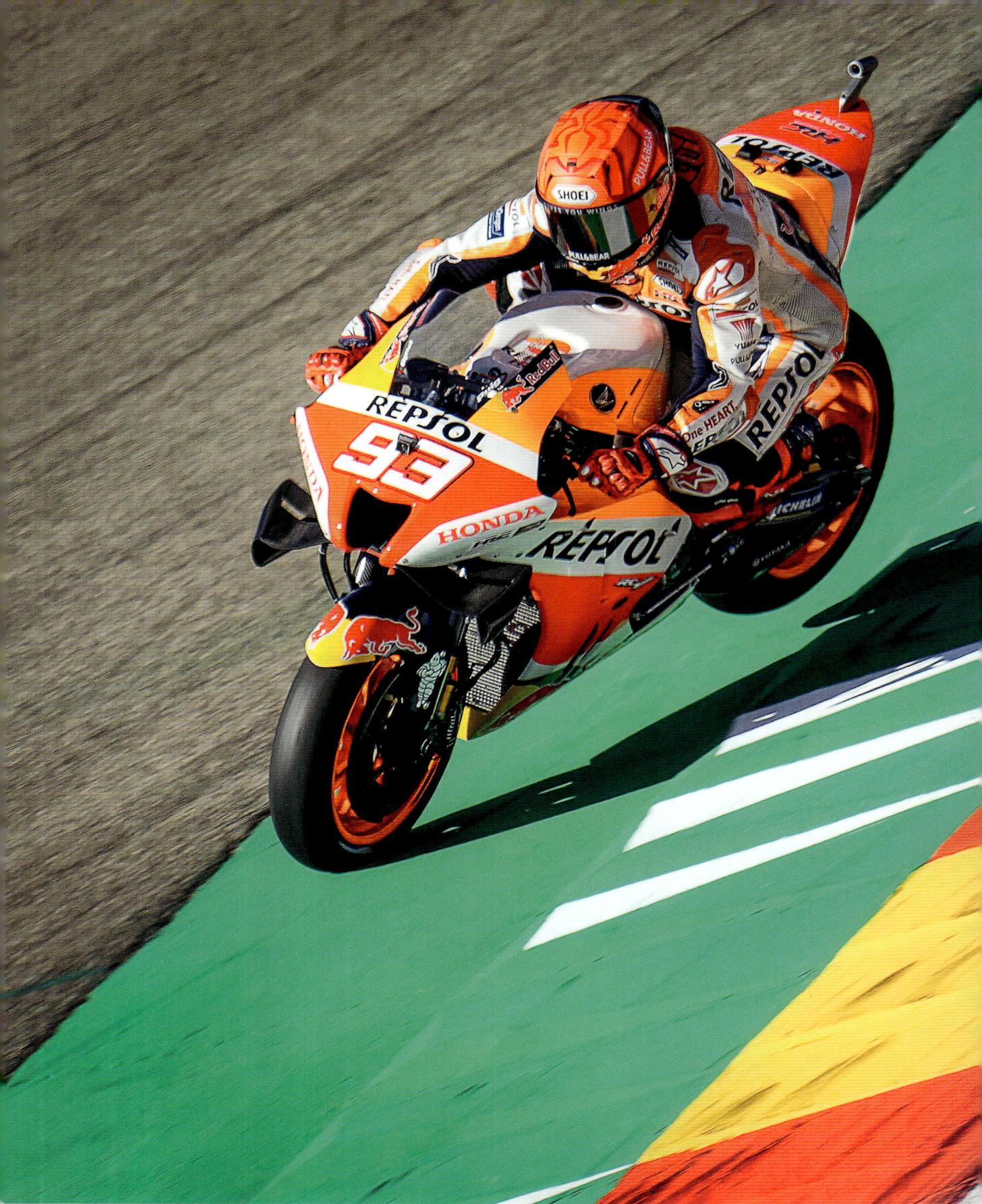

← Searching for the limit in free practice at MotorLand Aragón, Spain, in 2021, after returning from injury lay-off.

brake is behaving, that sort of thing. If you don't protect your ears, the exhaust drowns out the engine noise. But if you want to be quick, you have to hear the engine. Unlike most road bikes, you really do ride a MotoGP bike by ear. With my Honda you hardly feel any vibration on the handlebars. The bike is extremely smooth.

At the start, I ride purely on instinct. I shift up a gear when I feel it's time. I can't tell you how I feel it, probably due to tiny vibrations, because I don't have time to look at the dashboard and check the revs. It even goes as far as me not knowing how I overtook which competitors, and when, as I analyse the race afterwards. How did I get past them there? Sometimes I can't explain it to myself that evening either. Normally I remember my overtaking manoeuvres very well, but when I am in instinct mode, full attack, then there are always moments when I am amazed at myself.

Once the race has calmed down a bit, it's time for me to take care of my fellow competitors. I know who will fight back after an overtaking manoeuvre from me and who will usually let it be. There are a couple of guys out there who it's definitely not a good idea to tangle with, but basically I don't care. I'll mess with anyone because it's my job to win races. I only make exceptions when it comes to a championship and my main goal is to bring home more points than my direct world championship competitor. Then – but only then – I'll settle for fourth or fifth. I've matured now, even if my instincts say attack, go and get the guy!

Corkscrew. A young Marc pulls off one of the most stunning overtaking manoeuvres against MotoGP legend Valentino Rossi in Laguna Seca, California, in 2013. The key section is a blind, steep downhill passage with a right-hand turn, known as the Corkscrew. Finding the limit there takes a lot of courage. It's almost impossible to overtake on this part of the track, but Valentino Rossi had done it in 2008 with a breathtaking manoeuvre against Australia's Casey Stoner. The experts agreed we would never see the likes of it again, and if we did, it wouldn't turn out so well next time. Until, that is, Marc got past none other than Valentino Rossi right there, in an even more hair-raising manoeuvre than the old master himself had pulled off. Marc and his Honda flew past the nine-time World Champion on the inside, both wheels in the gravel, as if he was sitting on a motocross bike, not a racing machine with slick tyres. He got back on terra firma, swerved and won the race ahead of an astonished Rossi. Their faces at the finish line, eyes wide open, the hugs, the pat on the back, showed the whole world that something sensational had just happened, something even the two champions hadn't expected. A moment that would go down in history.

I'd be lying if I said I planned that move. I was in a duel with Valentino, and up at the top of the Corkscrew I simply ran out of space. All of a sudden, I was next to Valentino on the outside. There was no intention, no genius on my part. I had gone into the corner too fast and the only chance to save the race was to stick to my guns, take a short-cut downhill through the gravel and get back on the track ahead of Vale. I knew that he had done the same trick himself in 2008, but at that moment there was no time to think about history. The media would later try to talk it up as being a great act of revenge against the legend Rossi, but the fact is I didn't care

who was in front of me, whether it was Pedrosa, Lorenzo, Rossi or someone else. I wanted to, no, I just had to get past. Names don't matter. And I didn't want to battle it out. I just wanted to overtake as quickly as possible.

When both wheels left the tarmac, it was one of those breathless moments that I talked about at the beginning. You release the brakes, hold your breath and wait to see what happens. Of course, the whole move could very well have gone disastrously wrong. It was like in qualifying, where you go out onto the track knowing there's a probability you're going to crash. Sometimes it goes well and you're the hero. Sometimes you fall flat on your face. With the Corkscrew move, I was the hero.

Sometimes you get overtaken too, sadly. Style matters in such cases, I think. At least I'll react accordingly. If it happens fairly – and that can be hard but OK – then I take it on the chin and let them go if they're actually faster – or I just wait for my chance to get them back. But if someone aggressively forces his way past me unfairly, I'll be coming for him on the next corner. He can be sure of that! I know no mercy in such cases. At times like those, I don't care about the race or tactics. It's all about one thing: getting the guy! In the last few years, however, I have noticed the odd subtle sign of mellowing with age. I no longer have to strike back immediately if someone does something stupid, but on the whole my fighting instincts are still intact, and my dear fellow competitors know that too. Do I make friends with that attitude? That's not the point.

It is striking to see in old videos that at one point I turned the riding style in MotoGP on its head. I was the first to rely entirely on front-wheel grip, those – what? – 10cm² of rubber that come into contact with the tarmac. To put it bluntly, I had stopped caring about the rear wheel during my time in Moto2, at the latest. The main thing is that the front wheel does

what I want it to. And that is perhaps also my weak point: if I can't rely on the grip at the front, you can forget the whole race. This usually happens to me at the Losail Circuit in Qatar. We just can't get the front wheel to work at that track and haven't been able to for years.

My front-wheel-oriented riding style only intensified from my time in Moto2 to my first years in MotoGP. That was down to the Bridgestone tyres we used at the time. They gave me so much confidence that I could let the back of the bike slide however I liked. You have a lot of tools to help you control a sliding rear: rear-wheel brake, engine brake, clutch, your body position. You get the back of the bike to swing out in the braking zone by actively shifting your weight forward, thus freeing up the rear. Then you jump on the rear brake to initiate and stabilise the drift. Now you need instinctive feeling to give the front tyre, which is already under enormous strain, only as much load in the braking zone as it can still transfer.

Much of the performance in the current bike generation comes from the aerodynamic aids we have today. This also requires a different riding style, because the more the bike slides, the more inefficient the aerodynamics. In recent years, the Ducatis and their extremely sophisticated aerodynamics have been the benchmark, and Ducati riders all have a similar style: brake hard, turn hard, get through the turn as quickly as possible, straighten up quickly, full throttle, a bit like in the two-stroke era. My natural style, shaped by flat track and off-road, is rounder, with a rear that always wants to swing out a little. On some tracks my style still works quite well; on others I get problems with the rear tyre because it overheats. So I'm having to learn to adapt my riding style to the current times.

The aerodynamic revolution has changed our bikes more than people realise. When I came into MotoGP, we could only

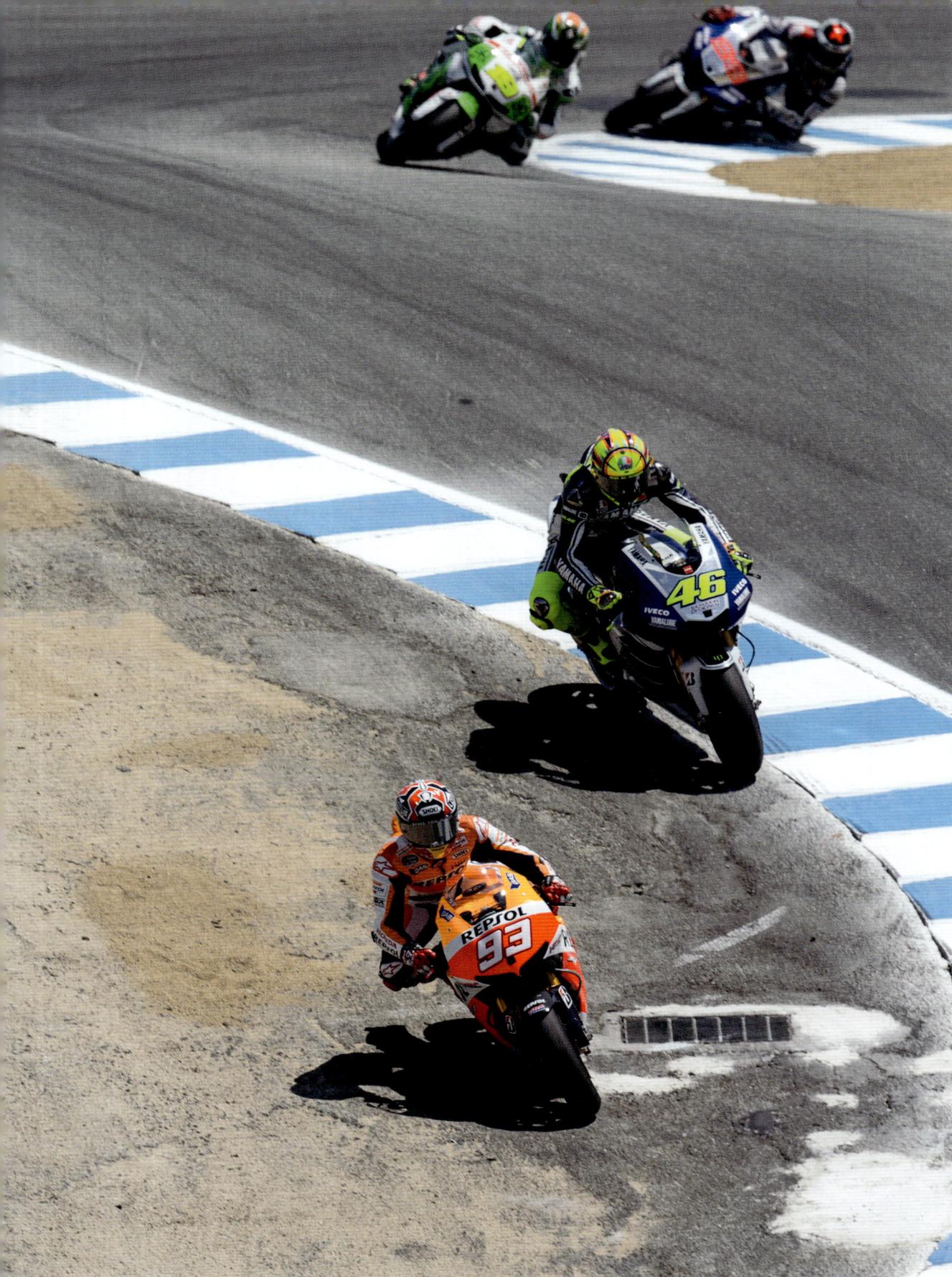

Curve 1

get maximum engine power from third or fourth gear. Now the electronics mean we can from second gear because of the downforce. You can also feel it when braking and especially on fast corners. For example, if you have aerodynamic parts on the bike that don't work well, as was sometimes the case with Honda in recent years, the bike will want to go straight ahead on fast corners. I lean the bike over far more than almost any other rider on the grid; 60° is normal for me. With some aerodynamic set-ups I couldn't manage more than 56°! I just couldn't force the bike down. We now have to ride this generation of aero bikes, and because they are faster than motorcycles without wings, I have to adapt to their idiosyncrasies, even though I am not a fan.

Aero bikes are faster, easier to ride and more stable – basically exactly what you want as a rider. But it annoys me that racing suffers as a result. What does a bike fan want to see in a race? Us going elbow-to-elbow against each other. Now we're getting to a situation where, depending on the track, you need to be at least three, four tenths of a second faster per lap than the guy in front of you if you want to have a go at overtaking. Motorcycles lose contact pressure in the slipstream, so that the bike of the rider behind brakes worse than the guy he's following. In the acceleration phase, you used to have fewer wheelies than guy chasing. With aero? The exact opposite! The wings are worse at holding the front down in the slipstream and the rider can't get on the throttle as quickly. None of this is good for action. Formula 1 took years to solve the problem of lack of overtaking due to their cars having too good aerodynamics. Now we're opening the same can of worms in MotoGP. However, aerodynamic aids won't disappear overnight, because of course the teams that have gained an advantage will defend themselves tooth and nail against any change. And we already have the first

← **A move that went down in history: Marc overtakes Valentino Rossi at the Corkscrew in an extraordinarily unorthodox way.**

commercial motorcycles with wings, which have evolved from MotoGP.

Another development that I'm not totally positive about is how smart our bikes are, relatively speaking. For a long time now we've been finding ways to improve lap times on computers and not in the riders themselves. There is only so much to be gained by adapting riding style. If your team doesn't have a handle on the electronics, the mechanics can forget about the set-up – suspension elements, geometry, tyres. Our bikes know where they are on the track, what they have to do there, how much power they can release. But saying that, I have to put it into perspective at the same time because the bikes were smarter still before 2016. That was before the standard Magneti Marelli electronics era. The Italian manufacturer has been supplying the same hardware and software for all motorcycles since then, and the teams can only configure them according to rider preferences. It saves money because no new developments are possible. My favourite bike – and at the same time the smartest – was probably my world championship bike of 2014. It suited me down to the ground.

To give an example of how complex MotoGP has become and how one thing affects another... When I came back in 2022 after my injury, my body position changed between Friday and Sunday because my physical level wouldn't let me go three days flat out. And so my Honda went from riding well to barely rideable at all, although we hadn't changed a screw, a shock-absorber or even made a click on a laptop. I felt good in Thailand and was consistently in the top five on the Friday and Saturday. In the warm-up on the Sunday I was in the bottom third. I felt tired, my bike slid more, tended to wheelie more, braked worse, and all because my fatigue meant that my position on the bike no longer tallied with the parameters in the system. Because I was tired, my body

→
Marc has great faith in his front-wheel grip. This pic goes to show why the rear brake disc can be so small.

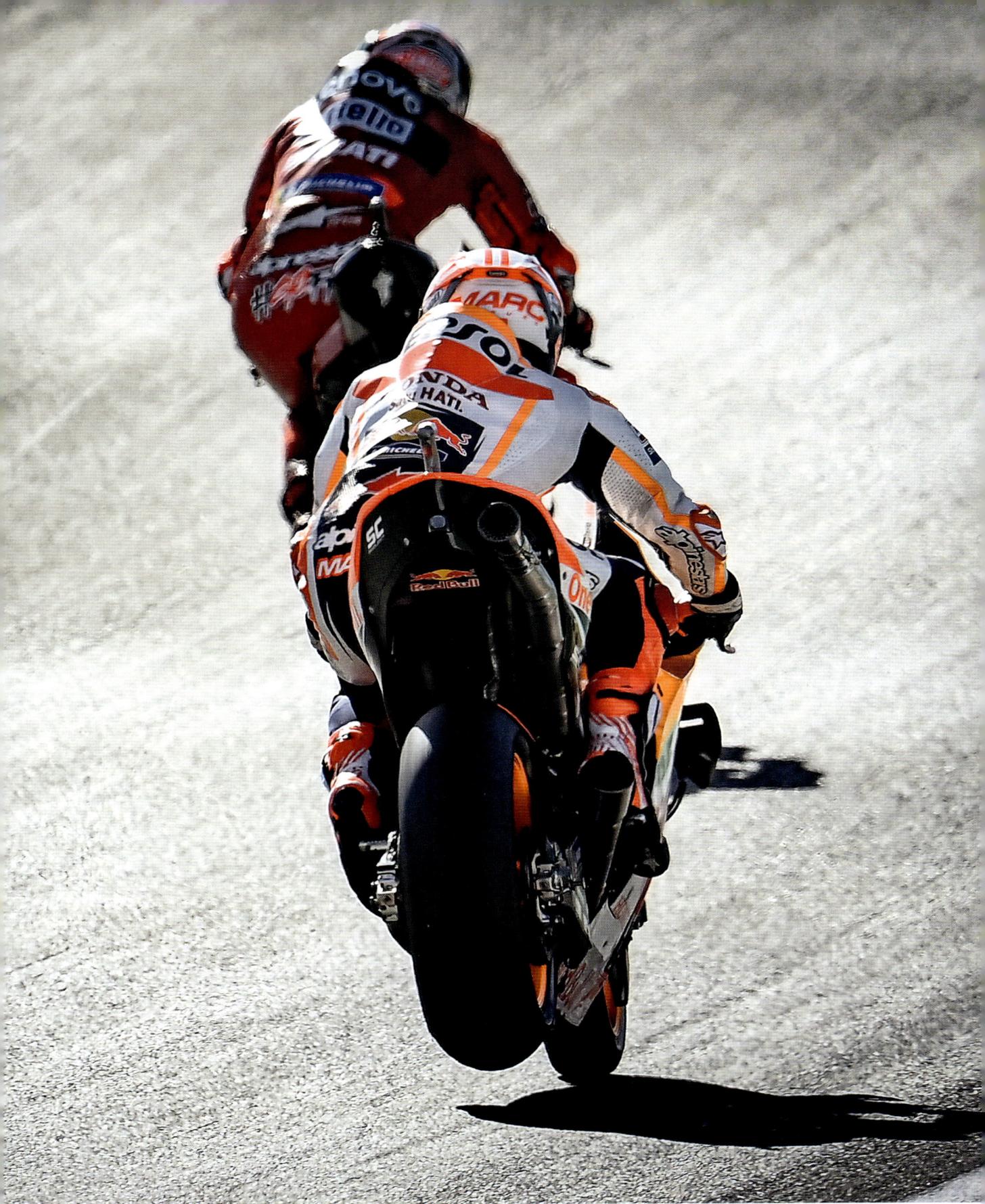

moved forward in the braking zones, which relieved the rear wheel a little more. That meant the engine brake was inefficient and I had to stay on the front brake longer. When the rear wheel came back into contact with the ground, the bike understood it needed engine braking and went for it full-on. By the time I turned, I had already missed the apex. So does that make our bikes smart or stupid? Let's put it this way: they are very good at doing what they are supposed to do in a perfect world. When reality kicks in, you need the rider back.

Before you get on a bike, you already know where you might crash. It's that simple. You know where you can take more risk and where you have to be a little more reserved. Misano and Phillip Island have turns like that. In other places you just try to see how far you can take it, and if you crash, that's just the way it is.

It's the crashes you least expect that occupy your mind for longer, like when my rear tyre kicked out completely unexpectedly during the warm-up in Indonesia in 2022. Those crashes aren't normal. Highsides where the sliding rear wheel abruptly finds grip again are particularly painful. You feel the highside coming, but there's nothing you can do about it. You feel like you're in the air forever. If you have time to think while you're flying through the air, you know that you are in the middle of a massive crash and that it's probably going to hurt quite a bit. From that point on, there's pretty much nothing you can do to minimise the consequences. Of course, you try to protect your body, but just curling yourself up in a ball, as your instincts tell you to, is no more useful than spreading your arms out wide when it comes to slowing down your rolling body in the run-off zone. You can probably only learn the right crash position with practice, and I have practised enough over the course of my career. I never learnt to control my body position in the air on

the trampoline, for example. I have learnt pretty much everything I know about crashing in pain on the racetracks of this world. Of course, instinct also comes into play. For the last two years, I've always tried to protect my injured right arm. It's automatic. There's nothing I can do about it. However, this has meant I could no longer balance when crashing, the result being that crashes hurt even more.

I need five or six laps after a big crash to take things to the limit again, to have my confidence back. And not just where I crashed. Everywhere. The average crash looks something like this: your front wheel slips away, and even as you're skidding along the tarmac, you think to yourself, "Where's my spare bike?"

The crash that divided my life into a before and after wasn't spectacular. It wasn't anywhere near the top ten of my big crashes. And yet it had the greatest impact. I talk about that in detail in Chapter 8.

Rule number one after any crash: get up and leave the track on your own two feet if you can. My parents drummed that into me from an early age. If you can get up, get up, so we don't worry! Even if it hurts, leave the crash site! That was the case when I was a child and fell off my bike or just while out running and then later on, on my motorbike too. You can worry about the pain later, but first get up! Even after my massive crash in Indonesia, where there are seconds I can't remember, I got up and staggered beyond the guard rails by myself, so automatically is it instilled in me. You don't stay down unless you have a broken leg or something like that and you really can't get up. Something that still really gets on my nerves today is when riders remain motionless in the gravel after a crash, play dead and then ten minutes later are happily back on the spare bike.

Some riders are fully fledged drama queens. As a rider, you are pretty good at assessing your competitors' pain. Going down over the front wheel is an everyday

"When that time comes, it will give me extra motivation to try to delay the changing of the guard and to understand what it is that makes this young guy who wants to take my place so fast."

thing. You really don't have to make a drama out of it. In our world it's basically a splinter, and yet some people act like they've been struck by lightning. I find that unnecessary.

I flinch when I see my brother Álex crash, as do my parents, of course. But we have all experienced so many that we are very good at distinguishing between a bad crash and a normal crash. Crashing is part of the job, and our parents know that too. Over the years, they have become experts in crash analysis, as I experienced during my enforced break. Even during the crash, they are able to distinguish the type of accident. I was sitting next to my mother in front of the TV when Álex was hurled off his bike and she was trenchant in her analysis. "What the hell is he doing!" – and this was while he was still skidding along on his backside. But when it came to the more dramatic dismounts, silence. And it stayed silent until he was back on his own two feet again, a good five seconds later. Five seconds can be quite a long time when your brother or son has just been very unceremoniously separated from his MotoGP bike.

I'm 30 now, back in good shape and still quick on two wheels. I see that every day when I train with my brother. I also get a lot of confidence from the fact that there is no one who can ride a Honda faster than me. No one. One day – today, tomorrow or in a couple of years' time – someone will come along who can ride my bike faster than I can. That is a completely normal, natural way for things to develop. When that time comes, it will give me extra motivation to try to delay the changing of the guard and to understand what it is that makes this young guy who wants to take my place so fast.

In recent years, careers have become much longer, especially in motorsport. Valentino Rossi and Fernando Alonso have shown that you can still keep up with the world's best even at the age of 40 if you remain willing to adapt. A generation ago, sportsmen of that age were unthinkable. It goes to show how professional the scene has become in the last decade. You have to invest a lot more today than we did when my career was starting out, especially physically. The days of your job as a racer being Thursday to Sunday at the track are long gone. If you want to get to the top, you need to understand that racing is a year-round job, seven days a week. November is the only month training slows down a bit. It's also when I lose a kilo or two, even though I don't change my diet. It's me losing muscle mass. At the beginning of the season, I'm back to my fighting weight of 65kg, which I'll maintain until the autumn. I'm so attuned to my body that I feel weaker if I weigh 64kg. I don't need scales to know that either. If I can sense that something is wrong, I try to find out why that is.

Some of the guys work that out at an early age, and those that don't want to know won't have great careers. As long as your body is in good shape, there's no reason why you shouldn't be able to ride MotoGP for 20 years, and it really is one of the most exciting things you can do, believe me!

All crashes great and small. Top: slip-up in Argentina in 2017. Bottom: huge highside in Thailand in 2019.

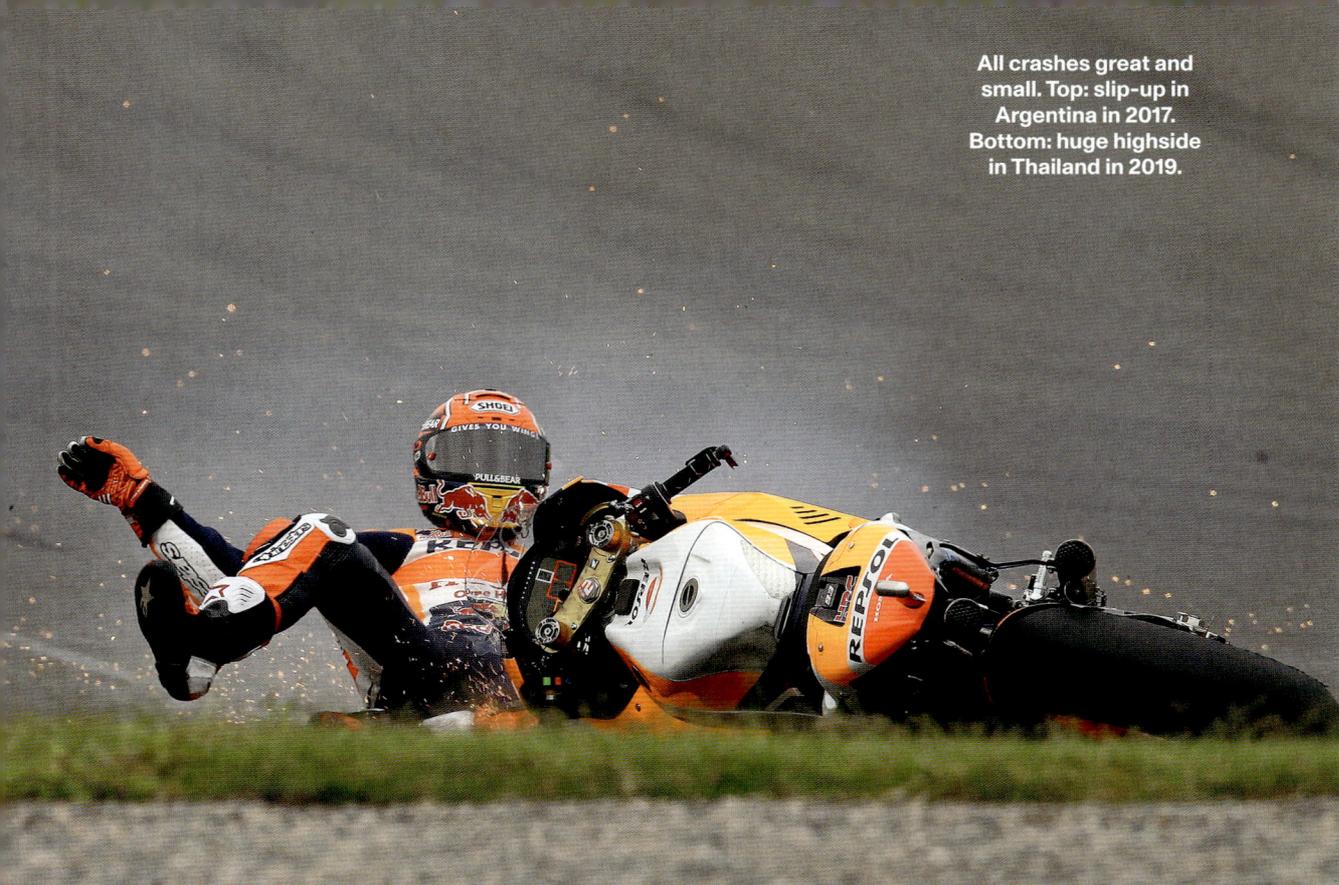

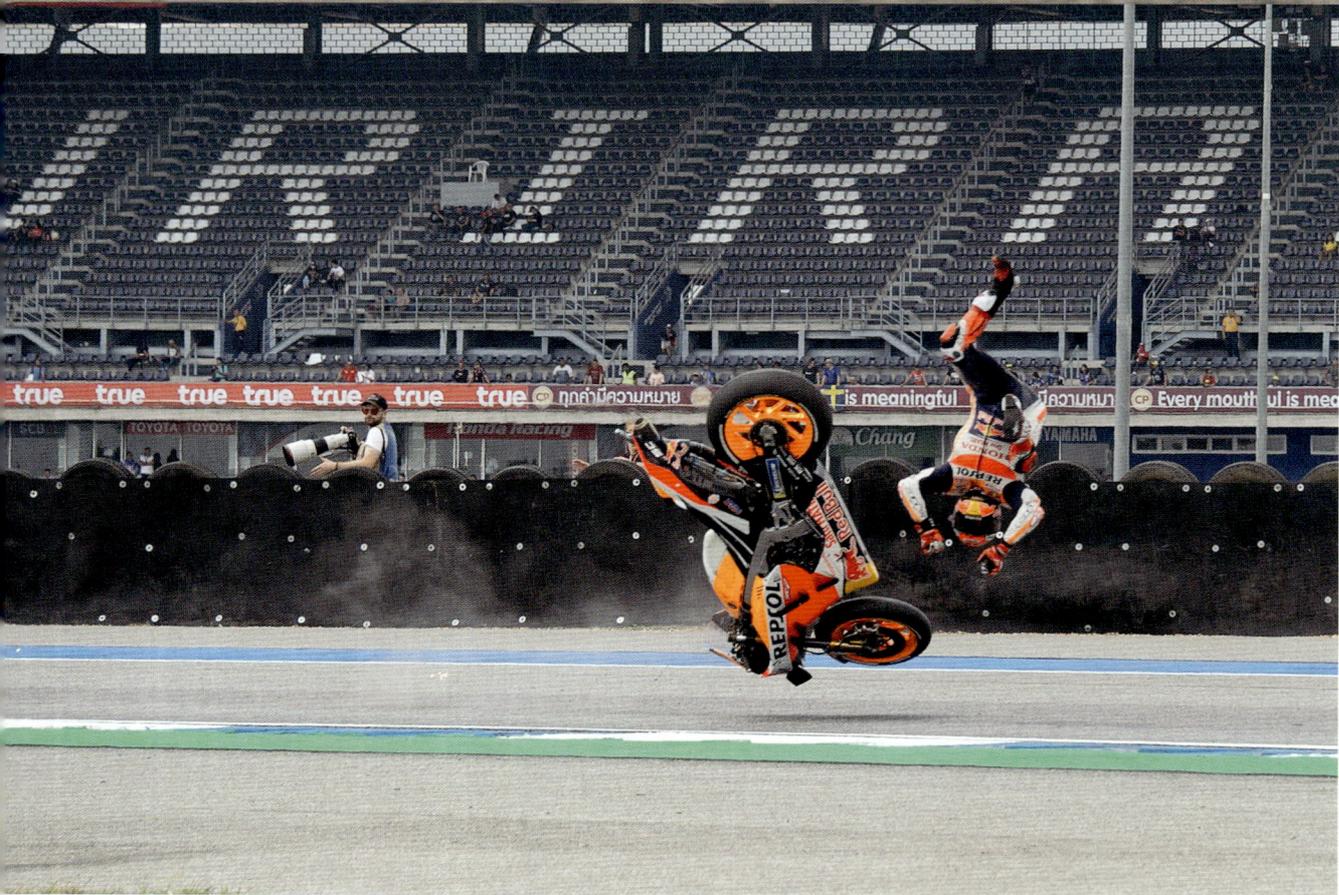

Small crashes that feel big. Álex Márquez takes a harmless-looking slide at Le Mans in 2021, only to painfully cartwheel in the gravel.

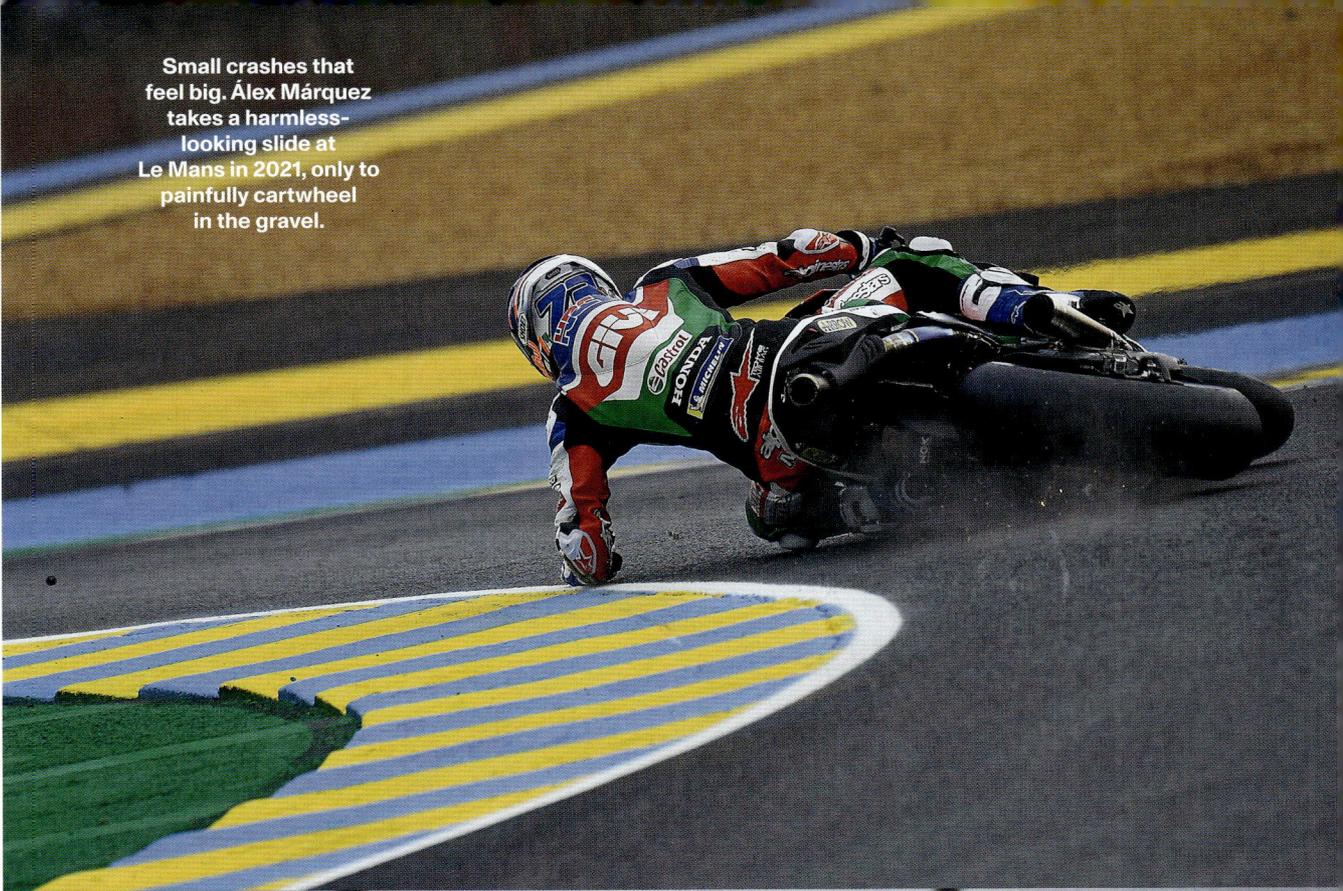

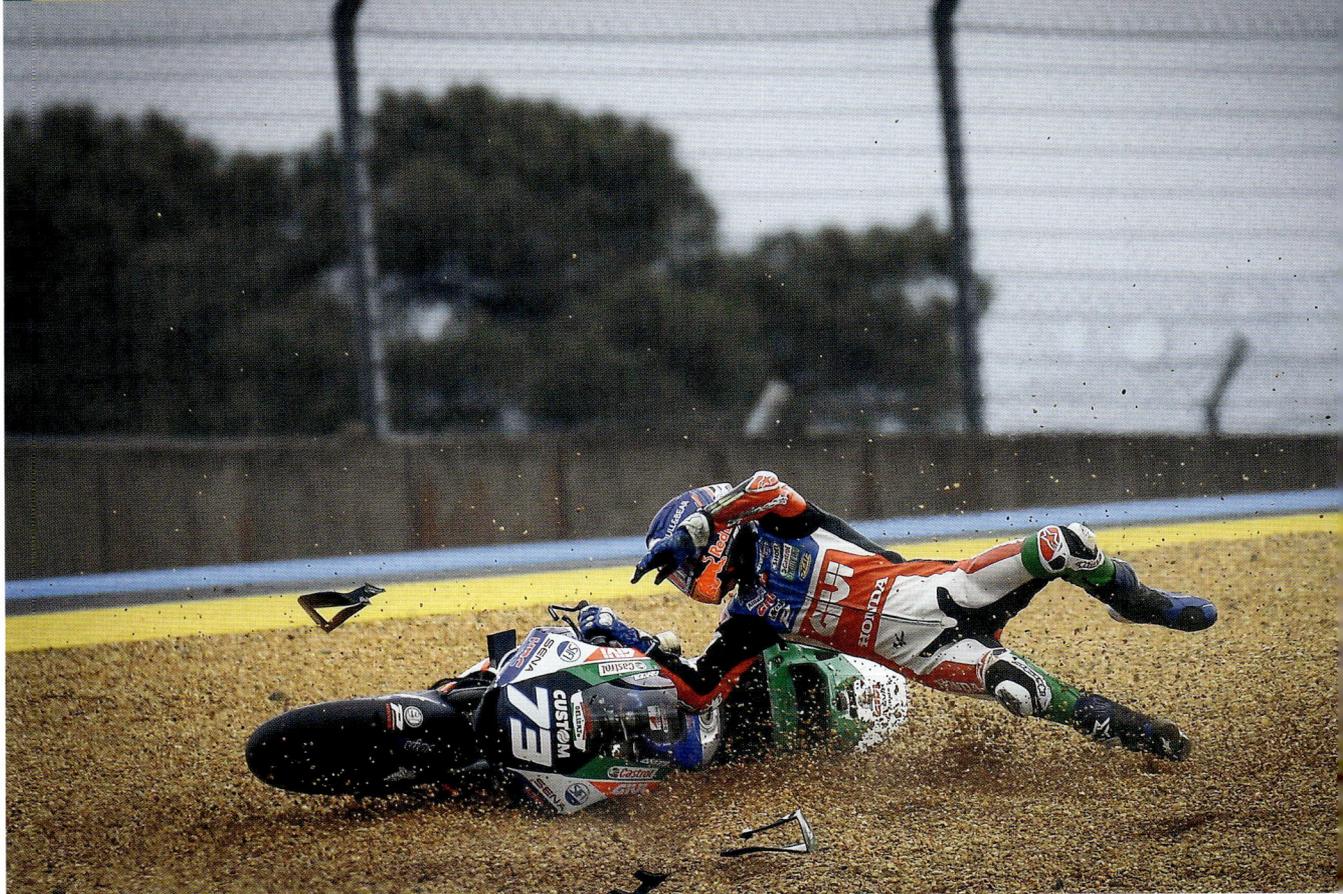

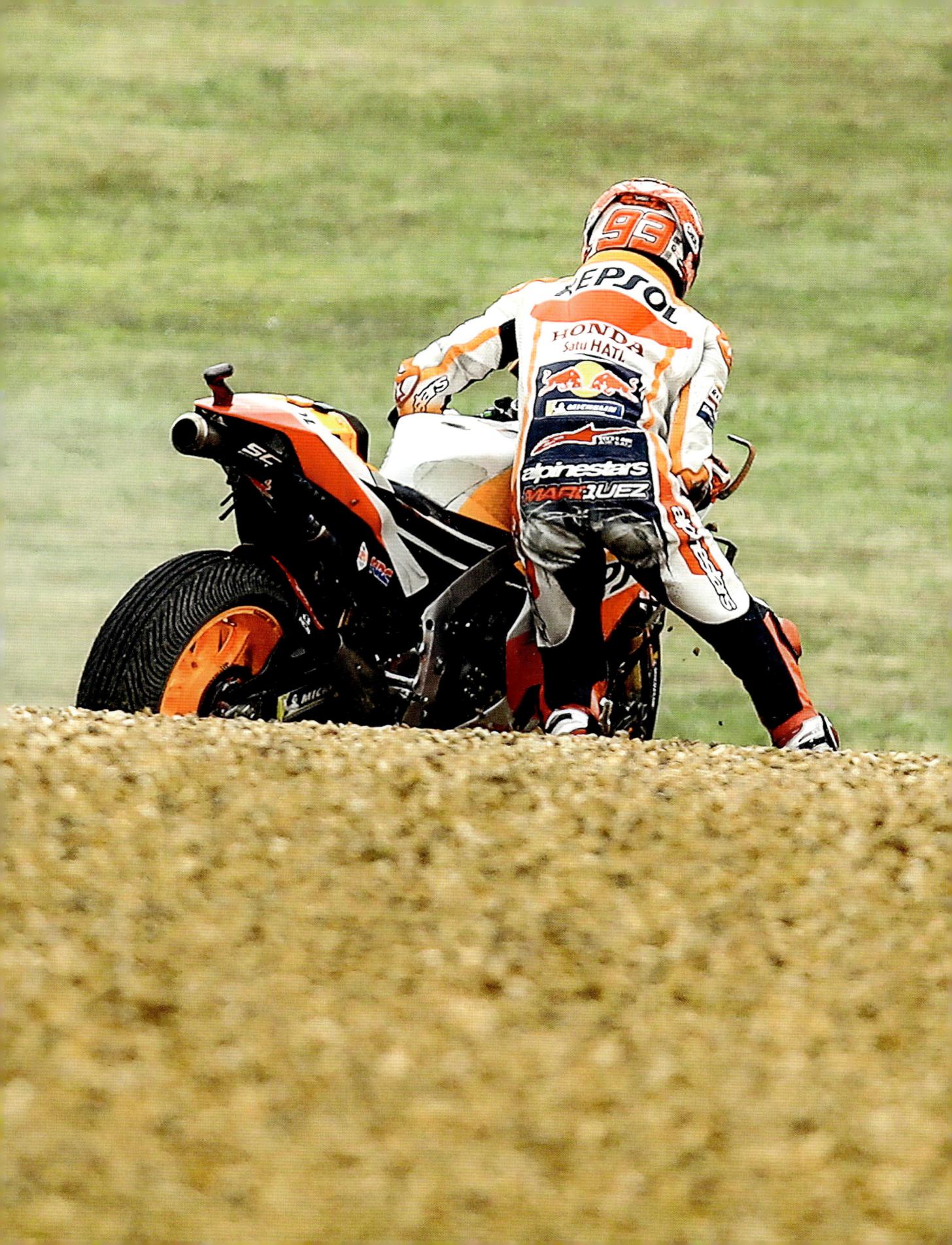

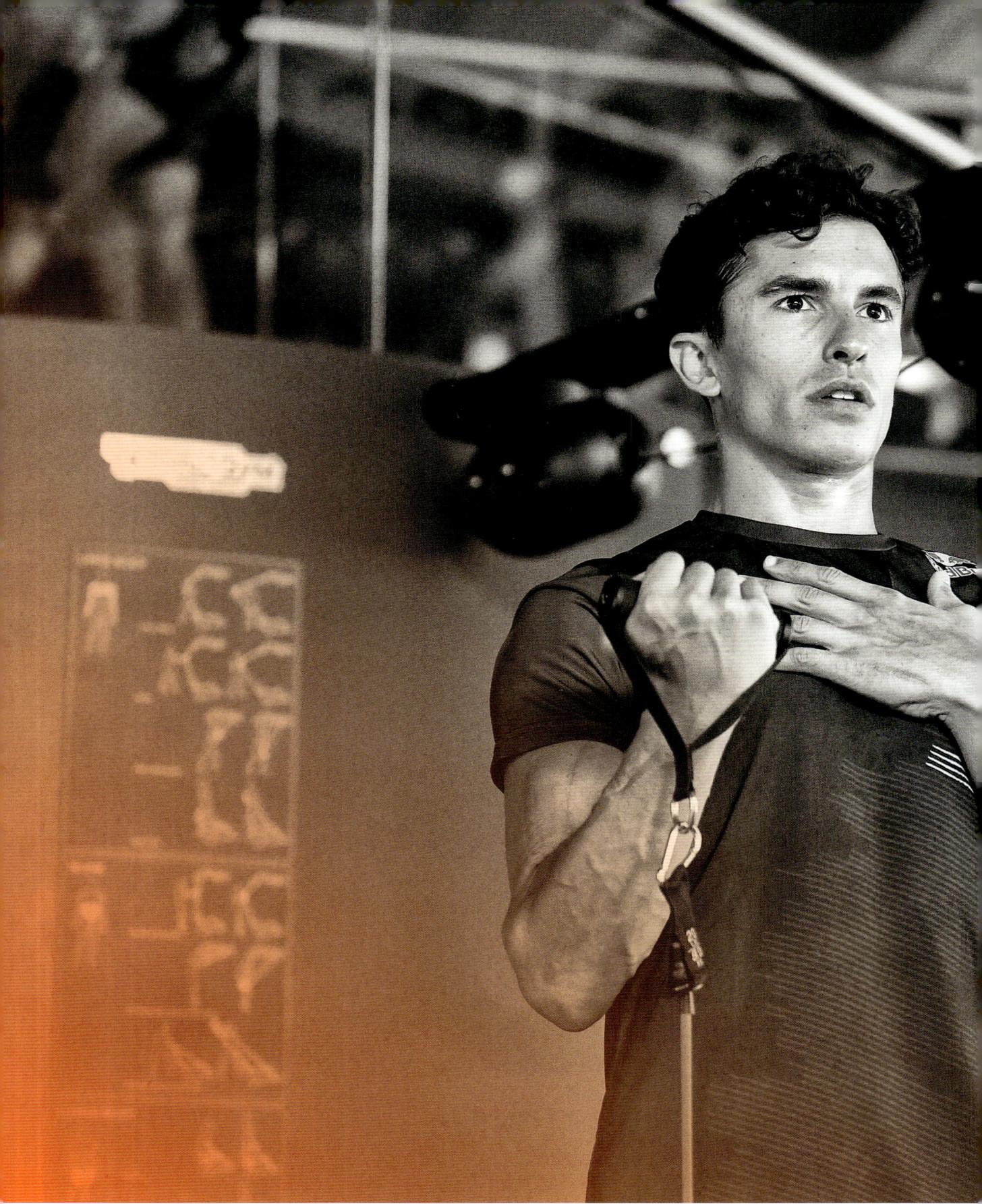

Concentration

Routines that make
life easier

Every rider, every sportsman or woman, has their own routine before they even start. Some routines come about subconsciously; others are a conscious ritual. Science talks of "pre-performance routines", or PPR for short. Valentino Rossi would get down on his knees next to his motorbike and talk to it. Pierre Gasly tests his reflexes by catching tennis balls. Rafael Nadal tugs his clothes and touches his face before his serve. These routines have two purposes: on the one hand, they reassure the athlete, remind them that they have been in this situation many times before, that they already know what is about to happen. And secondly, they are a wake-up ritual for body and mind. Uh-oh! Things are about to get serious. It's the calm before the storm. Athletes get into the "zone", the state that allows them to perform at their best. A 2021 study published in the *International Review of Sport and Exercise Psychology* confirms the effectiveness of PPR across sports and genders. The science distinguishes between rituals and routines. Routines are recurring sequences that benefit the process, the thing itself. Rituals have a more symbolic character that convey emotional security: like the footballer who crosses himself before a game, or keeping a lucky charm in a shoe, as Sebastian Vettel used to do. Marc's father Julià also has a ritual: when Marc is racing, he stands in the box with his fingers crossed. And as for his son? He is more the routine type, and very precise routines they are too.

→
The calm before the storm: things get real when the visor comes down. Body and mind are on heightened alert even earlier.

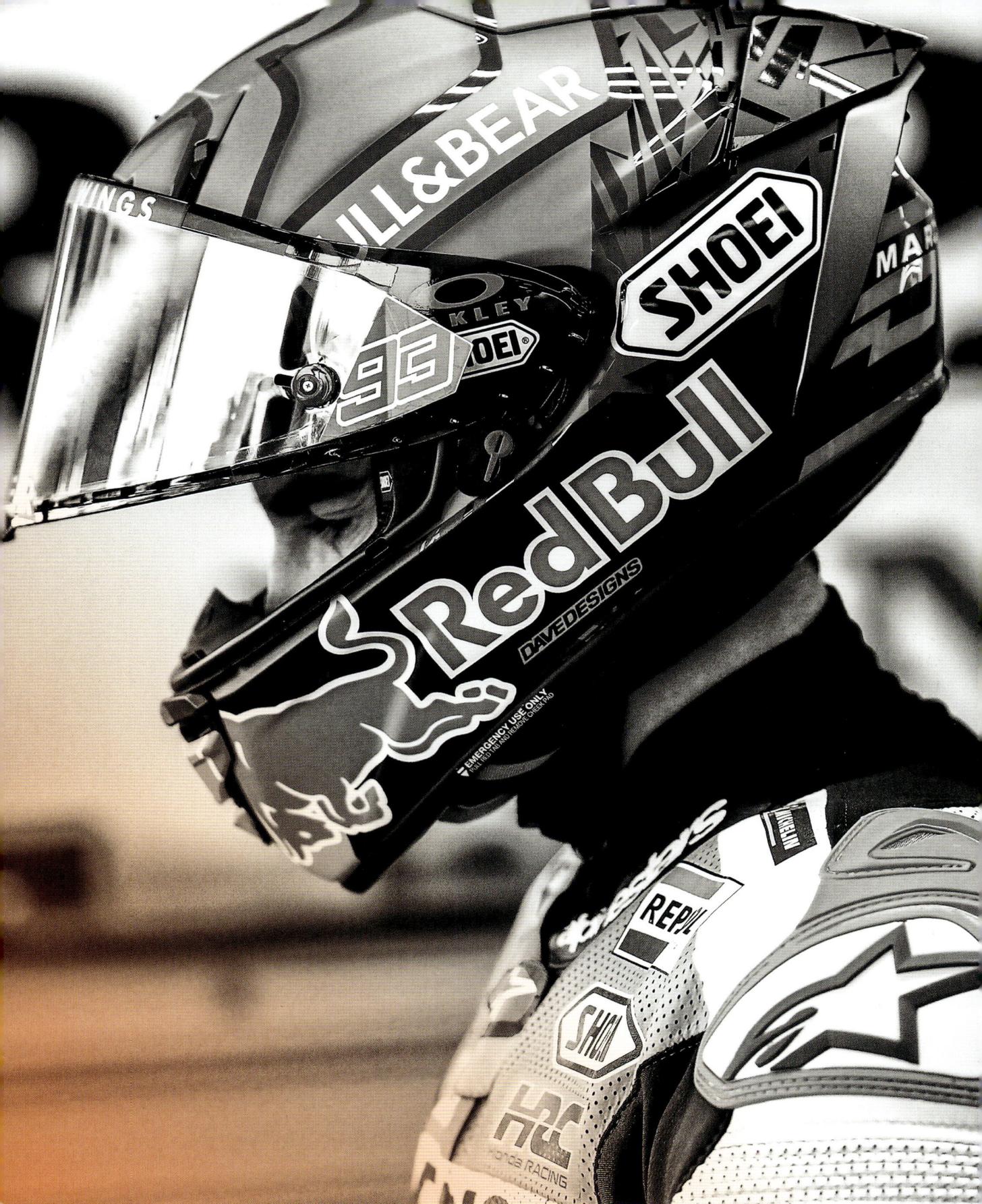

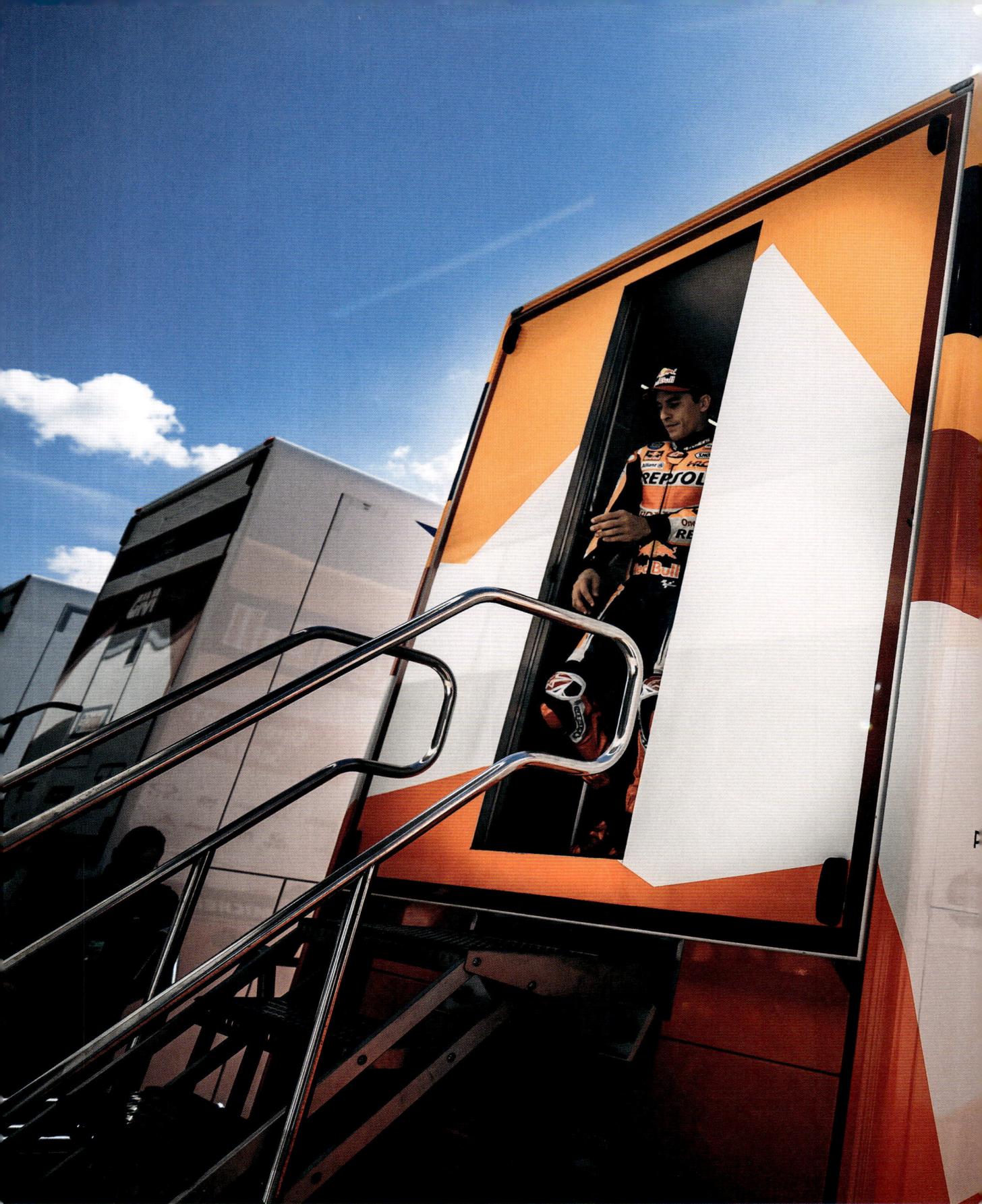

← Office, changing room, refuge: the Repsol truck in the paddock.

Ialways do the same thing to get into the zone, and someone watching on TV only sees the half of it. It starts with me always getting up at the same time on race weekends, 8:10 AM on Fridays and Saturdays. Not eight. Not quarter past eight. Ten past eight. On Sundays, I get up at 7:55 AM because race day schedule starts a quarter of an hour earlier. I get up, have breakfast, then shower, always in that order. On the track, I go from my motorhome to the box first, say good morning to my mechanics and have a coffee with them. Then I disappear into the truck and start my warm-up exercises to make my body flexible. Once I'm done, I slip into my leathers at exactly the right time. After that, we go over to the box, perhaps a minute – but no more than that – either side of the set time. When it's time, I put my helmet on in my corner on the right-hand side of the box and slip on my gloves – always at the exact same minute.

I never break these routines. The idea of stopping to talk to someone on the way from the truck to the box is unthinkable. If someone approaches me, I put them off until later, and as a rule I am met with understanding. The only possible exception might be before a free practice session, if someone very important or perhaps a child is waiting. Then I stop for 20 seconds max, say a quick hello and pose for a selfie, but that's it. As a point of honour, I give 15 minutes to fans waiting for me after practice, but beforehand, no chance.

In my routines, there is no distinction between practice, qualifying and race days. The process and the timing are always the same. At the circuit, I live in my motorhome next to the track, but as soon as the day starts, I switch to the Repsol Honda truck in the paddock. The truck is my workplace, the motorhome my home. At home you're relaxed, and I don't like to feel relaxed on weekends, or not too relaxed, at least. There's constant coming-and-going in the truck. There is a lot of fooling around and laughter until an hour before the race. That's when the atmosphere changes and you can literally feel the concentration in the room, or at least hear it. It gets quieter.

I am more nervous some weekends than others. There are even races I go into pretty relaxed because I feel I have the situation under control or, at least, have nothing to lose anyway. If I'm not in the running to win the championship or have to start from way back, there's no reason to be nervous. So I was quite relaxed when I returned in 2022, with the exception of two occasions: I knew I could win at Phillip Island and Valencia, so there was immediately that excitement again.

I like that tense feeling, though of course I do always wonder what the hell I'm doing and why I'm subjecting myself to all this. But I can now manage those thoughts pretty well and put myself in

a good, focused mood, regardless of how nervous I am. That was far from the case when I was younger. I guess you gain that ability over the years. It's about finding that fine line between being too relaxed and too tense. There are said to be sportsmen and women who throw up due to nerves before every race or game. It hasn't been that bad for me for a long time. On the contrary, if I feel too relaxed, I drink a coffee before the start. It helps trigger that tingly feeling. I know myself very well; if I'm too relaxed, I'm lacking that last little bit of focus and there's a higher chance I'll crash.

When things finally get started, it's time for that part of the Sunday I hate the most: the sighting lap from the pit lane to the grid, and then the warm-up lap. You have to look out for really boring things like fuel consumption and going easy on the tyres, getting the bike around the track, nice and easy. It totally contradicts my instincts. Riding a MotoGP bike slowly intentionally feels unnatural. I want to get out of the pit lane and attack immediately, from the first corner.

As soon as I can feel my bike beneath me, I become another human being, a racer. I'm allowed to go a little faster in the warm-up lap, but I would like to push even harder. When things finally begin and the lights go green at long last, I feel like a fish in water; I go at my rivals on the first corner perhaps 90% of the time.

You still had time to think as you lined up on the grid five years ago. Now, you have to concentrate fully on the tasks at hand: activating the holeshot – launch control – device front and rear, getting your body in the correct position, paying attention to even weight distribution... By the time that's all done, the marshal is already on the move with his flag, making sure the track is clear, and the lights go on.

"I want to get out of the pit lane and attack immediately, from the first corner. As soon as I can feel my bike beneath me, I become another human being, a racer."

There were push starts in motorcycle racing world championships up until 1987. The riders ran alongside their bikes and released the clutch to start the engine. This went relatively smoothly due to the comparatively low compression ratio of the two-stroke engines used at the time, and being able to make a good start was seen as part of a complete rider's repertoire. Such starts were banned for safety reasons; when a bike in the front rows didn't start and other riders came roaring up from behind, things got dangerous. In the decades thereafter, the delicate interplay of the throttle and clutch hand was necessary for a good start, until finally wheelie control arrived with more electronics; if the sensors showed the motorcycle was in danger of rearing up in the air, power was reduced. In 2019, Ducati brought a device we know from motocross – the holeshot device – into MotoGP for the first time. It compresses the suspension fork and manually keeps it low. This lowers the centre of gravity, reduces the bike's tendency to wheelie and allows the control electronics to release more engine power. The system was subsequently extended to the suspension strut, which lowers the bike's overall centre of gravity. The holeshot device disengages in the first braking zone, the bike roars back to life, regains its normal height and can tilt fully again. Launch control, by contrast, allows the rider to go at full throttle. Regardless of what the rider specifies, the ride-by-wire system, which does not require a fixed connection between throttle and engine, means maximum torque is only ever equivalent to what can actually be brought to the track, dependent on how aggressively the electronics are tuned, of course. Ideally, a MotoGP bike should go from 0 to 200 kph in 4.8 seconds, 0.4 of a second faster than a Formula 1 car!

I think my aggressiveness at the start even comes across on screen. I always go full throttle, with my elbows down. Some of my rivals like to play with the throttle. I control engine power with the clutch and rear brake, and fully open the throttle straight off. It also depends on how aggressively I tune the bike's electronics. Admittedly, my way of starting isn't the fastest, but it's the most reliable for me. Getting started manually and balancing power with your wrist can go really well, or not. Thanks to my technique, I regularly get away from the start pretty quickly and rarely gain or lose more than one position.

In the warm-up round, there are always riders who try mind games, getting right in front of you, coming extremely close to overtaking, that kind of thing. At that point, I don't care. I'm paying close attention to my rivals' tyres. We do get a list from Michelin beforehand of which rider is going with which spec, but it isn't always accurate, of course. It's a trick, and my team is in on it. You say you're using the softer rubber compound, but in reality it's the harder rubber compound, or vice versa.

The rubber compound influences race strategy, and the warm-up round is the last chance to review that. Who will go flat-out at the start? Who might still have aces up their sleeve towards the end of the race? You take a good look at your closest rivals on that front, especially when it's getting down to the nitty-gritty in the world championship.

On the starting grid, just before the race starts, there is something I now double and triple check based on experience, namely, IS THE BIKE IN FIRST? If the bike is still idling when the light jumps to green, you are in mortal danger with 20 MotoGP bikes bearing down on you from behind. So, if the "1" for first gear is showing on the dashboard, I can feel if the traction comes when I release the clutch lever slightly. Some of you may still remember Argentina 2018, when I had my

→
Holeshot is a term used in motocross to describe the first racer to get through the apex of the first turn: Marc doing just that at the 2018 Spanish Grand Prix in Barcelona.

Autódromo Termas de Río Hondo, 8th April 2018

legendary balls-up at the start. What happened was, I was on the grid, the N was showing on the dashboard, but I was somewhere between neutral and first. Either I wasn't properly in gear or it was a technical problem. Either way, the bike stalled as soon as I released the clutch. I have become much more cautious since then and am extremely careful in the way I touch the clutch lever at the start so it doesn't happen to me again. You can't always rely on the display. It was a miracle that I managed to get the Honda going again on my own. I had to get back in position with the engine running as the man with the red flag was already on the starting line. So I drove a big loop round, reversed, took up my position at the start again and then got away pretty quickly at the actual start.

It really was a wild start to a crazy race in Argentina. It had started raining before the race so all the riders, bar Ducati's Jack Miller, put on rain tyres. But the track dried off really quickly and everyone – bar Miller – came into the pits just before the start of the race to switch to slicks. So 23 riders would have been starting the race from the pit lane, which would be far too dangerous. The stewards came up with a creative solution: all the riders were pushed 23 places down the grid, i.e. to the back of the field, with Miller alone at the front. And Marc's engine was stalling in the middle of all that fuss. The fact he got his 1000cc Honda to start again was probably down to adrenaline. Not even the international TV commentators were aware of what the right thing for Marc to do was according to the letter of the law, and nor, clearly, was the race steward. Once Marc was back in position, he started the race normally, without having a penalty imposed on him. Marc didn't

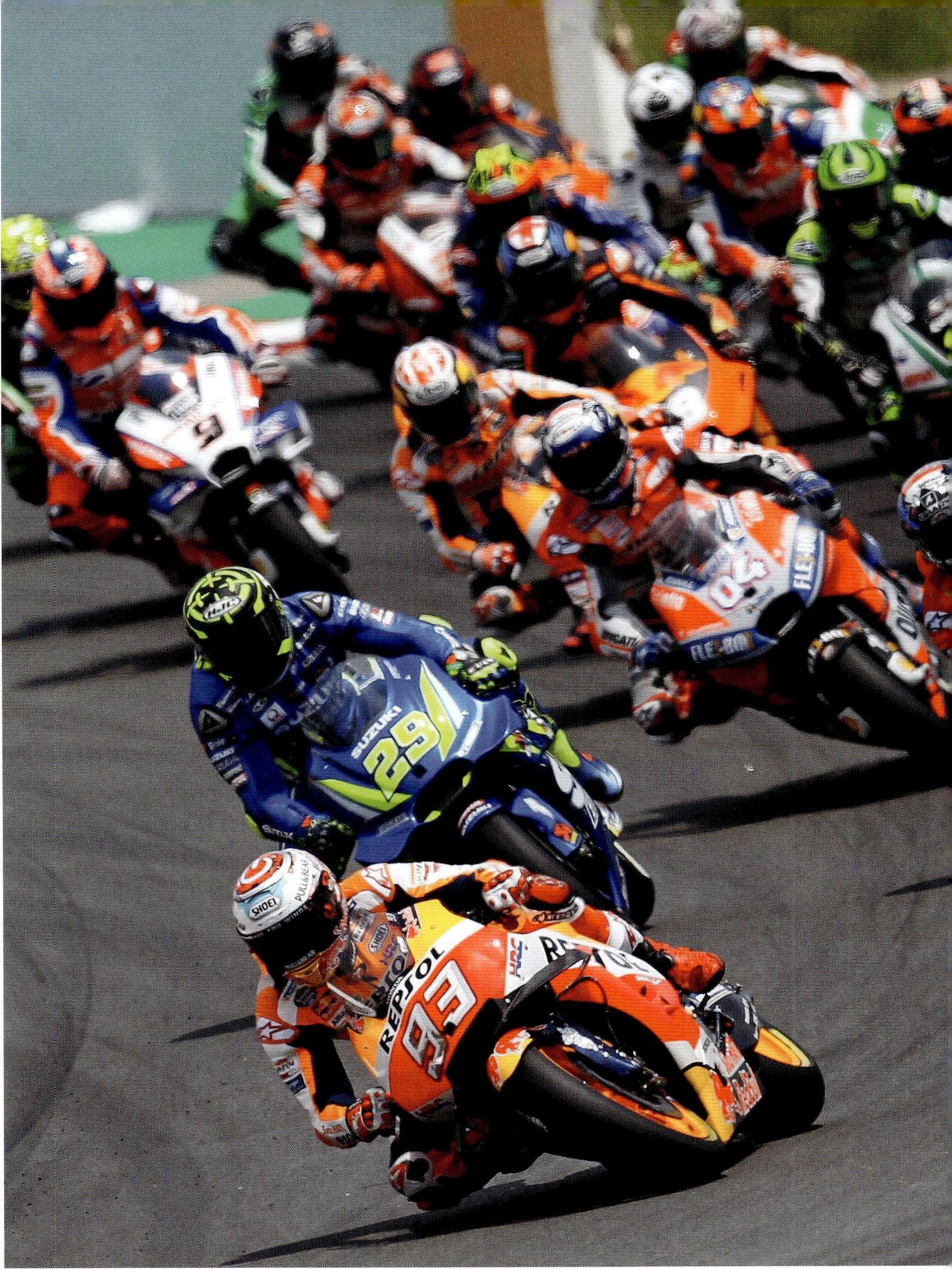

→
Starting on pole makes life easier: Marc ahead of Andrea Iannone (Ducati) and Jorge Lorenzo (Yamaha) at the 2015 Australian Grand Prix.

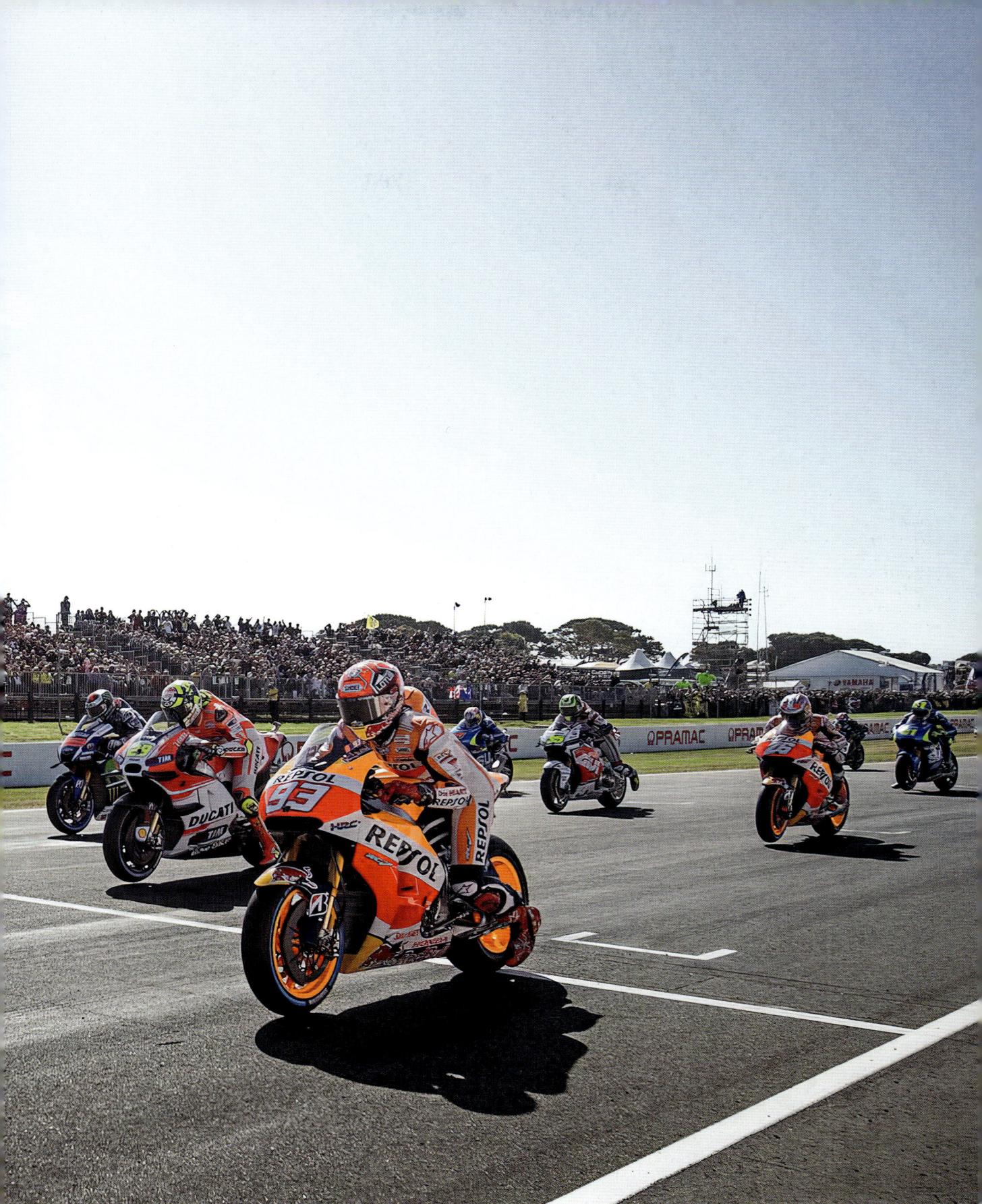

need a second invitation. Within one-and-a-half laps, the man who had barely managed to start the race had taken the lead from Miller, who had had a 50-metre head start, but was then given a ride-through penalty for his manoeuvre at the start. The fastest man on the track ended up with no world championship points after colliding with Valentino Rossi.

Secretly, I did expect a penalty, but going back round like that was just the quickest way back to my starting position. Plus I didn't have much time to think about potential consequences. I acted on instinct. They let me keep my start position, though I couldn't go on to make use of it in the race, and then I still got the ride-through penalty. In any case, the rules changed after that. If you stall the bike at the start now, you're off the grid.

Chaotic scenes like those in the run-up to the 2018 Argentinian Grand Prix are the exception. As a rule, you're very focused during the race. If you're out in front with a lead of more than four or five seconds, your thoughts wander and you run the risk of losing focus. In my younger days, the pit crew always advised me to keep pushing in order to maintain my focus, but now I disagree with them. My approach is to use practice to find out which corners I can safely push at and which ones I get warning signs at. By warning, I mean where I've crashed or almost crashed in practice. I pay even greater attention to those turns in the race, especially if I have a comfortable lead.

Leading usually feels very natural, very smooth. You usually ride very well and don't have to make many alterations or pay too much attention during the race, except of course on those potentially dodgy corners. And then there are those races where I'm in the lead but can feel the guy behind me gradually making up ground. Some of you may know this feeling from kart racing or motocross, focusing on what's going on

behind you rather than in front, checking how large that pesky rival is looming in the proverbial rear-view mirror. Once that happens, part of your focus isn't where it should be, namely, on the racing line. As a result, you end up losing more time. A prime example of this occurred at the Sachsenring in 2021. I had a lead of two or three seconds but Miguel Oliveira on the KTM was clawing back one or two tenths of a second off my lead every lap. Only when I stopped focusing on him, and focused on myself instead, did I manage to get away from him again. Unlike in motor racing, you don't have to aggressively defend yourself on motorcycles. Cars are much harder to overtake than bikes. Once your rival on four wheels is ahead of you, he usually stays there. Aggressive defending in MotoGP would only ruin the tyres and slow your lap time, because blocking your opponent takes time, of course. That's why the best defence strategy for the last few laps in MotoGP is simply to get out in front. To put it in football terms, if you've got the ball, your opponents can't score.

Depending on the track, it is sometimes easier, mentally, to go into the decisive phase of the race in second place. It allows you to study your opponent carefully and consider where you want to make the all-important overtaking manoeuvre. When I was younger, my pit crew would sometimes hold out a pit board that said, "P2 OK" or even "P3 OK", but of course there was nothing OK about a second or third place to me. In the last ten years, no one has held that sort of thing in front of my face. My guys know me now. Plus, in a professional environment like MotoGP, you discuss your racing strategy very precisely in advance and think about what will be possible when and how anyway. In the lower classes, though, it can be quite useful to prevent young impetuous riders, like I once was, from crashing near the end of the race by showing them calming messages.

In MotoGP, the box has another way of communicating too. They can send messages to the dashboard, the digital display behind the fairing. We decide in advance which information I want to get at which point on the track. Typically, this is about the advantage I have over championship rivals or whether anyone has crashed. In flag-to-flag races, where we change bikes dependent on conditions, I want to know when someone has come in to swap. There are, of course, spots on the track where, as a rider, you just can't take this information on board.

To understand things best, I probably need to be somewhere close to the correct position on the bike. I probably don't need to explain to anyone that no rider in the world has the time to check text messages in a 200 kph corner while tilting 50°. But even on the straights, we're not just sitting there, waiting for the breaking point! To be as aerodynamic as possible, you have to have your backside off the seat and both elbows flush with the body. Your helmet should be behind the fairing, which means you have to really stretch your neck, with the wind putting drag on your whole body. You can imagine how that position is physically exhausting, but if the designers work well, you can help yourself by resting the chin section of the helmet on the tank (which isn't the tank at all. It's the air box. The tank is mostly under the seat). What I want to say is even going straight ahead on a MotoGP bike is more complicated than you'd think if you do it correctly. We even took my bike to a wind tunnel to attain perfect performance on the straight, but it turned out that what's perfect aerodynamically doesn't make for the most dynamic ride. Aerodynamicists want the bike to be as streamlined as possible: streamlined fairing, streamlined seat. But a rider can't go fast on those. The perfect streamlined bike is advantageous on five, six, maybe seven tracks in the season, those where top speed brings improved lap times. On the majority of circuits, it's how fast the rider gets his motorcycle through the turns that counts. In any case, the straights, which usually last just a few short seconds, are the only time during a race the rider is even able to read information that the box considers relevant and then process it and react accordingly. This sort of communication is naturally a one-way street. I can't text anything back, so I have to demonstrate through my lap time and my manoeuvres that I got the message.

At some point every race is over, and ideally I'll have won it, of course. As a rule, my displays of emotion afterwards are completely spontaneous. Occasionally, towards the end, I think where on the run-off lap I'll get off the bike to celebrate with the fans. What I do once I'm there I decide there and then. At best, in races where I've had a big lead, I have a chance to think about a specially choreographed way to cross the finish line: a wheelie, or the proverbial Colt when I won in Texas.

The only time I knew in advance what would happen in any of my world championship celebrations was in 2014. Since then, fan clubs, teams and my designer have been meeting behind my back ahead of a world championship win. They brainstorm and concoct some choreography, come up with a theme. They design T-shirts and a special helmet. To celebrate my eighth title, for example, it was a black pool ball with the number 8 on it. I don't want to know ahead of time. I want to be surprised. Excitement and concentration right to the end is the way it should be.

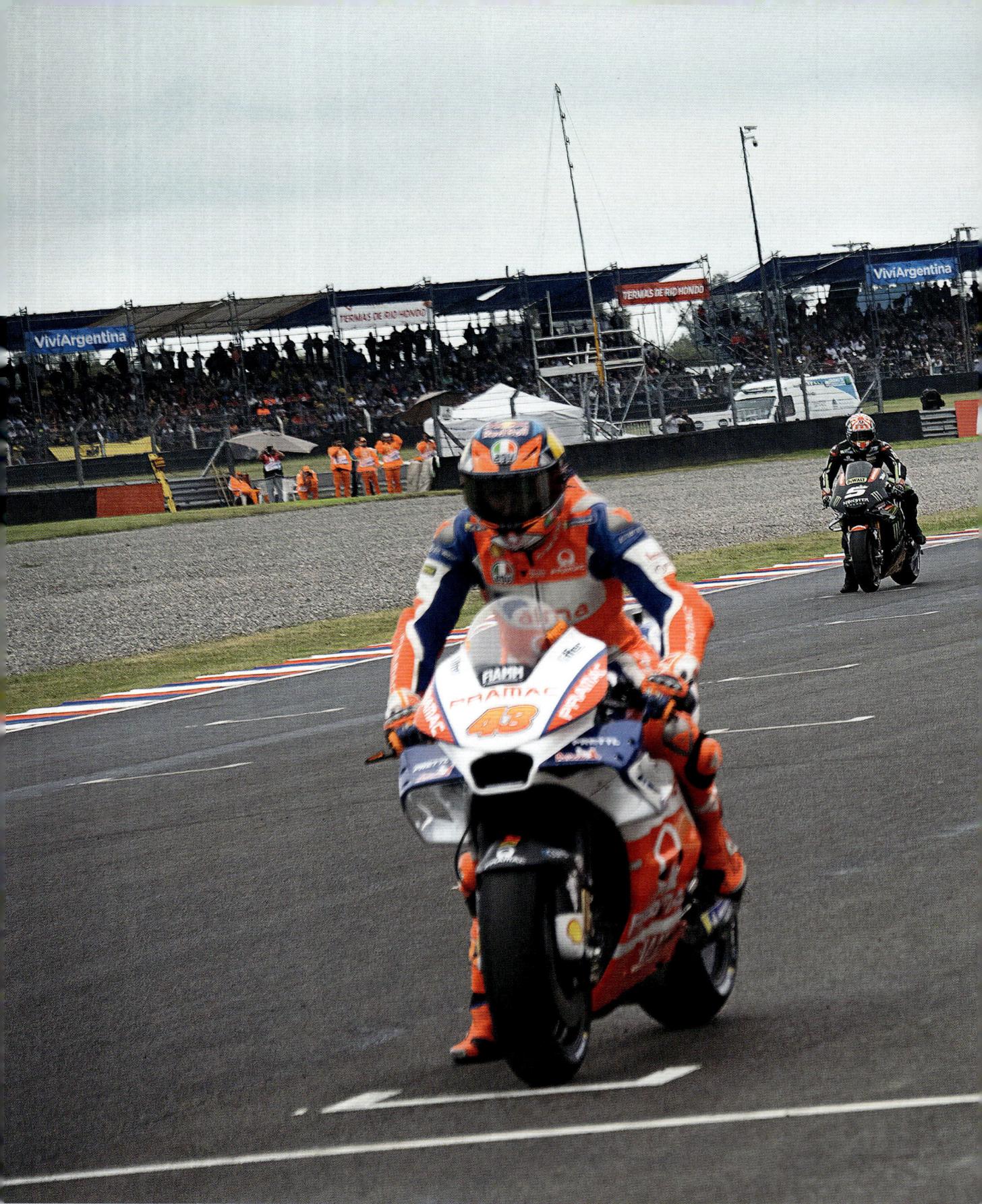

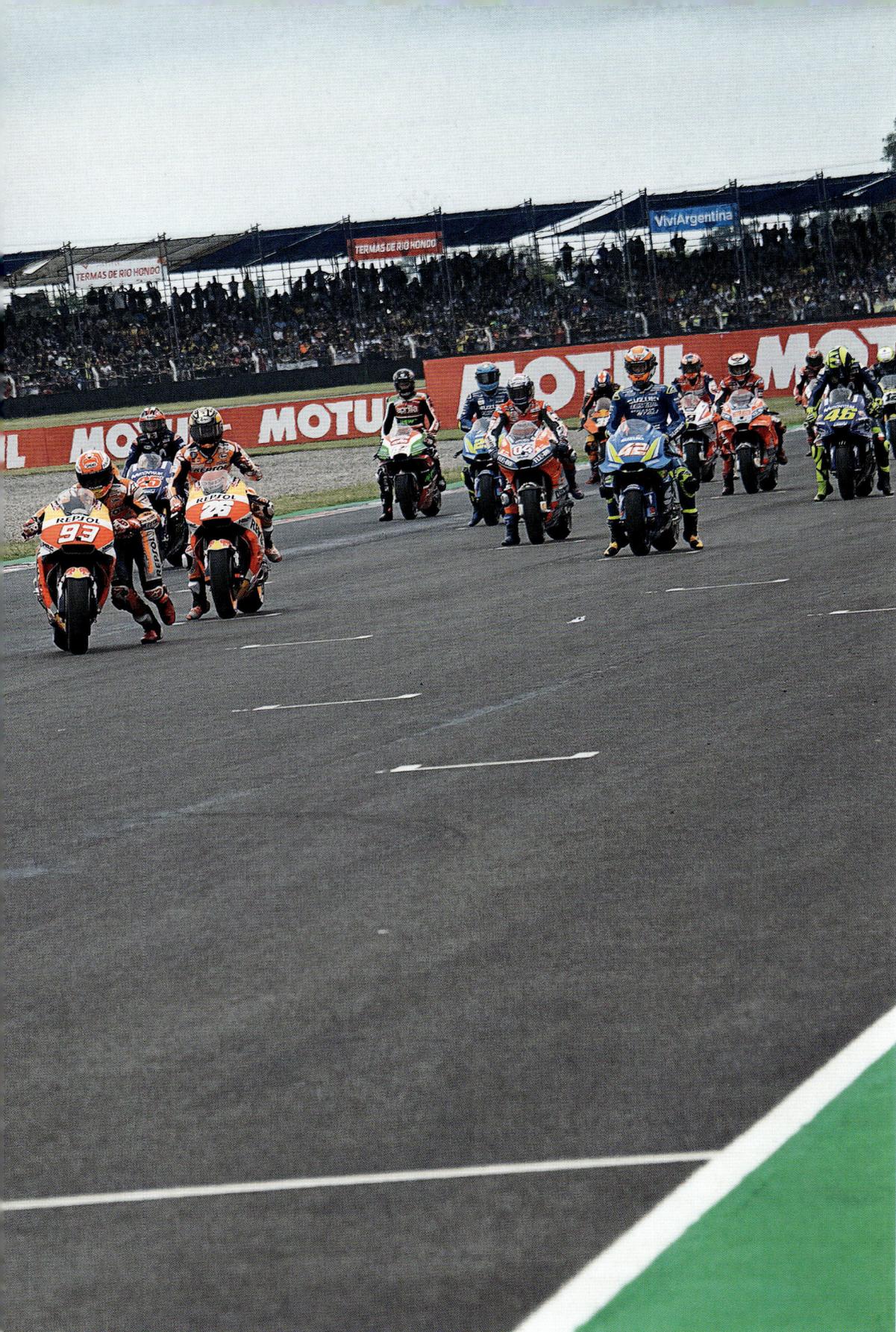

Jack Miller all alone at the front, Marc pushing his bike around: a curious scene at the start in Argentina in 2018.

→
The red wall
in Valencia:
traditionally
the last race
of the
season used
to also be a
huge party
for the world
champion
and no. 93.

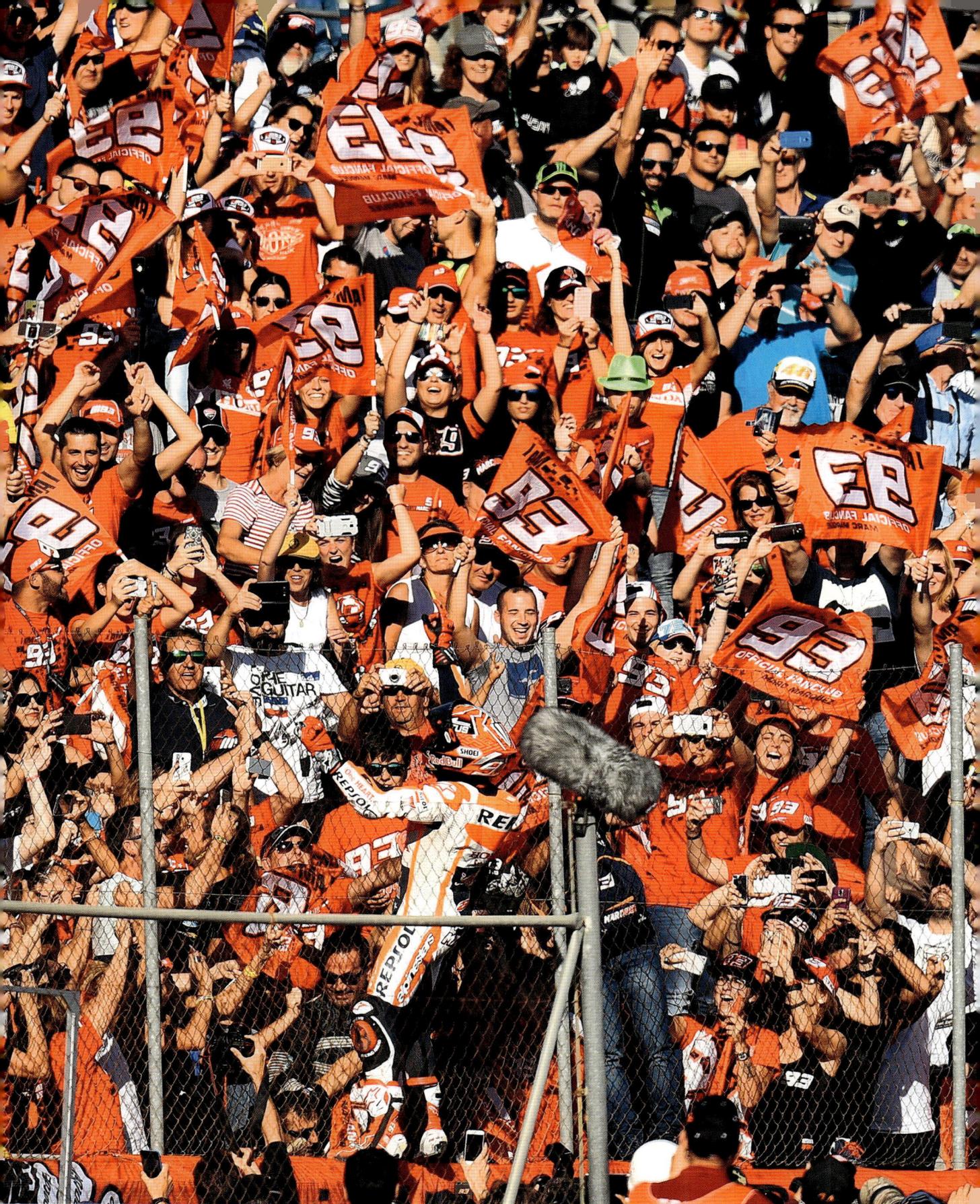

→ Valencia, 2018: the fan club came up with the 8-ball to celebrate World Championship no. 8. Marc knew nothing in advance.

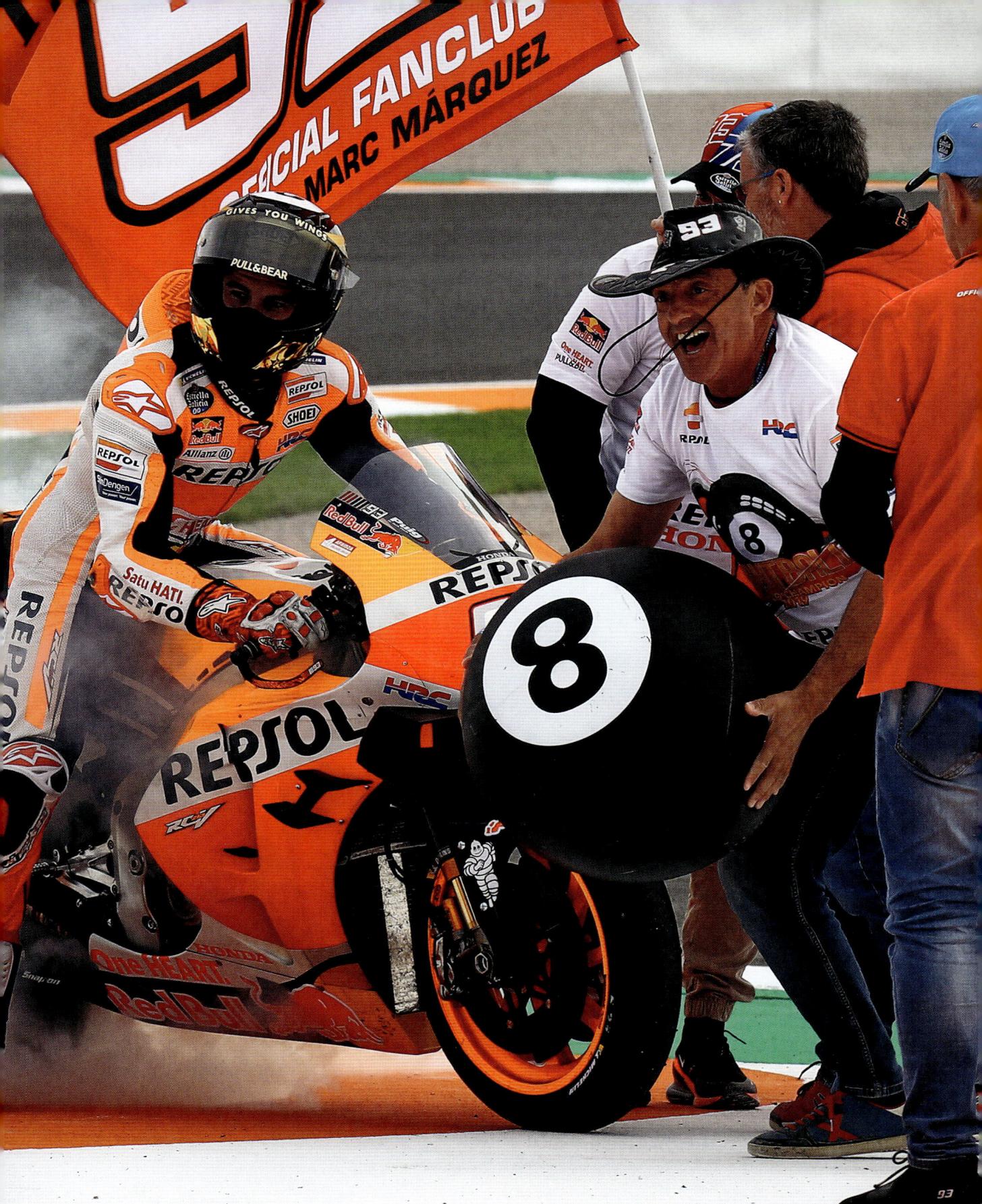

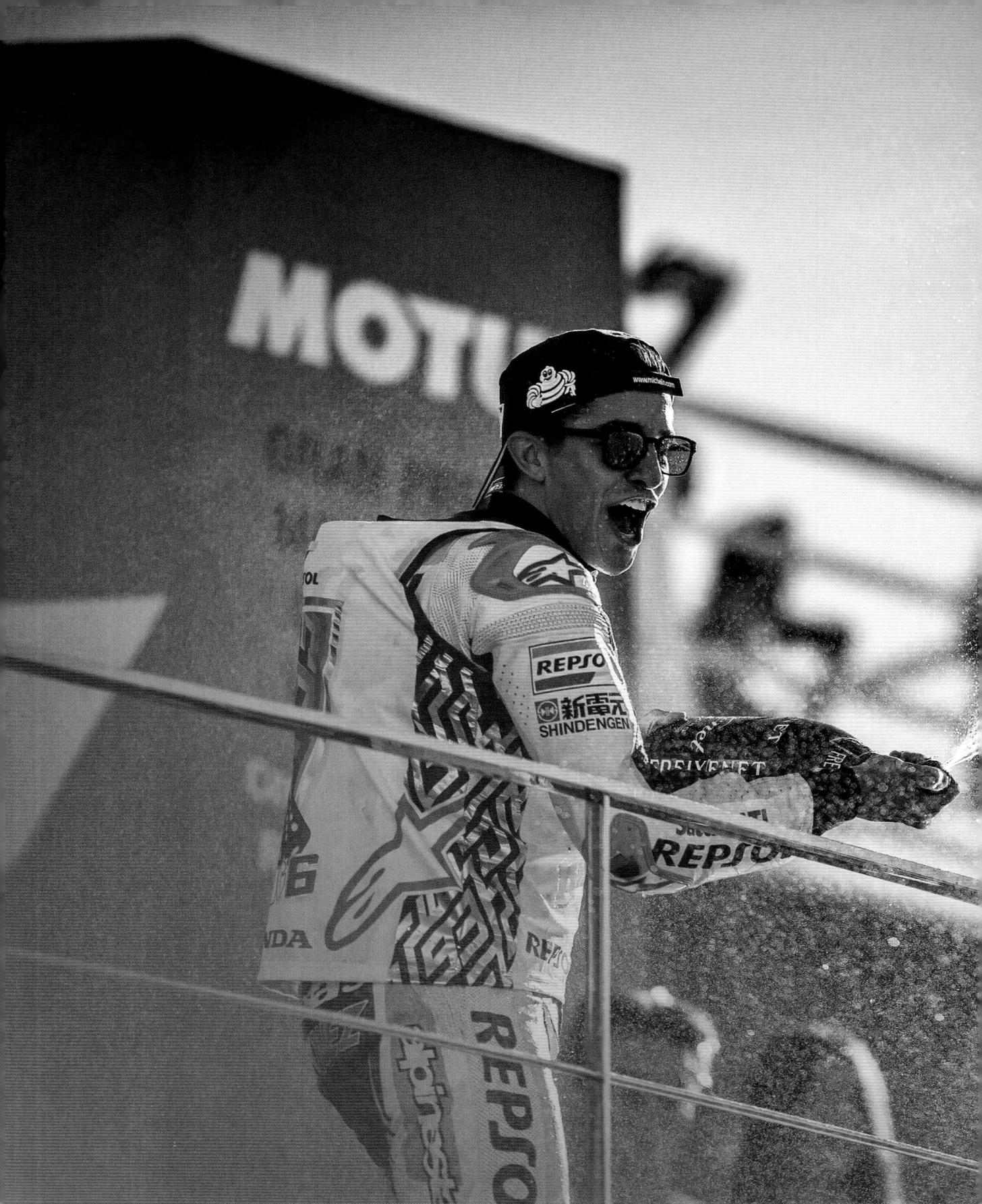

Loyalty

Why the grass is not
always greener on
the other side

Continuity has historically been one of the key factors for success in the premier class of motorcycle racing. The whole system of the rider and his bike is so delicate that it is good to be able to fall back on certain basic conditions. To that end, you need people by your side you can rely on without question. A key role is played by the crew chief, the chief technician, who is responsible for every detail of the bike set-up, in consultation with his rider, at all times. From electronics to geometry, tyre selection to shock-absorber and fork tuning, there are many parameters that not only directly affect lap time, but also subjectively affect the rider's well-being and self-confidence when he is taking it to the limit. For his most successful period, Valentino Rossi had the Australian, Jeremy Burgess, by his side. Originally at Honda, they both moved to Yamaha and then Ducati. After the dream team split, just before the 2014 season, Rossi won only one of his remaining 138 races. Of the 218 races they'd contested together, Rossi had won 77. Marc's crew chief is Santi Hernández, and the two Spaniards have been working together since the 2011 season. They clicked straight away. Even before his career in MotoGP, Marc Márquez had thrown his lot in with Santi. You can't have one without the other, and the partnership has benefited Honda. Together they have become by far the most successful pairing in the last decade. Delving further into the statistics, it is easy to see the importance of continuity in motorcycle racing World Championships. In the entire history of the premier class (500cc from 1949 to 2001, MotoGP from 2002), only five riders have managed to win titles on different bikes: Geoff Duke (Norton and Gilera), Giacomo Agostini (MV Agusta and Yamaha), Eddie Lawson (Yamaha and Honda), Valentino Rossi (Honda and Yamaha) and Casey Stoner (Ducati and Honda).

→ Inseparable for more than a decade: Marc and his crew chief Santi Hernández.

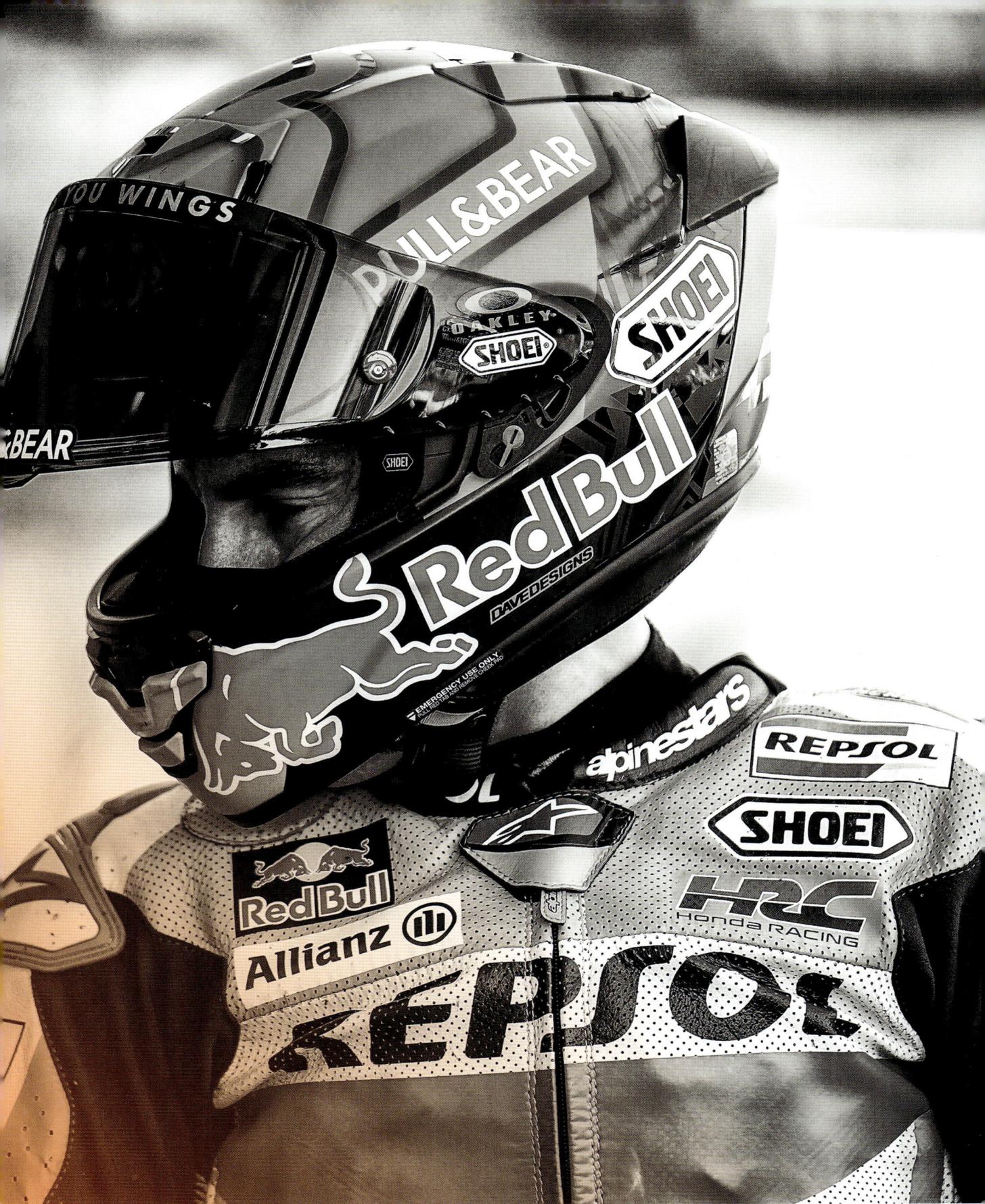

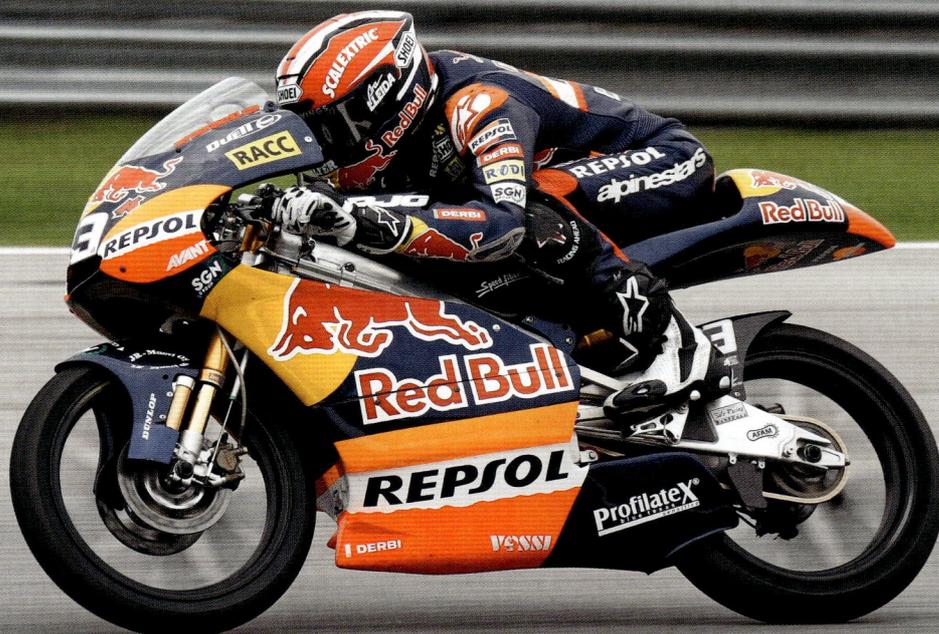

Rare sighting: Marc won his 2010 125cc World Championship on a Derbi.

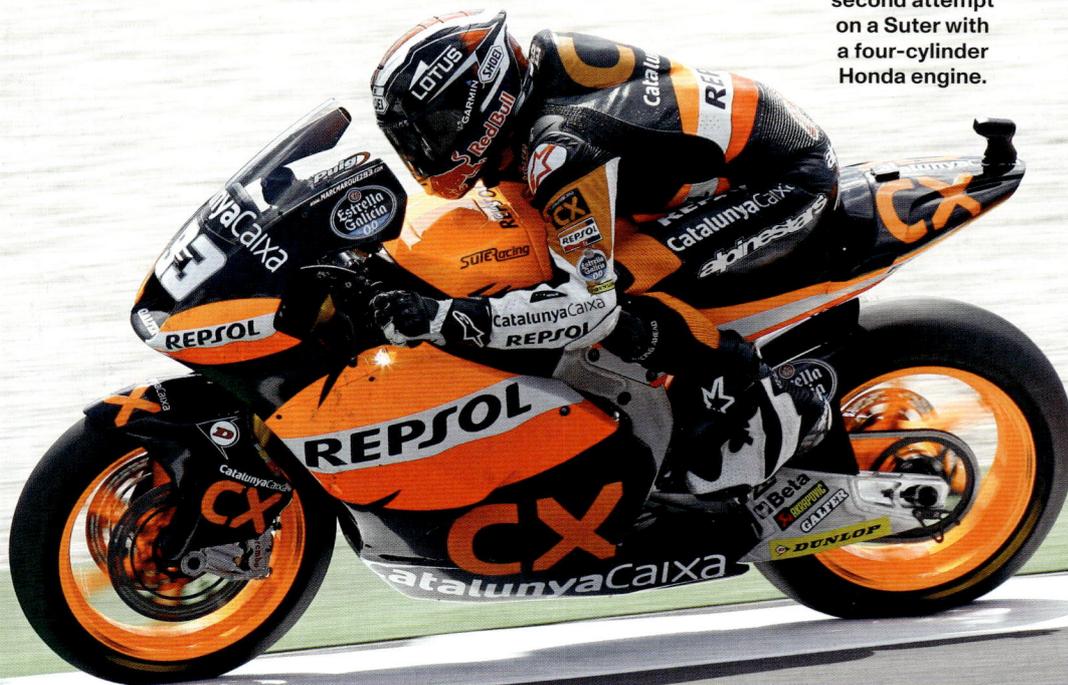

Moto2 World Champion on the second attempt on a Suter with a four-cylinder Honda engine.

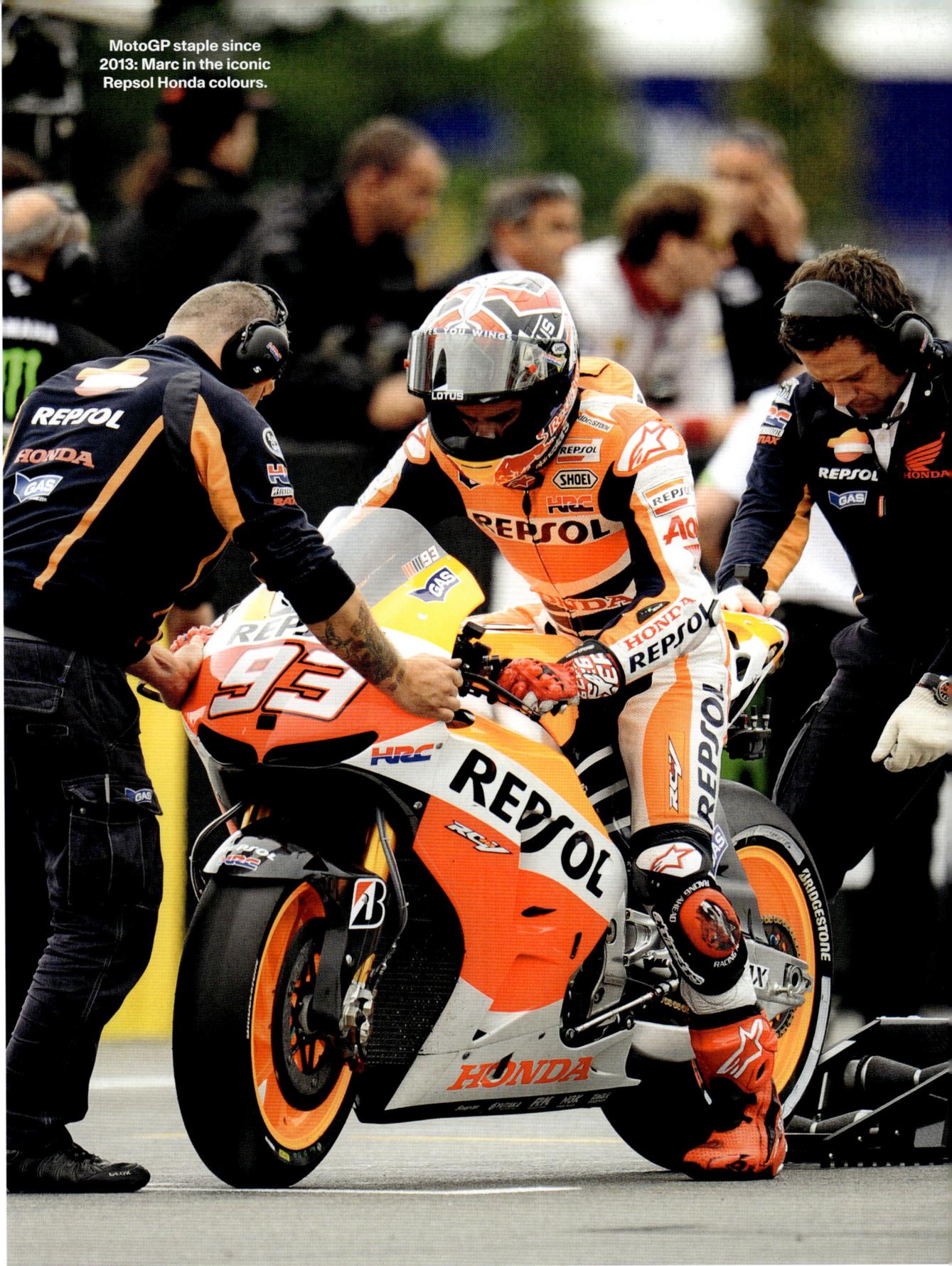

MotoGP staple since 2013: Marc in the iconic Repsol Honda colours.

Back in 2008, my first year in motorcycle racing World Championships as a rookie in the 125cc class, I told my manager Emilio Alzamora I wanted to ride for the legendary Repsol Honda team, the most successful team in the history of the premier class of the sport. Riders including Mick Doohan, Àlex Crivillé, Nicky Hayden and Casey Stoner had become World Champions at Repsol Honda and Valentino Rossi, Dani Pedrosa and Andrea Dovizioso had won races. Ending up in the team one day was more than just a rookie dream, even when I was being supported by Repsol in the smaller classes. That year I was riding for the then Repsol KTM team. Even then, I was only thinking of Honda in terms of a potential future promotion to the premier class. Honda had the best bike at the time, or at least one of the best. And the resonance the iconic Repsol Hondas have, with their orange, white and blue design, is huge, especially in Spain. When Pol Espargaró joined the team in 2021, he spoke of a dream coming true. Maybe it is for us Spaniards, in the same way it must be for an Italian to ride for Ducati.

I didn't talk to any other manufacturer before moving up into the premier class. Honda was the only option for me. The first serious contact came in 2011 during a Moto2 test in Brno. My manager Emilio informed me that Honda had vaguely spoken to him about a contract for the coming season. Honda did offer me a job as a factory rider there and then, but I was meant to ride for the private LCR team. Then 19 years old, I refused outright.

I had two reasons. Firstly, I really wanted to be the Moto2 World Champion and secondly I wanted to ride for the Repsol factory team, which wasn't really possible at the time. The rule stated that those coming up had to be recommended to the premier class of the sport via a satellite team in order to then be promoted into the real factory team. When the first offer came in from Honda, I was 60 points behind Stefan Bradl, then leading the Moto2 World Championship, because I had crashed so many times early in the season. I had closed that gap by the end of the season, but it was questionable whether the World Championship title I was after would come off. It was also unclear whether Casey Stoner would stay at Repsol and whether a place in the team would free up for the coming season. Neither happened and I stayed in the Moto2 World Championship for 2012.

Stoner won the World Championship title for Repsol Honda that year, but announced in the spring that he would be retiring at the end of the season. I tore my way through Moto2, as I had expected to, and felt ready to move on up into the top class. The all-important meeting with Nakamoto-san, the head of HRC, the Honda Racing Cooperation, took place

at the Italian GP in Mugello in mid-July. Livio Suppo, the then Repsol Honda team principal, was also there. First and foremost, Shuhei Nakamoto made it clear to me that Honda wanted me for the factory team, so exactly what I'd been dreaming of. For this, they were even willing to work together with the governing body of motorcycle racing, the FIM [Fédération Internationale de Motocyclisme, or International Motorcycling Federation], to bypass the clause that said there was no place for rookies in factory teams. And I had another ace up my sleeve.

Our next meeting occurred at the 2012 Czech Grand Prix in Brno. That's when I put in my next demand/request to Honda. I wanted to take my crew chief Santi Hernández, with whom I had had so much success in the Moto2 World Championship, to MotoGP with me. The negotiations dragged on, and I eventually presented Honda with a choice: if you want me, Santi comes too. If you don't want him, you don't get me. Pretty assertive for a 20-year-old who only had a single World Championship title in the smallest class to his name at that point! I don't know if I actually would have gone through with the threat, but in the end I got what I wanted. Santi joined MotoGP with me. It's easy to explain why I insisted on Santi: we speak the same language when it comes to tuning the bike. With Santi, I know that I'm going to get what I need on the technical side to ride the way I want. We are inseparable now after all these years together, but it was already clear how compatible we were and how well we complemented each other back in Moto2.

Before the 2013 season, the team agreed on the following solution: on paper my chief technician wasn't Santi. It was the Italian Cristian Gabarrini, who had already led Casey Stoner to his World Championship title on the Honda and currently looks after the Italian world champion Pecco Bagnaia at Ducati.

We have always had a good relationship. I respect Cristian very much. But I believe in Santi, his ideas and our mutual understanding. I left the final decision on everything technical on my bike to Santi right from the second race of 2013, only my second in the premier class, and that's the way things have stayed to this day.

There are definitely differences in mentality between us southern Europeans and the Japanese. But I've always done well with one rule: show Japanese people respect, and they will respect you all the more. If you don't show respect, you'll make enemies of them. If I understand the culture correctly, there is very little grey area when it comes to competition. It's black and white: you are a friend or foe. In the event of disagreements, it is crucial, therefore, to address those responsible correctly. Be polite, but to the point. Communicate clearly so as to avoid panic and not trigger complete chaos between Europe and Japan, but in no way insult their honour.

The more experience and success I've had, the more respect I've had from Honda, even when I've been more demanding. The bike was perfect in the first two years, but when the first technical difficulties began to appear after our third season together and the competition got better, the Japanese technicians were more than happy to ask me which way things should be developing.

"Show Japanese people respect, and they will respect you all the more. If you don't show respect, you'll make enemies of them."

By Marc's standards, there is one gap in his otherwise impeccable MotoGP record. His 2013 and 2014 World Championship titles were followed by a setback in 2015. Yamaha now had the best bike in the field, not Honda, and in veteran star Valentino Rossi and Jorge Lorenzo they had two World Championship hopefuls riding for them (who didn't always get along, which

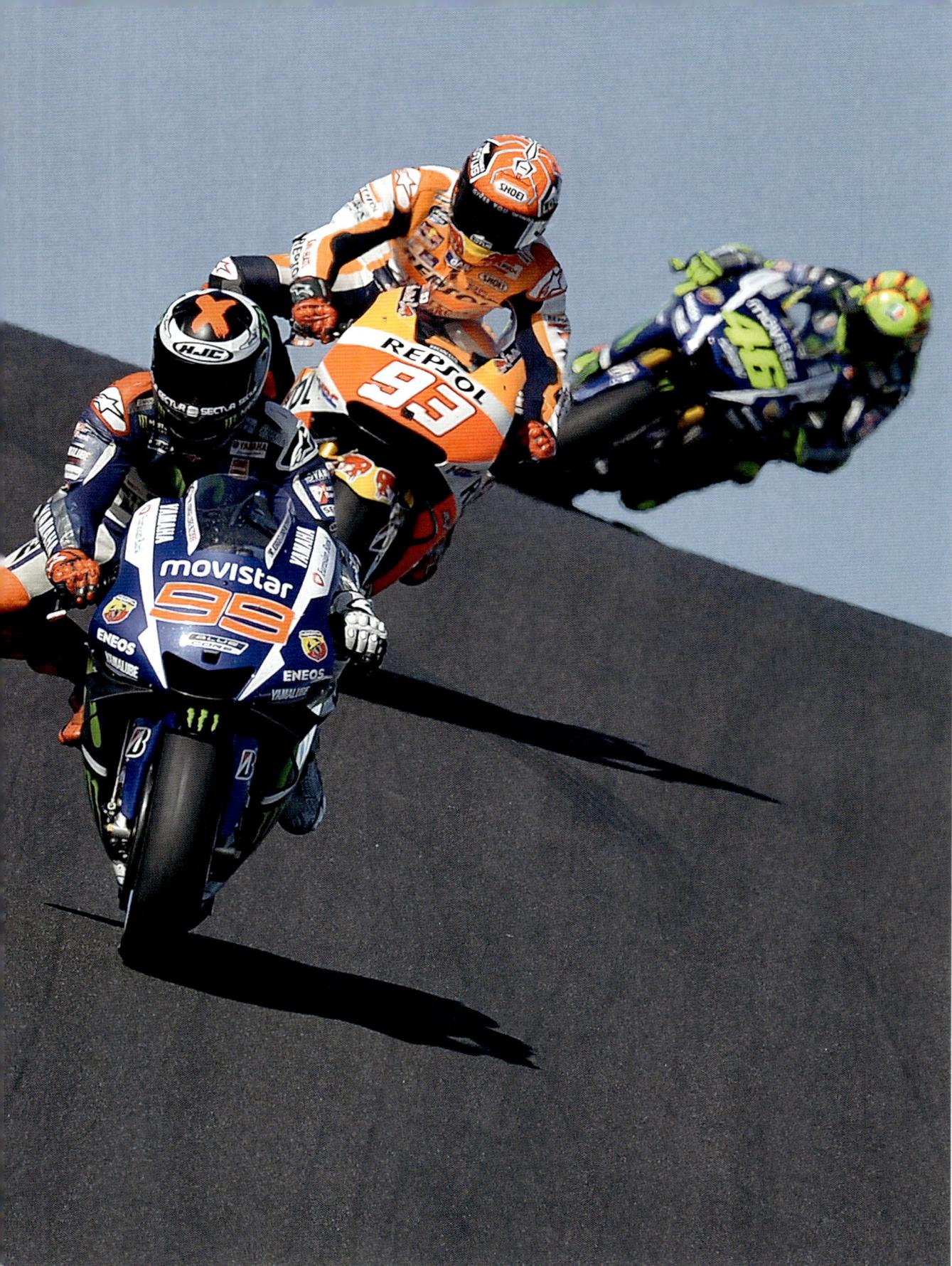

added an element of spice to the proceedings). Marc made up for the technical disadvantages with dedication. He and veteran Rossi regularly engaged in wild skirmishes throughout the season, which did their relationship no good. Rossi, once Marc's idol, became an adversary like any other, and the press did their best to add fuel to the fire. Things escalated at the penultimate race of the season in Malaysia, after which Rossi was relegated to last place on the grid for the season finale for a physical attack on Marc, costing him the race. Rossi would have had to finish at least second – if his rival Lorenzo won – in order to secure his tenth World Championship title. But he didn't. Honda's two Spaniards, Márquez and Pedrosa, crossed the line behind the man from Mallorca, Lorenzo, with Rossi trailing in behind them. Lorenzo was world champion, and Marc and Dani had to defend themselves against accusations of having secretly concluded a Spanish non-aggression pact. The relationship between Marc Márquez and Valentino Rossi did subsequently improve, but was never again as warm as it had been at the beginning of Marc's career in MotoGP.

The biggest change for the 2016 season was the new tyre supplier. We would now be using Michelin tyres, instead of my beloved Bridgestones, which had given me the confidence I needed, especially at the front. It was clear that it would take work to adapt the bike, quite apart from fine-tuning my riding style. After the difficult 2015 season, we were back at the top in 2016, with a newly modified bike that we in Team Honda had developed together based on the experiences of recent years. I took over the lead in the world championship at my home Grand Prix in Barcelona and didn't give it up again until the end of the season. That year, 2015, was our first mini-crisis, and we emerged from it stronger.

← In 2015, Honda could only play second fiddle. The Yamahas of Lorenzo (front) and Rossi (rear) were better.

One thing's for certain: if you work with Japanese people, you need to be patient and understand their philosophy. The European approach is problem – solution. The Japanese approach is a little longer: problem, analysis, discussion, solution. I still sometimes lose it because I would prefer a more direct approach, but on the other hand, I do know whatever comes out at the end of this seemingly lengthy process will work. It takes time, but it works. And it works long term too. It's no coincidence that Repsol Honda has been the most successful team in MotoGP history, with 15 World Championship titles since it was founded in 1995!

Working with a Japanese corporation – in my case, exclusively Honda – has always been a pleasure and a privilege. Two examples: being the impatient person I am, I can't spend three hours discussing a single topic. Japanese engineers, on the other hand, can do that no problem. But they know I'd get bored. So I tell them what my wishes are, they sit down around a table and I am spared their meetings. I can use the time I've saved productively for myself, while they are productive in their way. That way everybody wins. Secondly, Honda was unendingly patient with me when I was out injured for so long after 2020. They never pushed me to come back, didn't shower me with invitations to events, nothing. Honda got nothing from me during that time, yet our relationship carried on like I was winning races every weekend. They paid my salary without batting an eyelid, even though I couldn't do anything for almost two years! Just think about that. To my mind, that's a mark of the respect they have for me. Respect isn't a one-way street, and I respect Honda at least as much, if not more, than they respect me.

I have said this several times, both internally and publicly: it would be an honour for me to spend my whole career at Honda. But, and here comes the but:

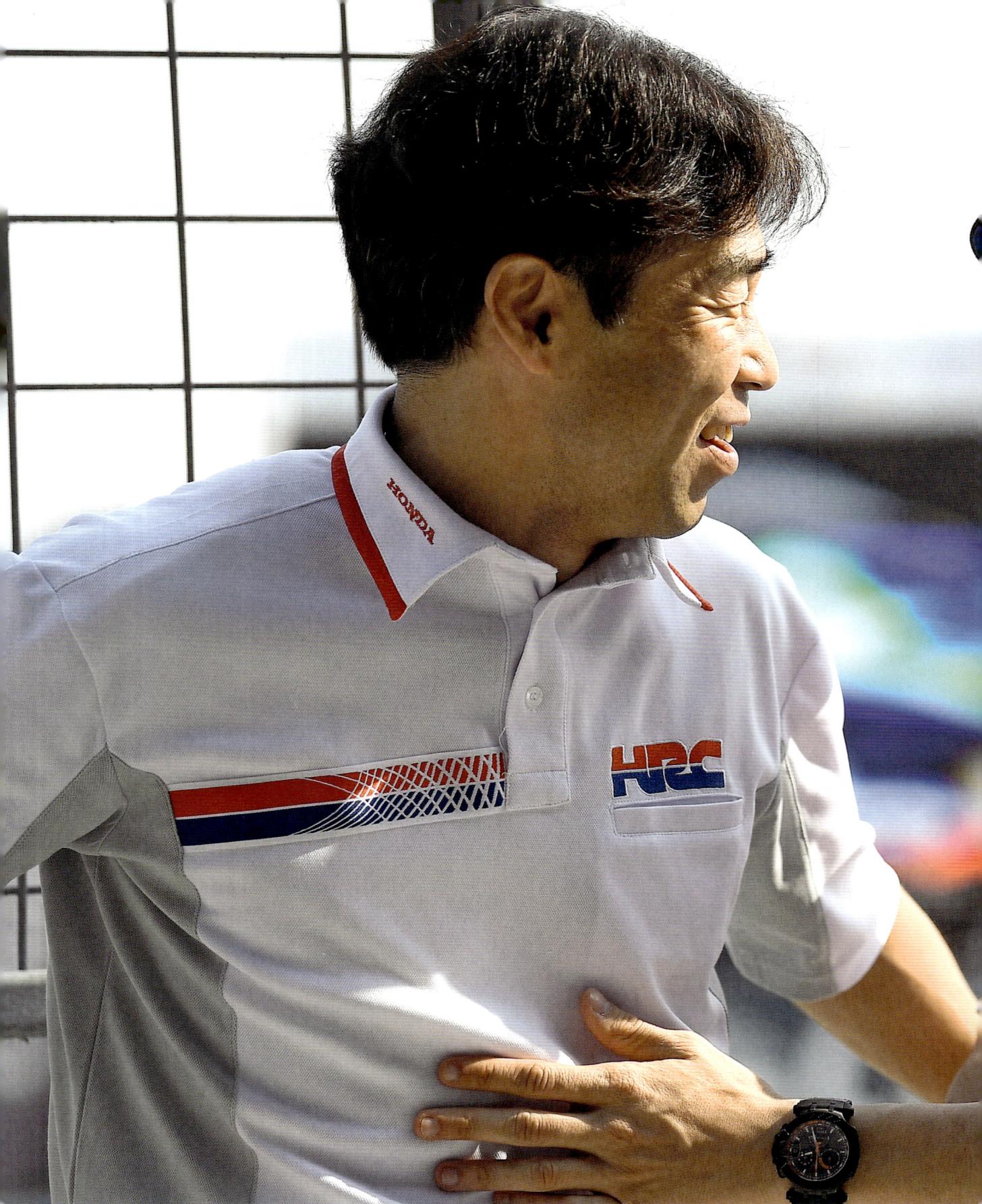

Together through thick and thin for years: Marc and HRC director Tetsuhiro Kuwata.

for that, I need a winning plan. I have to feel like I can win. That's what drives me on. It's the reason I ride motorcycles: I want to win. And Honda has to provide me with a bike that makes that possible. The gloss of the iconic Repsol Honda team has dimmed for me in recent years, but it's still there. All the great riders who have ridden here, almost all the legends of recent years, from Rossi to Stoner, Pedrosa to Lorenzo... I see the current weakness as temporary. The team will be back, of that I'm sure. And hopefully there'll never be another year like 2022, in which we couldn't win a single race.

When, after every world champion, the HRC boss personally thanks me for bringing the title home to Honda, it shows how much the company values me. And they know that if they lost me, they would lose a big part of what it is that has made Honda able to shape MotoGP in recent years. Respect: that's what I feel when I think of Honda.

I was really struck by the significance I have for the company at the end-of-season party, the Honda Racing THANKS DAY, in Motegi in 2022. Max Verstappen and I were the main attractions. You get goosebumps when a whole stand, all decked out in the colours of Repsol Honda and Red Bull Racing, is chanting, "Marc, Max, Marc, Max!" On the one hand, I feel very flattered at moments like those, but, on the other, I also feel the responsibility. There are many Honda employees among those fans who work their butts off at the factory every day to build me the best bike possible. I feel obligated to them and this helps me to sometimes say no, when no is appropriate, even when I actually want to say yes. Maybe I should go out partying with my friends instead of training? No, I stay strong because I feel this connection to the very many people who give their all for me because they want to see me win.

Since 2020 at the latest, many have considered Ducati the best bike in the field,

"I have to feel like I can win. That's what drives me on. It's the reason I ride motorcycles: I want to win."

and it is definitely a bike many different riders can win on. Would I, say, for a little bit of money ride for Ducati or another manufacturer? Well, I would be tempted to try a different bike for a race, just to see what it feels like, but in practice it isn't realistic, of course. It's just a mind game. You commit to a manufacturer contractually and give them your all.

Being fast on the track is just one of the qualities you bring to the team as a motorcycle racer. A rider is also a unifying factor in the team. There are companies and people in my entourage who would come with me wherever I went, I'm sure. And I'm also an economic factor, of course. All this would definitely be a factor in the hypothetical game of changing team once my Honda contract expires at the end of 2024. A MotoGP project can be financed in different ways. It is not set in stone that the manufacturer has to pay all my fees. These mind games may be there, but they don't have an impact on my decision as to whether to continue with Honda once my contract expires.

Money is necessary, of course, and a legitimate driving force for almost all of us. But for me, it was never the most important thing: not in Moto3, not in Moto2, not in MotoGP. If money were so important to me, I would live in Switzerland, Andorra or Monaco. But no, I've paid my taxes in Spain all my life, the full 50%. But, in principle, that doesn't matter, because I want to live in such a way that I can perform perfectly, in an environment where I feel comfortable. And I have that at home in Spain.

It's the same with sport. The top priority for me has always been a project that I could believe in, that I thought would enable me to win. I have never played that much-loved game of sending my manager from team to team to increase my value. Whenever it's been time to renew my contract, I have gone to Honda, asked them if they wanted me to carry on and on what

terms. After that, we had an exchange of views, came to an agreement, looked each other in the eyes and signed.

Many of my partners, companies such as Red Bull, Alpinestars, Shoei, Oakley, have also been with me for years, sometimes decades. I like all their stuff, but what I really like is their people: Gabriele Mazzarolo from clothing manufacturer Alpinestars, a super guy with whom I have a very close relationship. Or Antonietta Secco, the woman who has taken care of my leathers since I first appeared in the world championship. Whenever one of my loyal sponsors has a special request on a weekend – meeting and greeting a VIP, stopping by at a dinner – then I'll do everything I can to fit it into my schedule. This isn't in any of my contracts and sometimes it's really difficult to find enough time, but I almost always find a way for my old friends.

After I injured my arm, Thomas Überall, the Head of Red Bull Motorsports, called me several times a week to ask how I was, almost like a father. It was really touching. He didn't have to, and probably had a thousand more important things to do, but he cared. I matter to him. So it makes perfect sense for me to make myself available when he has a request.

What I want in return is commitment. If my team or I start a project – an MM93 fan line, for example, or a replica helmet – then my partners Alpinestars or Shoei need to be there with us at the forefront of the campaign. And that's exactly what they do, and they do so happily. The design for these items is usually created here in Spain by a designer we know. But there is one important exception: the guys and girls at my helmet manufacturer Shoei get carte blanche from me for the Grand Prix of Japan in Motegi. Shoei is a Japanese company, and they can do what they want with my helmet for their home race. I give the final details the nod at the end, and should they one day decide to send me out onto the track at Motegi in a pink helmet, I would wear it out of respect for our shared history. And if Alpinestars design new MM93 jackets they believe will be a success, even if I'm sceptical, then by all means. I'm not going to interfere in their business.

There are things even my best friends don't get from me. That includes the leathers I've worn in a race. I keep two as a memento from every season: a new set and a used set. Everything else – or what's left of them – gets sent back to Alpinestars. I don't know what happens to them. Maybe they get destroyed or end up in a museum. It doesn't bother me. I've already got my two sets. Sadly, even with the best will in the world, I can't say how many racing leathers I get through in a season. What I can say is with the amount I crash, it's a lot! By the way, minor scrapes after harmless crashes are seen to there and then on the track by cutting out the affected area and replacing it with a new, intact piece. Totally ruined specimens go to the company headquarters in Italy for a complete overhaul. It also protects the kangaroo population, because our leathers are made of their very durable and fine hides. But as fine and cuddly as it is, I prefer to wear racing leathers that have already been worn in, not completely new ones. They just feel more comfortable. Alpinestars know that and fit me up for the race accordingly. The same applies to the boots, and there, too, sustainability is key. We often scrape our soles on the tarmac when braking, which is why an otherwise completely intact, comfortable boot is sometimes totally ruined underneath after just one race. Alpinestars have now found a way to only change the soles.

I also keep one used and one unworn helmet from each season. There are, of course, also a number of replicas that look like my helmets, but I have never worn them. These are gifts for special people, VIPs or my mechanics, say. I don't actually

Marc Márquez hasn't only been wearing his Alpinestars leathers since joining the world championship. He's worn them out.

Helmet manufacturer Shoei traditionally comes up with a special design for the Japanese Grand Prix. In 2019, it was a comic samurai.

Marc never lacks energy, here during a TV interview in the pit lane.

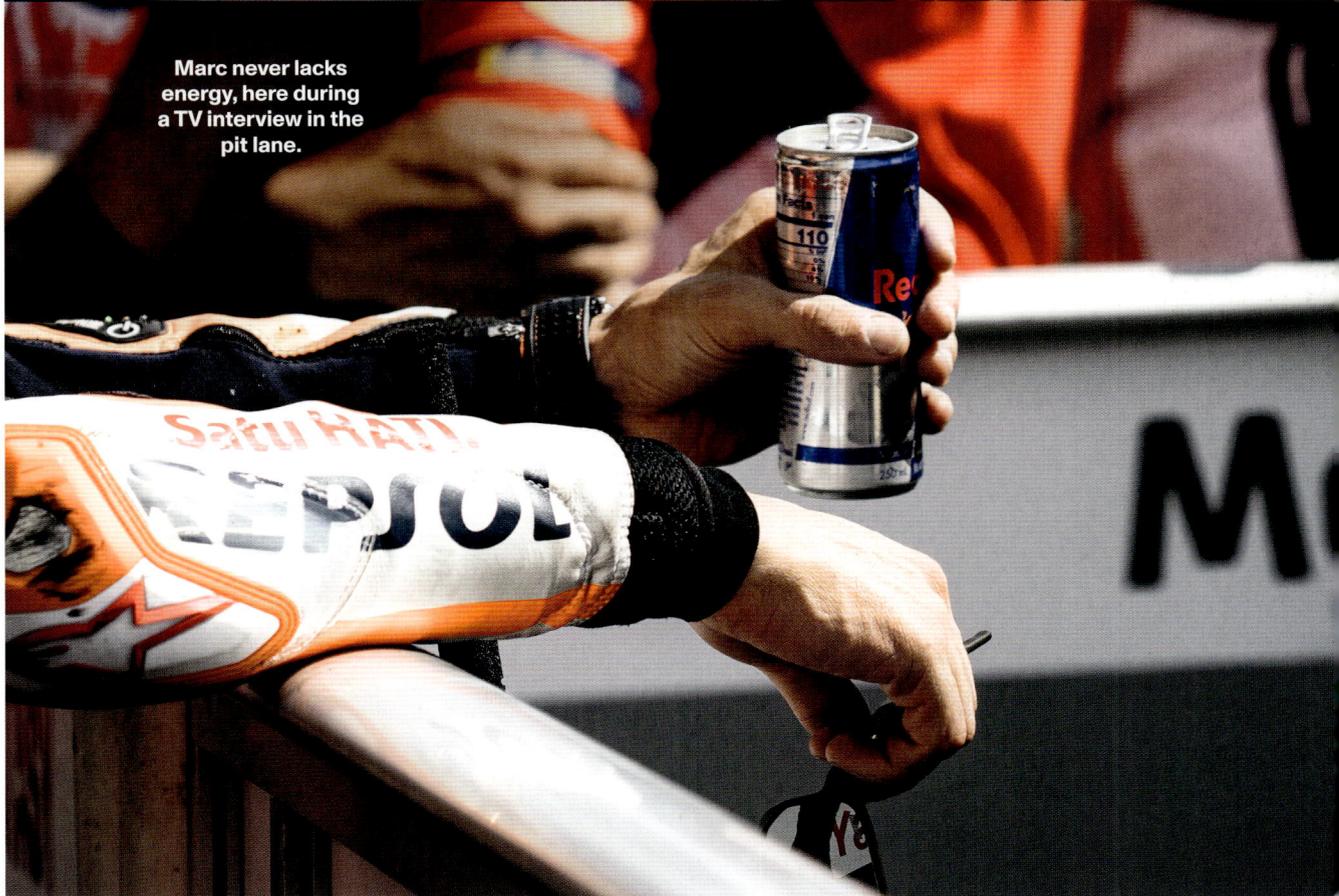

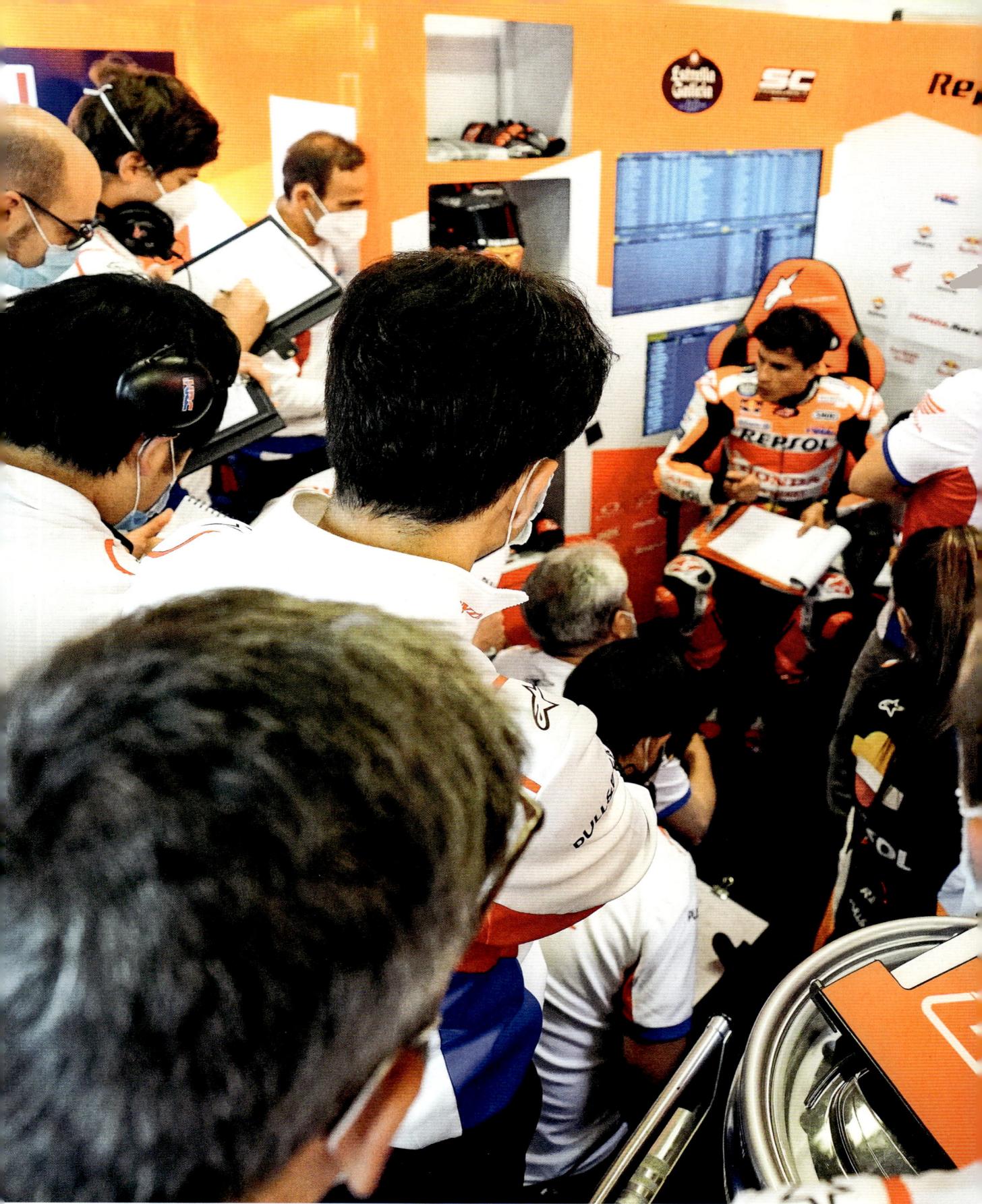

use more than four or five helmets per season. They rotate during the races. If I destroy one, we replace it with a new one.

I would definitely call myself a creature of habit. That applies both to my kit and to the people who have accompanied me throughout my career. It raises the question of whether we'll all retire together one day because we're so close. The idea does go through my head sometimes, but a lot of people from my team and immediate entourage are still very young. Their careers in the MotoGP world shouldn't be over if I stopped one day. If one or two of them ended up working for someone who is one of my rivals today or for a young rider whose name we haven't yet heard, I'd be happy!

My mechanics at Repsol Honda are paid properly, but none of them is made for life. They'll have to keep working while I'm lying in a hammock all day doing nothing (the second part of this sentence is a joke). If I can help them find a follow-up project for MM93, I will, of course. Maybe my name on their CV and the fact that they had a lot of repairs to do as my mechanic will help. Who knows? The relevant people in the paddock know all about the qualities the Repsol Honda employees have. Maybe one or two of them have already had requests from other teams. Yes, and there have probably already been attempts to recruit my mechanics. But it's never got back to me. To date, all my guys are still with me. Just like with Honda, respect is mutual, and it is a kind of respect that doesn't need to be expressed or emphasised in any way; it's just there, is completely natural, is perceptible every day, and has been for years. The grass definitely isn't greener on the other side of the fence, even if it sometimes looks that way.

← On first-name terms with the crew: having known each other for over ten years, they speak the same language, both on and off the track.

→
One to go ...
The Red Bull
Ring in
Spielberg,
Austria, is
the only
circuit on the
MotoGP
calendar
Marc has
ridden at
repeatedly
but never
won.

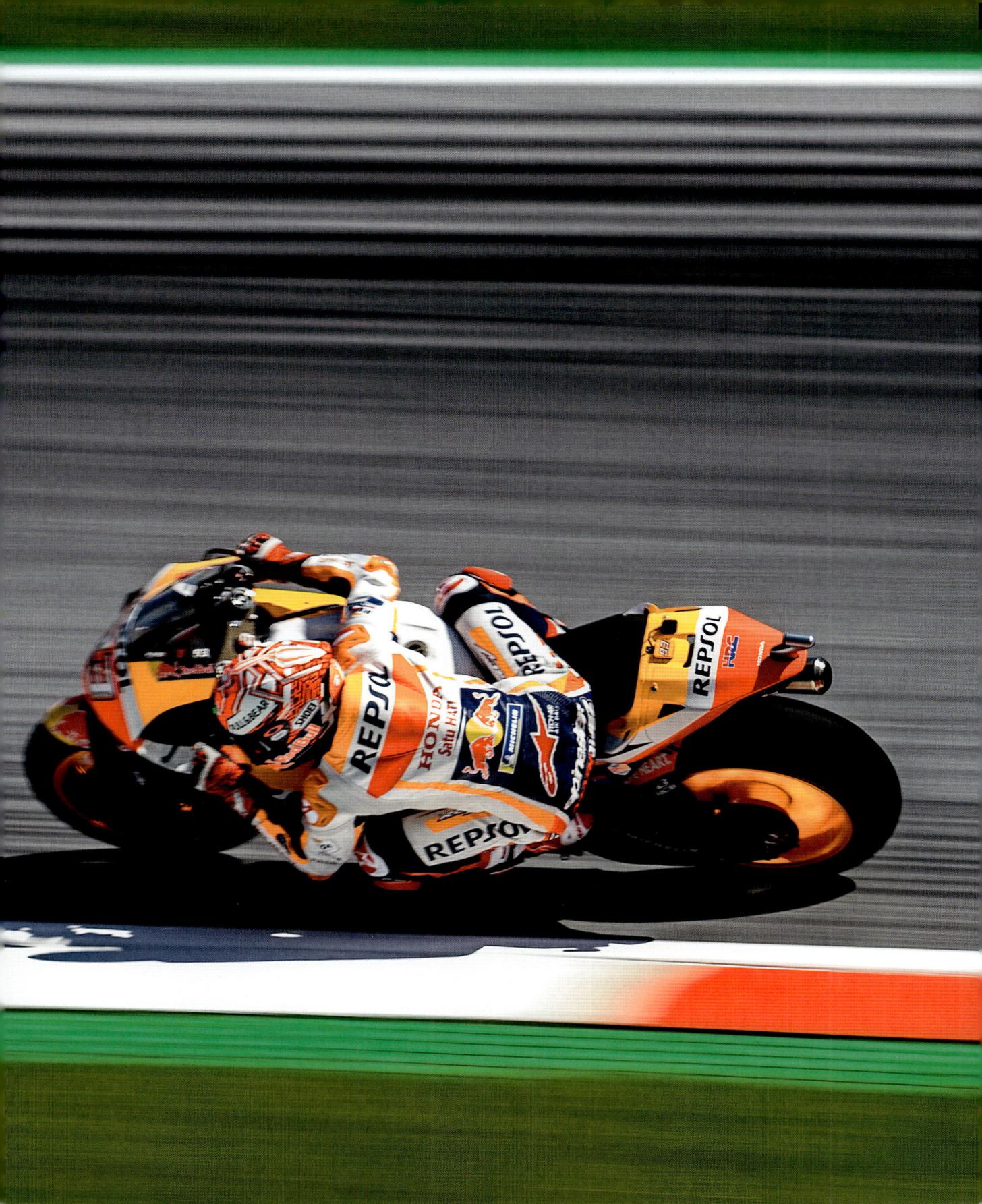

Friendship

The environment
I need to perform

④

Just because Marc finds someone nice doesn't mean he's his friend. Not by a long chalk. In his world, friendships take years to develop. Glory-hunters who want a selfie with him after exchanging three sentences and then immediately post it on social media? Those people are fans, not friends. People hoping to get deals out of him? Business partners at best, not friends. Even superstars need friends, perhaps to some extent even more than those of us not in the public eye. Real friends. Honest friends. People under the spotlight in the way Marc is in MotoGP can only benefit from independent input. It is necessary to allow criticism or, as he so trenchantly puts it, to have a bucket of water poured over your head every now and again. We humans are social beings who need each other as a stabling influence and need places to retreat to, to be ourselves. In this chapter, Marc takes us into his very personal human relaxation zone, the place he finds the power that has carried him through a decade of MotoGP.

→
The high-point and winding down of every race weekend day: dinner with Santi and the mechanics. True friendship.

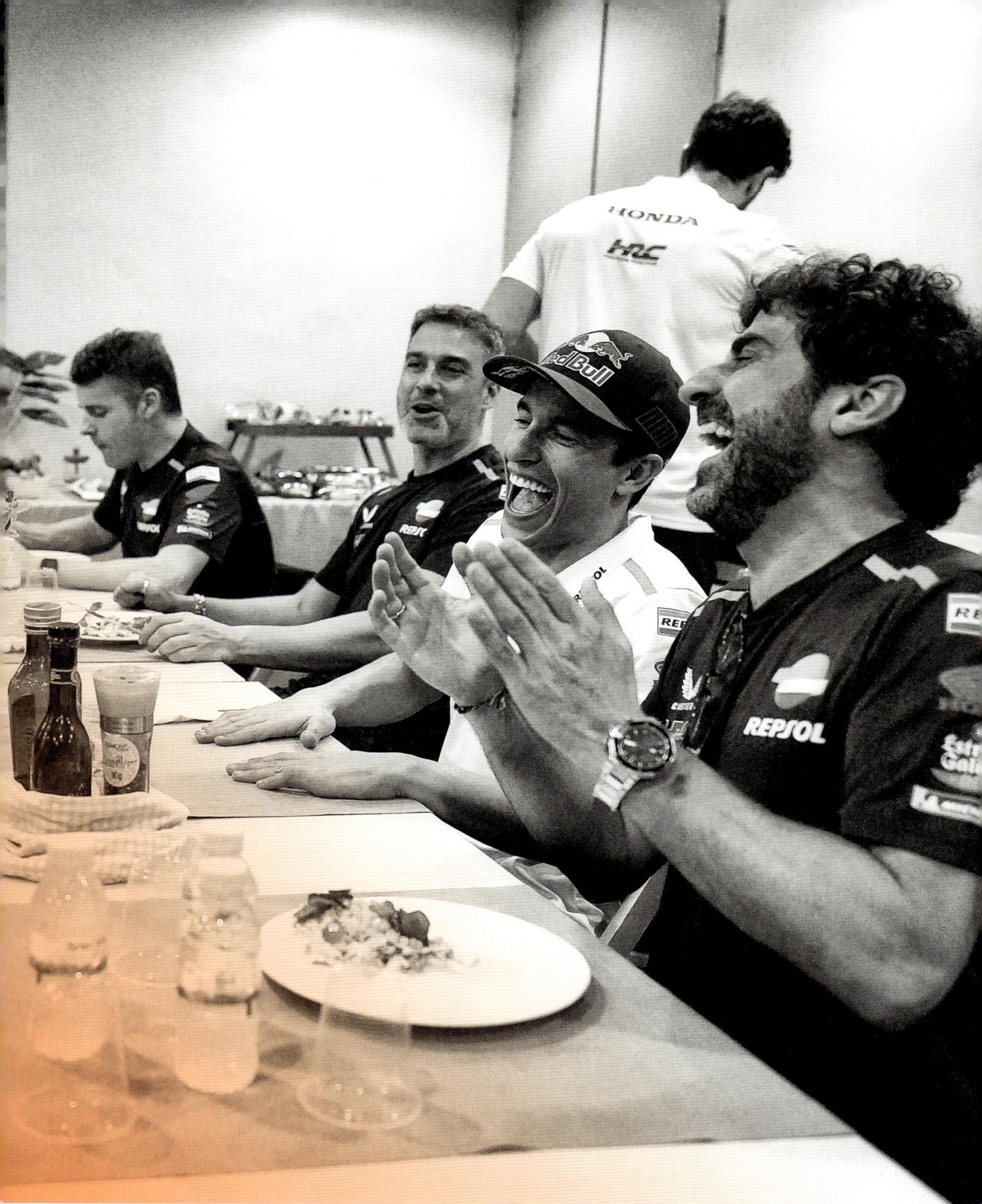

I need to have the right people around me to be in my comfort zone, to feel at ease and to be able to perform as I want to on a race weekend. Friends. The first person to mention is José Luis Martínez, a Spanish former motocross champion. We've been working together since he retired from racing in 2015 and have known each other much longer than that. We work out together and are real friends who can talk about things other than racing too. Then there's Santi Hernández, of course, my crew chief. We speak the same language when it comes to bike technology, but we also speak the same language on other matters too, and have done for over ten years. And then there are the ranks of my mechanics, who have also been by my side for years. That's the core, the group where I feel most comfortable on weekends. There are weekends when I don't get to eat with my father at all and only have dinner with these guys. These dinners are a ritual, the highlight of our days at the racetrack.

And don't the engineers attend these dinners? No, as a rule, I actually sit down to dinner with the mechanics, mainly. As a rider, you talk to the engineers all day long as it is about the job, the bike, performance. The mechanics and I talk about everything and anything at dinner because their work is done as soon as the bike is ready for the next day. Their thoughts are free, unencumbered. We talk about life, women, other sports. And of course we fool around. We hardly talk about the race, not even on Saturday nights.

Once I have found my people, I am insanely loyal. The people working on my bike today are, at their core, the same group I became Moto2 World Champion with back in 2011. Maybe there are a couple of mechanics in the paddock who would work even better than one of my boys or would have special strengths in a certain area, but what does "better" mean? It takes more than just performance to be part of my team. Equally crucial is that it works on the human level, creates the right atmosphere. One group member has to make the others better. People who work well together and have a good relationship with others strengthen the whole team. If one person makes a mistake, the others fix it. The same applies to me. Within this group, I am one of the boys. There can also be three minutes of silence while everyone eats quietly. Comfort zone for me means being allowed to be myself on race weekends, not having to worry about the others and wondering if they're OK.

We know each other very well, which only makes sense after all these years. Experience saves you words. You can sense how the others are doing. There are two or three Spanish guys in my crew who like to play up a little. One of the Italians provides the casino, that is, makes some noise, when he thinks things are a little too quiet.

Santi and Carlo Liuzzi, my electronics engineer, are rather quiet. Their thoughts are still sometimes on the bike. They sit at the table without being present, but that's fine.

My role in the group changes. Some days the boys carry me. On other days, I'm the one lightening the mood. Santi says the group is quieter when I'm not there, that I bring positive energy to the table. I can't be the judge of that, of course, but it is true that I like to laugh, and even days that didn't go well I try to end on a positive note.

The Australian Grand Prix, Phillip Island, 20 October 2013. Rookie Marc Márquez is sensationally still in with a fighting chance of winning the World Championship title. Up until that point, in his very first season, he had finished every race he completed on the podium. His only crash was in Mugello. Otherwise he had an impeccable record. His toughest rival, Jorge Lorenzo, was still hot on his heels. He, too, had only one finish outside the points. It was a world championship scrap in which mistakes were pretty much forbidden. In the run-up to the race, the ultra-fast track had been resurfaced, causing the tyre technicians at Bridgestone, the sole supplier at the time, to sweat. For safety reasons, the tyres couldn't be used for more than ten laps. Any longer and their durability couldn't be guaranteed. That meant changing bike mid-race, because just changing the tyres, like in Formula 1, isn't an option in MotoGP. In a 19-lap race, there are precisely two possible ways of doing that: either at the end of lap nine, and then the second tyres would have to complete the maximum allowed ten laps, or at the end of lap ten. Marc's crew chief Santi Hernández left his protégé, who had been in a dogged battle with Lorenzo

up to that point, out on the track for an extra lap. The crew only realised its serious mistake with Marc out in front all alone, the last rider not to have made his mandatory stop. He was immediately disqualified.

Santi was clearly responsible for the mistake and he was as contrite as you would expect him to be, to put it mildly. Would it cost us the World Championship title, the first by a rookie in the top tier of the sport since Kenny Roberts in 1978? But I told him not to worry about it. In Mugello, I crashed three laps before the end. That was my fault. I threw away 25 World Championship points that time. Now he had. Both are done and dusted. We win and lose together, and that applies now too. Another example: I got off the grid badly in Austin in 2022 and was the very last to turn into the first corner. It was human error, not a technical problem, without wanting to go into too much detail here. After that, it was damage limitation to the best of my ability, but I couldn't do any better than 6, and this on a circuit that really suits my riding style.

My boys were down, predictably, after the race. So I took them aside and asked them how many times I had trashed the bike in the last few years and how many times they had had to fix it. How many points had I thrown away in recent years from crashing? And how many technical problems had I had during that time? Zero, not a single one. We are a team. We win and lose together. That applies today too. I want us all to go to the Red Bull Party tonight after dinner, like the years I won here. Some jaws dropped, others had tears in their eyes. The guys needed that at that moment, the feeling of being part of a unit that goes through thick and thin together, even when mistakes are made. We are a family. That's what it feels like to me. Austin was the right moment to remind everyone of that.

Even my brother Álex doesn't attend these dinners with my mechanics. He has his group. I have mine. He has his engineers, his mechanics, his problems. I have mine. Even though he's my brother and we've both been riding Hondas in recent years, we don't talk much on race weekends. We do that the rest of the week when we train together. When we occasionally do talk at the weekend, it's never about technical stuff, only about the way we ride: how do you approach such and such a turn? What do you do here or there? We only spent a single race as team-mates, not the entire year as we had hoped, because of my break, due to injury, in 2020. But I don't think our approach would have changed at all, even as team-mates. If you want to win races – and that is our job – you can't worry about another rider's problems and worries, even if he is your brother. It is a matter of self-protection: you can easily get bogged down in other people's problems. A tiny comment here or the odd question there can create problems where there was none before. A concrete example: one person describes entering Turn Three slowly in order to be able to accelerate better when exiting. Suddenly, the other person is thinking about something he wasn't thinking about before. Differences and preferences in the way we ride are much starker on two wheels than in motor racing, say. There are often several ways of getting a good result on two wheels, and that depends on the bike set-up too. Knowing that, we leave each other alone out there on the track. Everyone does things their own way. As we were using the same kit in recent years, I could give Álex the odd pointer here and there as to which technical innovations or electronics settings worked better for me and which less so, but the final decision was his.

Apart from my brother, I have no friends among the current crop of MotoGP riders. Not a single one. That's probably

→
What a welcome! José Luis Martínez and brother Álex hail Marc on the track to celebrate his fifth World Championship title at Motegi in 2016.

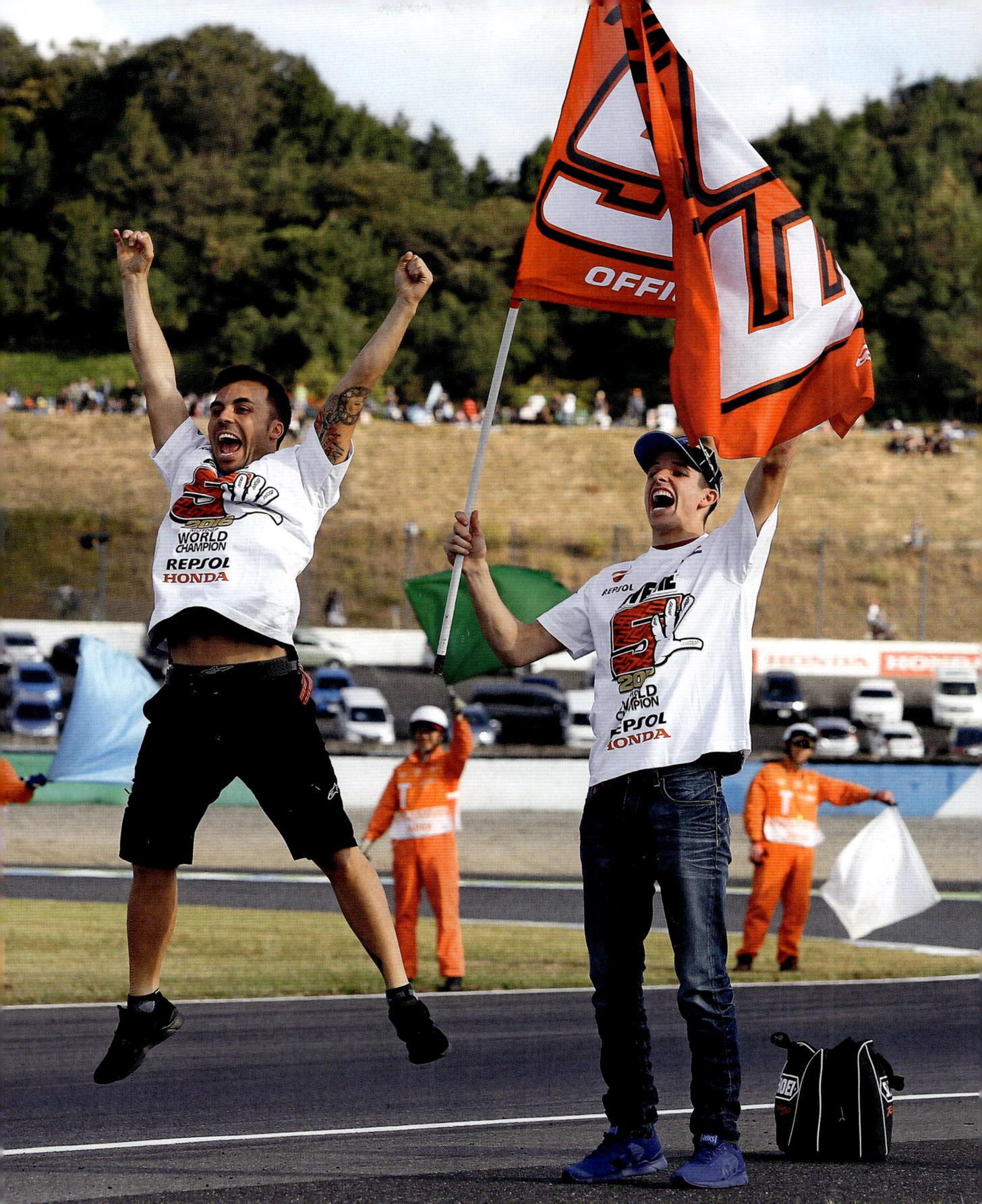

The world champion doing his own cleaning. When Marc rides motocross with his brother Álex and buddy José, the set-up is no different from that of an ambitious amateur. They are faster, though. El Bunker, near Madrid, 2023.

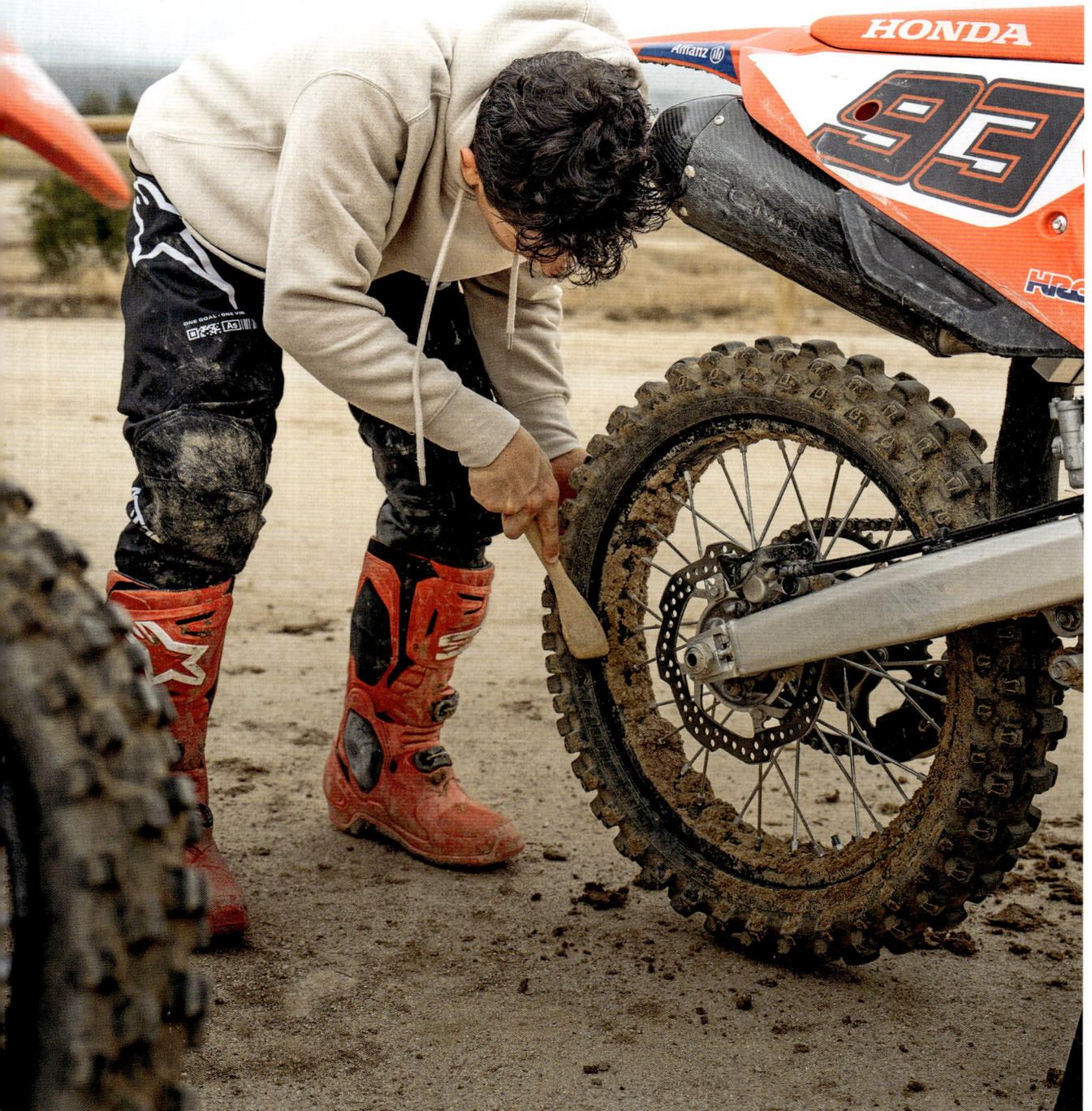

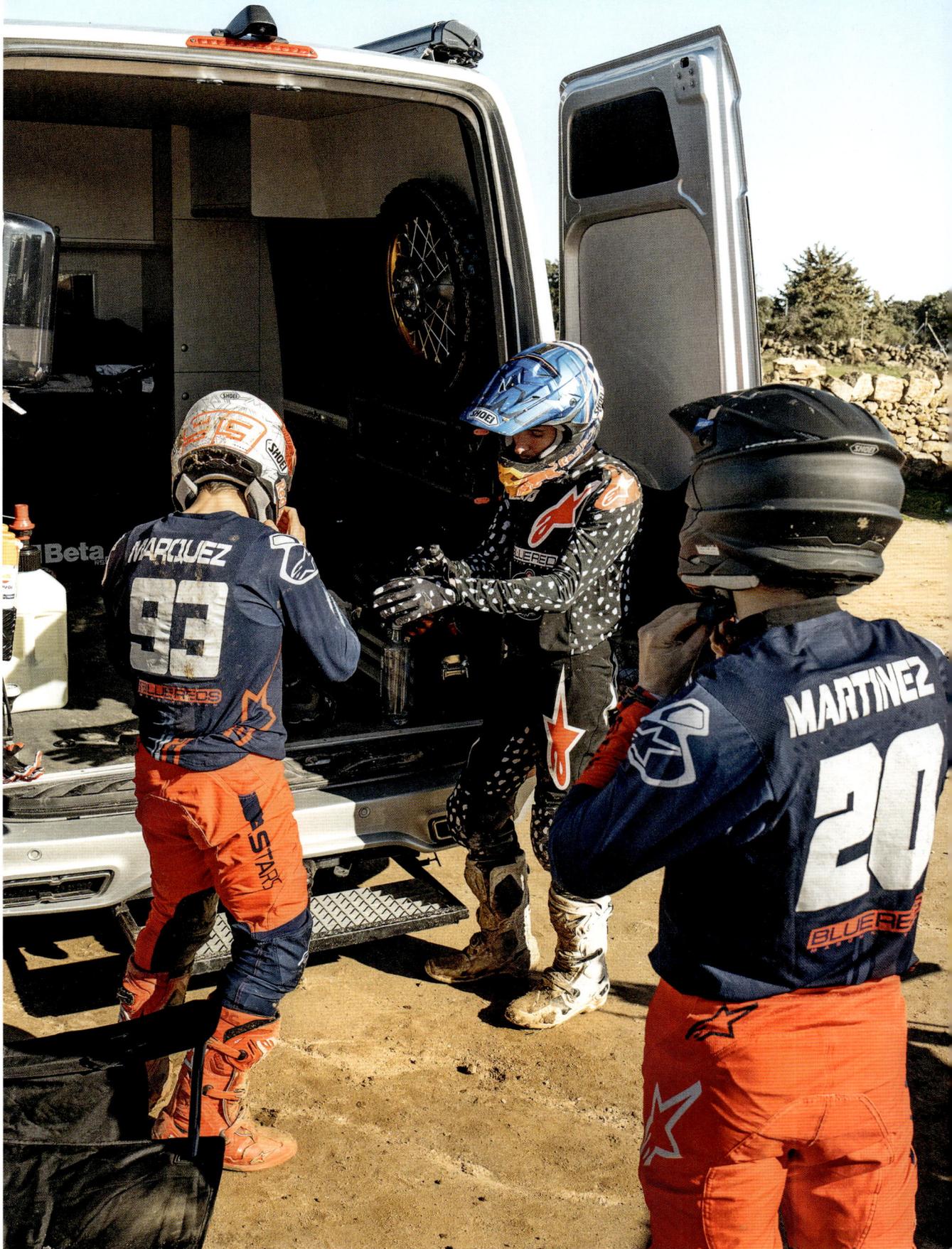

due to competitiveness. I'm always getting to know people from different sports but never from my own paddock.

My friendships beyond the racing circus, which of course also exist, work differently. I have known many of my friends from my home town Cervera since childhood. Even if they visit me at a race, I don't have dinner with them in the evenings because they're in a different mood from me. They come to the track to have fun. I'm here to do my job. The two things somehow don't go together, even if they are my friends. I feel responsible for them. When they visit me at a race, I want to show them my world, or at least feel like I should.

With real friends, it doesn't matter when you last saw them. Friends reconnect where they left off last time. I hadn't heard from or seen the Cervera boys for three months before we spent last New Year's Eve together, and it was just like it always is, even though I've moved to Madrid now. Real friends can call me any time and vice versa. If someone wants a ticket for such and such a race, I'll work out something if it's a friend. Real friendships evolve, and there isn't an infinite number of them. Real friends? I have five, maybe ten.

I'm very bad at asking people for favours. But with real friends I can because I know they won't hold it against me. They do what I ask and that's the matter dealt with. Other people want something in return. That's fine in principle, but in turn makes me more reluctant to ask them for anything. A typical favour might be bringing my car to be serviced, waiting for it to be ready and putting it back in my garage. Not a huge deal, but incredibly helpful to me at times.

Real friends don't need a reason for doing something. Sometimes I invite them on holiday, just because I want us to have a good time together. Sometimes I pay for things we do together, sometimes I don't. I don't feel like I have to pay for my buddies

all the time, but sometimes I want to. Nor do they always expect me to pay. If I take everyone out for dinner, I can assume that the next time someone will at least cover my share without my even having to get my card out. This goes for both my old buddies and my mechanics on the track.

I'm not out of touch and know that some restaurants we eat at during the year are quite expensive, more expensive than my mechanics can really afford. But I'm kind of forced to go there, and not to the pizzeria on the corner, to get some peace and quiet. But because I want them with me, it makes sense that I foot the bill on those occasions.

We often also have bets on the go, in which, unfortunately, I rarely have anything to win, but often have something to lose. I often start these bets myself. If I win such and such a race, I'll invite you all out after. If I don't crash in practice, you have to get dinner. If I qualify in under 1:35 minutes, so and so will happen. It also motivates me and lifts the mood in the team.

What I love about my friendships is that I'm just one of the guys. They treat me like one of them, not like someone special. If someone wants to prick my ego in a situation, then he does so, as I would with him. If someone has had one too many, we get him home, as you just do with friends. My sport isn't a major topic of conversation when we're together. Basically, what we talk about hasn't changed much since my international career began.

I'd be lying if I said that my popularity and lifestyle didn't affect friendships at all. In Spain, in particular, it has become quite difficult to lead a normal life. Sometimes friends come up with these great plans for adventures together, which, sadly, I have to turn down. I have remained a completely normal person inside and try to behave that way, but many people see things differently and think of me solely as the star and world champion. At the moment,

the fun is over for my boys too. It is better for me to forgo partying for now and let them do that without me. At least that way, they have fun. Not being completely free to do whatever I want is the price I have to pay for my popularity, but I'm not complaining.

I totally see myself as a social person, but I need time to really trust people. Sitting at a table with ten people and keeping them all entertained? Easy. But to build trust, to be able to discuss private matters or to invite someone to my house... That all takes time. A lot of people want to be my friend, but it's not that easy. Before I really let a person get close to me, I have my eye on them for months. If in that time I discover things that bother me, even small things, you can forget about it! I don't need fake friends. A classic is to ask for a selfie with me the day we meet and then post it on Instagram straight away. What's that all about? It's obvious the person just wants to give themselves airs by pretending to be close to me. I find that sort of thing disrespectful.

Yes, I do post on social media too, but almost exclusively Marc the professional. Unlike with many other riders, there are no party photos of me. My social and private life are just that, private. I'm not an influencer. I race motorbikes. That's why I keep my fans up to date with race and training pictures. Social media is a double-edged sword. It's great for being close to your fans and I love my fans. On the other hand, they always know where I am. Some of my colleagues complain about their lack of private life, but you can also control it to a certain extent. And it's just part of the profile requirement for an athlete today, to be there for their online fans. You know what you're getting into.

I decide how much to post on social media based on what I feel like. During race weekends, I have neither the time nor the nerve to look at my mobile phone. There is someone who has access to my account who, after each session, uploads a photo with a caption that I dictate. If I post training pictures or videos, like from motocross or the gym, then I'm doing that just to show my fans what I'm up to and not to prove to my team principal that I'm training on a day off, say (I don't even think he has an Instagram account). Bosses are interested in results, not clicks. But maybe the odd worker at Honda in Japan, busy creating parts for my bike at his CNC machine, will see that I'm not letting myself go and doing everything I can to make our joint project successful, regardless of the day of the week or the time of day.

Over the course of my career, I have always decided myself who I trust and who I don't. I discuss decisions affecting my job with José and Álex, not my mother or father. They are too sentimental, which is only to be expected. I changed my manager last season after 18 years. I had known Jaime, or Jimmy, as everyone calls him, for five years before we started working together. I repeatedly asked him to do me favours over that time, and he was always there for me, without my worrying that he might be totting it all up in his head, only then to present me with a bill for it all. That's what convinced me.

I was able to work with his predecessor, Emilio Alzamora, for an incredible 18 years, and what we achieved together is unbelievable. I am really grateful for that. But three or four years ago, our relationship got a little tired. It was still working, and we were still successful, but the ease and naturalness of earlier times were no longer there. In discussions we got more cautious, lost our trust and stopped daring to speak our minds. Nothing big ever happened, it was just that we had gradually lost the groove, as unfortunately sometimes happens in a long relationship. Respect and distance grew. I stopped doing certain things the way I wanted to, because I was thinking about how Emilio would react.

"Sitting at a table with ten people and keeping them all entertained? Easy. But to build trust, to be able to discuss private matters or to invite someone to my house... That all takes time."

You see the no. 93 everywhere in Marc's home-town of Cervera, about 100 km north-west of Barcelona.

ENTREPANS

ENTREPANS FREDS

Pernil país	3.5
Formatge	3.5
Fuet	3.5
Xoriç	3.5
Tonyina	3.5

ENTREPANS CALENTS

Llom	4.2
Llom amb formatge	4.
Bacó	4.
Bacó amb formatge	4.
Botifarra	4.
Botifarra negra	4.
Truita	3.
Frankfurt	3.
Biquini	3.
Patates braves	4.

DILLUNS NO HI HA
SERVEI DE
RESTAURANT

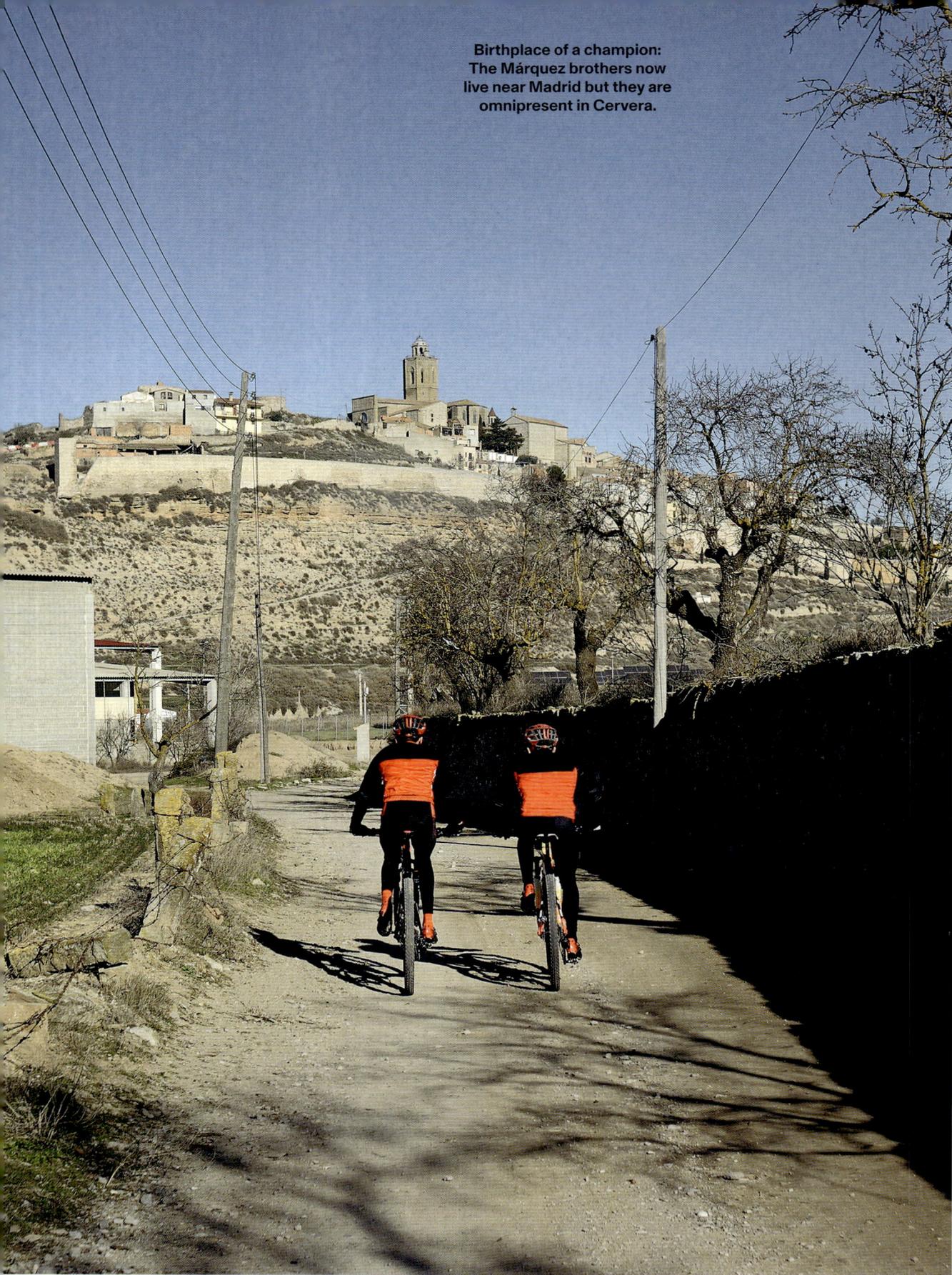

Birthplace of a champion:
The Márquez brothers now
live near Madrid but they are
omnipresent in Cervera.

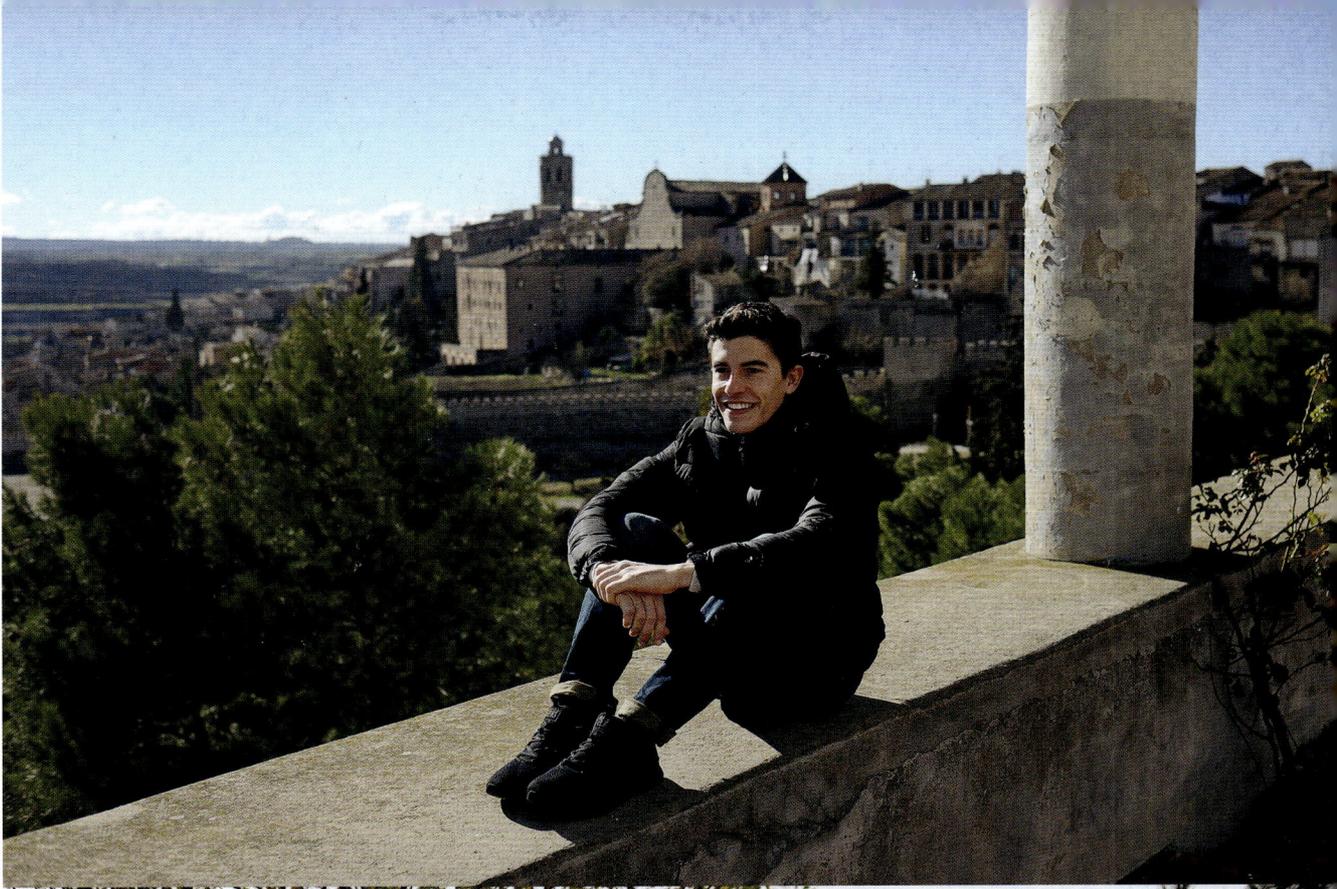

LA CIUTAT DE CERVERA
AMB MARC MÀRQUEZ

CAMPIÓ DEL MÓN MOTO GP

93

PAERIA DE CERVERA

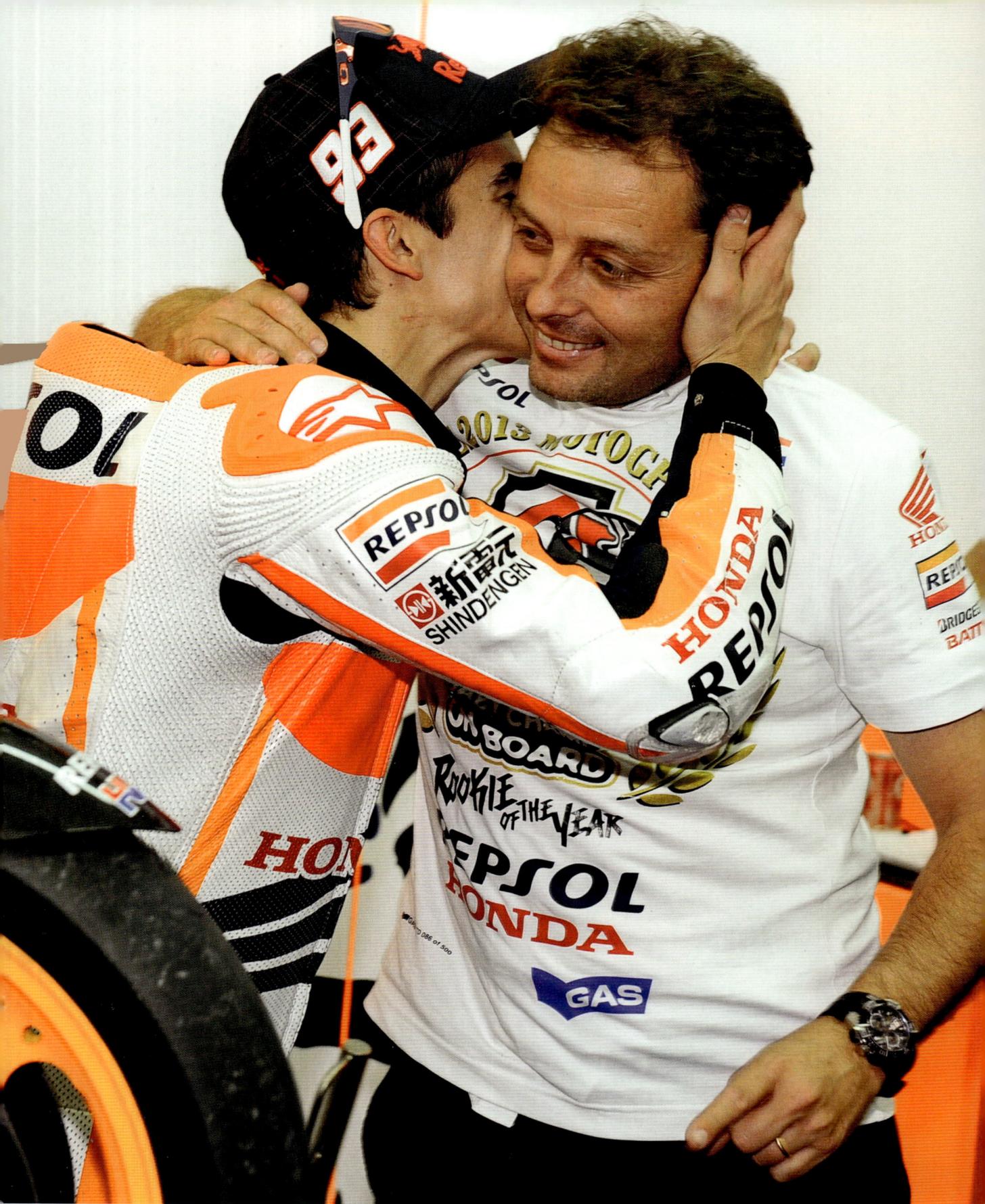

So the idea crept in that a new start at this point in my career, at the age of 30, would do me good.

What I learnt in the process of separating from Emilio was to discuss things, and most importantly, discuss them at the right time. When you no longer broach certain topics or push them away, they snowball. The more momentum that snowball gets, the harder it becomes to stop. It seems to me that I'm getting more direct in what I say as the years pass, and maybe I overdo it sometimes. I like the totally direct, blunt way Max Verstappen communicates with his team, even though I usually don't know his reasons for making the decisions he does and how he makes them, of course. But when he makes one, he stands by it, and everyone knows where he's at. I think it's necessary to distinguish between the decision itself and the way it's communicated, and in the latter Max is absolutely brilliant and unequivocal.

I need a certain amount of love and security around me to perform at my best. People I trust. Of course everyone who joins a new team wants to impress those around them. Hi! Here I am! That can, granted, provide extra motivation and tease out a few percentage points more performance. If everything works right from the start, that's great. But don't you get into trouble! For when you do, it is unendingly comforting to be able to rely on your usual entourage and know that no one is going to descend into panic mode. This goes far beyond work on the track. For example, when my crew chief Santi notices that something is wrong in my private life, he speaks to me about it. My entourage knows when I need some tender loving care or a kick in the backside. We have built up implicit trust. Small gestures are enough for us to understand each other. An example... Sometimes, as an athlete, you are mistreated by journalists, so that they can get a certain story into circulation. It's enough for me to get

advance warning that something might be in the offing. I don't even need to know what it's about. Just getting a little verbal warning sign before I go to the press conference is enough. Not, "Say this, don't say that." I can think for myself and don't take kindly to anyone telling me what to do or say. I can react really aggressively to that kind of thing. My people know that. Or people choosing the wrong time to tell me their opinion... I take my helmet off, I'm pouring with sweat and someone comes at me that I rode like crap. Seriously bad timing. That evening still wouldn't be the right time. Wait a day or two, then tell me when emotions are less raw.

When you've been with the same people day in, day out, as I have, you no longer need many words. Body language and facial expressions often tell the whole story, to the extent that I only need look José in the eyes in the pits to know whether he was satisfied with my performance on the track or not.

I've had countless manager offers ever since I was 12 and there have been some good deals from serious managers. But if it doesn't feel right to me, I don't go there. In that sense, I'm very much driven by my heart, not my head. I've noticed that I'm changing in recent years. I need different things now from when I was 20. The world has changed since I joined the sport's top flight. Jimmy brings a fresh approach, and I like that a lot. It's what I need right now.

What I appreciate about both Emilio and Jimmy is the feeling that they're not dependent on me. Of course, this is business, but they could both survive without me. When I stop being their client, they'll move onto other things. They have a plan B. They work for me because they want to, not because they have to. Jimmy has the best contacts through his previous job at Red Bull. José has his motocross school. My mechanics are so good they can take care of other riders after me if they want to. It's important for me to feel that

←
Winning team over multiple seasons: Marc and his manager of many years, Emilio Alzamora, once a racer himself, seen here after Marc winning the MotoGP for the first time in 2013.

no one will fall into a hole when I eventually retire and everyone won't be looking back on the beautiful time together when we achieved so many incredible things as a team. Of course we're doing business here. The people around me make money through me. But, and this is the point, they do so out of passion. We all do it out of passion.

My love of sport also affects my private life, of course. I've had two relationships: one when I was 19/20, with a girl from my home town, and I also had a girlfriend during my best season, 2019. Maybe my attitude will change, and maybe I just haven't met the right partner yet, but to be honest, I haven't yet felt ready to commit to something longer-term. I hate compromise. I love my job, my profession, and I'm the same in my private life: it's all or nothing. During the season I'm very strict with myself. On race weekends in particular, there's not a second to spare, and in between there's training, plus other obligations. That means that the year from March to November is very full and I don't have much real free time, though I'm less strict with myself than I used to be. Even going out on a non-race weekend used to be unthinkable! I think you can guess how precious my free time is to me. If I had a girlfriend, I'd have to compromise and worry whether she was happy. Should I go to the cinema with her? Should we go shopping together? I like doing those things too, but I want to do them when I feel like it. I'm more the spontaneous type. I've booked a holiday home in the past and then not felt like it. So what did I do? Sent my friends on ahead and then joined them when I actually felt like it! Or, also while on holiday, I got bored after a couple of days and I looked for a nearby gym to burn off energy, even though it wasn't in my training schedule. So, as I say, I'm more of a spontaneous type, and the people around me have to be able to deal with that.

→
The new manager by Marc's side: Jaime "Jimmy" Martínez has been taking care of business since summer 2022.

Lots of people are pretty different from me on that front. There are athletes who need their family close by to function, and there is nothing to be said against that either. It is a question of personality. Aprilia rider Aleix Espargaró almost always has his wife and twins around him, and that does him good. He still trains harder than ever and he's quicker than ever. The old adage that kids slow riders down? I don't believe it. When Aleix secured his first podium finish for Aprilia, he stormed straight to his family, contrary to all victory ceremony norms. You could see the energy he gets from them, how important it is to him to share his races with them. That's the way he ticks. I tick differently. As I've already said, I separate professional Marc from private Marc.

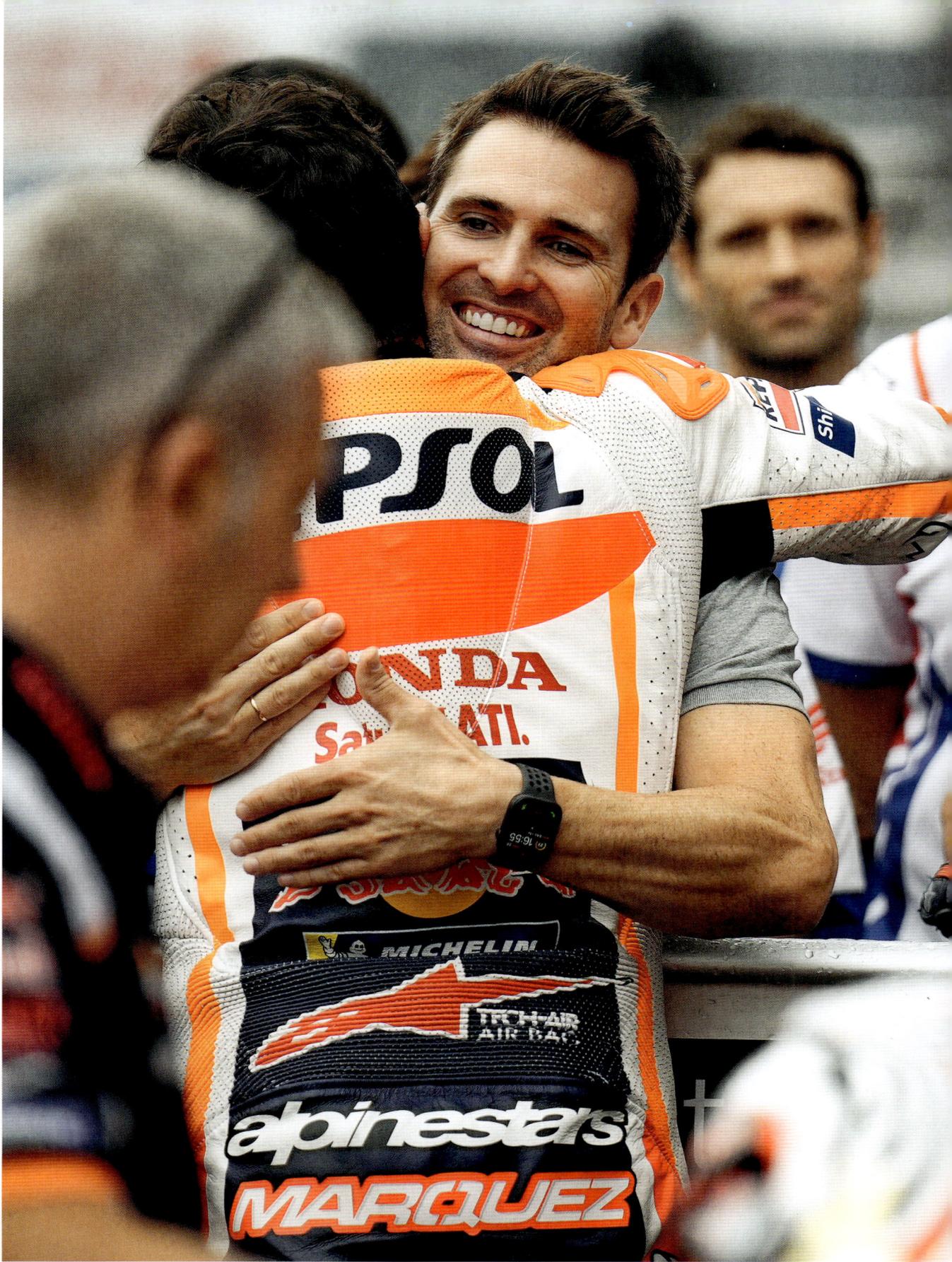

→
Brothers,
best friends,
training
buddies,
colleagues
and so much
more.
Sometimes
Marc and
Álex even
go fishing
together
under
rainbows.

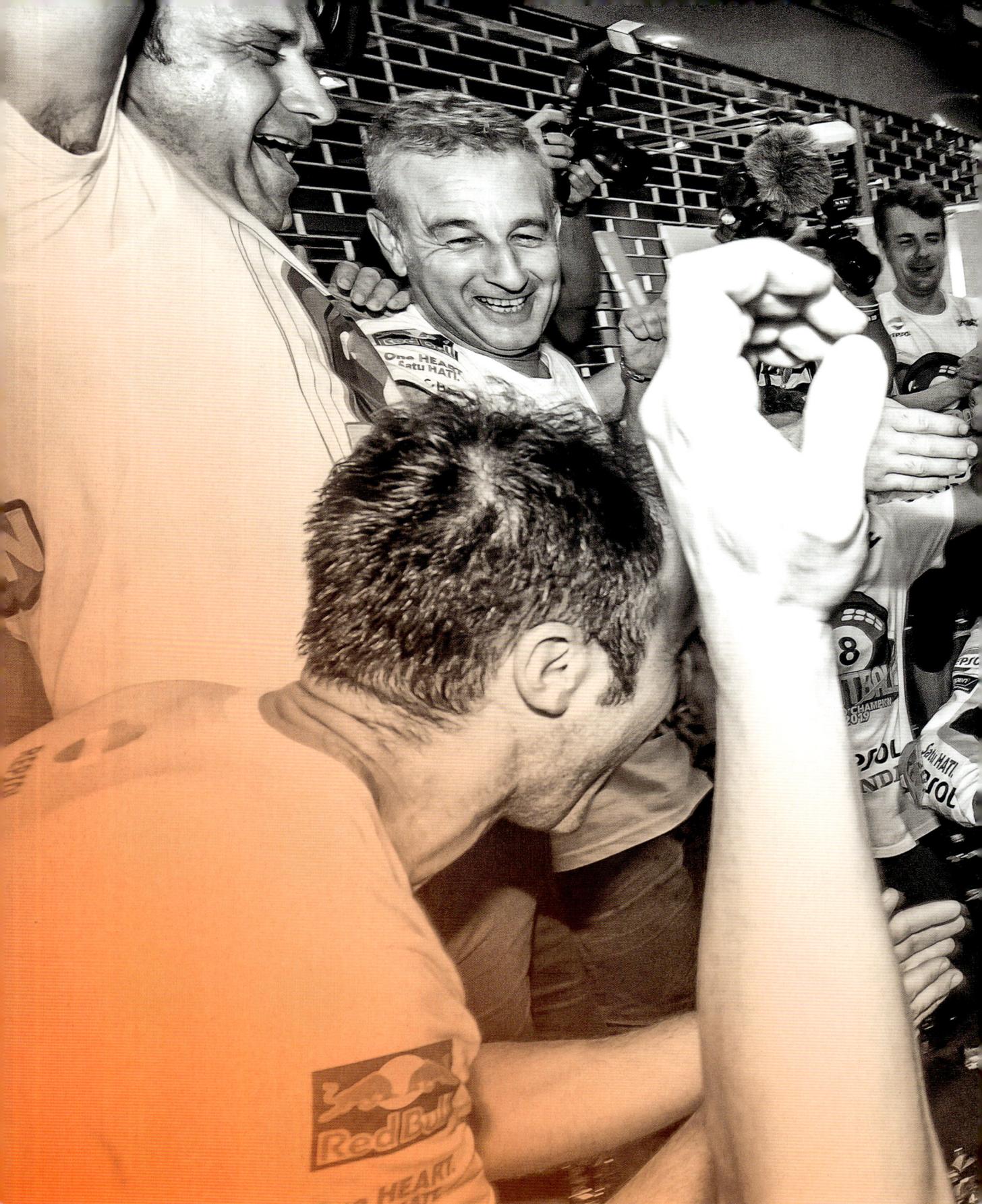

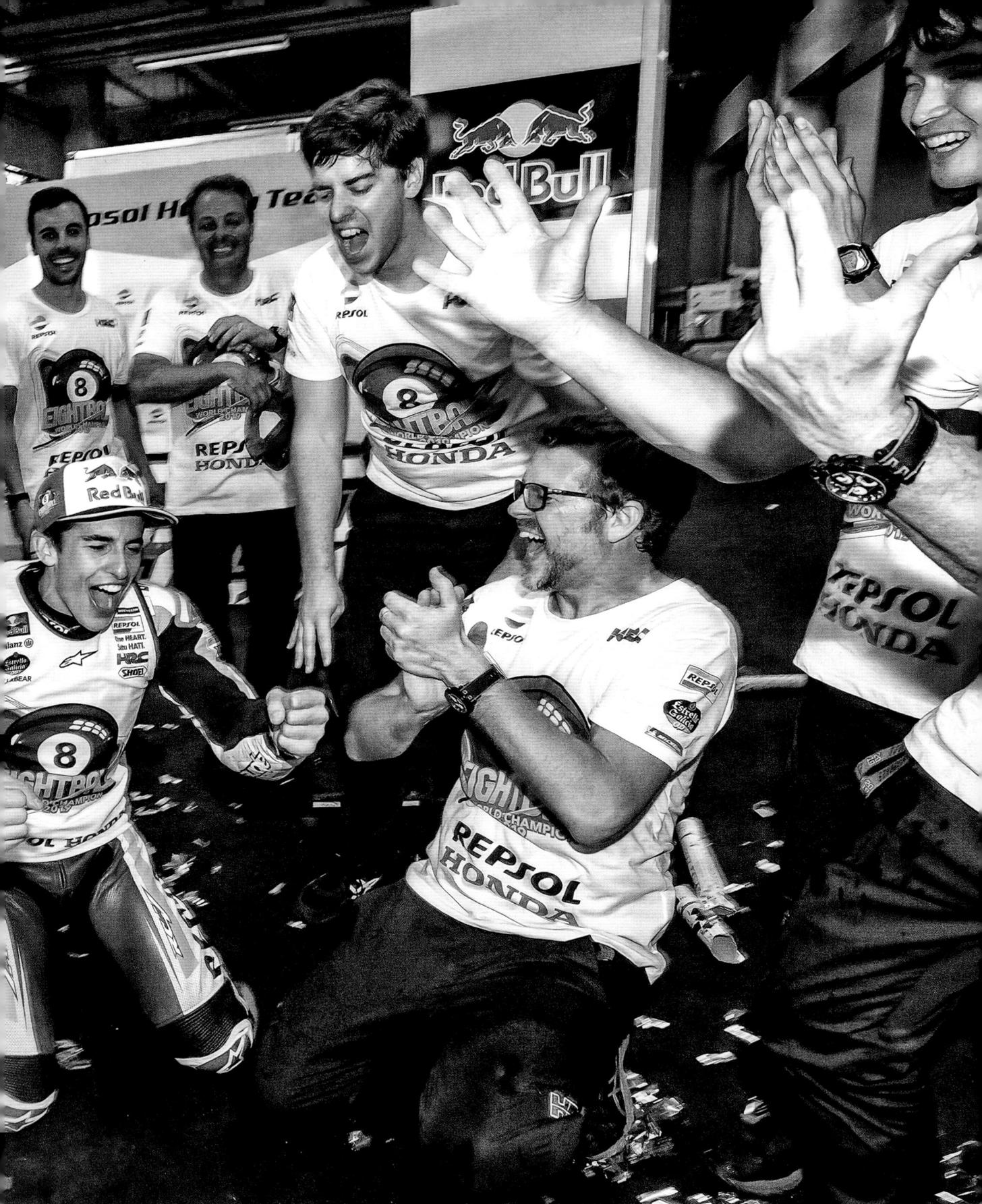

At Home

My father, my brother, me and the road to the top

It is a phenomenon that runs through all sports: time and again, siblings appear who are world-class in the same profession: the Schumacher brothers in Formula 1, the Williams sisters in tennis, the Sedins and Staals in ice hockey. And, of course, in MotoGP, in the Márquez and Espargarós we have two pairs of brothers who are rivals on the track but still family the rest of the time. Julià Márquez, Marc and Álex's father, is popular with the cameras at the circuits. He lives the highs and lows with his sons so visibly, it's as if he were riding himself. His face among the Repsol Honda crowd celebrating a victory by Marc shows just how much he has enjoyed the journey that began some 25 years ago with children's races at the local motorcycle club, where he was a track marshal and his wife, Roser, made the sandwiches in the canteen. The relationship between the Márquez parents and their long-since adult sons, both world champions, has changed in many ways down the years. But one thing has remained constant: Marc learnt the trust and respect for others that he calls for in his working environment at home in Cervera, Spain, with Roser and Julià, his grandparents, and brother Álex, three years his junior.

→
Marc and Álex at their home near Madrid, watching football together on TV.

→
The throttle's
on the right.
Dad, Julià,
showing
Marc (right)
the ropes.
Notice the
stabilisers!

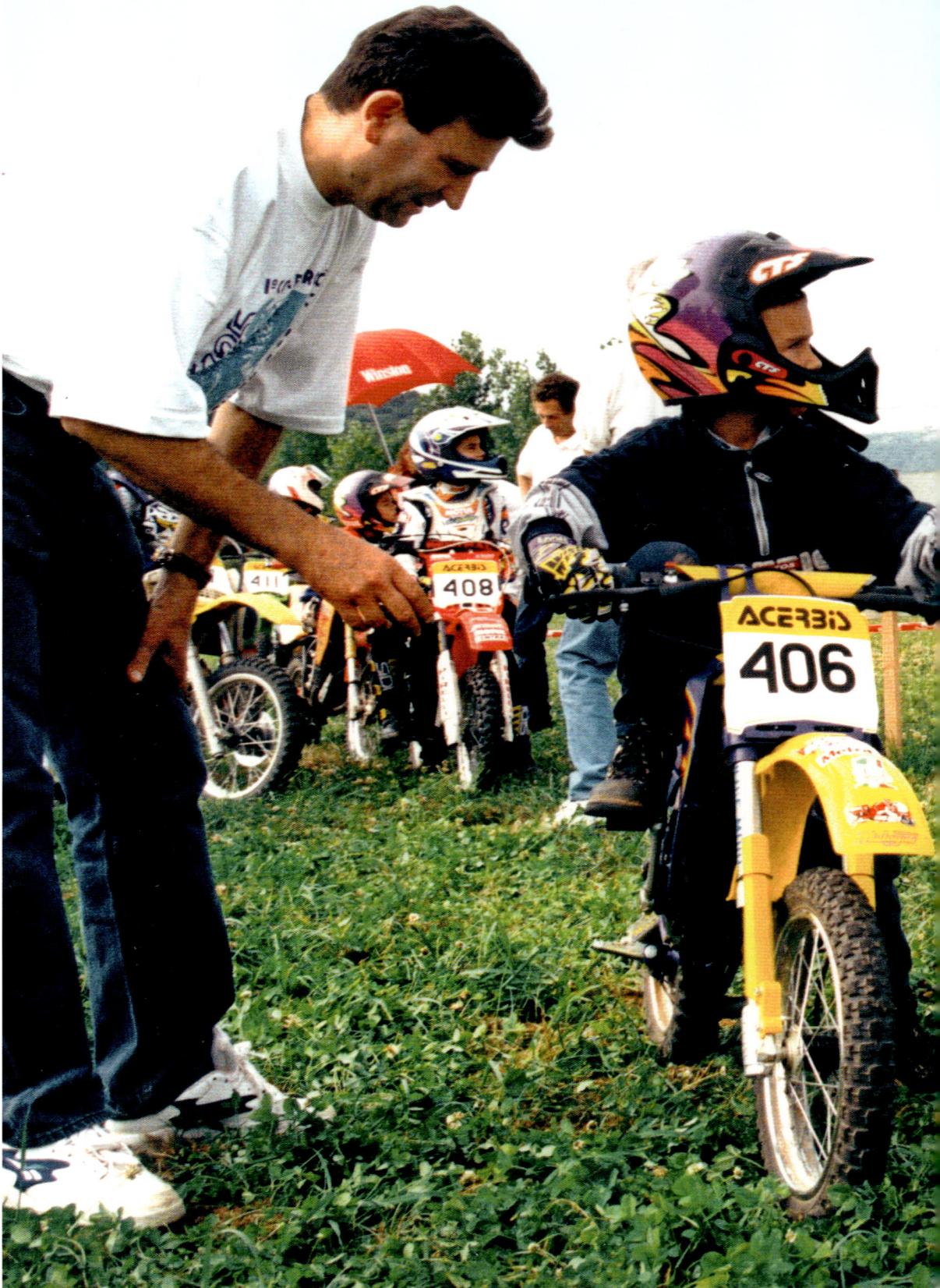

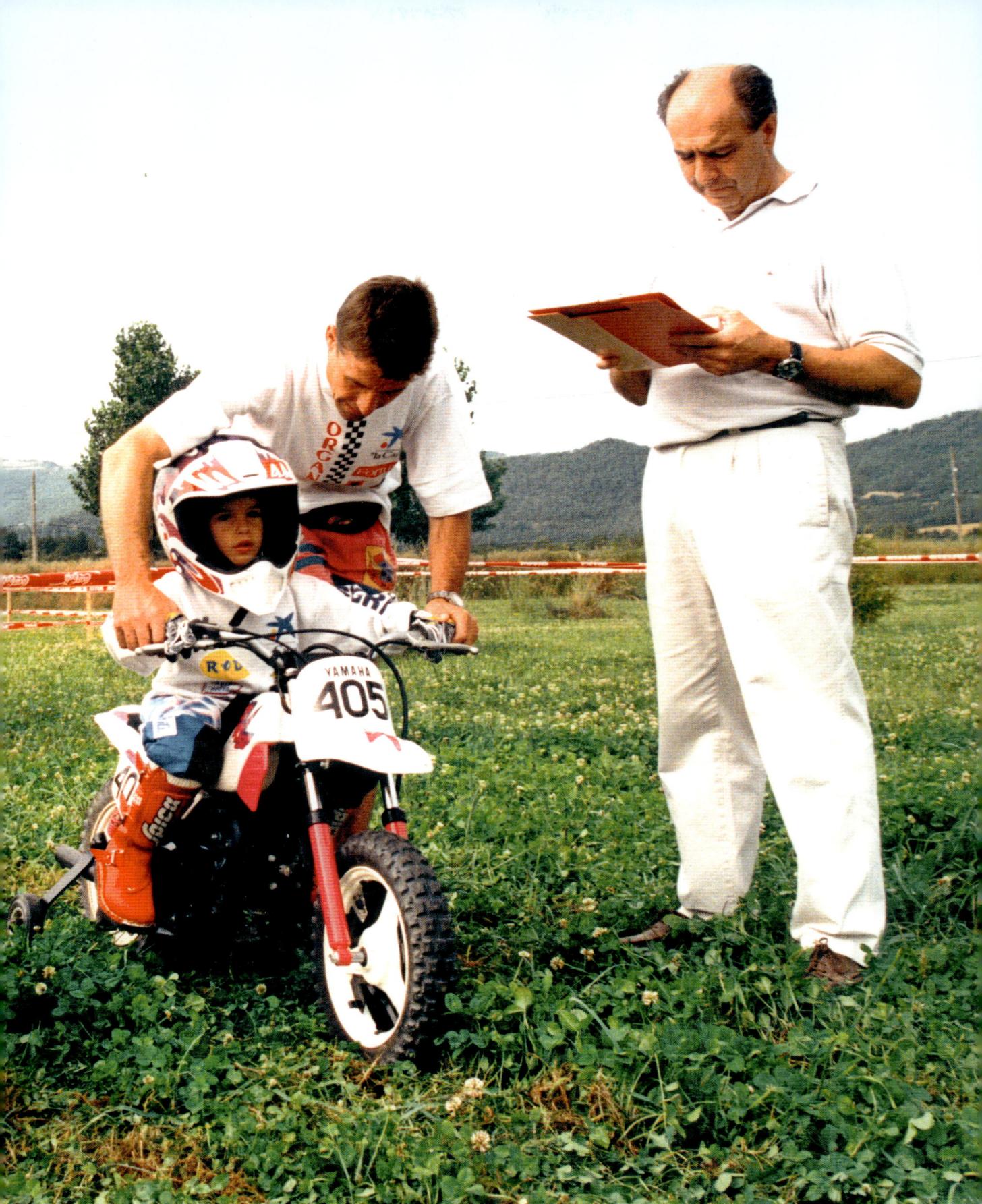

I would like to take this opportunity to give some context to a small anecdote that has been doing the rounds for years. The claim is that Álex wanted to be my mechanic, not a racer. It's basically true, but he was only five at the time and still too little to understand what motorcycling was and how much fun it is! I was his racing big brother. He was just a spectator at first. And he came up with the mechanic idea so as to have something to do at the track. His true passion for motorcycling didn't really appear until he was ten or eleven years old. Some days he was more motivated than others. But one day that changed dramatically. Ever since, he's acted like someone who wants to be at the top and he has been at the top for a long time now.

OK, I know I'm not just his older brother, I'm an eight-time World Champion, so he still seems to be in my shadow. But Álex, don't forget, has won two World Championship titles and the Spanish Championship – something I've never done. He finished on the podium twice in his first season in MotoGP, once in the dry and once in wet conditions. How many rookies before him have done that? That's why I find it unfair when he is still perceived as "Marc's brother" and not as Álex Márquez, one of the best motorcyclists in the world. How many current MotoGP riders apart from us brothers have more than one World Championship title on their CV? Pecco Bagnaia in Moto2 and MotoGP, Johann Zarco twice in Moto2, Joan Mir in Moto3 and MotoGP. That's it. It's a very exclusive circle we belong to and two of the five members are called Márquez!

To be very clear, my brother is not in MotoGP because of me. He's here on merit. Maybe it was easier for him in smaller classes because he is a Márquez. That must have opened a door or two for him. But as soon as he had walked through the door, he was on his own and under even closer scrutiny than the others. How good is he really, this "brother of"? That increases the pressure. How many riders had the same opportunities as Álex and never became world champion? That's the difference. He took his chances. The assistance we can offer each other on the track since we both arrived in MotoGP is actually more limited than you'd think.

Jerez, 19th July 2020

For years it was a familiar picture. Before he lined up on the start, Marc Márquez would go and watch his younger brother race, tell him to keep a cool head in the pit lane and celebrate his victories and World Championship titles as if they were his own. In 2020, the time had finally come; with the rise of the "little" Márquez brother, who was three years younger but 15cm taller, the two of them had become

competitors in the premier class of the sport. Another element promised extra spice; just as Marc had done seven years earlier, Álex also came up as Moto2 World Champion, and joined him at Repsol Honda. There hadn't ever been brothers on the same team before, and everyone was wondering if and by how much the experienced Marc would outpace his rookie brother. So far, every single one of the world champion's team-mates had come off a very poor second best. Qualifying went as expected. Marc was on the front row, Álex the last. We know what happened next. Jerez would turn out to be the only race where the two of them competed for the same team. Marc's accident forced him out for the entire season, so newcomer Álex was suddenly the number one rider in the most prestigious team in the paddock, spearheading Honda, with occasional appearances by test rider Stefan Bradl by his side. You can hardly imagine a tougher start to a MotoGP career than the one Álex had. And yet he was able to create some highlights. At Le Mans, he rode his number 73 Honda to a second-place finish in the most difficult of conditions on a wet track, and did the same again in the dry at MotorLand Aragón. He finished his first world championship in the premier class in 14th, one place ahead of a certain Francesco Bagnaia, who would himself be crowned world champion just two seasons later.

The age gap visibly disappeared as years passed. Yes, I could teach him a thing or two in the earlier days, but Álex has his own personality, his own mind. And he's an adult, of course. There's a difference between a 17-year-old talking to a 14-year-old and a 27-year-old to a 24-year-old. I felt very mature when I joined MotoGP at 20. In a way, I probably was, even though I seem like a baby when I think back on it today, ten years later. I am 30 now. My brother is 27. Even if we live under one roof and do the same job, he has his issues, his problems, makes his own decisions, and I make mine. Yes, I share my experience with him and help him where I can, but he must also be able to make his own mistakes. That's the best way to learn. Being the protective big brother would be totally wrong, especially in professional sport, which is no petting zoo.

We rarely argue, and if we do, it's over quickly. Yes, we exchange views, and as we are both strong characters with a healthy sense of self-confidence, we do so directly, bluntly. When that happens, we benefit from a common character trait: if we get angry, it passes within five minutes. These small outbursts aren't usually deep-seated. It's normally more likely one of us has had a bad day and snaps at something the other one has said, whereupon he takes offence for a moment and storms out.

As we get on so well – like brothers, literally – we moved to a new house together in a suburb of Madrid. It really is our common home. I don't live in his house. He doesn't live in mine. We live in our house. And it will probably stay that way until a woman moves in with one of us one day and there are children running around! Living alone in a house would be boring. As things stand, the situation is ideal. We train together, we travel together, we eat together. This is where the real advantage of us competing as brothers in the highest motorcycle class is, not on the track itself. We are well organised and work well as a team. Two examples: I used to drive to training or the airport but now mainly Álex does because I'm constantly on the phone. The passenger seat has clear advantages on that front!

At home, we both have our own area, which we design the way we like. We share the kitchen and the garage, of course. There are two of my bikes on the stairs: a replica Honda RC213V, my racing bike, and a Honda Fireblade. I have six MotoGP trophies in Madrid. The rest are divided

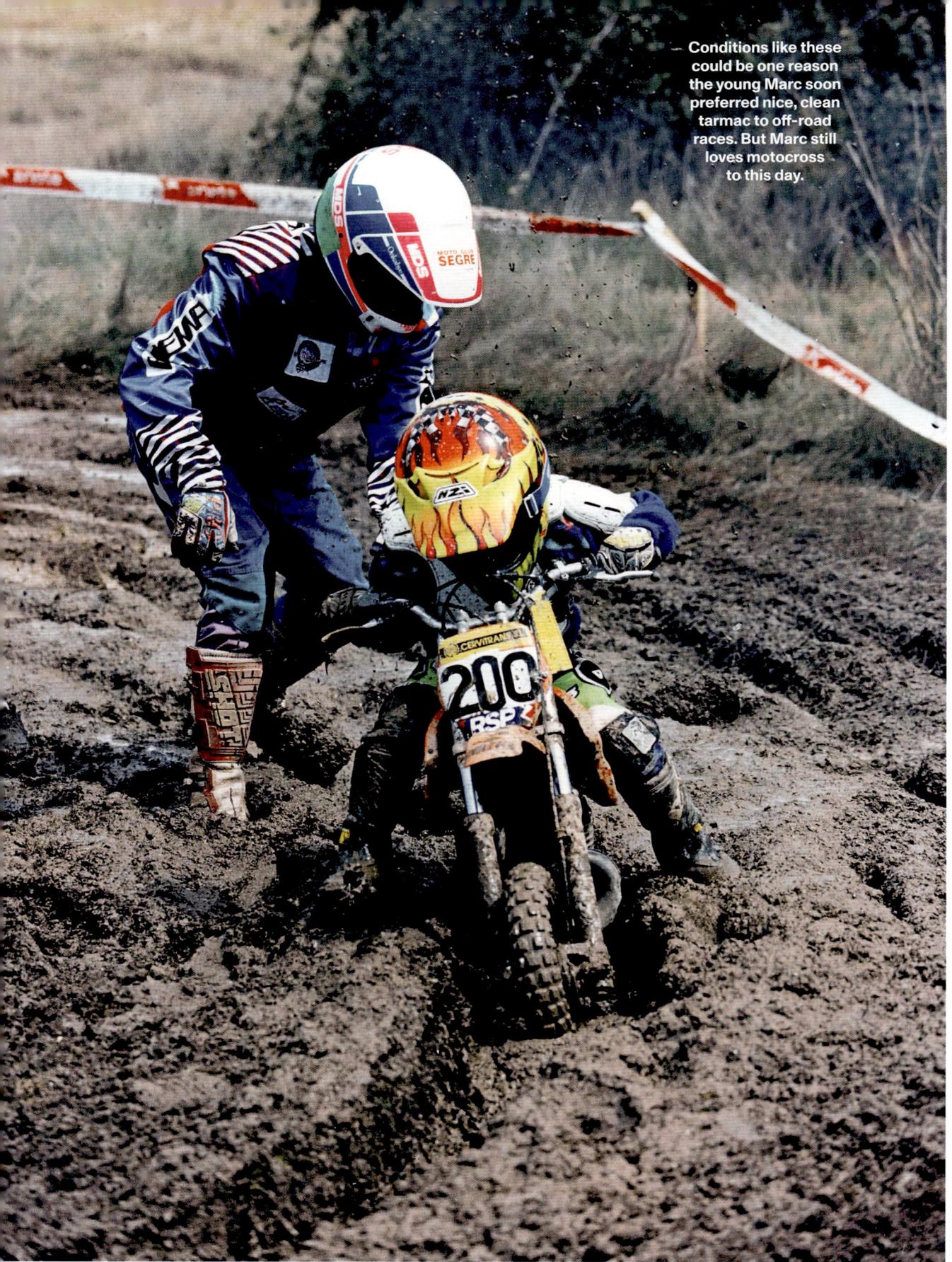

Conditions like these could be one reason the young Marc soon preferred nice, clean tarmac to off-road races. But Marc still loves motocross to this day.

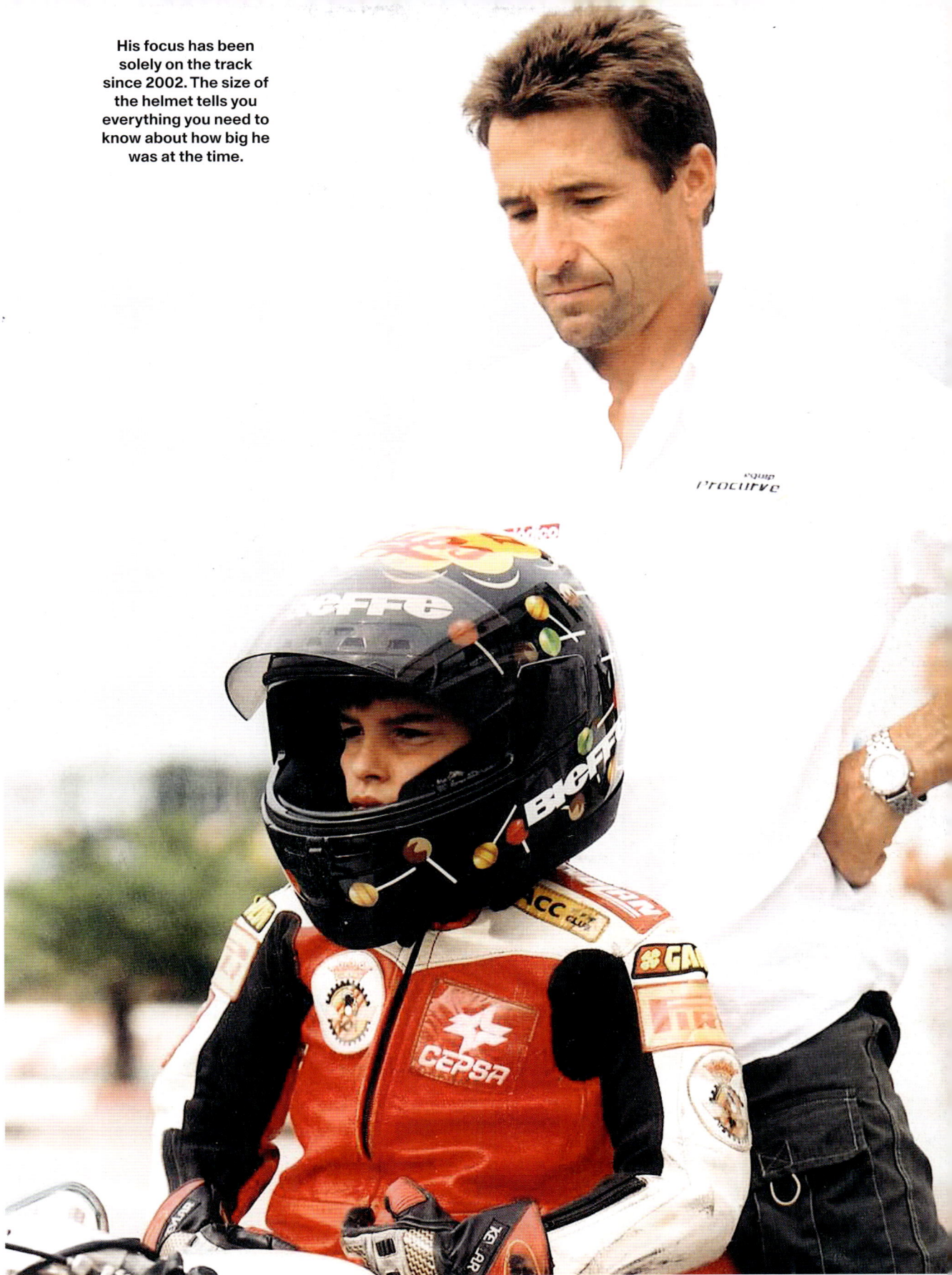

His focus has been solely on the track since 2002. The size of the helmet tells you everything you need to know about how big he was at the time.

between my parents' house and a small museum that already exists in Cervera. I keep them all. My father insisted. He started the tradition of hanging on to all the helmets, all the leathers. I've come to appreciate that. Seeing my old helmets and racing leathers now already makes me emotional and when I stop racing one day, I imagine that will only increase. When I retire, the plan is to exhibit all this stuff in one place and share these good memories with other people. Cervera makes sense as a location, but I'll only think about whether it should be a real museum or more of a showroom when the time comes.

It's not like I'm sitting on my couch thinking about what's going to happen one day. I'm generally not the couch-potato type. The hardest thing for me is to have one full day off. I get bored straight away. I can't just sit around at home. I can still just about watch a complete Formula 1 or Superbike World Championship race on TV. I love our home, but I have to keep busy at all times, by going to the garage, for example, by taking my dachshunds Stitch and Shira out for a walk, cycling, even if only for an hour. I regularly play *Call of Duty* or *FIFA* with friends online on the PlayStation from 7.30 to just before nine in the evenings. For me, this is less about gaming and more about switching off. We talk about this and that and play on the side. It is almost meditative. Unlike my brother, I'm always in high gear. Don't get me wrong. He works hard, but he needs someone to push him. By contrast, I tend to do too much, which isn't ideal either. In this respect, we complement each other very well.

We also live together on race weekends, in our motorhome right by the track. It's big enough not to get under each other's feet. We both have our own section,

↓
The Julià Márquez we know and love: fingers crossed in his sons' box.

and we might just see each other for breakfast and talk about the weather, because by then everyone is so absorbed in their own thoughts. We don't do everything together, nor do we do it alone... Maybe that's the best way of putting it.

I would also like to put something about our father into context. It looks like he is always in my box, and TV footage makes it look that way too. In actual fact, he spends just as much time with Álex, but because his former team, LCR, a private team, had a smaller box than mine – the Repsol Honda factory team – he was usually with me during hectic sessions so as not to get in the way of the mechanics. It was more of a pragmatic solution. That's why he's on my side of the Repsol box with his index and middle fingers crossed because he hopes that will bring us luck. My brother and I like to tease him that he'll end up with arthritis because of us but Julià is undeterred. Even if the crossed fingers are usually associated with me, I strongly suspect they're just as much for Álex. But I've never asked him and I won't either. What he does for us in the box and why is entirely up to him. His rituals are his own private matter.

The fact that my father comes to the races is solely because he wants to. It is his will, not his sons'. In my first three years in the World Championship, 2008 to 2010, he wasn't with me. I just travelled with the team and my then manager, Emilio Alzamora. That was good and the right thing to do, because it forced me to grow up, to act independently. Perhaps "allowed" would be a better word than "forced" here, because those three years really helped me come out on top in motorsport. In extreme situations, a father tends to side with his child and protect him. It was important that that protective shield was taken away in those early years. That strengthens your character, which you desperately need in the unforgiving world of elite sport. It was never as

dramatic in my case as it was with Max Verstappen, whose father once left him on an Italian motorway after he had screwed up a race. But I have also felt I was on my own every now and again and had to learn to deal with problems, failure or pressure by myself.

The second reason my father stayed at home in those early days was quite banal; he had to work. I don't come from a wealthy household, and at the time it was unthinkable that my parents could have given up their jobs before my first World Championship title in the 2010 season. We spent a lot of time with our grandparents as children. As caregivers, they were just as important for us as our parents at the time. We went to their place every day after school, then our parents picked us up from there after work and took us home for dinner. Neither of them earned a huge amount, so they could only make a limited investment in my career in absolute terms. In relative terms, though, it was substantial. What other parents spent on summer and winter holidays, mine put into launching my career. But we were lucky enough to find a team that believed in me when I was nine and that took on the racing costs.

Driving home together from races... I like looking back on that. The mood in the car was the same whether I had won or lost. It was crucial for me as a child; my parents treated me the same no matter how the race went, whether I had won, finished second or landed flat on my face. I was always worth the same to them. That experience takes an enormous amount of pressure off a child. The mood only changed if there were technical problems because my parents would already be wondering how they would be able to afford the repairs.

They made a lot of sacrifices during our childhood and I am convinced they would do it again. Of course, I have repeatedly given them gifts down the years, long before I bought myself a car in 2021,

→ A mum's embrace: Roser Alentà celebrates Marc securing his sixth title at Valencia in 2017. On the right: true friend and crew chief Santi.

in fact. That was my first gift to myself. For me, a gift is something you don't necessarily need, rather something that makes you happy. That's the difference between gifts and investments, such as a house. The biggest gift I can probably give my parents is just spending time with them, and I try to do that too. But we can never repay the time our parents have invested in us, in any case.

In 2012, my father came with me to the European races. Since 2013 and my joining MotoGP, he has come to almost all of them. He knows the role he has to play very well, and he knows mine too. He knows that the team is my entourage and that he is there to enjoy himself. He can't help me on the racetrack, and he fully accepts that. Away from the track, he is certainly a help, especially emotionally. Anything else would be odd. He is my dad, after all!

My mother's role has also been incredibly important since childhood, if less conspicuous. She still comes to some of our races now, but she stays away from the spotlight. You will never see her in the box. As a rule, she hangs out in the team hospitality area and stays there as long as she wants. By the time we're off the bikes in the afternoon on training days, she might already be looking around whichever city we're in and enjoying her holiday. She isn't as actively passionate about it all, at least not on the outside. If she's at home, she watches the races on TV. We stay in touch with her, of course, but there is no ritual, no phone call every evening. If the day has gone smoothly, and no one has crashed, we might not hear from each other at all. Or I get a short text message in the morning where she wishes me good luck or tells me she loves me.

My parents know our job really well. When I couldn't ride for almost two years or at least not the way I wanted to, my father was the person I could share my thoughts on retirement with. I knew it

was impossible to ride to my own high standards with my arm in that condition. I've won eight World Championship titles. I never have to worry about money again. So why not call it a day? After my highside in Indonesia, I had double vision again and my arm hurt. It would have been very easy to throw in the towel and bring my career to an end. But I'm not one to just give up. I analyse problems and look for solutions. There was a solution for the arm. They would have to saw through the bone, rotate it and bolt it back together. At that stage, my mother was more, like, "Stop!" while my father was more on the "Solve the problem!" side of things.

I have traits from both parents in me. There's no denying it. I have my father's perfectionism, when it comes to racing, at least. Anyone who meets me in everyday life may struggle to see the perfectionist in me, but as soon as it comes to the job, I am just as fussy as my father and pay attention to the smallest detail. The relaxed side and going with the flow comes from Roser. Not agonising too much, being happy-go-lucky. The ability not to take problems personally, but to see them for what they are: things that can be solved. The division isn't perfect, but I have more characteristics from my father on the bike, and more from my mother in everyday life.

Álex, on the other hand, is much more similar to our mother. He's even happier than me. He doesn't majorly agonise over things. He just does them. But if something affects him deeply, if a big problem gets in his way, then his mind is occupied with that until it is sorted. That's our father in him.

It's three hours by train or a four-and-a-half-hour drive from our parents' house in Cervera to our house in Madrid. Because of that distance, my parents and I have got closer. When I visit them now, I stay for a couple of days and we spend more time together than before and it's more intense too. We speak more than when we used

to see each other on an almost daily basis. When my mother cooks, I'm there next to her, I lay the table, so conversations happen all by themselves.

After dinner, it's the same procedure as ever in the Márquez household, with everyone clearing away their own dishes. My parents have never treated me as a world champion, but always just as Marc, their son, a normal man who lived at home until his early 20s and who had his duties around the house, just like everyone else.

There were a couple of rules in the Márquez household that were crystal clear and non-negotiable. First and foremost, respect for one another. Secondly, a sense of community and sharing the workload: everyone has to tidy up, take their turn. Álex, Mum, Dad, me. And thirdly, manners: you can state your opinions honestly and directly to one another in a respectful environment, but in a polite, decent way. That was the way things were in my parents' house, and in my grandparents' house, and I try to live by that culture and those values in my team now as well.

→ Flicking through the family album in 2015: Marc used to go to grandfather Ramón's house after school.

Ego

How I get what
I need – on and off
the track

An unwillingness to compromise, passion, toughness – both towards oneself and one's opponents... These are basic characteristics without which no sportsman or woman will make it to the top. That is certainly the case in MotoGP, at least. Only one rider can own the corner, the straight, the race, the World Championship title. Only one can have their fairing out in front. Much of the fascination of the motorcycling premier class is down to the tough battle fought out between the best and probably the mentally strongest sportsmen on two wheels the world has to offer. They say you have no friends at 300kph, which is even truer at 360kph. But for Marc that's true even at 30kph. If there's going to be one person out in front, then it's him. Period. In his decade in MotoGP, he has worked hard to burnish the image of the uncompromising fighter who will stop at nothing. The other riders know you'd better not mess with number 93. Some of his battles have long since been part of the mythical canon of MotoGP. Wheel to wheel, tougher than tough. Marc Márquez is one of the most likeable sportsmen you can meet when he's standing on his own two feet. But there's one thing you really don't want to do, and that's go up against him on two wheels.

→
Room for two: Marc is notorious for finding a way through. Here he brakes his way past Michele Pirro on the Ducati at Misano in 2017.

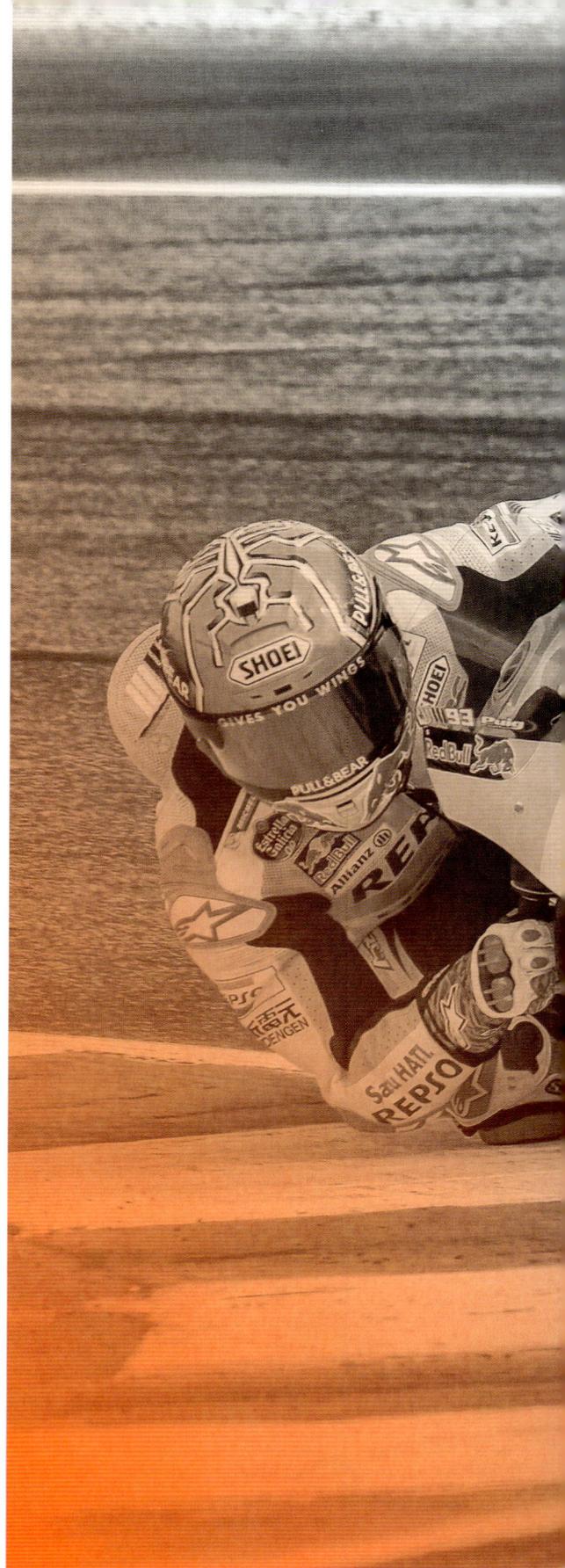

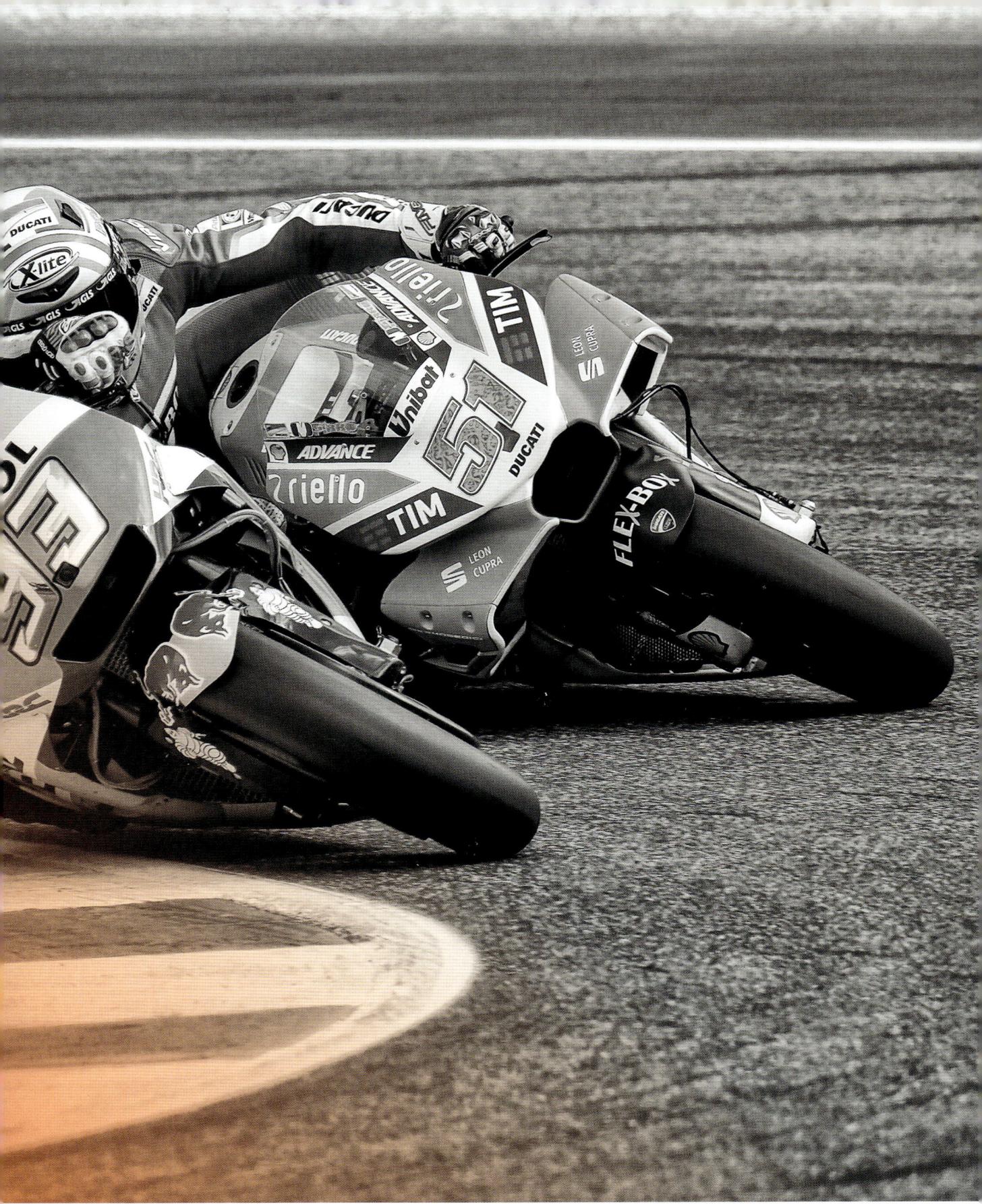

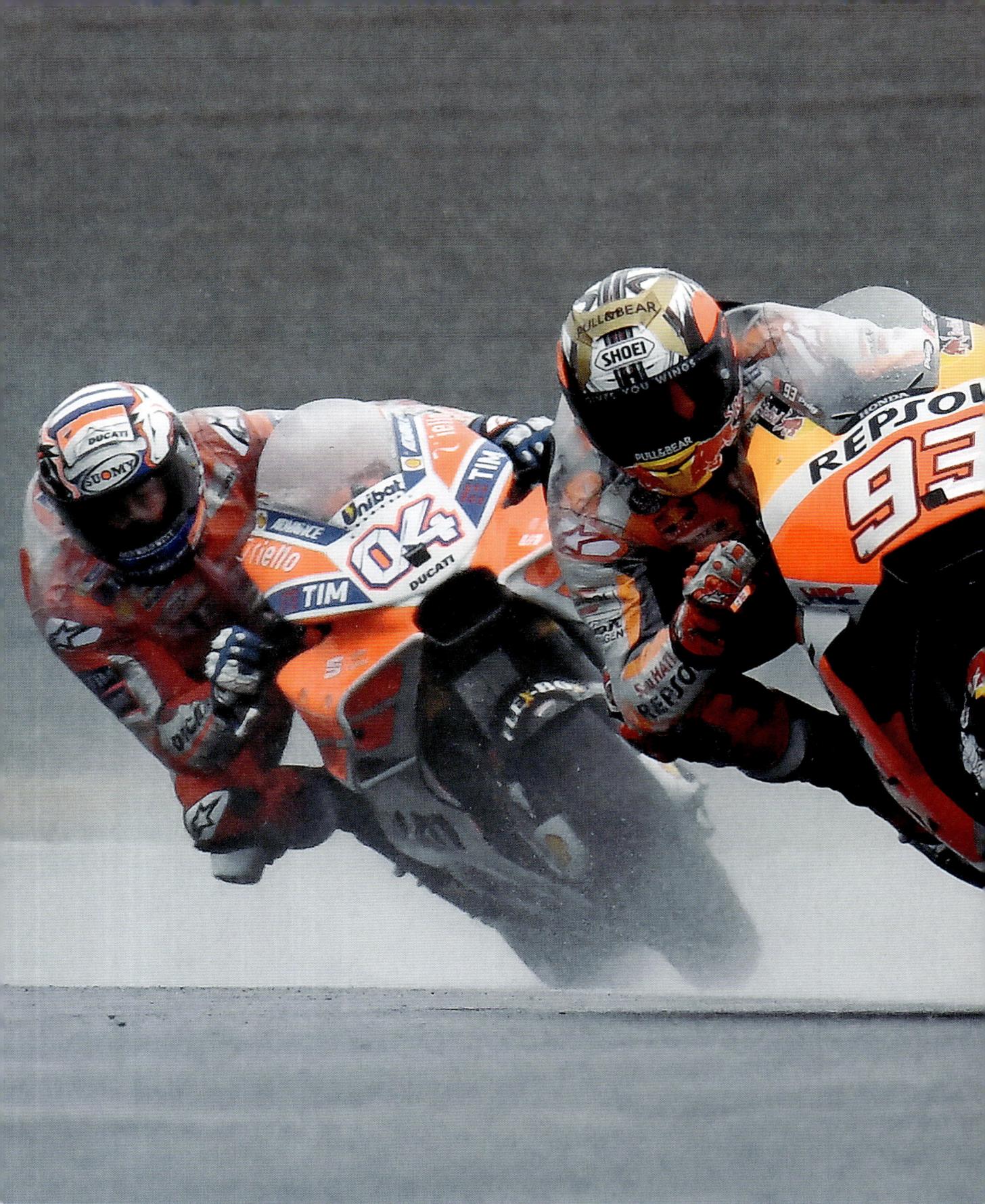

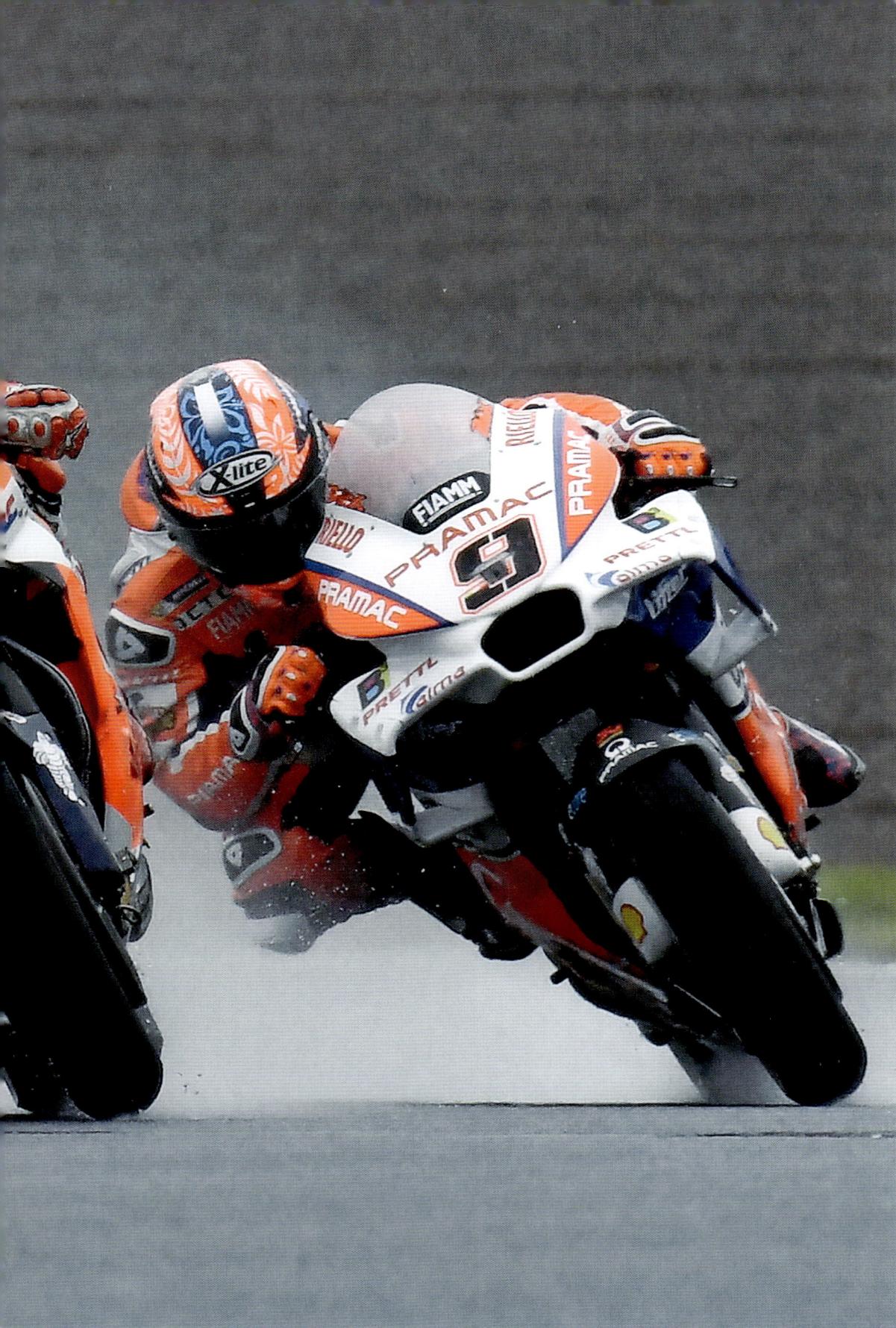

← Elbows out, *no pasarán*, not least the Ducatis of Andrea Dovizioso (left) and Danilo Petrucci (right). Motegi, 2017, in the rain.

If I see a wall, I go through it. It's as simple as that. It doesn't matter how many goes it takes or how hard I hit my head: I won't stop until I've got through the wall. This is true for life, and of course true on the racetrack. This has always been my approach, and it will never change; I want the best possible result in everything I do. I am completely uncompromising, because what would be the point of all this effort otherwise? To put it even more simply, what would a life without goals be? And my goal on the track is to win, to overtake the man in front, to be in the lead. That's what it's all about, and I give everything to make that happen.

And now the complicated bit. The goals you set must be realistic. Saying, "I want to win every race next season," isn't a goal. It's childish nonsense. It's not a real goal. You have to set your goals in such a way that they can be achieved using energy, concentration and preparation, plus knowledge, toughness and sometimes luck. Goals are motivators, which is why the sentence above is so wrong, because that way you can only fail. For example, if the goal is to become world champion, that's the wall you have to break through. I'll tell you a wall that isn't worth breaking through: overtaking a competitor who is no longer significant in the overall standings at full risk to yourself. Understanding that was a learning process, at least for me.

I have often been asked what my problem is with seeing someone else's motorcycle in front of mine, and in years gone by, my answer has always been it's the biggest problem ever! Nobody has any business being in front of my front wheel! So the only answer on the track has been to attack without compromise! And that's exactly why I've crashed quite a lot. Has this mindset been a success overall? Definitely, otherwise I wouldn't have won so many races and wouldn't be an eight-time world champion. With the experience I have now, however, I would like to note that I no longer have to win every single race provided that doesn't impede the bigger picture — the world championship — if conditions are right. If the guy in front is just ahead of me, look out, I'm coming for you! However, if he's already got a lead on me of a few seconds, it may now be the case that I don't do everything in my power to track him down, and let him get away this time. I don't see this as mellowing with age, but rather as a calculation, an extra quality that comes with being an experienced rider.

Buriram, 6th October 2019

The 2019 Thailand motorcycle Grand Prix at the Buriram International Circuit was one of these prototypical races where Marc charged through walls. In a season where he didn't finish a single race worse than second (except for one retirement),

it was only a matter of time before he would don the world championship crown. His last remaining opponent, the Italian Andrea Dovizioso, was already 98 points behind with five races to go. To do the maths, 13th place would have sufficed for Marc to win the title. But that's not the way he ticks.

French parvenu Fabio Quartararo was on pole on the Yamaha and led for long periods of the race. As Marc kept trying to brake his way past him, he missed the apex again and again compared to the excellent-on-the-turns Yamaha, and Quartararo was able to stay ahead. It would have been the first victory in the career of the then 20-year-old Frenchman and the prospect clearly inspired him. Marc Márquez, by contrast, only had to cross the finish line, because second place was more than enough for him to complete the job at hand, i.e. finish no lower than 13th and get the three World Championship points he needed to secure the title. If there hadn't been just the minor bother of a Frenchman on a Yamaha in front of his front wheel. There was a high risk of him throwing it all away in a daring manoeuvre and perhaps even injuring himself and having to wait longer to secure the title, which was waiting for him on a silver plate. But what did Marc do? On the last turn of the last lap, he outbraked Quartararo spectacularly and slipped past at the very end; his margin of victory was 0.171 seconds and he had secured the world championship with a hard-fought win! Fabio Quartararo had to wait until the following year to win his first race in the premier class.

I am well aware that I haven't made any friends in the field with my "get out of the way, I'm coming!" attitude, but that can never be the goal of a professional sportsman anyway. I don't regret anything I have done on the track. I'm not there to make friends. It just can't be that way, because each of us on the grid wants to beat every-

one else. This is the essence of sport, the *raison d'être* for us athletes as well as for the spectators at the track or watching at home; we want to find out who's best here and now, in these conditions. If it wasn't me and I've finished third, say, I have no problem at all showing my respect to the winner; he was the best man on the day. I congratulate him and mean it completely sincerely. If someone was better than me, I can respect that. However, no one should confuse that with friendship, because he knows as well as I do that we will do everything we can to beat each other again in the next race. These are very clear rules and regulations; it's you or me, under controlled conditions, with mutual respect for each other's performance and an incentive to be the best.

In the past, the boundaries of fairness – or perhaps more accurately, of what passed for acceptable – have repeatedly been redrawn. Experience shows that anyone riding round the track alone with no pressure is about a second slower than when battling it out with his peers. This is where the racing really happens, riding faster than you think you can, because the others push you to places you wouldn't go otherwise. And you do the same to your opponents. You push yourself way beyond any comfort zone, and even a qualifying lap on a MotoGP bike with no opponents on the track isn't a cakewalk emotionally either. That's important if you want to understand our battling mentality.

In the mid-2010s, the enmity between Valentino Rossi and me escalated to the point where we completely lost respect for one another. He was my hero once, but within a few months I was finished with him. I still am, and will continue to be.

He accused me of absurd things between Australia and Malaysia in 2015 and added more at the press conference in Malaysia. So I lost respect for him on the track. Then he took things further still, collided with me so that I came off the bike.

→
Last-corner move: Marc outflanks future world champion, Frenchman Fabio Quartararo, at the 2019 Thailand Grand Prix, thus securing title no. 8.

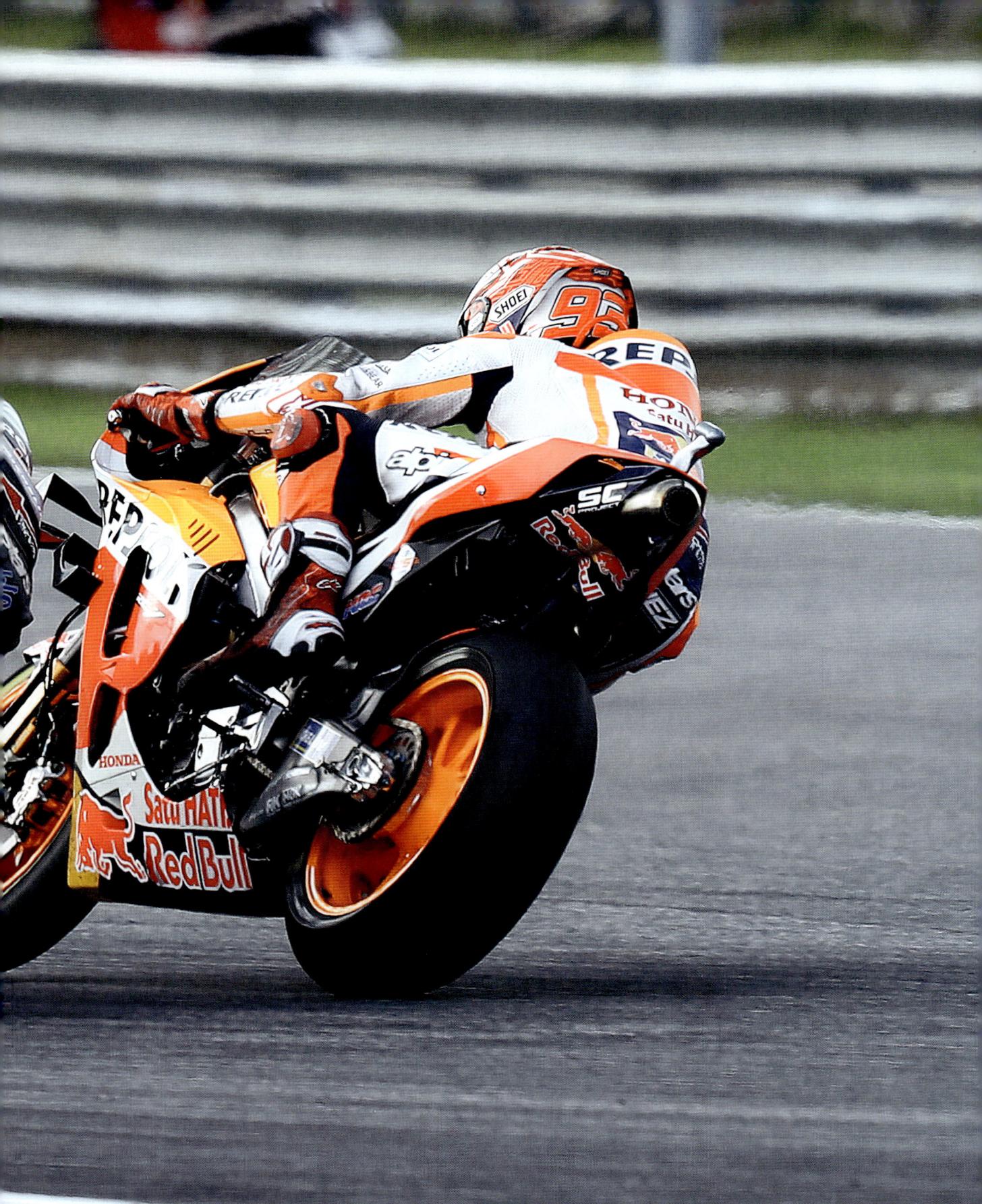

That year's world championship head-to-head comprised Marc Márquez up against his two Yamaha rivals, Valentino Rossi and Jorge Lorenzo. For Rossi, who was then 36, it was probably one of his last chances at a tenth World Championship, and he did everything he could to make the most of the opportunity. Grandmaster of gamesmanship that he is, he pulled out all the stops. No one was able to pursue their goals with an innocent look in their eye and endless charm as tenaciously as the "Doctor". Now he was fighting on two fronts: both against Lorenzo in his own camp, for whom he had felt deep disdain for years, and against Márquez, who disrespectfully messed with and repeatedly overtook Rossi on the track in a way the old master thought went against the grain. He denounced Márquez's riding style as dangerous and ended up stating publicly that he doubted whether Marc had ever actually been a fan in his youth or had just said so to suck up to the superstar. Unsurprisingly, accusing Marc of lying didn't make him any nicer on the track. You can imagine how hard he went at Rossi at the next Grand Prix in Malaysia. The Italian had finally had enough: on a right turn, he kicked Márquez off his bike with his boot, even if he asserted his innocence afterwards, claiming he had lost his balance, his inside leg had slipped from the footrest, and he had had to regain balance with the outside leg and hit Márquez. The officials saw it differently and put him to the back of the grid for the season finale in Valencia. Team-mate Lorenzo was crowned world champion, also partly because Marc and his then team-mate Dani Pedrosa ended up between the two Yamaha riders and took decisive points away from Rossi.

Dani, Lorenzo and I hadn't talked about what we were going to do beforehand, which Rossi fans accused us of afterwards. I was far from being Lorenzo's

friend, because in the years before he had been one of my bitterest rivals who sometimes behaved in ways that were severely out of order. But unlike Valentino, he was never disrespectful to me.

Could I have tried to get past Lorenzo more aggressively in the season showdown in Valencia? Yes, probably. Would it have been too risky? Yes, pretty risky. Was I mad at Valentino? After all that had happened in the few weeks previously, definitely. There had been angry Rossi fans outside my house in Cervera, after all! Did I want to determine the world championship with a rash move against Lorenzo and risk making us both crash in an overtaking manoeuvre? Definitely not, especially as it would have been to Rossi's advantage. If Lorenzo had made a mistake or there had been any other way to get past the quickest rider in the field at that time with little risk, I would have done, as my instinct has always told me to. But there was no Spanish conspiracy against Italian Rossi.

I have never lost respect for Jorge Lorenzo, Dani Pedrosa or my current rivals. As long as they respect me, I respect them. I don't expect friendships or concessions; on the contrary. I want good, strong competition, as that only increases my respect for them. But I also want to be respected. If you don't respect me, you're done, as far as I'm concerned. Over. I'm very bloody-minded on that front.

Valentino Rossi is one of the few people to have blown it with me. After Luis Salom's fatal accident at the Circuit de Barcelona-Catalunya in 2016, we shook hands for the first time since all that lack of respect of the previous year and tried to rebuild our relationship. He won, I came second, and after shaking hands at the finish, I thought we had buried the hatchet. But then, in 2018, I made an error in Argentina where I lost control of my bike and knocked him off. Totally my fault. I was quite rightly penalised by the stewards and of course I accepted that.

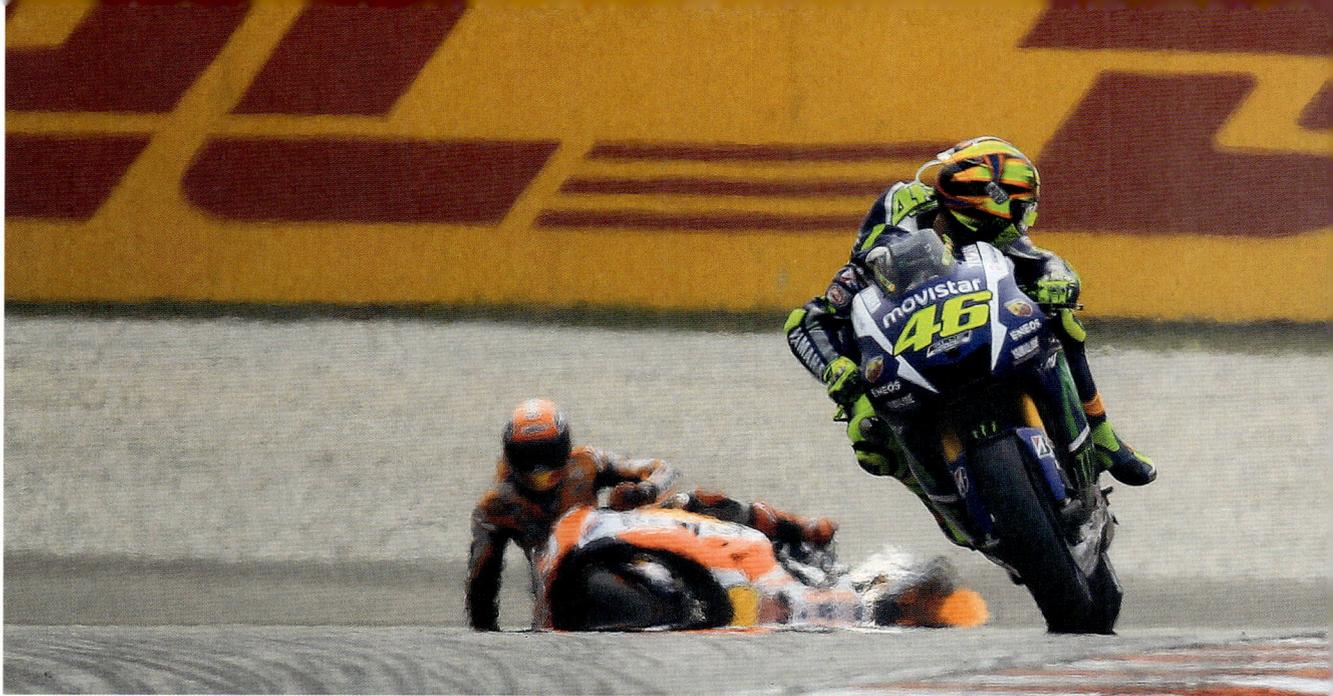

↑
Rossi's attack: In Malaysia 2015, the Italian kicked Marc off his Honda – the beginning of the end of a bromance.

I was too aggressive and tried to apologise to Valentino so we could put it behind us. But he wouldn't even let me into his box and cast further aspersions to the press. That was the moment I finally thought, "You know what, forget it."

You don't have to be everyone's friend. There's no need. Some people should live their lives, and I'll live mine. Valentino Rossi was – and probably still is – the most popular motorcycle racer of recent times. He has a lot of fans around the world, and if I make an enemy of him, I make an enemy of them too. But what was the alternative? Be untrue to myself? No way. I hate playing to the crowd, being dishonest. Tactically, it would have been better to pretend to be Valentino's friend, of course, but I'm not like that. I'd rather be brutally honest, even when it does me no favours. People say I have a friendly, open personality, and I agree. But I can also make tough decisions and accept all the consequences, if need be.

The personal relationship you have with your rivals also influences the quality of the battles you have. With Nico Terol in the 2010 125cc class World Championship and Pol Espargaró in the 2012 Moto2

World Championship... It was fierce combat, where we fought tooth and nail. We couldn't look each other in the eye at the time, but I've long since had a good relationship with both. Later on, in MotoGP, the scraps with Lorenzo and Pedrosa sometimes got so heated that it became personal and we got really angry with each other too. But that was always down to the moment, the adrenaline. The respect was always there, under the surface, which is why we get along well today. Early jousts with Valentino, like at the Corkscrew in Laguna Seca, California, which I describe elsewhere in this book, were great too. They gave it all that extra something, the thing I love so much about racing. Or when cheeky rookie Fabio Quartararo showed up in MotoGP and took it to me. Wonderful. More of that sort of thing, please! I love competing, and the better the competition is, the better it feels.

My default setting between the green light and the chequered flag is to attack. I think you can see that in my body language. If I can't attack due to physical problems, as in 2021 and 2022, there's something lacking. Having self-confidence and conveying that to the outside world

Rossi down after Marc missing the breaking point in Argentina in 2018. The relationship never recovered.

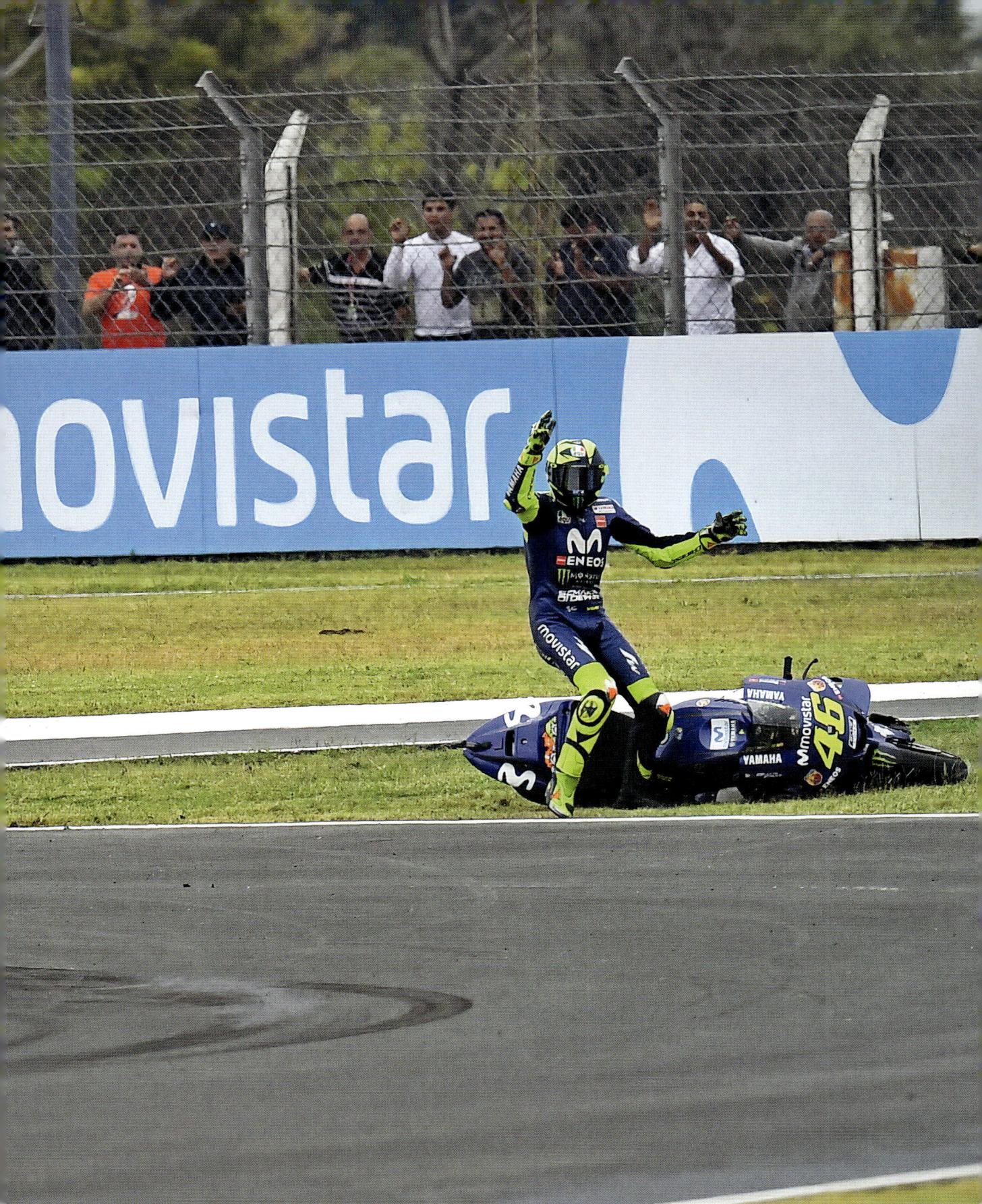

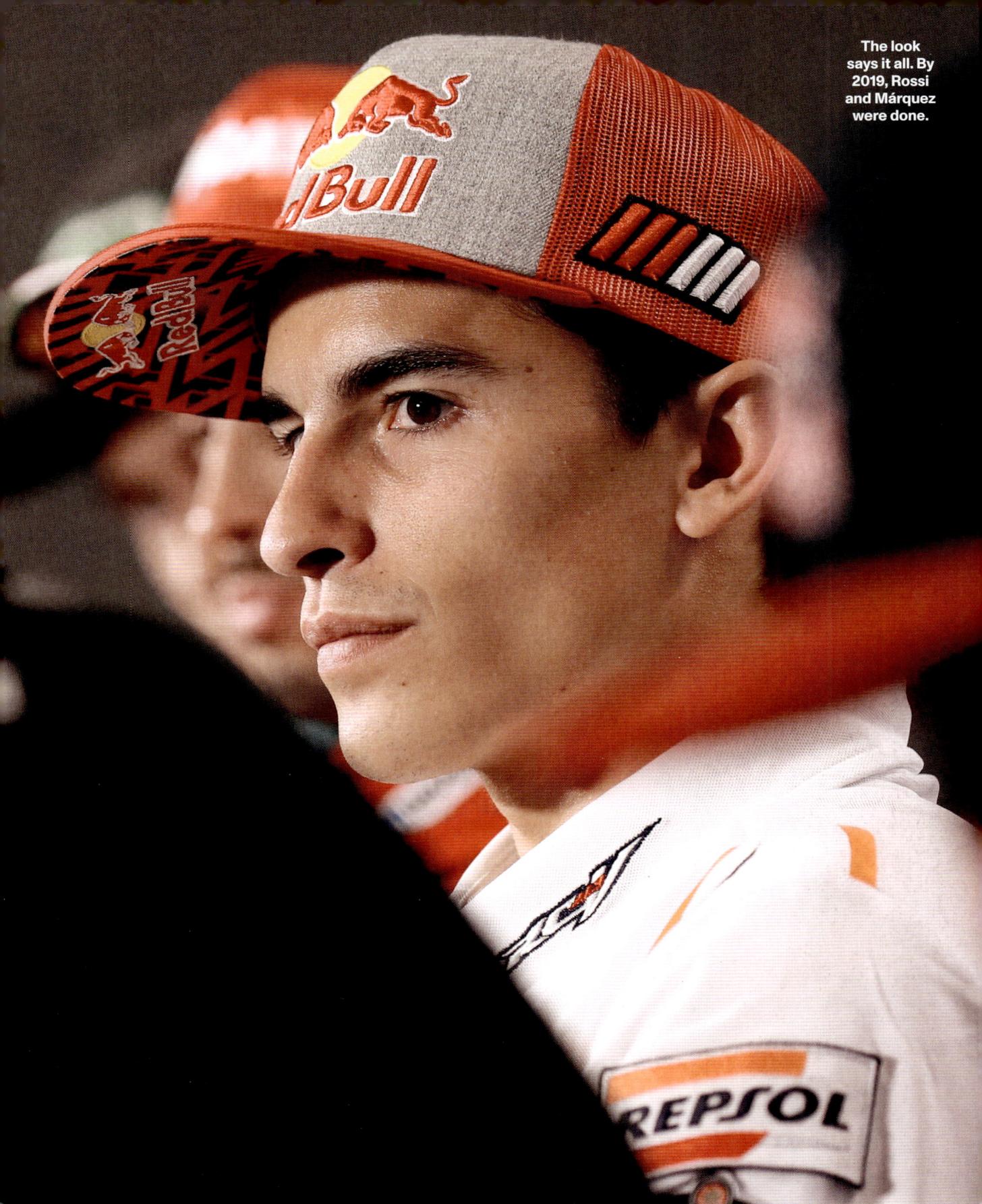

has always carried me through my career. Yes, there have been races where I knew in advance that I would lose the fight on the last lap, either because my tyres had already worn down too much or my rival's bike was more powerful, but every single time I fought and tried everything I could to stay ahead, despite inferior weaponry.

The Red Bull Ring in Spielberg is the circuit on the MotoGP calendar with the highest percentage of full-throttle sections. Due to the three straights – one of which has now been defused by a chicane – engines run at the absolute maximum for 50% of the time, turning the circuit in the Austrian state of Styria into Ducati Land. The Italian manufacturer is known for being able to generate the most power. In 2017, Andrea Dovizioso used the advantages the track provided to produce a multiple-lap battle and victory over Marc. What the Ducati had in terms of engine power, Márquez made up for with courage on the brake. In the last nine or ten laps, the lead changed constantly, often several times per lap. It was shaping up to be a ding-dong battle right to the very end. And so it was: Dovizioso was first into the two right turns, Marc braked his way past, but lost momentum and had to let the Italian past as he accelerated to the finish line. There was a repeat performance in 2018, only this time Marc's opponent was Jorge Lorenzo, also on a Ducati. The same thing again on the last laps, only Lorenzo's lead before the two turns was already too big for Marc to repeat the 2017 manoeuvre. In 2019, he had different tactics for the now traditional final-turn battle to decide victory against a Ducati (this time Dovizioso's); he went into the double-right-hander in the lead, and had to watch as the Italian pulled off the manoeuvre he'd been unable

Spielberg, 13th August 2017

to in 2017 and for which he was a decisive three to four metres too far behind at the braking point in 2018.

In 2017, it would have been easy to stay on Dovi's back wheel and finish the race a few tenths of a second behind him. a good, honest battle. Well done. Nobody would have been mad at me, but that's not the way I tick. In subsequent years, I tried to analyse my rivals' weaknesses more thoroughly and try again, but it hasn't yet worked out here at the Red Bull Ring. Besides Portimão [which was only added to the race calendar in 2020, Ed.], it is the only track where I haven't yet been able to win.

The decision as to when I overtake which rival, and where, follows a precise plan, but still depends on a number of factors, especially towards the end of the race. Have the tyres still got one more overtaking manoeuvre in them? Where was my rival good in the preceding laps? Where is he vulnerable? What shortcomings of my own do I have to take into account? Preparing to overtake begins three or four turns beforehand. You get into position. You close in, get ready and go for it. There's only ever spontaneous overtaking in the chaos of the first few laps. If there is a gap, I go for it.

Overtaking is an art form. I try to overtake everywhere, even where no one else does. Everyone tries where it's easy as it is. But maybe I have an advantage at other spots? I try to find out what those are and make the most of them. It's harder, but at least there's a chance it might work. So I try.

That makes me unpredictable to my rivals. If you're ahead, knowing you have a cautious rival behind you, it's easier to manage the lead. But having someone like me behind them who attacks on every turn? Totally different kettle of fish! It is typical to expect an attack by a Ducati known for its top speed at the end of a long straight. You can almost bet on it making

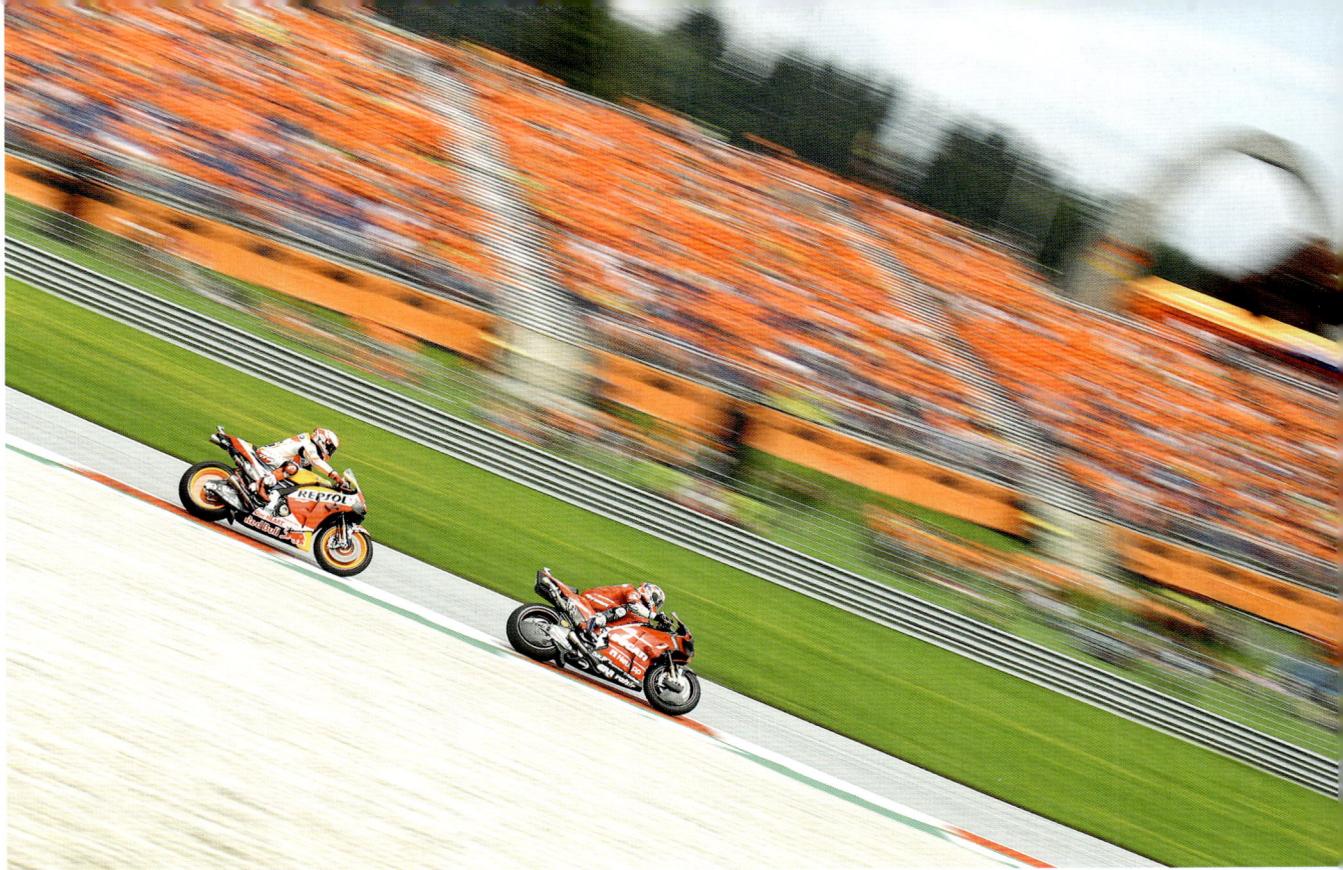

↑
The eternal battle at the Red Bull Ring: Marc on his Honda against the superior firepower of the Ducati.

a move in the braking zone. You don't have that option on a Honda or Yamaha at the moment, so it takes a different strategy, one where you have to keep plugging away.

I don't know whether there's a psychological effect on my competitors if they know I'm close by. Whatever the case, they can be sure to expect something from me. But it's not a one-way street. Anyone who's made it into MotoGP is a complete rider who knows how to defend his position and fight back. And yet sometimes it seems that not all of my opponents defend with the same vehemence. Or maybe not for long, because they know I won't rest until I'm through, no matter where, no matter when, no matter how.

Once I've decided to overtake, I go all in. That leaves no questions unanswered, nothing to ponder over. You can compare it to a motocross jump: once you've decided to jump, you've got to make the landing. Second-guessing yourself, braking or

making a half-hearted attempt would be fatal at that point. In both instances, you need to be confident that everything will work out well.

Overtaking with self-confidence is also a matter of safety, for both parties involved. Half-hearted overtaking – and there have been plenty of examples of that down the years – often ends up with the rider who is trying to get past running into the side of the other one. It is actually safer to be too optimistic when overtaking than to be too cautious; if I overtake with too much excess speed, I won't hit the apex, I'll go wide and won't have the ideal line of the guy I'm trying to get past. He finishes his corner as planned, while I have to go round the outside and slot myself back in behind him. Another argument for this aggressive type of overtaking: the opponent can see you the whole time. That isn't the case with cautious moves when you try to sneak past subtly on the inside. It often leads to confusion, with the slower rider

pulling in too tight inside, because he doesn't notice the other guy until it's too late. Or the guy on the inside simply slides out and takes the guy on his outside down with him, because he had too much speed for the tight radius of the inside of the curve. I think it's better to get in there with my big ego and make my presence felt.

I'm completely at the limit in qualifying, usually alone, with no one around me. In most overtaking manoeuvres in the race, though, I'm a little bit off the absolute limit, especially when there's not much space separating me from the guy next to me. But in qualifying I would take those corners faster. I make a difference between two types of crash. If I go down while overtaking, I've made a mistake. If I crash in qualifying, I've pushed too hard. In the race, my assumption is I'll come out of the turn riding. In qualifying, that isn't always the case. There I'm looking to take it to the absolute limit and squeeze every last drop of effort out of myself. Sometimes my instinct tells me I'm sure I'll be flat on my face, but somehow I do still manage to turn the corner. That's not what happens in a race. There are too many unknowns, and most importantly of all, nobody intentionally wants to knock another rider off his bike on the off-chance it might possibly work out well in the end. Those moves are best left for moments when you are alone on the track.

The last time someone made me push was during a test in Malaysia. My team manager Alberto Puig said, "On this one turn you have to go all the way in, then come back out and then back in again…" OK, I said to him, I will. Stand at that turn and I'll do what you say. Of course I ended up on my backside. He apologised to me back in the box and promised never to push me again. We were trying out aerodynamic parts at the time, and you just couldn't hold the line he was proposing. Not with the kind of aerodynamics we had.

Not with our bike. But I tried anyway, because he clearly wanted it.

Hara-kiri moves like that almost never occur in races. Many things that may look wild and risky are actually part of a finely tuned strategy. I set myself intermediate goals to catch the race-leader. In a certain number of laps I want to have closed the gap to a certain number of seconds. Three laps later I want to be at such and such a point on the straight when he turns. Benchmarks to be worked on. Very pragmatic, very rational. If I pull it off perfectly, I almost invariably win the race. However, sometimes my dear rivals screw up the plan, of course. I aimed to win the 2022 Australian Grand Prix. My strategy was perfect, right up until I suddenly had to struggle with Jorge Martín five laps from the finish. Battling it out with him meant I missed the upcoming benchmarks, the checkpoints I had set myself, by a few tenths of a second, and so wasn't in the position I needed to be to win on the last lap. You can't overtake more than one or two riders per lap in modern MotoGP. Due to the time I'd wasted with Martín five laps from the finish, Álex Rins slipped past on his Suzuki on the last lap and beat me by less than two tenths of a second.

The perfect overtaking moves for me – and this may sound surprising – are not the particularly spectacular ones, but the ones that are timed to perfection, the ones that don't take up any time and let me work my way through my checkpoints, my benchmarks during the race, in a very pragmatic and unspectacular way.

Motegi, 14th October 2012

This is the worldly wise Marc of 2023 speaking. In his past, though, there were indeed also plenty of races that have gone down in history as "PlayStation Races". Races that looked like someone had dramatically lowered the difficulty level

and Marc was competing against a field of half-asleep computer bikes. Races where he overtook five or more riders per lap, reeled off qualifying lap times in the middle of the race and almost playfully overtook opponents left, right and centre. At the 2012 Japanese Grand Prix in Motegi, Marc, who was still in Moto2 at the time, didn't get off the starting line. On the front row of the grid, it was a miracle that no other riders rammed into him. When he finally got his bike going, he was 31st out of 33 riders. Incredibly, he then tore through the field and won the race. He repeated the feat at that season's finale on a damp track in Valencia. Having been moved to the back of the grid after colliding with Simone Corsi in practice, he still left the entire field in his wake. The riders he left looking like extras included: Pol Espargaró, Andrea Iannone, Takaaki Nakagami, Johann Zarco and Bradley Smith, to name just a few of those whom, despite this drubbing, we would later see in MotoGP. But what made the Valencia race so special was that Marc was already world champion. This daring escapade of overtaking the whole field was merely the free programme after the compulsory exercise.

I took a helluva lot of risk in those races. Incredible amounts of risk from today's point of view. I had the situation less under control than I really wanted to. Those were races I could only finish thanks to my self-confidence. I just rode like I couldn't crash. But I wasn't just crowbarring my way through without knowing what I was doing. I had a plan. No one brakes fully on the first corner, especially in the middle of the pack. There is movement in the field, you do what others do, the tank is still full. In other words, it is possible to brake later on the first corner of a race than the rest of the field does. That's exactly what I did, coming right from the back of the grid, in both Motegi and Valencia. I took my latest possible braking point from practice and braked right there in the race, regardless of what the others were doing. That's how I was able to overtake 20 of my rivals in Valencia on the first lap. I can find no way of explaining now how I managed that through all the traffic without hitting anyone. I just didn't think about what the others were doing and concentrated on the job at hand. For much of the race it was like Painting by Numbers: braking point, tilt, accelerate. If anyone got in the way, I found a way past him. Over the course of my career, I have used that attitude again and again on the track. I know I can ride my bike as fast as is technically possible in the middle of traffic, regardless of what the other racers around me are doing. But sometimes it also takes a bit of luck for opportunities to open up, even just a few centimetres, enough to slip through and be able to ride perfectly, quickly and efficiently again straight after. But a mistake by just one guy ahead of you can sometimes be enough to break your rhythm. Then things get difficult.

But if I put myself in that position today, on the last row of the grid, rear tyres and the back of other people's bikes as far as the eye could see in front of me, and in the next few minutes I reel them in, one by one... I don't know how I did it. I've seen it with other sportsmen and women; at a certain point in their careers, stars like Lionel Messi and Kobe Bryant conjured up things that no one could understand. We were already used to their excellence, but then there were these very special moments of magic, which they probably couldn't explain themselves. In my experience, at least, you only become aware of these magic moments in retrospect; they were one-off highlights that you couldn't plan for and certainly couldn't carry out intentionally. Even if you continue at a high level for a very long time, you only understand how special it was as a sportsman when

→
Even Marc's body language in Moto2 showed he saw this as nothing but a stepping stone to greater things: Aragón, 2011.

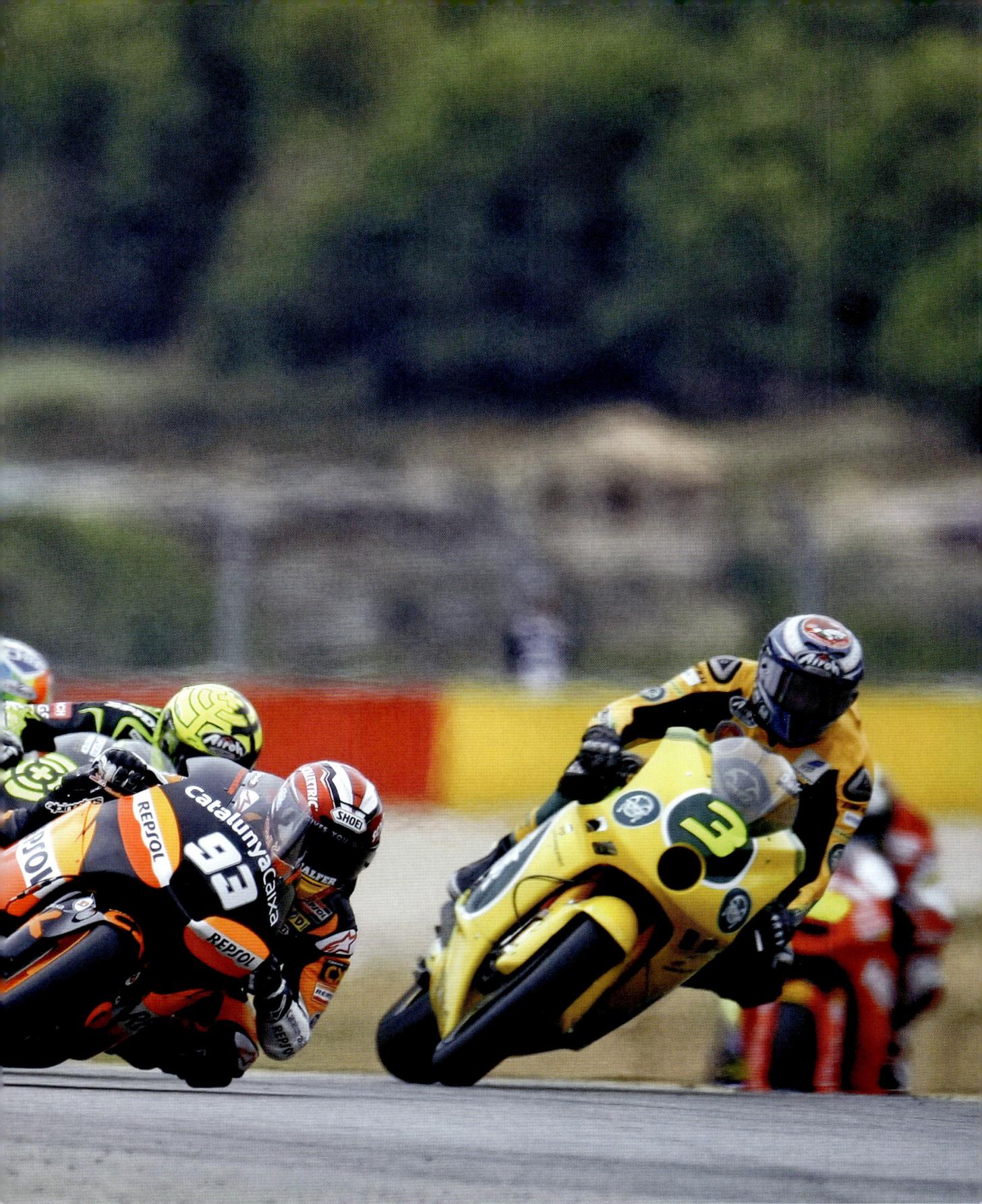

you experience another athlete's magic moments. But I think it is every professional's obligation to stay at the forefront of their game for as long as there is a chance, theoretically, of their producing something special, at least to have the prerequisites to be able to deliver a magic moment. Will that magic moment ever come? Impossible to say.

In the same way that I am a risk-taker in sport, I am conservative in business matters. The standard statement I make to my lawyers is, "I only take risks on the track." Apart from that, and especially in business, I want calm and to have everything under control. New business ideas? I can play with money after I retire. I will have all the time in the world – hopefully decades – for that then.

My passion is motorsport. I really notice this when I have to talk about supposedly good business models that have nothing to do with my world, i.e. motorsport or sport in general. I get bored very quickly. Competing has defined my entire life. When the day comes that I can no longer be on the starting line myself, maybe someone else will do it in my name. Who knows? Principal of my own MotoGP team? Why not? But I certainly don't see that happening in the next couple of years. But one thing is clear. I always want to have something to do in my life, something that fulfils and inspires me, because otherwise the days would get too long very quickly. Winning and testing myself against others is very much ingrained in my DNA.

→
Victory celebrations after one of the most impressive wins of his career to round off his time in Moto2 as world champion: Valencia, 2012

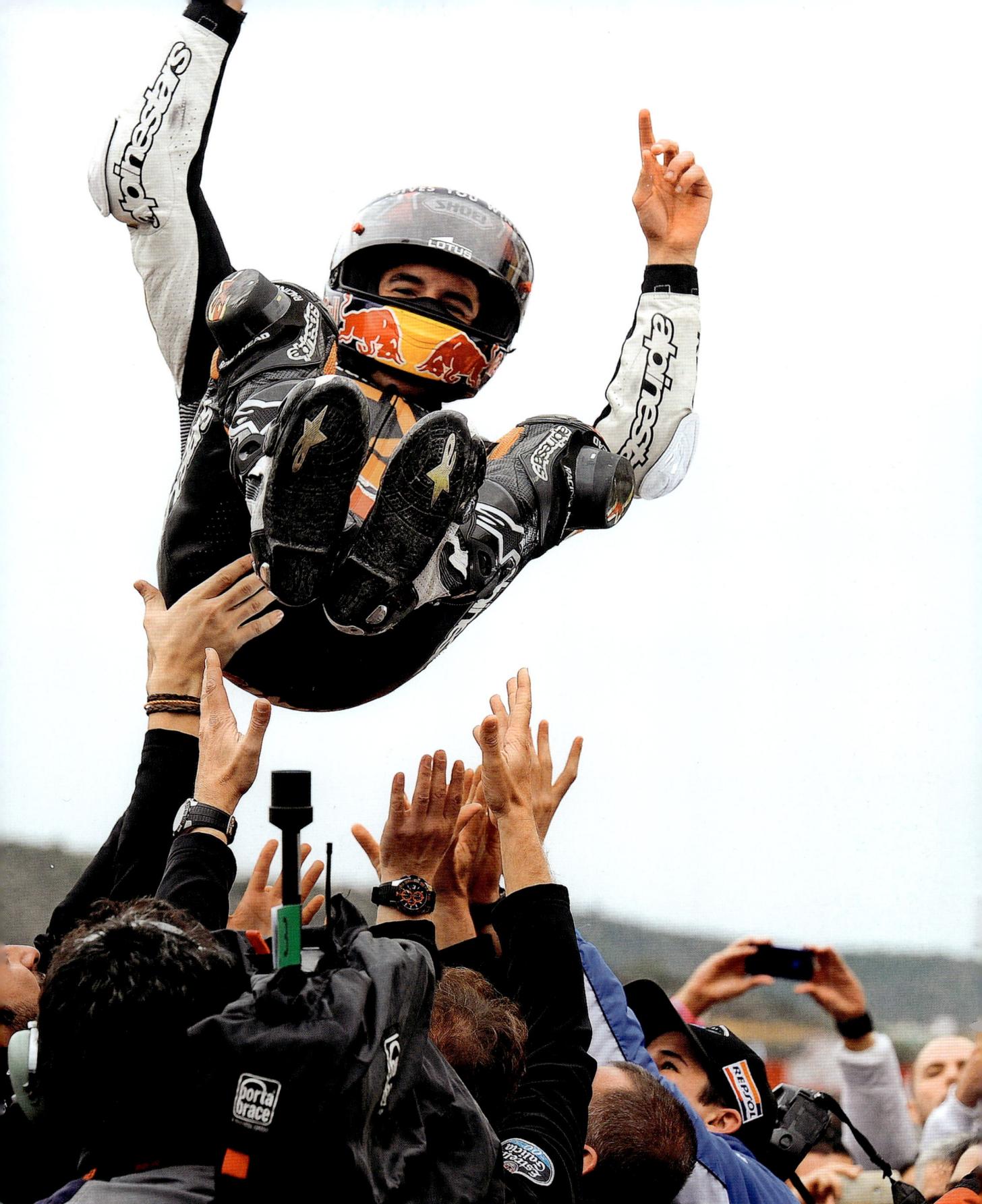

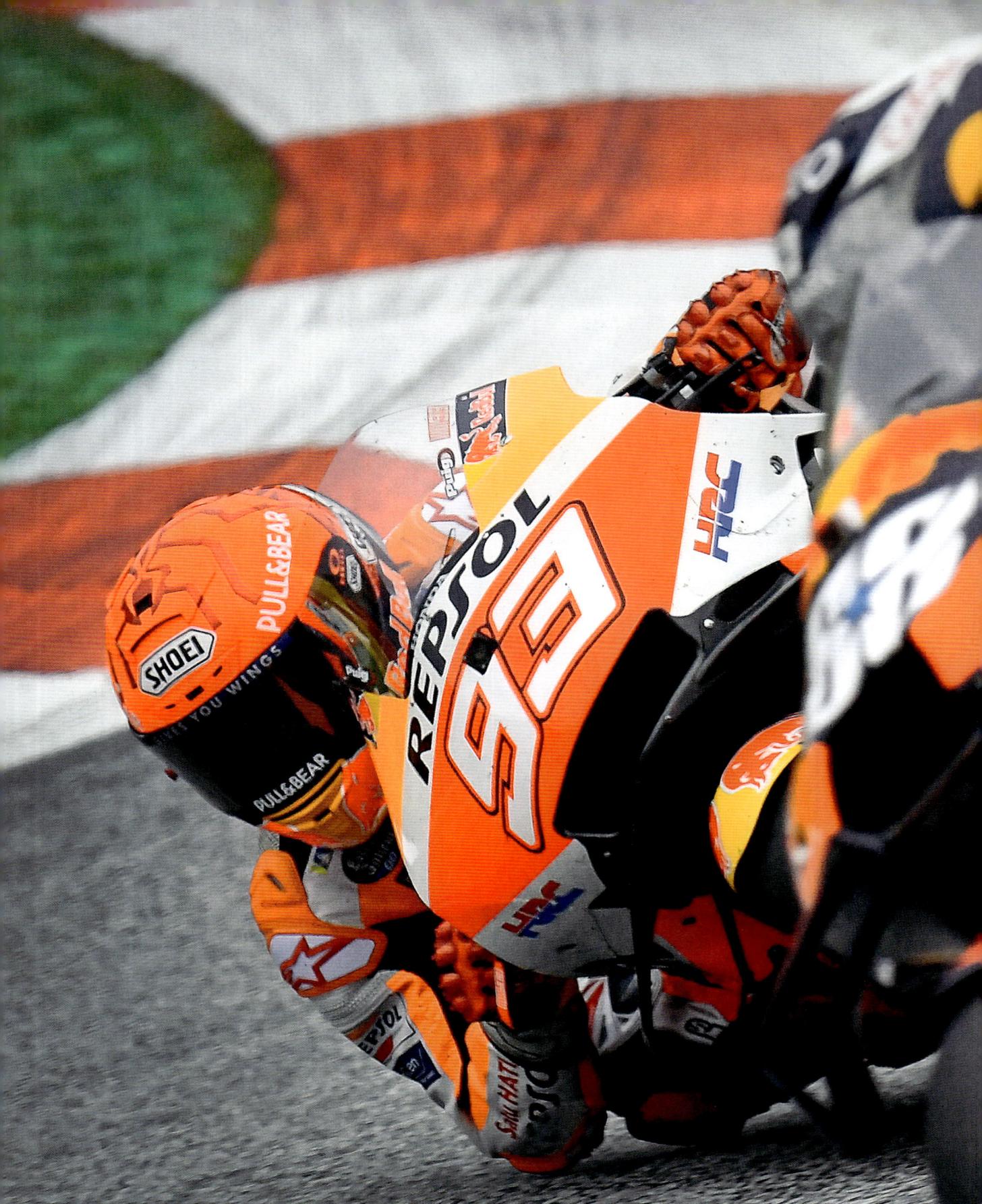

← Wherever there's Miguel Oliveira, there's room for Marc Márquez on the inside: Red Bull Ring, 2021.

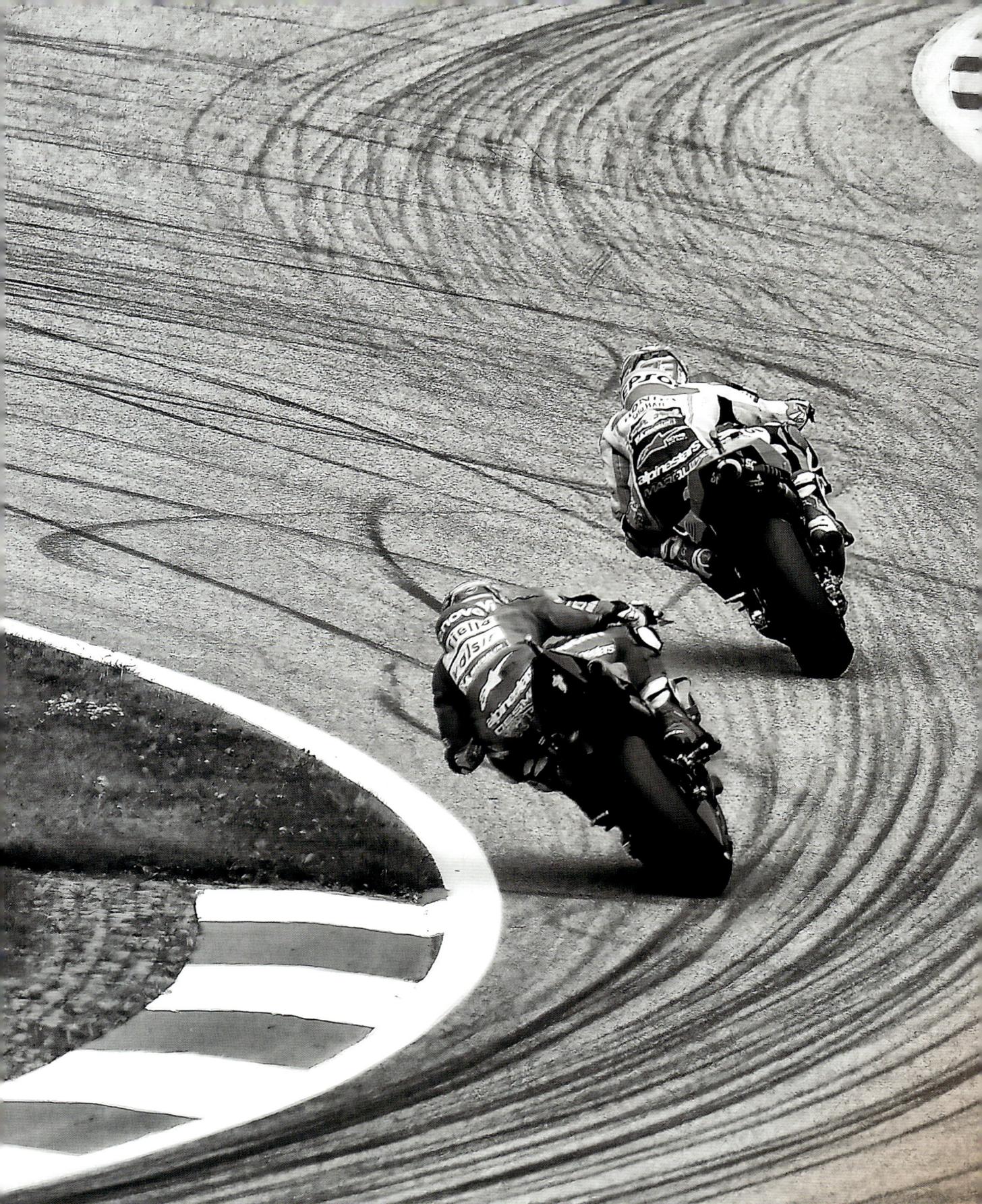

Curve 6

Role Model

What it means
to be a hero to
many people

7

The Styrian Green Carpet at the Austrian Grand Prix is a great event, especially for the fans. And you can see how momentous it is at times just by looking at the riders' faces. The idea is that on race day, the MotoGP stars don't just trickle into the paddock through the back door, but walk down a green – the state colour of Styria – carpet past the fans, as movie stars walk down the red carpet at the Oscars or Palme d'Or ceremony in Cannes. Rarely do the worlds of the sportsmen and the fans come together as closely as they do here. Due to their speed on the track, racers perceive fans as either a colourful mass in the stands or as a parade of people they drive through in a team car or the backdrop at any number of circuits around the world. Few fans have access to the paddock. It's the exception, not the rule. At occasions like the Styrian Green Carpet, by contrast, the fans can put a face – and voice – to the riders' names. And unlike classic autograph sessions, there is no set time for each rider to appear. There's a big cheer every time a familiar face appears, walks down the green carpet, stopping over and over again to sign autographs, pose for selfies, accept home-made gifts or have their photo taken with a fan club, family or bunch of regular attendees. Fans and competitors interact. Barriers come down. The person behind the helmet comes to the fore and enjoys these people's passion and joy. He provides joy himself and earns their enthusiasm. It's moments like these that demonstrate the incredible power of MotoGP, the passion, the admiration, but also why the riders give it their all every Sunday. As good as the action may have been in those spectator-free pandemic years, every rider would be happy to admit that without the fans at the track, without their enthusiasm and the colourful, eager, singing crowds, there was something vital lacking.

→
An autograph, another one, and one more too. Marc signing his way along the Styrian Green Carpet at the Austrian Grand Prix.

National heroes, long-time teammates and good friends of many years' standing. It's always a big deal when Marc and Dani Pedrosa do a double act. Jerez, 2018.

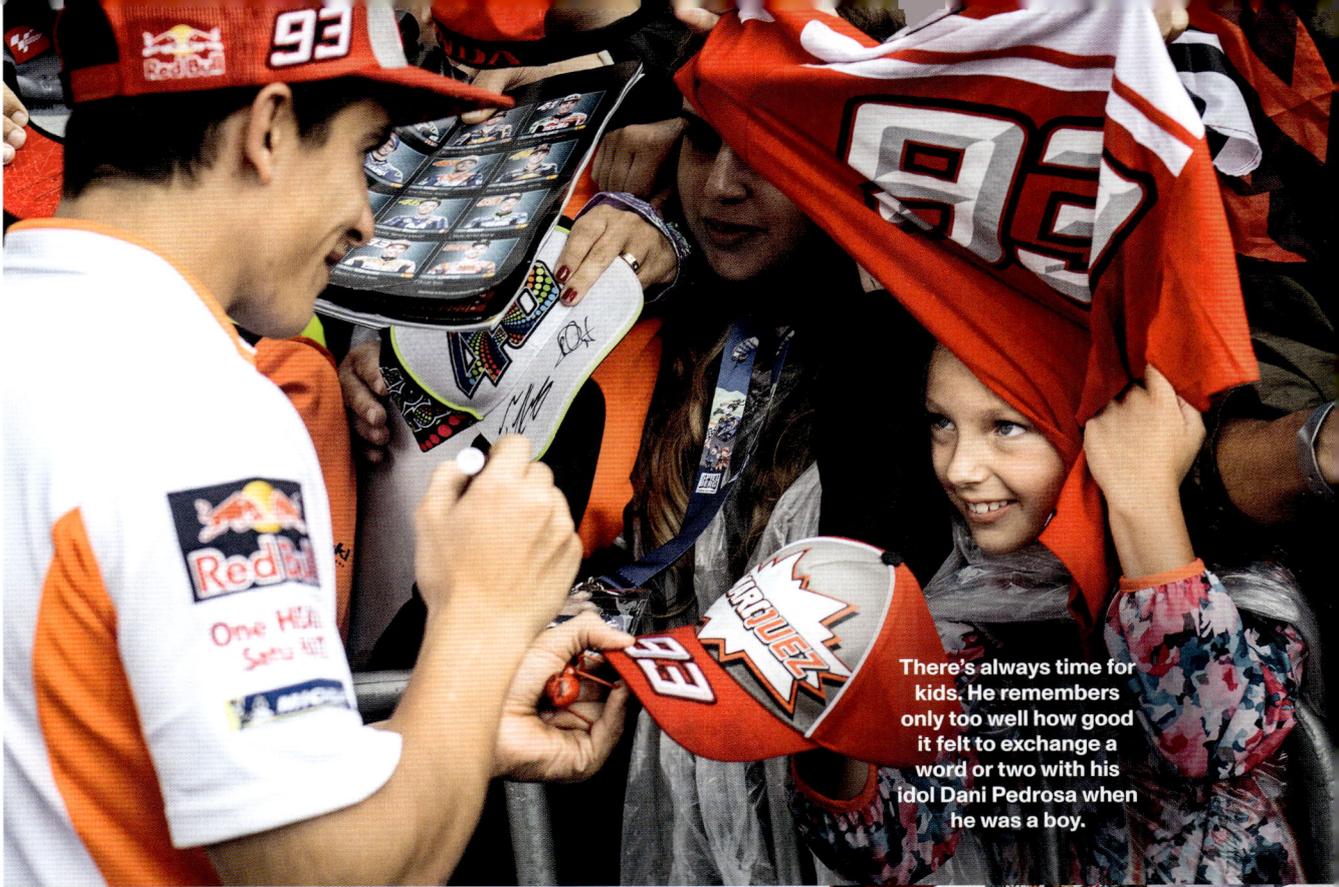

There's always time for kids. He remembers only too well how good it felt to exchange a word or two with his idol Dani Pedrosa when he was a boy.

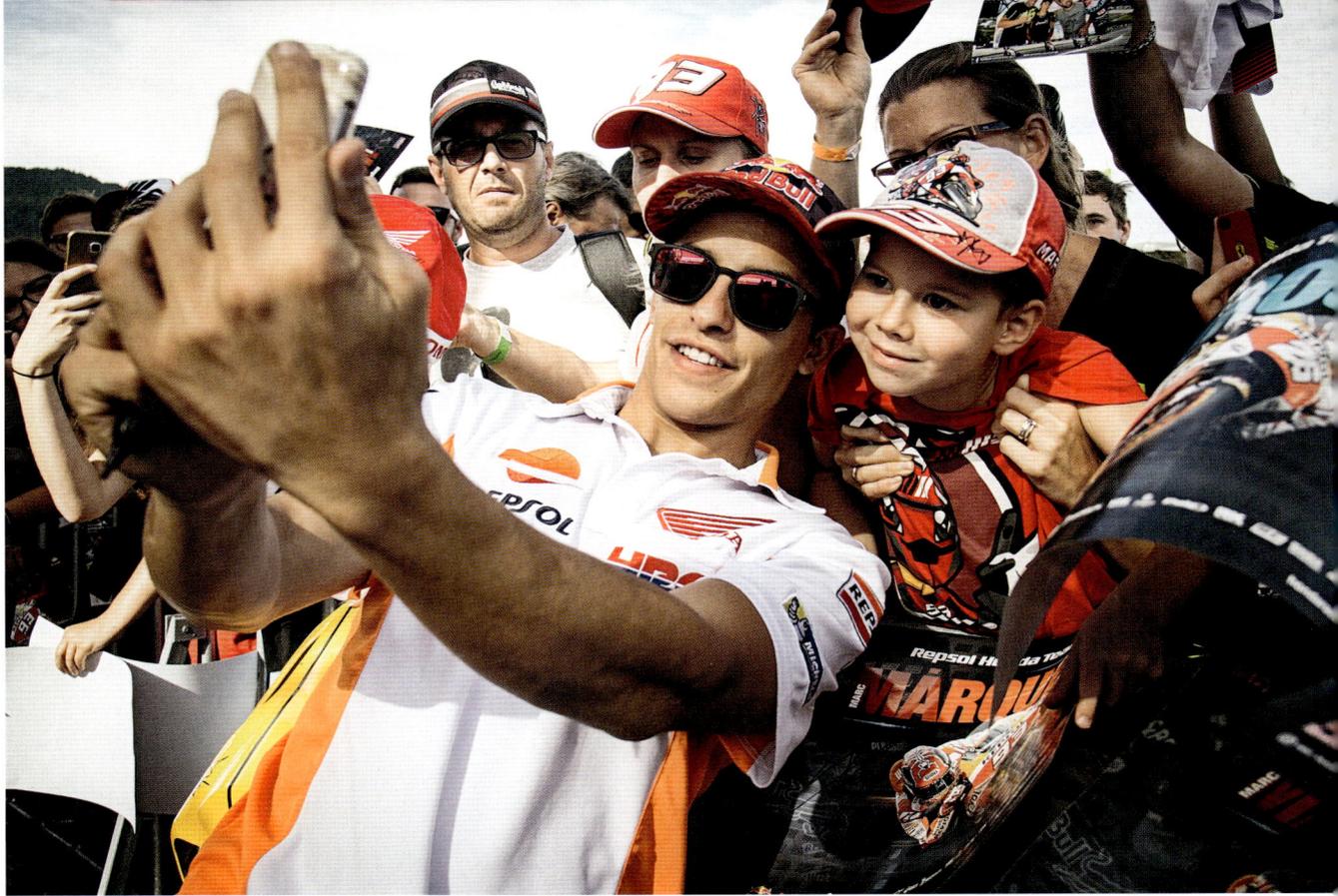

I had two role models when I was nine or ten: Valentino Rossi and Dani Pedrosa. Or, to be more specific, Pedrosa was my role model and Rossi was my hero. Vale won all those races and then always put on a great show afterwards. It was fantastic. I had already met Dani in person by then, though. He was small, and I was so small at the time that my parents went to the doctor to make sure I would grow eventually. Being small was a bond between me and Dani; he proved every weekend that body size wasn't crucial to success in motorcycle sports. Outside of motorsport I admired – and still admire! – Lionel Messi and Rafael Nadal.

In the course of my life, I have been lucky enough to meet all of my childhood heroes in person, and Dani even became my team-mate. Meeting my heroes was a bit strange at first, especially the ones I only got to know personally when I was already successful myself. After all, these were the people I had been looking up to ever since I could remember, and suddenly there they were in front of me, and we were chatting sportsman to sportsman, almost on an equal footing!

In recent years, I have been in contact with athletes from a wide variety of sports, especially through Red Bull. It doesn't matter what sport it is; everyone is good at the top, very, very good. These are exceptional people who are better at something than everyone else. I know some sports a little better than others, but I'm basically interested in all of them. Actually, I ask every athlete I meet about their sport, their approach. And I very often learn something that helps me to become better myself. Of course, I've also made use of old hands like Carlos Sainz Sr, who, at 60, just has so much experience.

Today I use other sportsmen and women as points of reference. The way Rafael Nadal deals with injuries, for example. Or Lionel Messi's hunger to finally win the World Cup with his country, having won just about everything else there is to win. Things like that inspire me. But young football players like Gavi from Barcelona also inspire me in the way they see and live their sport. There are a lot of athletes that I can watch and learn from.

In return, I pass on my knowledge to younger riders, the ones in the Spanish and Moto3 World Championships I have a good relationship with; I help them by sharing my experiences and giving them insight with the small details. But I don't shout about my input from the rooftops. Once the riders are standing on their own two feet – like Pedro Acosta or Izan Guevara – it's no longer an issue, but the smaller the category, the more important I think it is to act in secret. If I were to name the kids I expect to make the jump into MotoGP, that would only mean extra pressure for them. "Marc Márquez thinks I'm good enough to get into the world champion-

ship." I try to spare the boys that mindset, because it doesn't bring them anything. On the contrary. They're just teenagers, still at the start of their careers. They haven't achieved anything yet. Are they talented? Definitely! But talent alone won't get you anywhere, especially not in the world championship. Their journey has only just begun, and to move forward will require a lot of devotion, hard work and expertise. I can make my small contribution with the latter, but the rest has to come from them. Furthermore, external pressure on these young riders would increase if my connection to them was public knowledge. Motorcycle racing is so incredibly popular, especially in countries like Spain and Italy, that the pressure on the young riders is already enormous without my name hovering in the background. Staying invisible is also a condition for the financial support I sometimes provide. When I invest money in a team, there's no logo stuck on the bike's fairing proclaiming the fact. No one would benefit from that. On the contrary.

I realised that I had become a role model myself around 2013, when my MotoGP career took off. There was an ever-increasing number of fans around me. For example, if ever I was training at a public playing field, it was full of kids within an hour! Previously – after winning the 125cc and Moto2 World Championships – I had put my relative popularity down to the professional work of my sponsors; with Red Bull and Repsol, I had two strong partners behind me. But it really exploded in MotoGP.

The usual contact with a fan is a selfie, which is increasingly replacing the good old autograph. And then there are the special fan encounters, people who freeze as soon as they see me. Star-struck. Some shake. Others cry. Some spend a fortune and travel half-way round the world hoping to see me. Others still make creative gifts – especially in Japan – or give me things I never thought I'd ever get given by a com-

plete stranger. Underwear, for example, and yes, that usually happens in Japan too.

What touches me the most are encounters with children. I can hardly ever say no to them, even when I'm stressed. I really can always spare that one moment for a photo with them. I can only imagine how much it means to them. What is a fleeting moment for me is something they will remember for a long time, something that will stick. Being able to provide those moments means a lot to me because it reminds me of my own childhood.

Of course, the biggest crowds of fans occur at the races in Spain. On paper, the Grand Prix in Barcelona is my home race, because it is the closest to my home town, Cervera. But emotionally, Jerez is my home race. It is usually the first European race, which makes the atmosphere special. Plus it's the race with the greatest tradition, the loudest fans, the most colourful history. I love Jerez! I love the track layout, the atmosphere, everything. It's a good place for me, and even the fact I broke my arm there in a crash in 2020 doesn't change that.

It is sometimes a real problem for me to get to the track at all, especially at races in Spain. It's a catch-22. On the one hand, there are thousands of fans who have waited for me for hours, who are here because of me and who deserve a little of my time. On the other, there's the jam-packed schedule of a professional with preparation, meetings, track sessions, media duties, physio and downtime. Anything more than five minutes of fan contact in front of the paddock isn't usually possible. At first, it really used to stress me out! On the one hand, there's my media guy pushing me to the next appointment we're already late for, and on the other, the fans and the disappointment in their eyes. I've got a little more used to it over the years and I tell myself that I'm here to race and I'd never lay eyes on my bike that day if I wanted to please every single fan. You

There is now so much fuss at the start that the team has to set up barrier tape around Marc and his bike: Jerez, 2019.

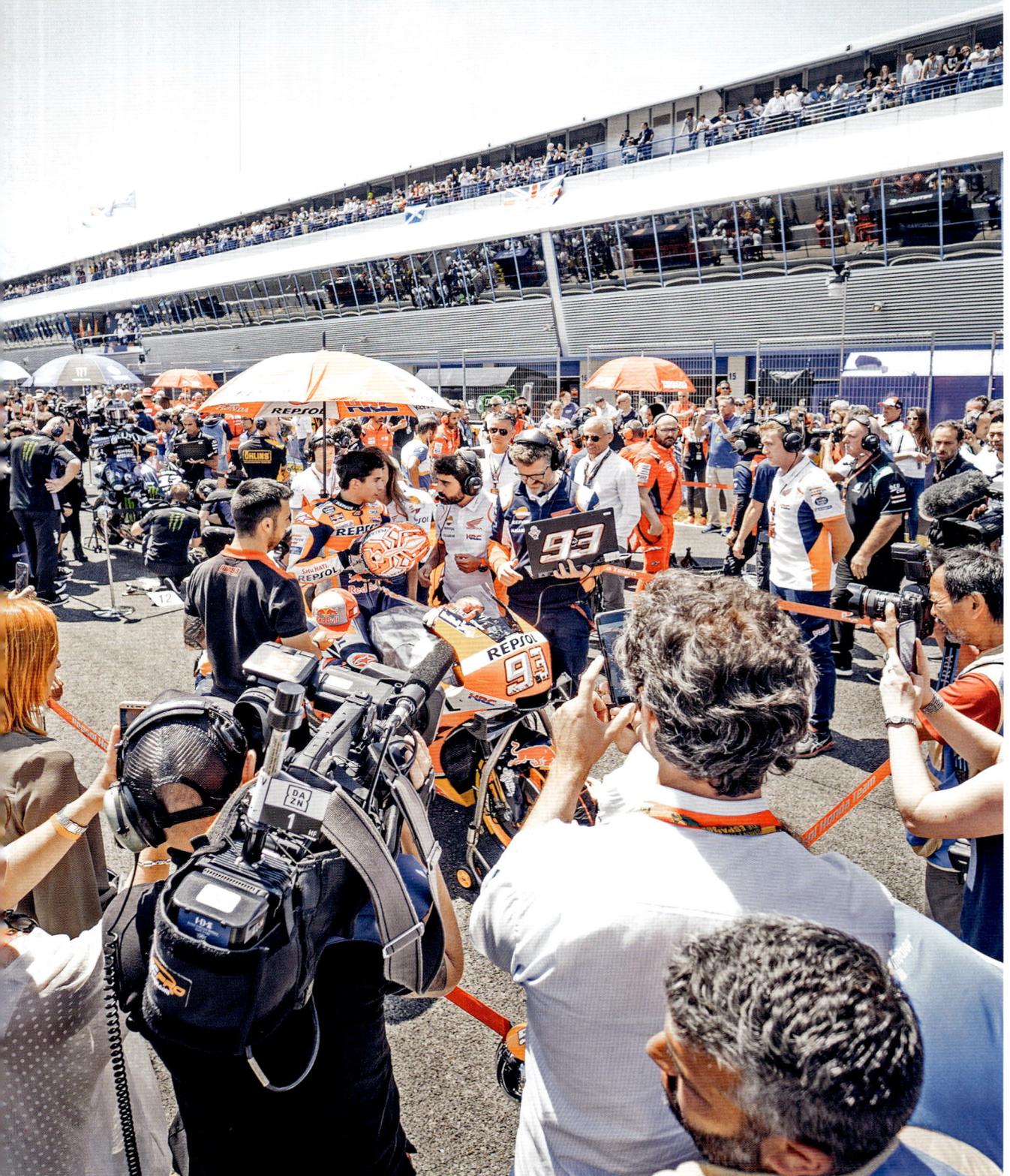

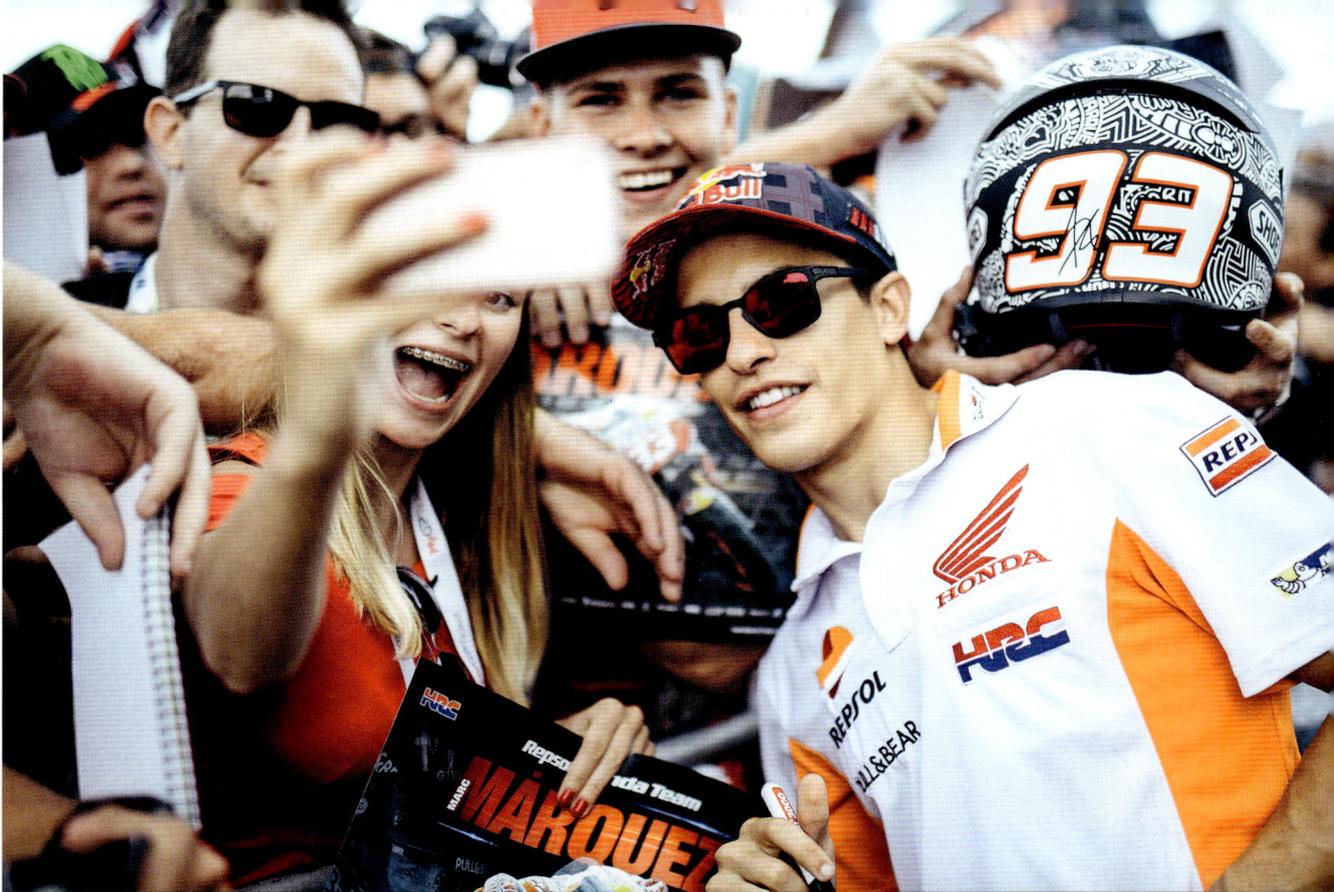

Another selfie, another autograph, another gift, another hug and yet ... There just isn't enough time to satisfy all the fans.

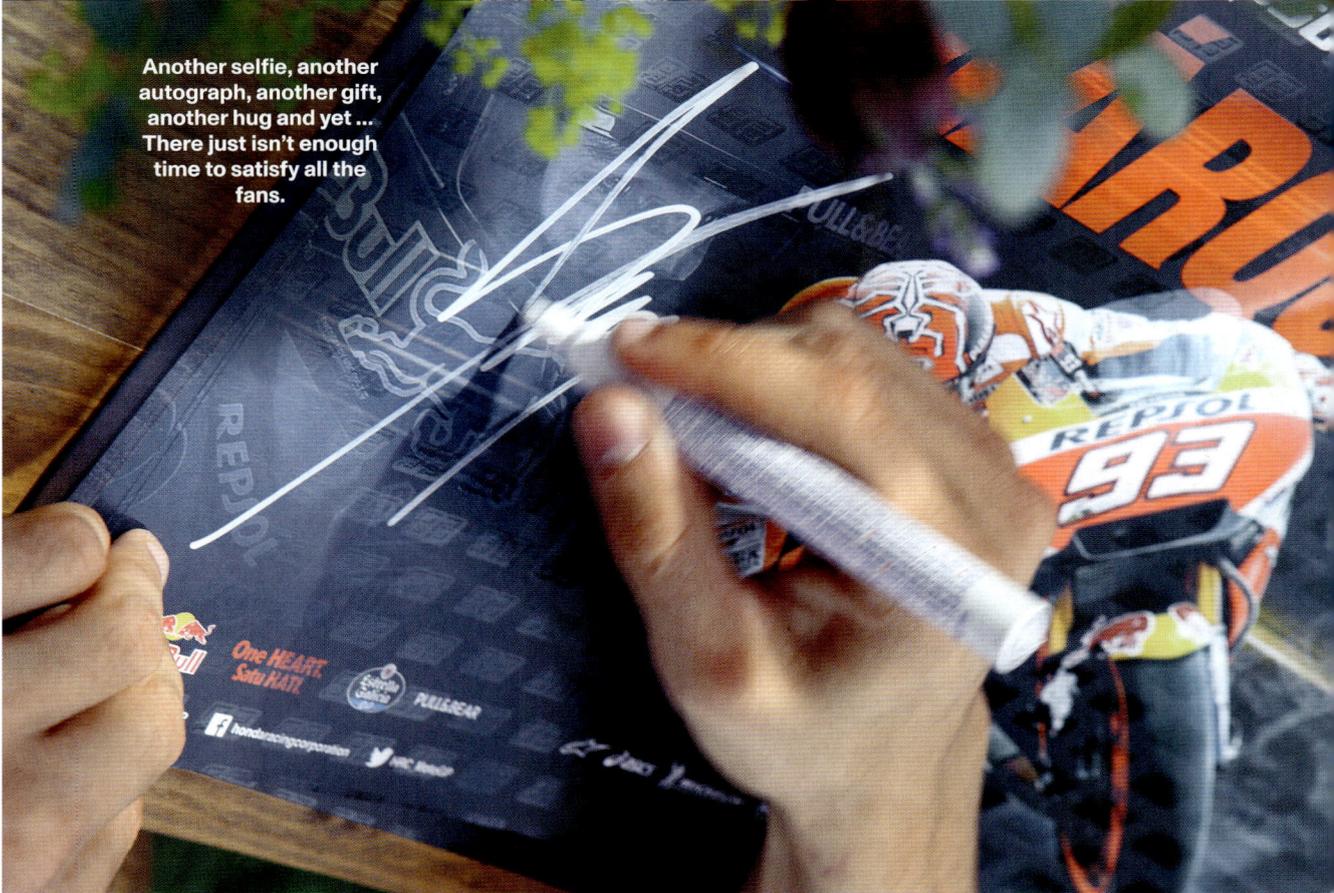

see so many eyes, so many faces, so many hopes, so much enthusiasm. That's what makes turning away and walking on difficult. This isn't an anonymous mass of people. They're all individuals I mean something to. And if these fans could spend one day, just one day, with me during a race weekend, I'm sure they would understand where I'm coming from. And there's another thing. My actual and most important job is to race, to perform. Distractions have an adverse effect, so I have to block the spectators out from a certain point. I hope those fans that didn't manage to get a selfie with me will still be just as enthusiastic in the stands on race day and cheer me on!

So that was the positive side of being popular. The negative side is that I am always under observation. It isn't easy for me, and the fact that the world is full of mobile phones with cameras in them also limits my privacy. When I'm free, I love to party. Who doesn't love a cool party?

The parties we throw after winning a world championship are always particularly awesome, and the most emotional one was certainly the one after my first MotoGP title in 2013. It was in Valencia, I had won the world championship, the first rookie to do so since Kenny Roberts, and the youngest winning rider in the history of the premier class too.

Marc went into the decisive final race 13 points ahead of Yamaha rider Jorge Lorenzo. If reigning world champion Lorenzo won, fourth place would still be enough for Marc to win a historic title. He was on pole, but messed up the start. Lorenzo took the lead and Pedrosa slipped past too. Right at the Doohan turn (named after Marc's legendary predecessor at Repsol Honda), he both missed the braking point and had to contend with Valentino Rossi. In the following laps,

Circuit Ricardo Tormo, 10th November 2013

Lorenzo controlled the pace and tried to keep the group up front as large as possible, the reason being there might then be enough riders between him in the lead and Marc for him to bring the world championship home. But it didn't go according to plan. The tactic got him tangled up in skirmishes with a feisty Dani Pedrosa. Twenty-one laps from the finish, both had to move away from the ideal line at, of all places, again, the Doohan turn. Marc briefly took the lead and then did what you wouldn't normally expect of him: he rode a controlled race, came home in a risk-free third place and thus dethroned Lorenzo in a confidently relaxed manner, or so it seemed to onlookers, at least.

I remember missing gears four or five times on the last lap, which never normally happens to me. I had completely lost my focus and, mentally, I was already celebrating my title. In Formula 1, you can hear what the drivers say on the radio when they cross the finish line and have won the title. We don't have that, but rest assured, you didn't need an on-board radio to hear me screaming with joy under my helmet the way I did that day. People must have heard me all over Spain! And the best was still to come. First I stopped off by the official fan club in the cool-down lap. I threw my gloves into the crowd, someone glued the number 1 over my traditional number 93 to show I was world champion, my original helmet was swapped for one with a special world champion design, and I had a specially designed T-shirt with "Baby Champ on Board" printed on it. Wonderful!

And then came the highlight, at least for me. It was back on the bike and off to the parc fermé, where my crew was waiting, between the bikes of Lorenzo, who had won the race, and my friend and teammate Pedrosa. It was a very emotional moment. I could finally turn the bike off and at long last collapse into my team's

arms! At moments like those I'm a total hugger. I love collapsing into people's arms, feeling hands patting me on the back, jumping up and down in circles together, being picked up and thrown into the air... It's the best feeling in the whole world! I think I floated that afternoon.

The party on the Sunday evening right after that decisive race didn't actually go on very long; those celebrations never really do, as I would learn in subsequent years. After a Grand Prix, you're just too shattered physically. But as for the big world championship bash in Cervera... That rarely finished before eight or nine o'clock in the morning! Those parties were legendary. The best ever. Ride hard, party hard!

However, I have to earn my parties, because I am very strict. And there are times of the year when there is a total partying ban. And when I do allow myself to get carried away, when I really deserve a little fun, unfortunately I can't usually go for it as much as I would sometimes like to. What's the point of partying in first gear? That's not who I am, sorry. Sometimes

I ask one or two friends to take care of me and pull the plug on proceedings before I do anything crazy and things get completely out of hand. That's a real downer for me, mainly because I have to think carefully in advance about when I can party and not live it up every night until three o'clock in the morning. But in my holidays I like to, just like every other Spaniard of my age.

But I also have to be careful in my day-to-day life and set myself very strict standards, whether on the road, at restaurants, in public. There's always someone watching what I'm doing.

There is another level still, and that is at racetracks with other motorcyclists close by. There is one scene I will never forget. I was training on a private racetrack on a Honda from my garage. During a break, I had to move the bike a few metres. Without much thought, I got on, started it and rode maybe 20 metres at walking pace to get it out of the way, without putting on a helmet. You can picture what happened next. Not long after, there was a kid dashing round the paddock

↓
Home win! Marc celebrates victory at the Catalan Grand Prix in Barcelona in 2019, his third at Montmeló.

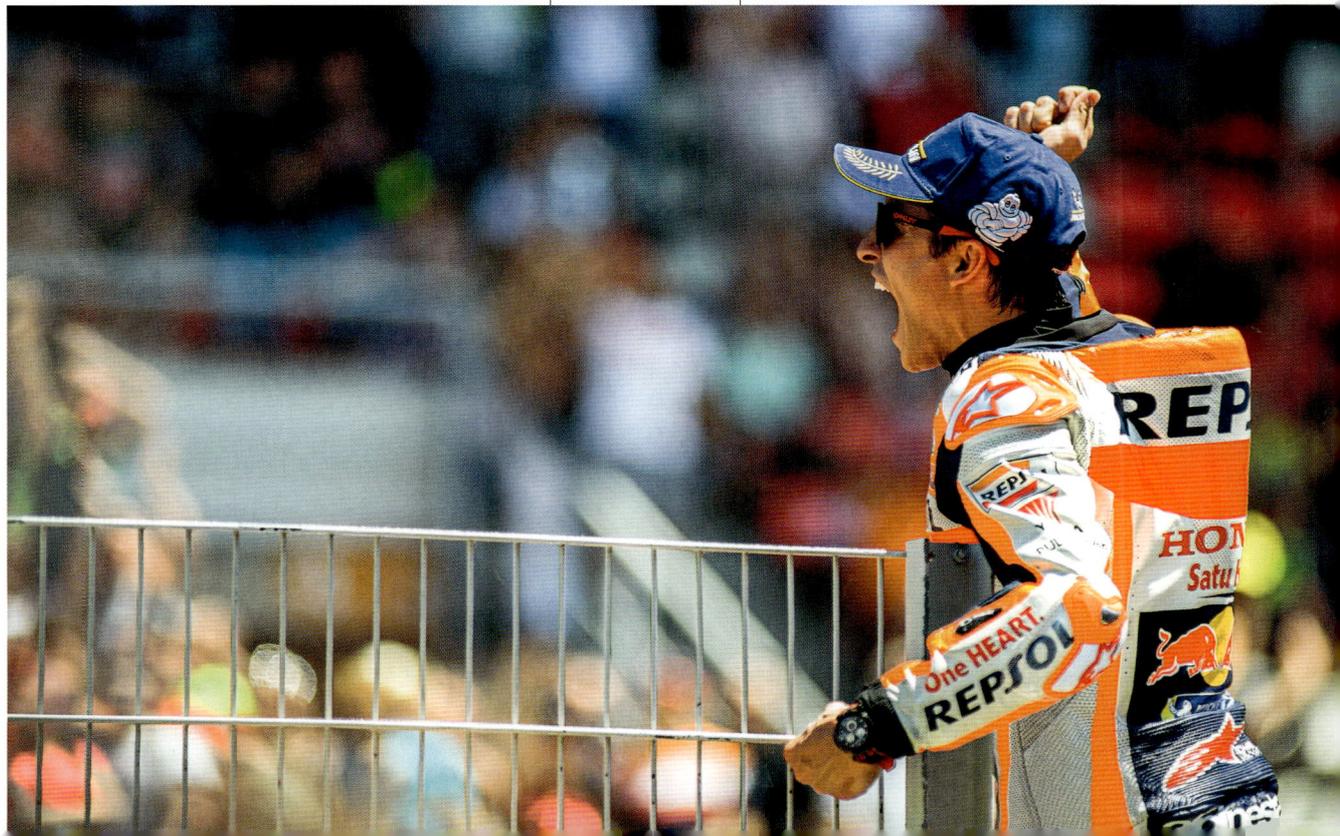

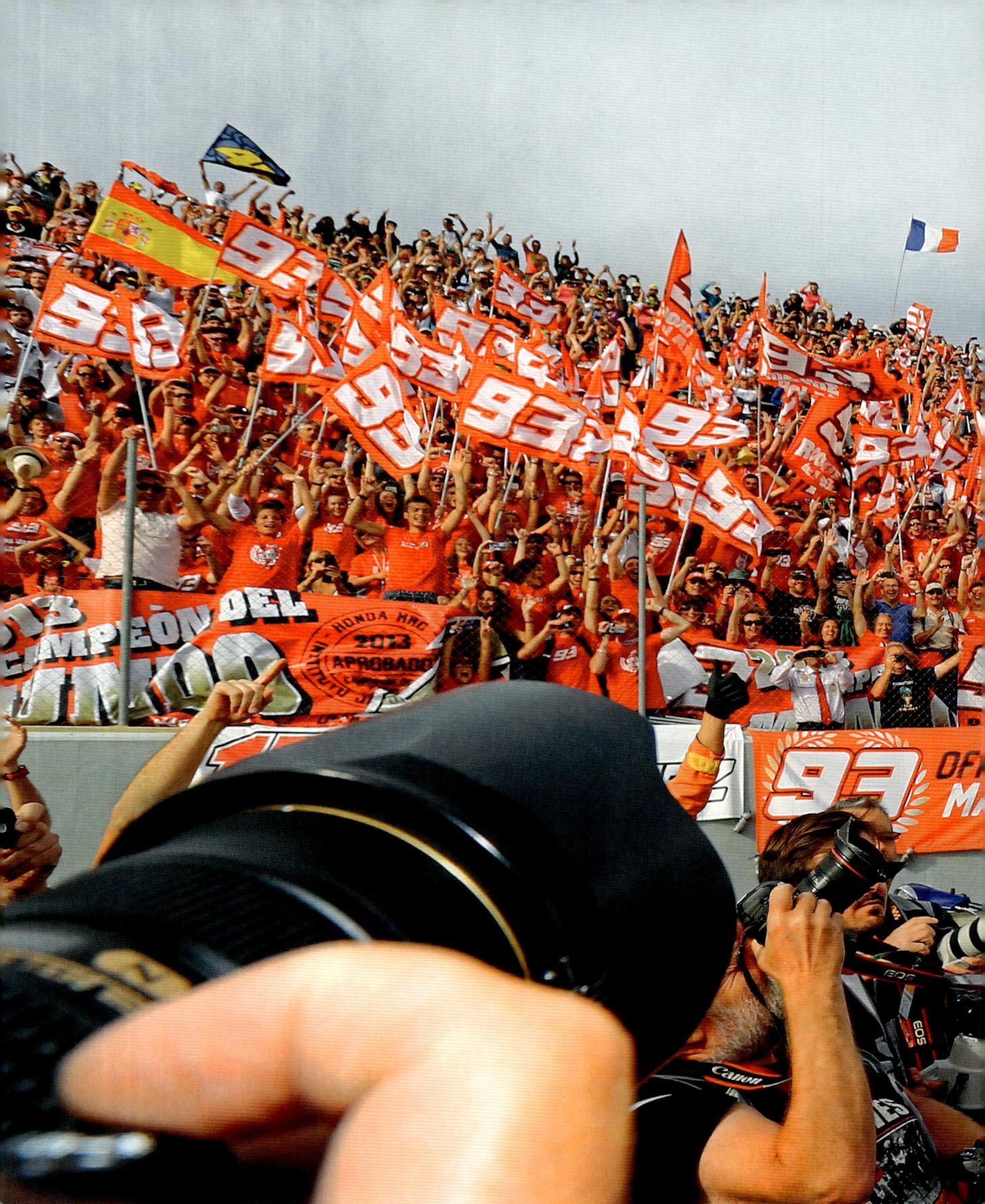

Curve 7

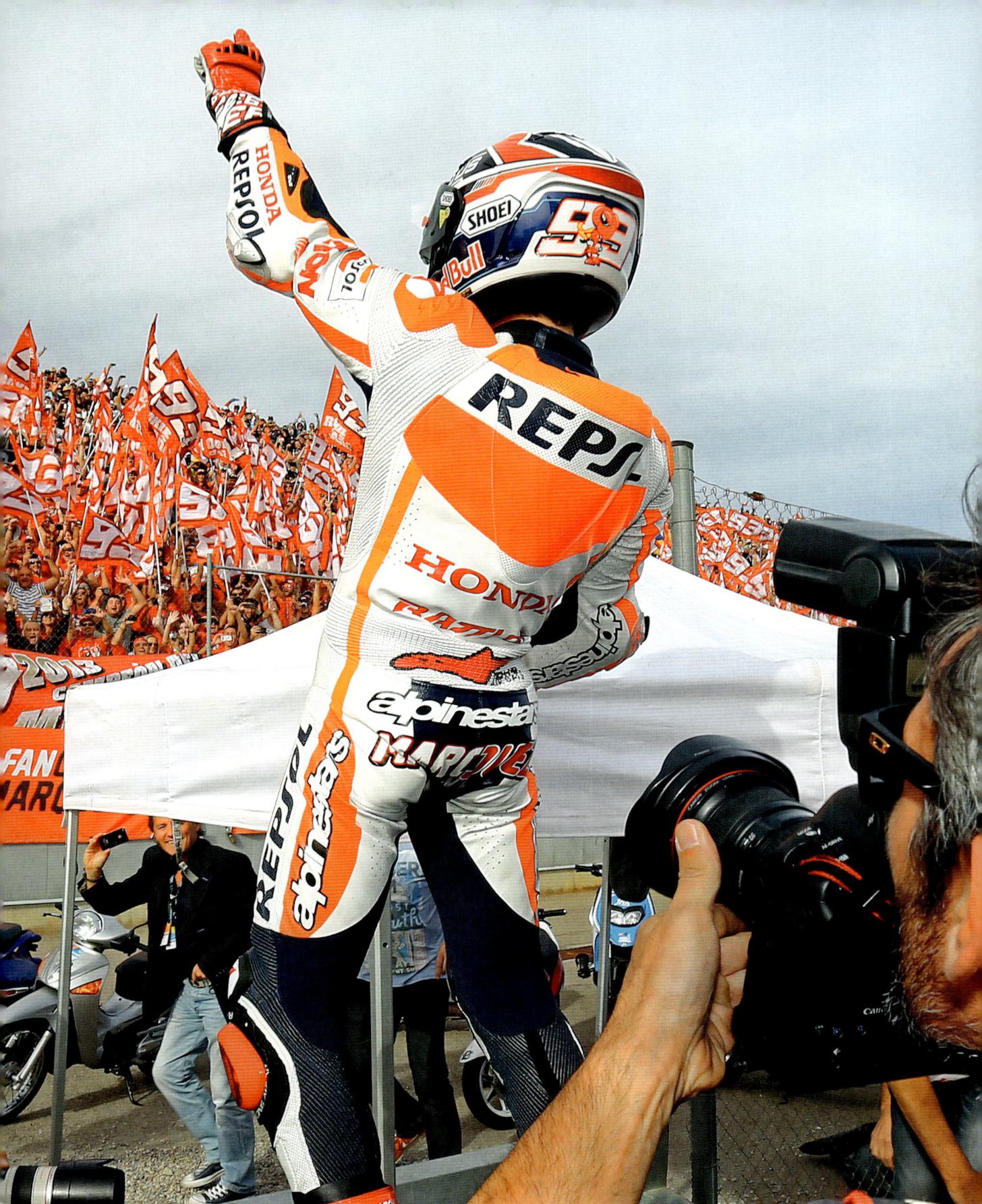

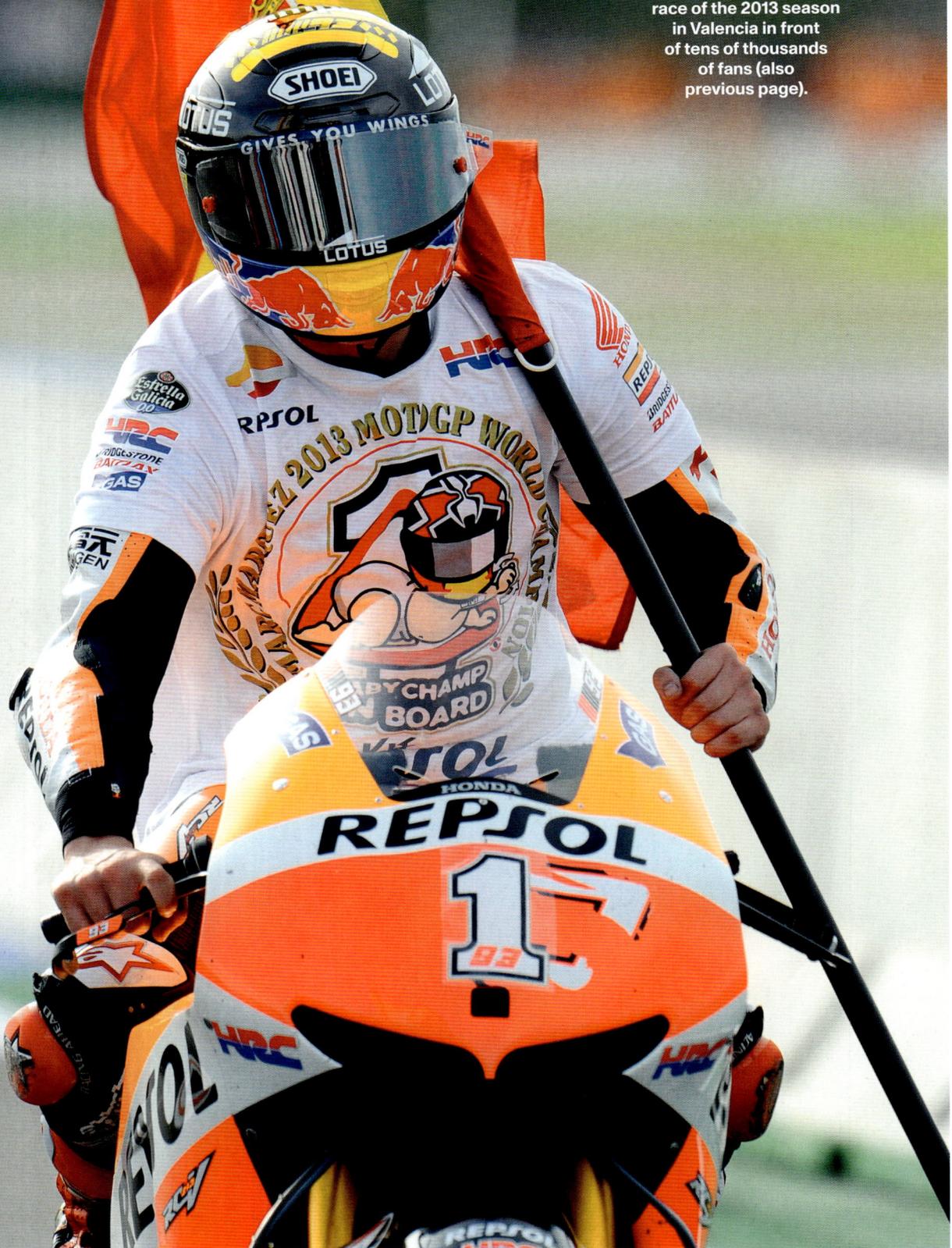

The first strike: starting no. 1 to celebrate the no. 93's first premier class World Championship title at the closing race of the 2013 season in Valencia in front of tens of thousands of fans (also previous page).

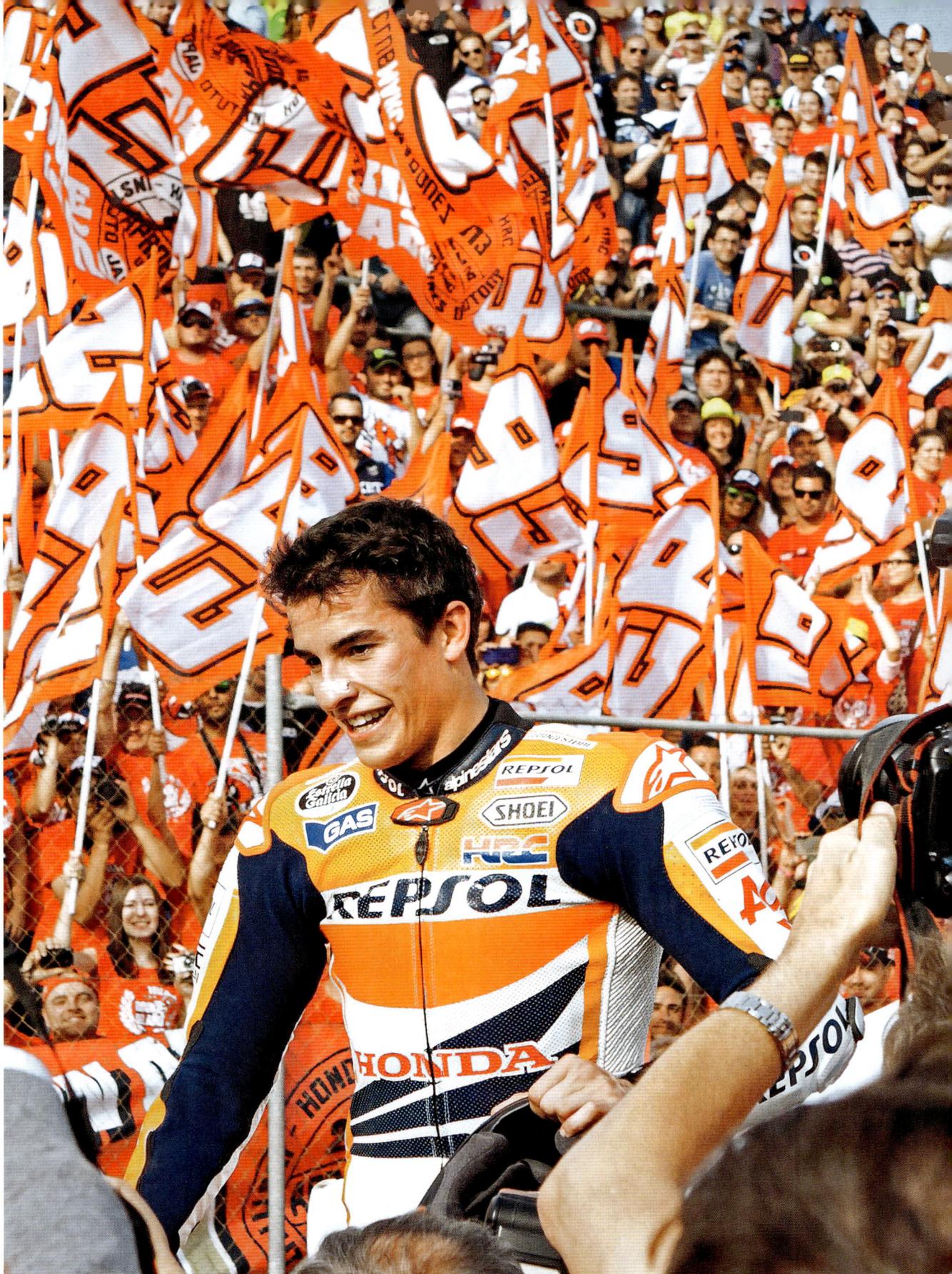

on his bike without a helmet. His father was furious, stopped him, and told him in no uncertain terms to put on a helmet. He answered, "Marc Márquez wasn't wearing a helmet either." No matter what the occasion, how short the journey or how slow I had ridden, as world champion, you are a role model 365 days a year – sometimes even 366 – and always 24 hours a day.

At least paparazzi are mostly uninterested in me. OK, there was the year I was with Lucía Rivera, and some popped up here and there, but that was probably more to do with her world and the fact that she is a model. So no, so far I haven't had any problems with my photos in the papers to date. Perhaps it's also because I generally ignore any reports about me. My team occasionally ask if I've read some nonsense or other that has been written about me. No, I haven't, because I tend not to read it. I'm happy to read about others. I don't read anything about myself. What's there for me to learn from it? But I have to admit one thing. Sometimes, when I'm feeling sentimental, I look at photos of myself from the past. Pictures from photo shoots, old

racing pictures, that sort of thing. I don't carry my favourite pictures around with me on my phone; they are stored on my laptop and I flick through them every now and again.

Over the past two years, I've had plenty of time to think about myself and my career. In addition to my injury, there were the technical problems at Honda. What do I want? Why aren't I ready to retire? During the break caused by my injury, I realised how much I still love my sport, how much I still love motorcycling and winning. I still have goals. I want to win races or at least be fighting to. That's what I train for. That's why I go to the gym, why I run, why I work with my physiotherapist... To win, not to finish tenth. I want to be at a physical level that allows me to consistently be in the top five. If I'm at that level, I can win. And if I can win, I can fight for the world championship.

When is the right time to stop? I would have liked to have been inside Valentino Rossi's head for his last four years in MotoGP. He is the winning type who had set himself the highest standards through-

↓
Fans ahead, photographers behind: sprinting to the stands after securing the 2013 World Championship.

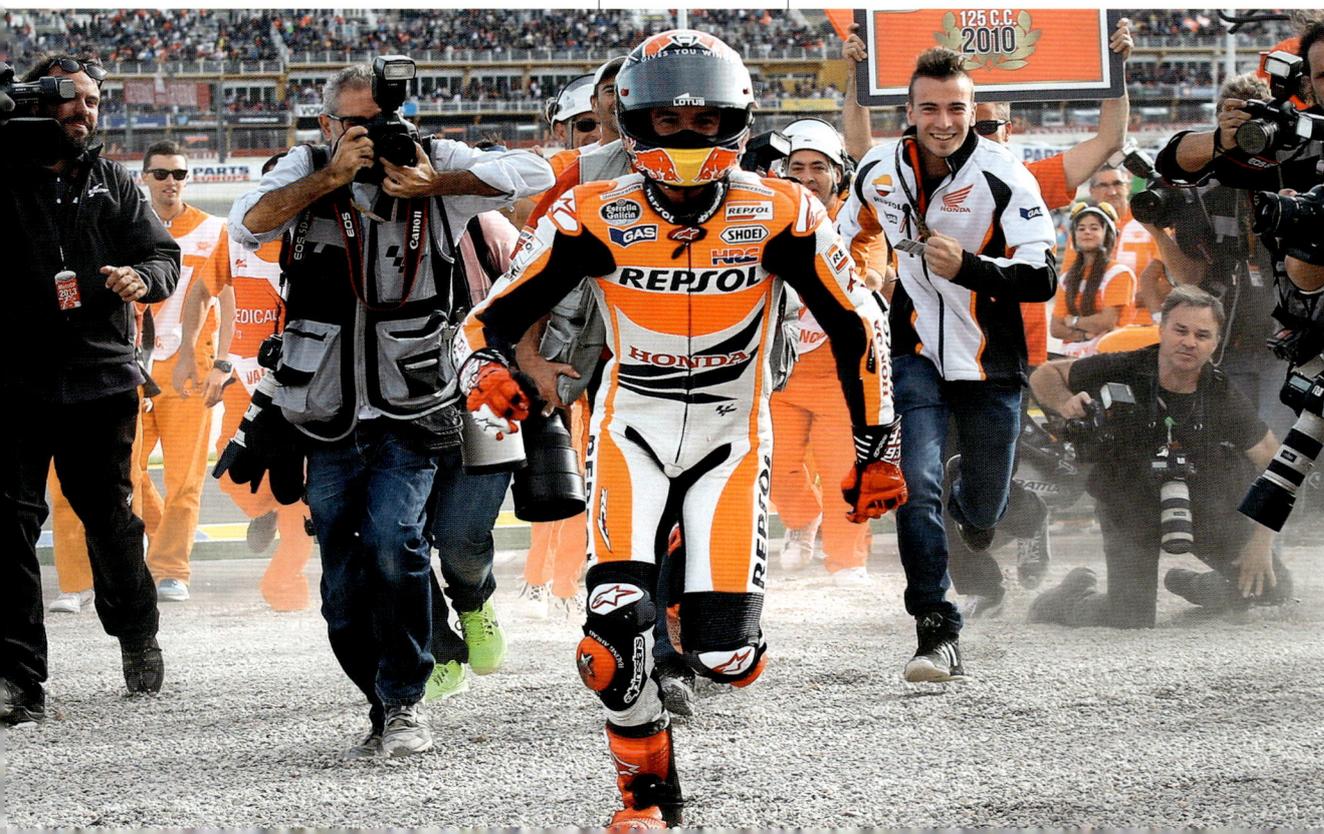

out his life. His career is unique, incomparable. Someone who, like me, is sad when he can't fight for the top spot. And then he had to plod his way round finishing between 10th and 15th for four years. *Vale!* For four years! Then he even left the factory team for a satellite team. The most successful motorcyclist in recent history! I'd genuinely be interested to know how he managed to get up and carry on every weekend under those circumstances.

Maybe someday I'll find myself in the same position, unable to stop because the flame is still burning brightly. In an interview with a Spanish media outlet in the winter of 2022/23, I explained how motivation changes over the years, at 20, at 30 and probably even more so at 40. If I could meet my 20-year-old self today, I would only have one piece of advice: enjoy the good moments!

Yes, I definitely enjoyed my wins, but because there were so many of them, they eventually became the norm. I've learnt that much in the last two years. It isn't normal to win every race, every title. Fighting, exerting yourself... That's normal. Winning is special. For me, winning was normal for years, and everything else was frustrating.

Am I more humble, more grateful now? Yes and no. Of course I'll enjoy the next win, precisely because it wouldn't be a foregone conclusion. On the other hand, I know how much investment I've put in, how hard I've had to work for it. Five or six years ago, I was Superman. Everything I did worked. The next win – if it comes – I will have worked for. Me, Marc. Not Superman, whom everything comes to on a plate.

My career has developed steadily since 2008. I became the world champion of the lowest class. I finished my first year in Moto2 in second place, and in my second year, I was world champion again. In my first year in MotoGP I won the title, but over the next few years I rode even better

and became more dominant. With the exception of 2015, when we had problems with the bike, every year was an improvement on the previous one. I consider 2019 the best season of my career so far. The best and almost impossible to repeat. Every race I finished either as the winner or no worse than second, and even my only retirement that year, in Austin, happened when I was in the lead and had a technical problem engine-braking. Then there was the freefall in 2020 with my crash and its long-term consequences. I have totally different motivation now thanks to my comeback. For years, it was normal for me to win. A win was just a nice day at the office! In recent years, I've realised that it isn't normal to always come out on top. There are 24, 25 riders out there who want to win. In the end, only one gets to celebrate and there is no law of nature that says that has to be me. But of course I will do absolutely anything possible to make it be me.

But what really spurs me on is the thought of winning championships. Do I care whether I'll have secured 100 pole positions or won 100 races by the end of my career? OK, maybe I will, but who's still going to care about that in ten years' time? The number of wins, fastest laps and pole positions will only be of interest fleetingly if someone beats my records one day. But the world titles will endure. How many races have Lorenzo or Pedrosa won? I, for one, don't know. But I know how many times they've been world champion.

> "But I also have to be careful in my day-to-day life and set myself very strict standards, whether on the road, at restaurants, in public. There's always someone watching what I'm doing."

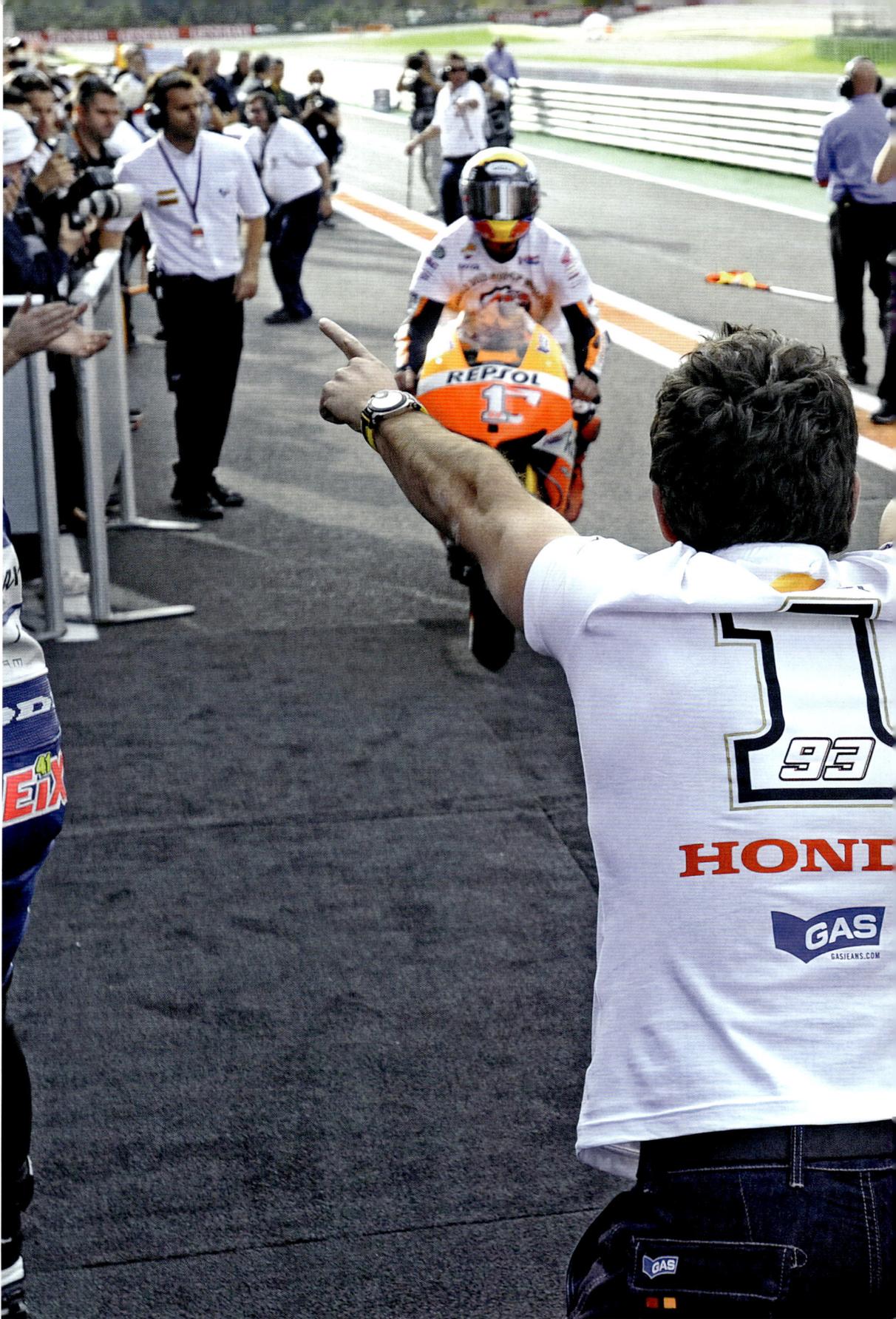

→
The end of a long journey: Mechanic Carlos Liñán embraces Marc in his first MotoGP season as the youngest World Champion in history.

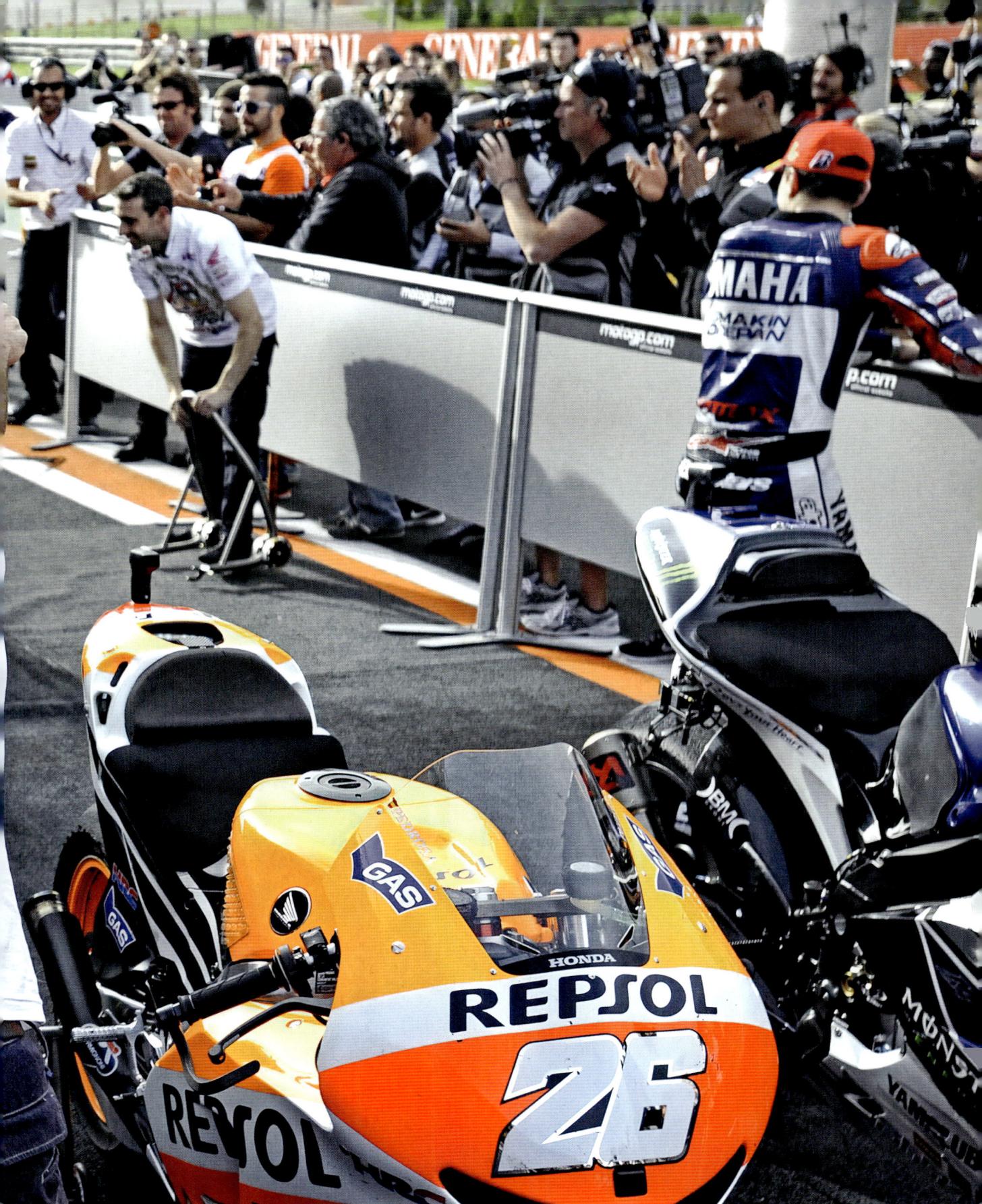

→
A sea of red:
The MM93
fan club
celebrates
title no. 5 at
Valencia in
2016.

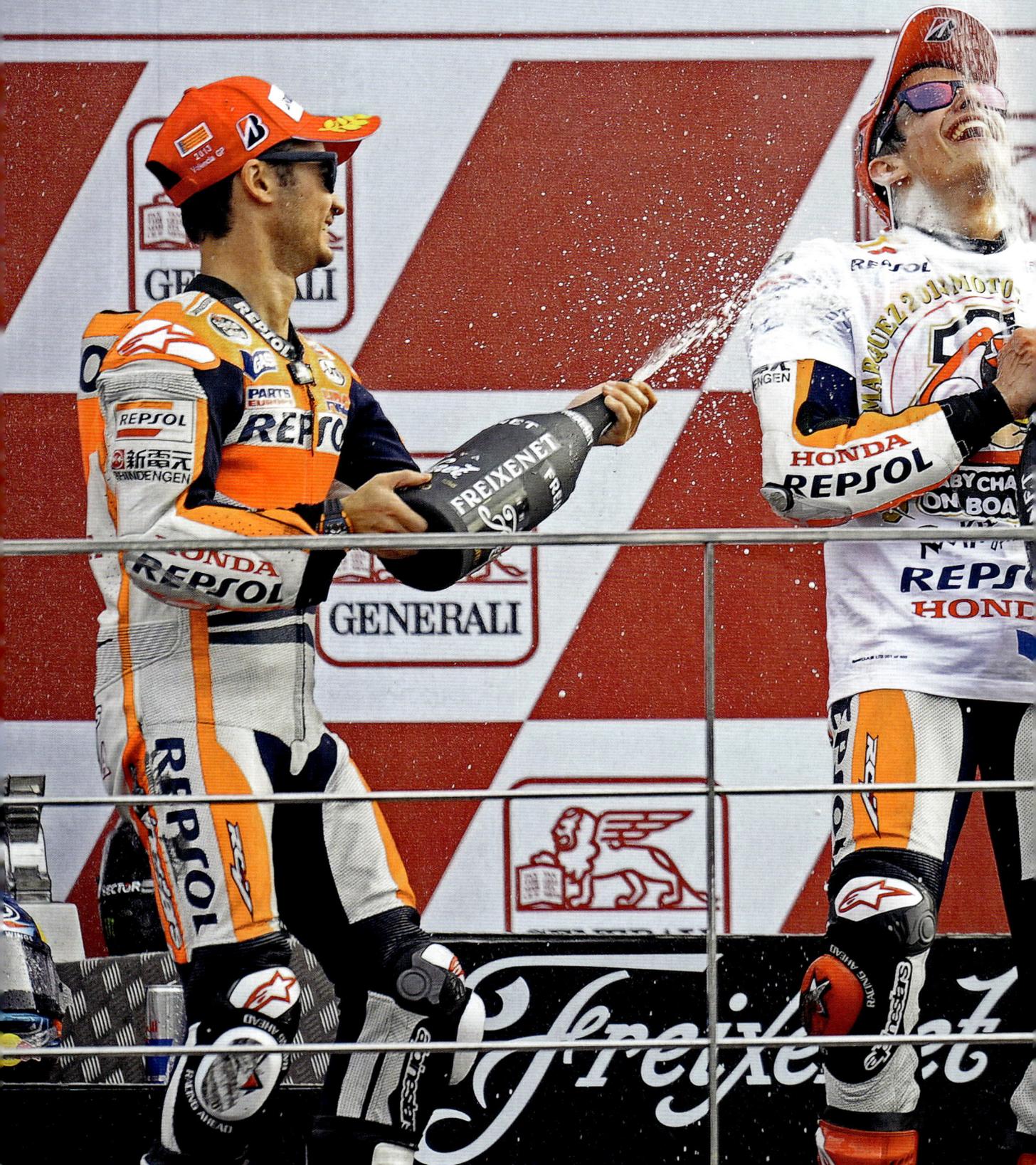

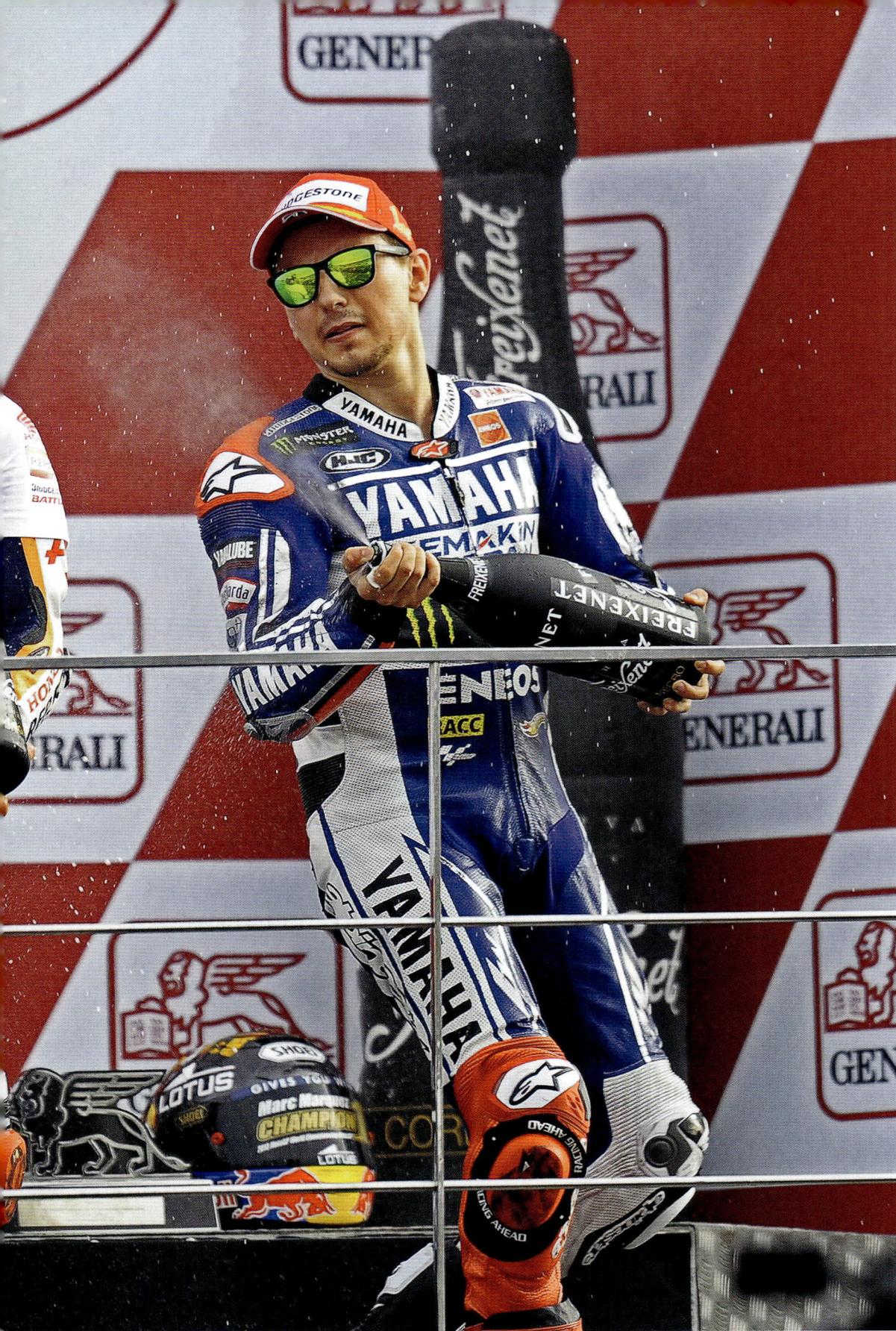

← Youngest MotoGP World Champion ever: Team-mate Dani Pedrosa and Jorge Lorenzo shower Marc after his title win in Valencia, 2013.

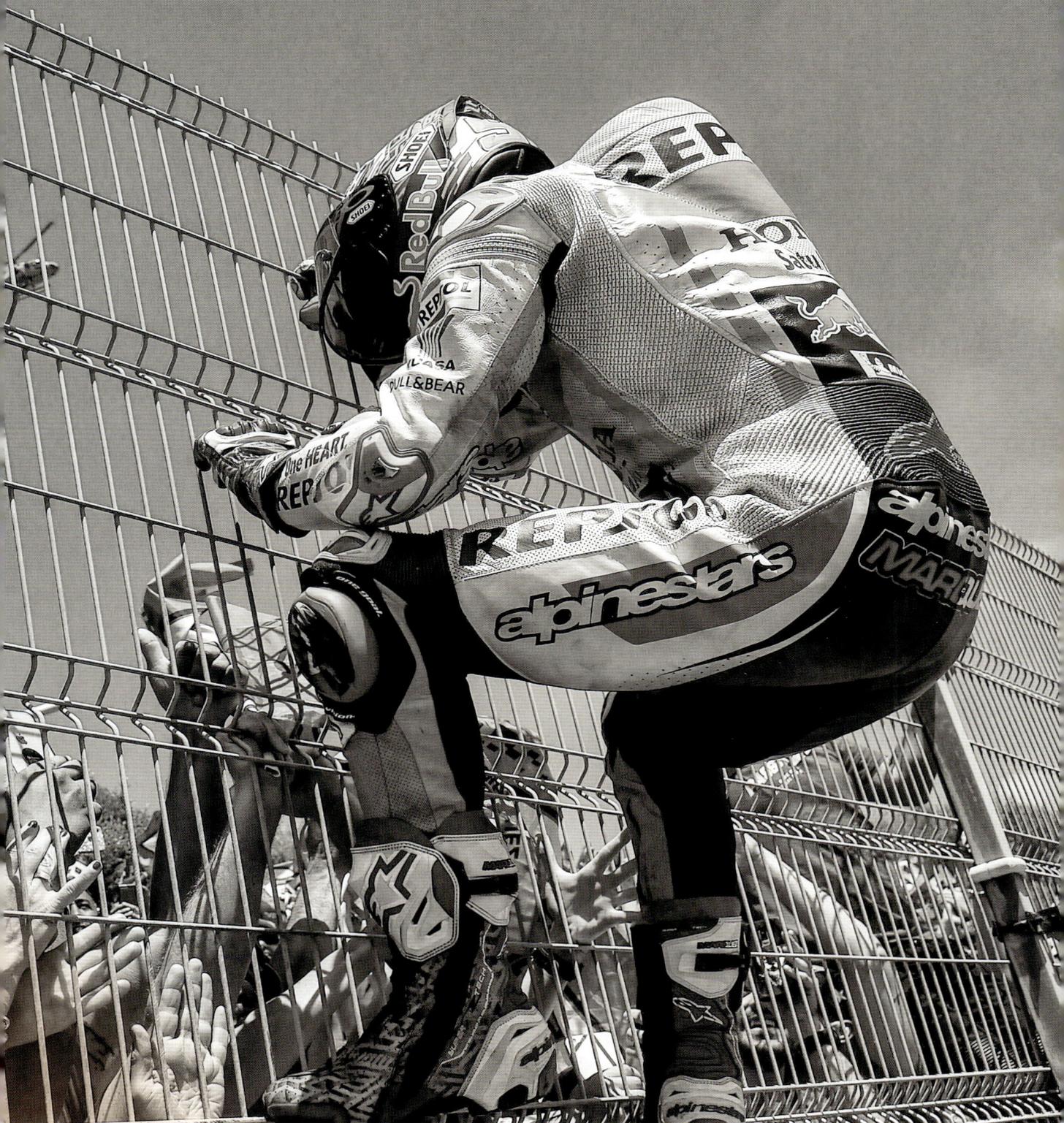

Grin and Bear it

The long road to the comeback, and how it changed me

The 2011 Malaysian Grand Prix in Sepang will forever be associated in the motorcycling world with the fatal accident of Marco Simoncelli, when the Honda of the charismatic Italian, with his frizzy hair and electrifying laugh, skidded out on a corner on the second lap of the race and was overrun by Colin Edwards, who was right behind him, and none other than his friend, Valentino Rossi, too. But on the Friday, the career of another great had come within a whisker of ending in the first free practice, in the most stupid, you could almost say negligent, way. Marc Márquez was in a dogged battle for the Moto2 World Championship with Stefan Bradl of Germany that year. Marc had lost many points at the start of the season due to his radical approach (crash or win), but later in the year he was making up ground on Bradl, who was more consistent than him, but slower. The German was three points ahead with two races to go. Malaysia would go some way to settling the winner and Marc was one of the first riders to take to a not-quite-dry track in the first free practice on his Suter. None of the track marshals had warned the riders about a small stream of water running across the track in one spot. Unprepared, many promptly crashed out there, including Marc in a particularly spectacular highside, hitting his head on the ground in the process. There was no obvious physical damage, so the reigning 125cc world champion tried qualifying again on the Saturday. The fact that he finished 36th out of 37 riders, five seconds off pole, clearly showed that something was very wrong. He had to withdraw from the race and the world championship was lost. And yet it was precisely this moment that revealed a facet of Marc Márquez's personality that would never have come to the forefront otherwise: the fact that he is a fighter willing to make greater sacrifices for his passion than most people could.

→
Even before his devastating crash in Jerez 2020, Marc's right upper arm has been his his most problematic area: Here after shoulder surgery with his physiotherapist.

Curve 8

I

nitially, I was angry, because I wanted to keep going and fight on for the world championship, but I couldn't. Frustration crept into that feeling of anger in the days after that, plus disbelief, because it had been such a stupid, unnecessary crash. It happened on my first lap out of the pits. No marshals had warned us about the water on the track. The first five riders on the track all crashed, including me. I tried everything in Sepang to keep my world championship chances alive, but after trying to qualify, struggling to complete three laps and end-ing up at the back of the field, it was clear that I was wasting my time. Before the final race of the season in Valencia a week later, with me 20 points behind Bradl, I visited doctors, physiotherapists and even faith healers, who promised to give me my energy back by laying their hands on me. Of course, none of it worked, but I didn't want to leave any stone unturned.

My problem was that the crash caused double vision. If I stared at a glass of water, my eyes saw two of them next to each other, and I didn't know which of the two to reach for. The technical term for it is diplopia. It was the worst injury I've ever had in my life, especially psychologically. You can't forget it for a second. It's there the whole time. It only goes easy on you for a few hours at night. The double vision was everywhere. On the TV. Forget reading! Driving was out of the question. Riding a motorbike unthinkable! You couldn't even go out to eat on your own. There is nothing you can do but let time pass. I was still living in my parents' house at the time and there was a TV to the left-hand side of my bed. Every morning, before I opened my eyes, I hoped that today would be the day when I would finally see a single red LED light at the bottom of the console. But there were always two.

Over the subsequent days and weeks, my mood changed. I had lost the title race, of course, because I couldn't even start the final race of the season in Valencia. Even Bradl crashing out didn't change that. The points he secured in Malaysia got him over the world championship finish line. At some point, I stopped being angry and frustrated and got more frightened. What if things stayed like this forever? Not only would I never be able to ride a motorbike again, I wouldn't even be able to live a normal life in this condition. So, no, things just couldn't stay that way! So we got to work…

We visited six or seven doctors to get diagnoses and treatment options. I ended up going with the first doctor we met on our odyssey, Dr Bernardo Sánchez Dalmau. At first he frightened me with his mercilessly open-ended prognosis. I would be in that condition for three months and then he could operate on my eye. Rehab would then take another two months. Only after that might I get my normal life back, but he couldn't promise I'd ever ride

a motorbike again. That's obviously not what you want to hear as a 19-year-old, and at first I hoped other doctors would hold out better prospects for me. I also dutifully did what they told me, but none of it worked. There was no avoiding an operation. So I went back to Dr Sánchez and his straightforward bedside manner. He is Spanish, but had studied and worked in the USA, and that affected the way he dealt with patients. His communication is crystal clear and he cuts out all sentimentality. He's brutally direct and frank. There's no, give this a go, maybe try that. He says it like it is. It would take three months for the eye to stabilise. Then he would operate. There are six muscles in the eye, and one of them was damaged in that severe crash. Each of these muscles has an antagonist muscle so that humans can look in all directions. The operation involves opening up the eye to weaken the antagonist muscle. It's a bit like adjusting an electric rear-view mirror by hand. OK, Doctor, if you say so... But what alternative did I have?

Before the procedure, Dr Sánchez asked me which direction was more important for me to see in, up or down? There would be a 30–40% risk of my having to accept limitations on that front. My answer couldn't have been clearer and it came to me in the blink of an eye, if you'll pardon the pun. The view at the top needed to be perfect again, because I'd need that when cowering down behind the fairing on my bike heading into the next turn. He was amazed at the answer, as the majority of his patients prefer tip-top vision below so as to avoid stumbling down steps or to be able to read better. No, I had other priorities.

My condition became worse than it had been, in the first weeks after the eye surgery, but Dr Sánchez had also warned me this was possible. I trained my sight for several hours each day with a special device that emitted light pulses.

"I know full well that the next massive crash could not only end my career, but also affect me for the rest of my life."

The training was quite exhausting, but very effective. Just as my doctor had said, the double vision disappeared, and my sight didn't just get good again. It was actually perfect.

I have the utmost respect for Dr Sánchez's work. After all, I was already world champion by then and a well-known face in Spain, and ideally I had a great career ahead of me. Some of the other doctors I had been to see suggested similar treatment, but they deemed the risk of operating on me too high. It was a lose-lose situation. If they made a mistake, my career would be over and it would be their fault. There was nothing to gain in it for them. If it went well, they would just have been doing their job. That's why I feel such respect and gratitude towards Dr Sánchez. He took on the challenge and didn't muse over what might happen.

The double vision reappeared after an enduro accident almost exactly ten years later, when I bumped my head against a tree, and then a third time after my massive highside before the 2022 Grand Prix of Indonesia. I immediately contacted Dr Sánchez again both times. He explained to me that hard knocks to my head could lead to this diplopia again and again. I guess I have to live with that. Although the operation I had in the winter of 2012 basically helps shorten rehabilitation times, there's still a chance I'll need another operation one day. He would be ready.

I like to have two plans. Plan A: the eye gets better by itself. Plan B: he operates. I'm a great believer in plans where proven experts are optimistic both will work. The time after my enduro crash, which brought me right back to the time after Sepang 2011, wasn't easy for me. Just because you've been through something before doesn't make the second time a cakewalk. The third time I had diplopia after the Indonesia highside only lasted a week, and the two red LEDs – to stick with that image – weren't as far apart as they

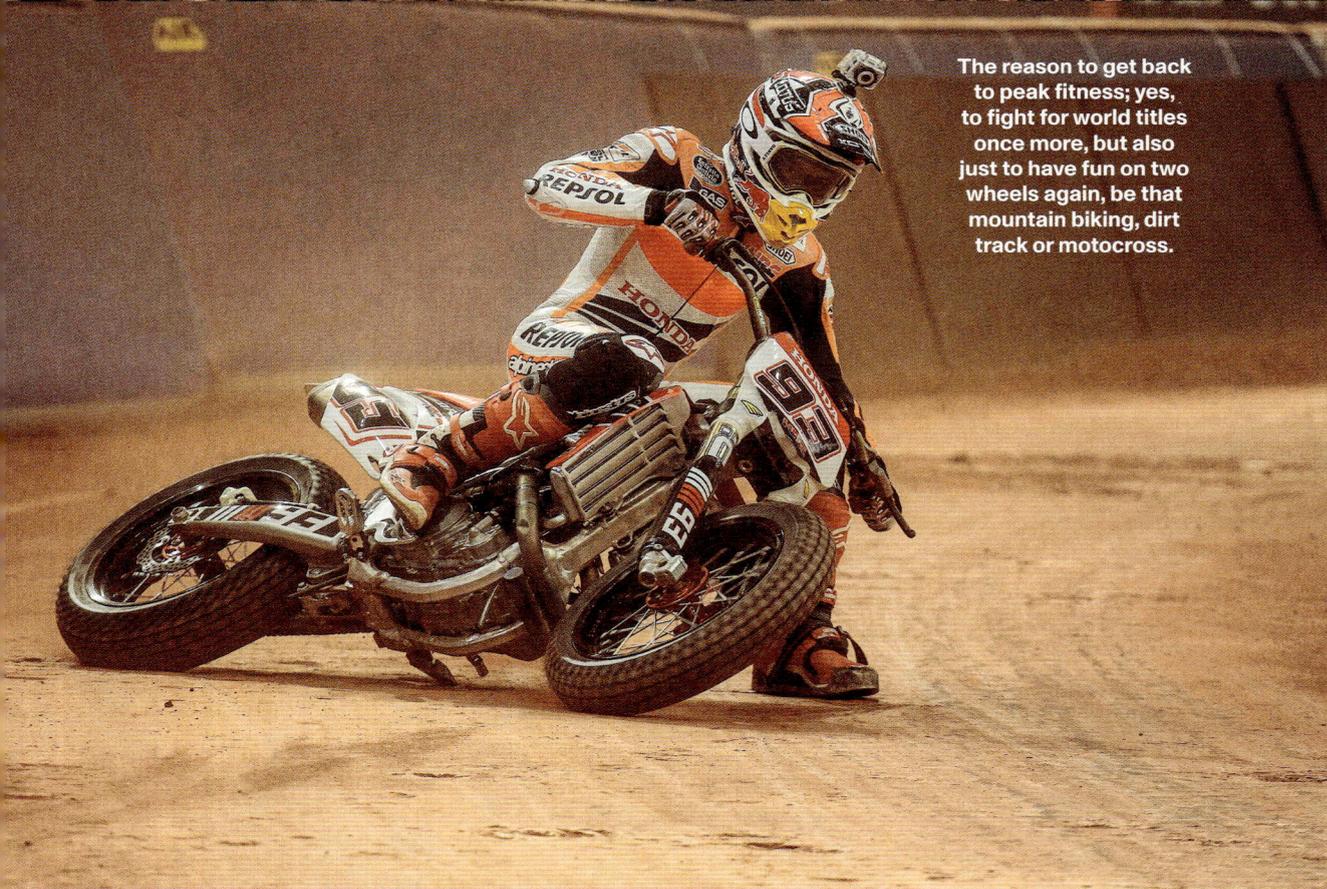

The reason to get back to peak fitness; yes, to fight for world titles once more, but also just to have fun on two wheels again, be that mountain biking, dirt track or motocross.

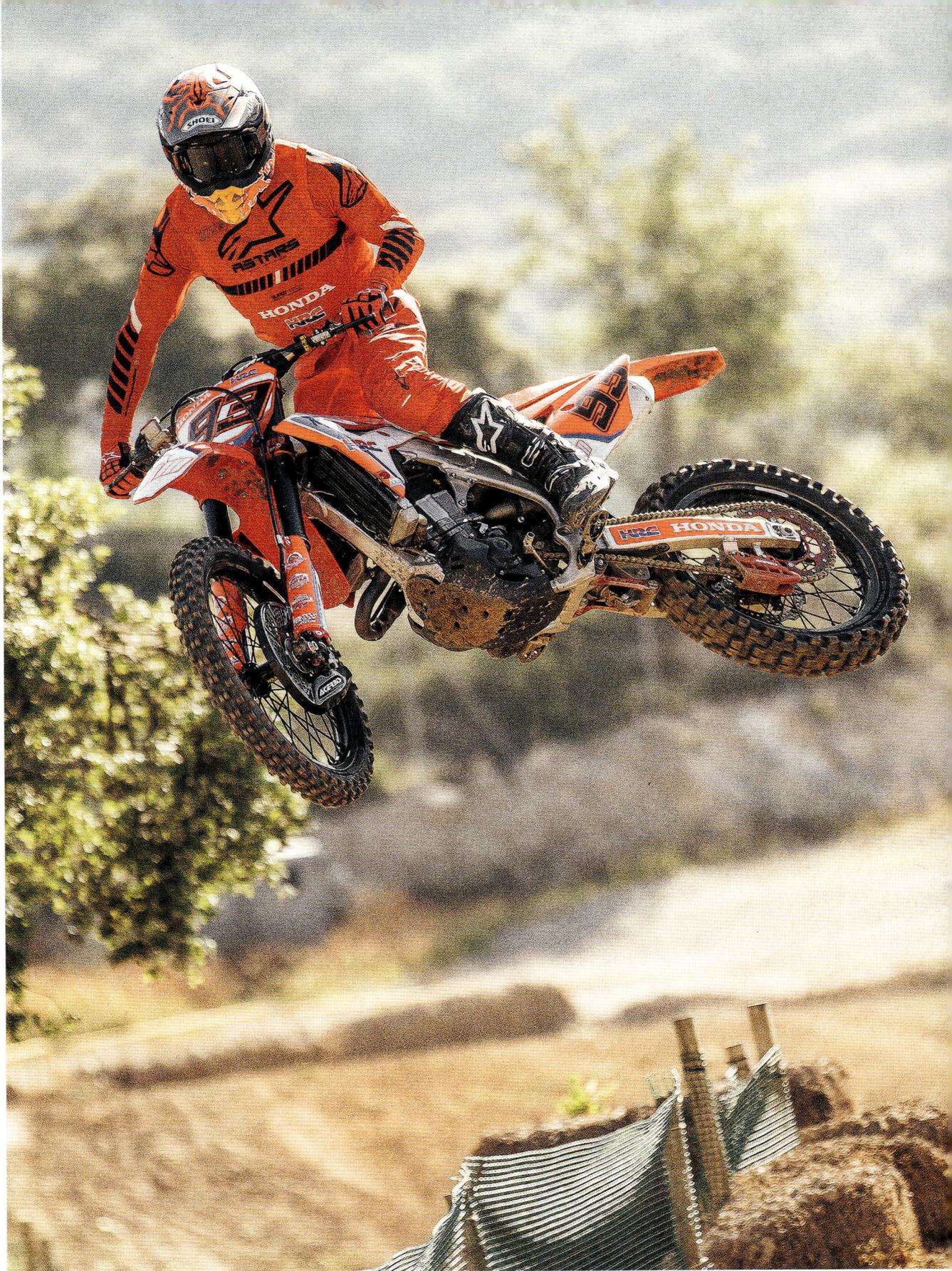

had been the first two times. So in that sense the third time was the least bad, but still, diplopia is something humans can do without; believe me.

I know full well that the next massive crash could not only end my career, but also affect me for the rest of my life. But I accept the risk because my passion for bikes is worth it. We MotoGP riders are like that. I crashed again and again in 2022, with my helmet striking the ground. That just can't be avoided. But really big crashes like the ones I had in Indonesia and enduro should be avoided as far as possible, i.e. crashes where I lost consciousness for a couple of seconds.

In all the years between my surgery in early 2012 and now, I've never lost contact with Dr Sánchez because when someone helps me as massively as he has, literally saving my career, then I'm all his. And it goes without saying that I also support his scientific projects financially. The amount – €100,000 – somehow went public, which I wasn't OK with. I didn't want to shout it from the rooftops. I was happy to donate that money for a cause, not to read my name in the newspaper. On the contrary! My sight is worth far more to me than that money.

In subsequent years, I met other people suffering the same fate via Dr Sánchez, such as Portuguese former Formula 1 driver Tiago Monteiro, whose diplopia was triggered solely by the high G force of an accident, not a blow to the head. Through my former team-mate Dani Pedrosa, I also put a Swiss skier who had suffered a crash in touch with Dr Sánchez. A Dakar racer from South Africa contacted me via a mutual acquaintance and I also sent him to Sánchez. The phenomenon of severely delayed eye or nerve injuries is more widespread than you think. When nerves get stretched in some way, they become inflamed. That affects vision – sometimes even smell or taste too, apparently – and it takes time for this inflammation to abate.

You can't ride a motorbike – especially not in MotoGP – without perfect vision. It is totally impossible. Any other rider will tell you the same thing. It made unqualified reports from journalists, who implied that I would get on the bike even if I was seeing double, all the more annoying. Can they see inside my head? You might be able to get back up again with a battered and bruised body, but not with impaired vision. That's why I used so much time and energy to get my vision back to 100% and only then did I get back on the bike.

I couldn't train before the 2012 season. I couldn't cycle, run or go to the gym. And I barely got on a racing bike either. I'd done a single test in Albacete, and another in Jerez when the season started. But I was absolutely convinced that I could either be world champion that year or at least fight for the title. This confidence came from the final few races in 2011, when I was easily the fastest. I was in the flow, and I wanted to get back there after my eye problems. I did that pretty well, because I won my first race back after the most serious injury of my life, the 2012 Qatar Grand Prix, and went on to be a clear winner of the world championship, even though the bike had sometimes been really difficult to ride.

Do I regret missing out on the 2011 title? No. Stefan Bradl was a deserving world champion because he scored more Moto2 World Championship points that year than anyone else. That's all there is to it. There's no such thing as an undeserving world champion. Everyone starts the season with zero points and we tot them up at the end of the year. Did Joan Mir deserve to be the 2020 MotoGP World Champion, even though he only won one race? Of course he did! Risk management is a factor when it comes to performance, a quality unique to a complete racer. You often have to take more of a risk to win, but you also need to know when it's too much. Some riders do it better, others worse. I've been looking at one of them in the mirror every

day in recent years. But for me, the extra risk worked out. I had to invest a hell of a lot, but I came out the richer for it.

Of course there are a few crashes in my life I would rather have avoided. Going beyond the limit too often at the start of the 2011 season, regularly ending up flat on my face and losing all-important points to Bradl was my decision and my mistake, so not a problem. The crash in Sepang, when we came to an impassable, dangerous spot with no warning, was bad luck. But I had been incredibly lucky that year just the race before, and in a situation I was solely responsible for screwing up.

The Australian circuit is one of the season's quickest. It's a rider's track, a ballsy track. Marc goes for it right in the first free practice, but crashes. The mechanics repair his bike and get him back out on the track by the end of the session. There isn't enough time to get a full practice in but Marc remains quick after the end of the session. Not race pace, but quick. The third, left-hand turn is one of the fastest on the track.

↓
Moto2 rivals: Marc and Germany's Stefan Bradl, now his test-rider at Repsol Honda.

Marc goes the long way round to overtake a rider crawling along on the inside. That meant he couldn't see Thai rider Ratthapark Wilairot on his FTR on his outside, who was shielded by the other rider. Márquez sees Wilairot too late and goes straight into the back of him. Wilairot ends up in hospital and Marc is banished to the back of the field by the officials for "irresponsible riding". On the Sunday, he charges his way through and finishes in third, just one place behind his world championship rival Bradl. It was one of young Marc's most legendary rides, a race like on PlayStation at the easiest level. The one small difference was Marc was up against the best riders in his category with the extra pressure of fighting for the world championship.

We did protest against the decision to put me at the back of the grid, because I drove much slower in the run-out lap, a full gear lower than I would normally have done. And yet the accident was down to me, of course. I was riding too fast in that situation. And I was lucky. Very lucky. I was almost uninjured, got to participate in the race and at least do some damage limitation. The fact that I was then really

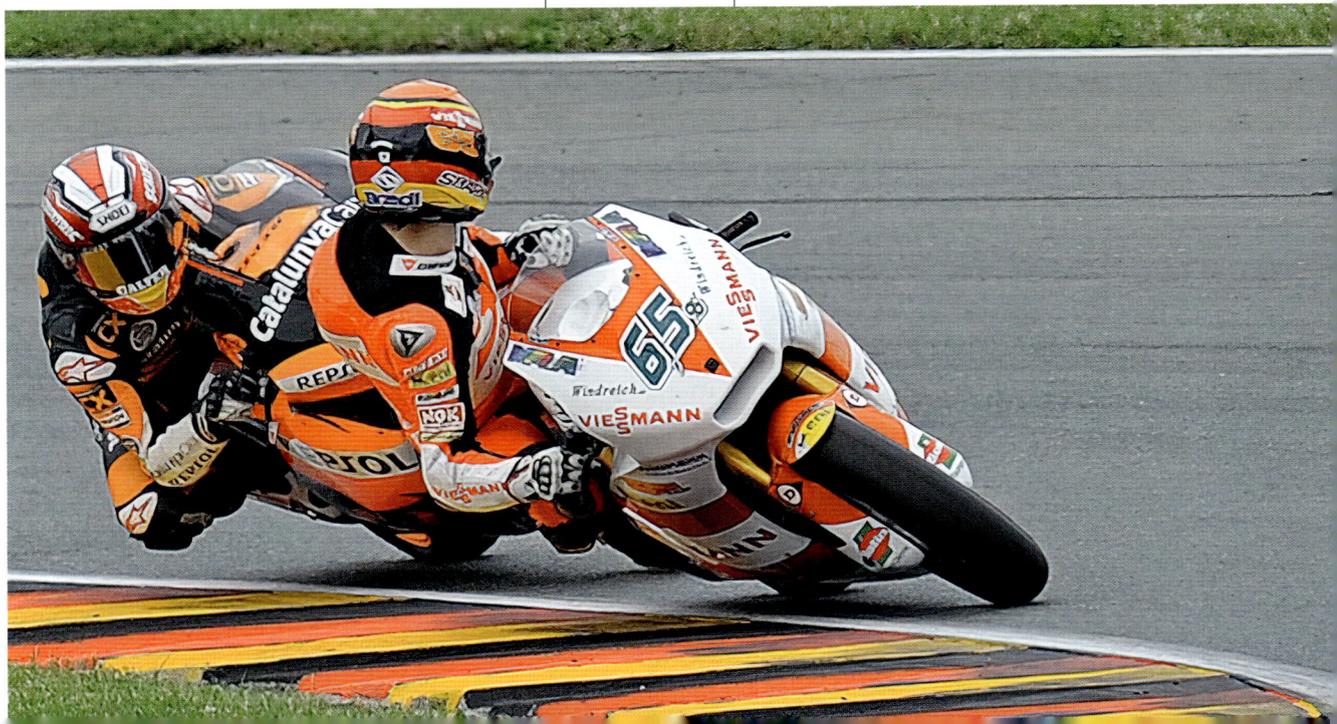

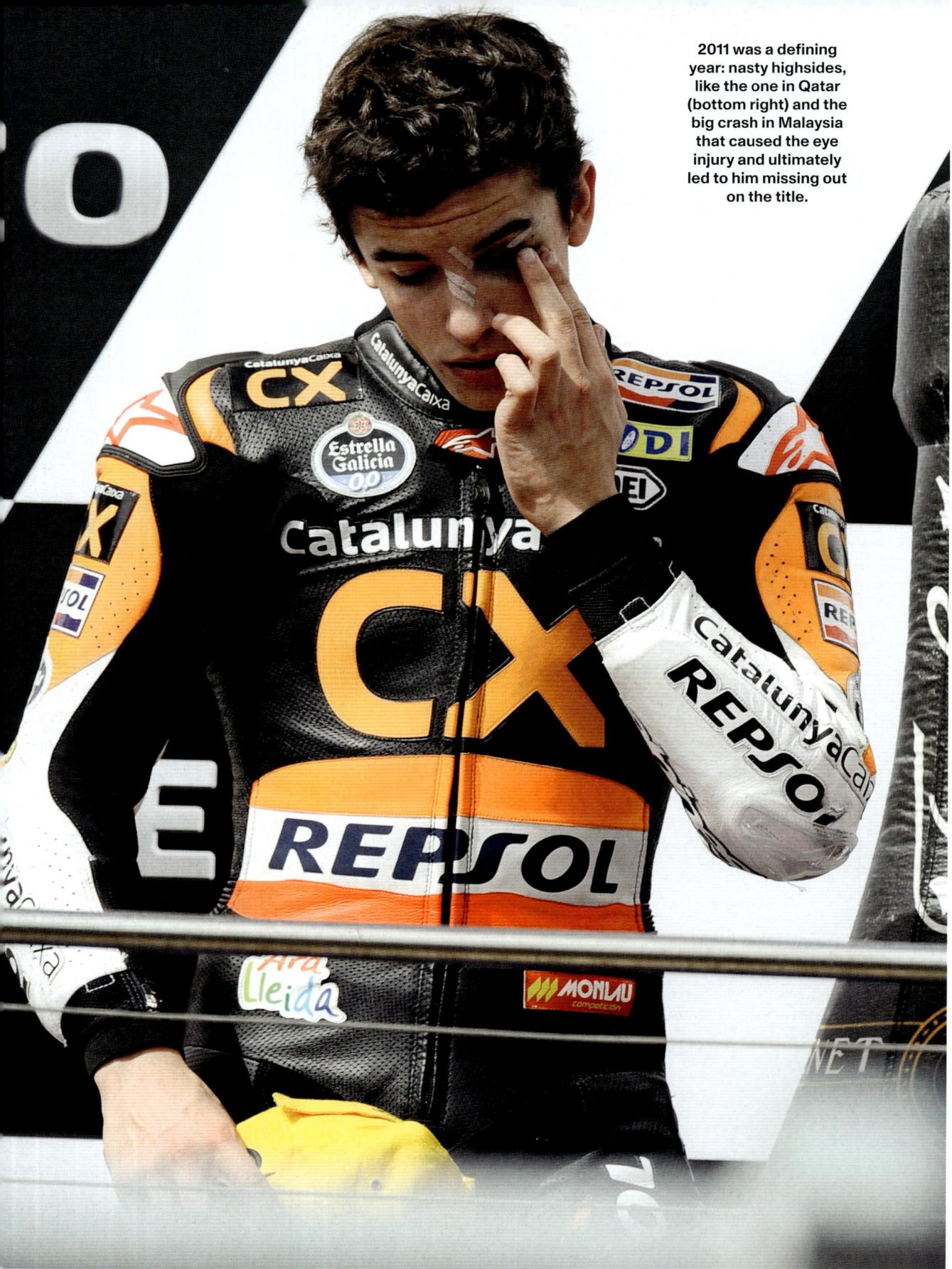

2011 was a defining year: nasty highsides, like the one in Qatar (bottom right) and the big crash in Malaysia that caused the eye injury and ultimately led to him missing out on the title.

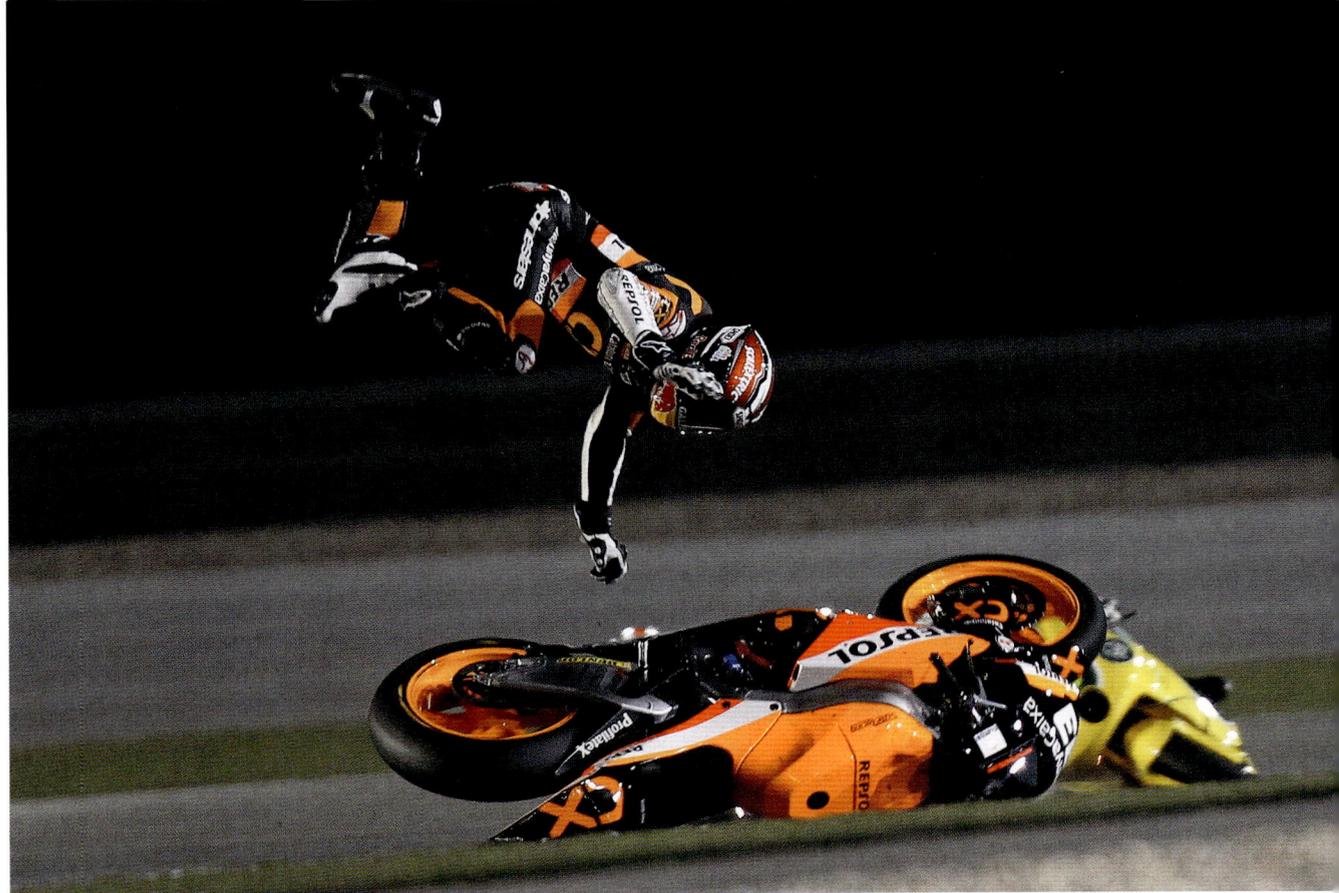

unlucky in the very next race and would miss out on the world championship is another story. In our sport there is good and bad luck, but not every crash is down to bad luck. If you take things to the limit, you're going to crash. That's to be expected. Some crashes just turn out worse than others, and it's not always the worst crashes that end badly. One such crash would have a lasting impact on my career. I mean Jerez in 2020, of course, when I broke my right humerus in a not particularly dramatic crash.

Due to the Covid pandemic, the MotoGP season had started later than ever. The lower motorcycle categories had got the season under way in Qatar as normal as they were already there for pre-season testing. MotoGP riders had to wait till the summer for the season to finally get started, and in front of empty stands, of course. The Spanish Grand Prix in Jerez was wild, even for MotoGP. It was particularly wild for Marc Márquez, even by his standards. He had dropped back into the last third of the field after an early error, whereupon he started to claw his way back in a way only he could. In the laps after his mistake, he overtook his opponents in every conceivable way and demoted the best motorcyclists in the world to mere extras, able to marvel at his magic from front-row seats with room to spare. Four laps before the end, he was already in the top three and closing in on the Yamahas of Viñales and Quartararo, at which point his rear wheel promptly broke off on turn three. Highside, into the gravel. By the time all the kinetic energy had dissipated and Marc got up onto his knees, shocked TV viewers understood there was something wrong with his right arm.

Jerez, 19th July 2020

Basically, it was a highside the likes of which I'd experienced dozens of times. The difference this time was that I flew off and the bike was coming in behind me. As a rule, the bike goes flying forward and is therefore out of the way. But not this time. I rolled in a pretty unlucky way and the front wheel of my motorbike must have hit me on the arm. You usually see this sort of crash in motocross. It was just bad luck.

I knew straight away my arm was broken. My motorhome was still parked in the paddock, but I spent the night at the circuit hospital. The pain was severe, even with medication. I slept – or rather didn't sleep – sitting up with my right arm in the air. An absolute nightmare. The next day I flew to Barcelona, where Dr Mir operated on me and bolted my arm together. I felt brilliant immediately. There's a reason Dr Mir is the go-to surgeon among us motorcycle racers. He had Jorge Lorenzo back on the bike with a broken ankle a few days after his crash, even though he had to get to the bike on crutches. We thought of him as a superhero because he had taken such a risk and got Lorenzo back up and running so quickly. The fact that Jorge crashed at the next race in Germany and broke his ankle again is another story.

We always ask the same first question when we come round. "When can I ride again?" Dr Mir said it might not be completely out of the question for me to take part in the next race a week later, if I felt physically up to it. It was on the same track in Jerez, though this time it was the Grand Prix of Andalusia. At the time, which was peak Covid, we were just glad that the season had started in July at long last. We would have been happy to race on the same tracks more often. To prove to Dr Mir how ready I was for the race, I did a few push-ups in my hospital room right after surgery, and it felt good. When we riders see the slightest chance of being able to compete in the race, we take it.

You couldn't think any other way. At least, I couldn't. I really turn into an animal that no power in the world could restrain. If it turns out in the course of a race that I'm actually not up to it, then I can deal with that. But I wouldn't be able to sleep if I hadn't tried.

But I'm not naive either. That time, I had to be sure my humerus would hold. "Definitely," the doctors said. "We've put a titanium plate in for you." Marc the cyborg... I kind of liked that. I took a flight from Barcelona to Jerez and was back on the Honda five days after my accident. On the Saturday, I hit the tarmac with a lap time of 1:37.8 minutes, which I didn't get anywhere near in 2022! The pain was bearable too. On the Sunday, I had to withdraw from the race but only because so much fluid had accumulated in my elbow that I could no longer move it. There's no point wanting to ride a MotoGP bike if you can't move your elbows. I didn't have any feeling in the fingers of my right hand either and I need to use them for the throttle on my Honda RC213V. I was sure

I had given it my all, that I had really, really tried, so I flew home feeling good.

I had two weeks to get fit again for the next race in Brno. I used them – having consulted my doctors – for intensive training and specific rehab in the mornings. I got up at seven, worked on my arm for an hour, had breakfast, and went to the gym at nine to start my normal workouts. On the Monday morning of race week, I opened a sliding door with my right arm to start my exercises. I heard a definite crack. Damn it! I woke up my brother and physio and told them what was all too clear to me: my arm was broken again.

Both the doctor and physiotherapist said, "Impossible! Titanium doesn't break!" "It does," I went on. "Please, wiggle my upper arm. It's broken, I'm telling you!" The surgery with Dr Mir had gone perfectly. The X-ray showed that all the screws were indeed in the right place. But the titanium plate had split! My intense training had worn it down, like a credit card getting bent over and over again. There is a reason why broken bones are usually left to rest. But if

↓
Medics remove a clearly suffering Marc after his crash in Jerez.

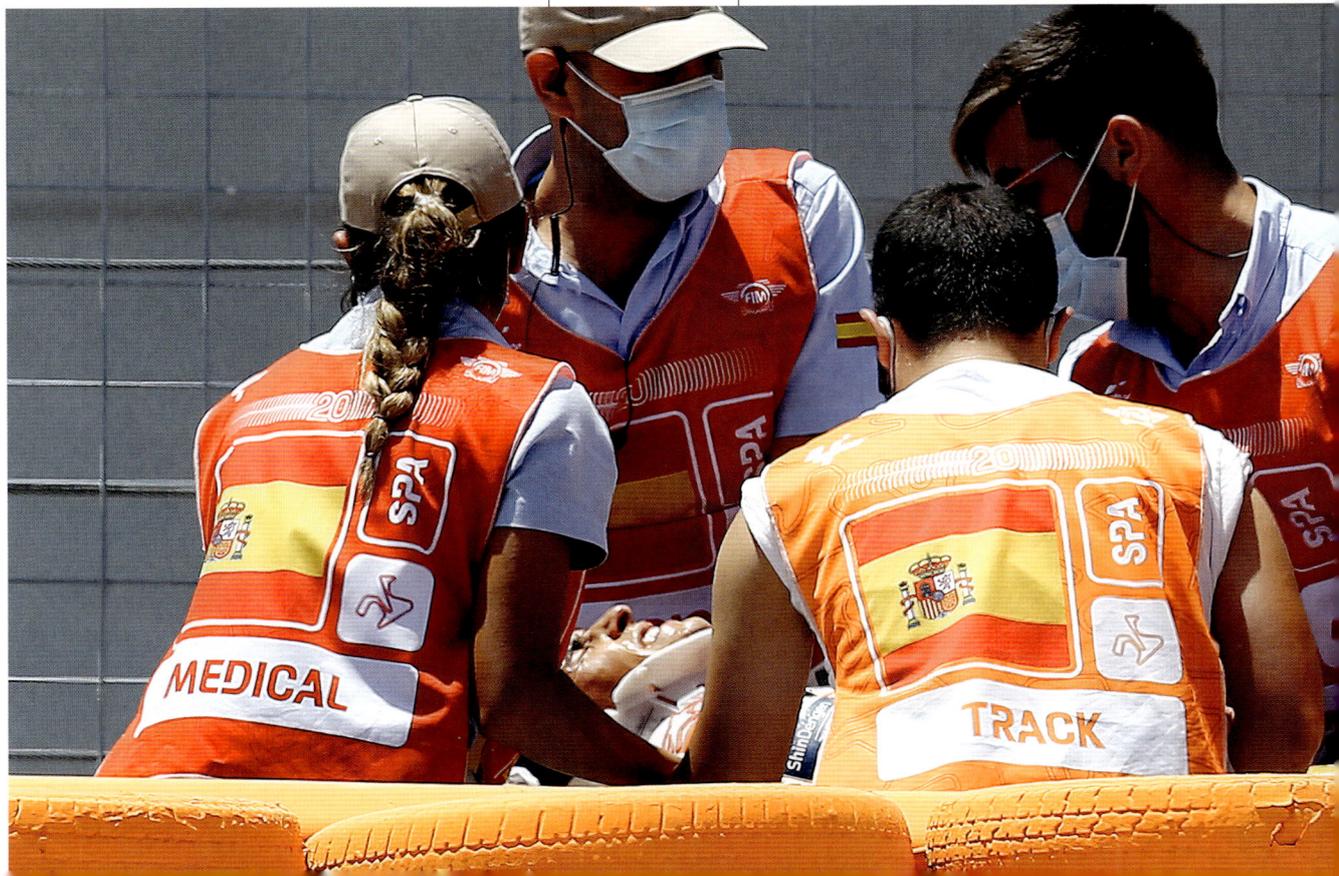

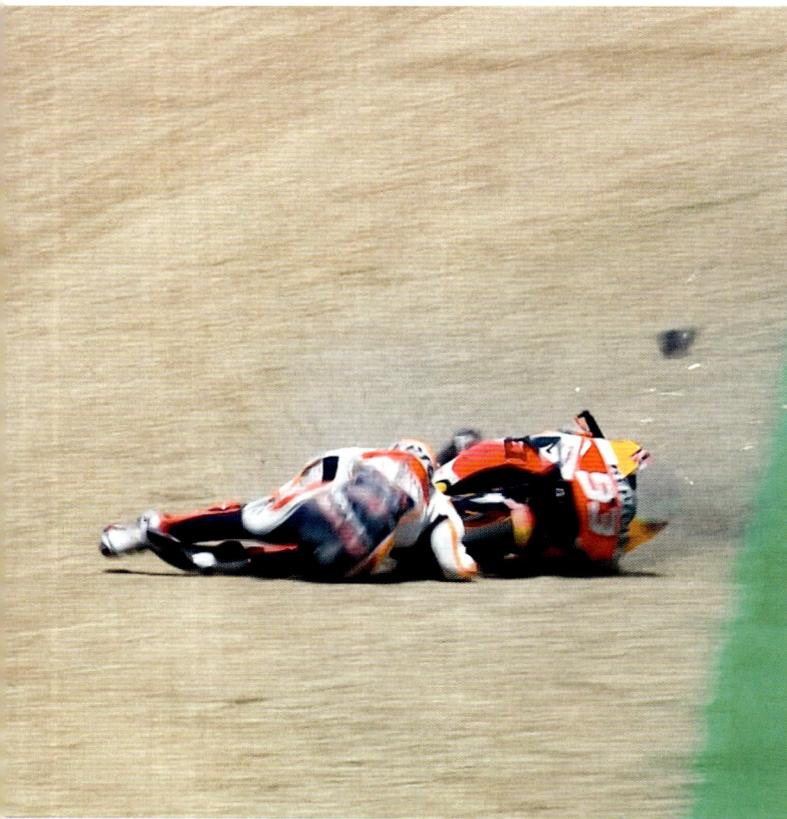

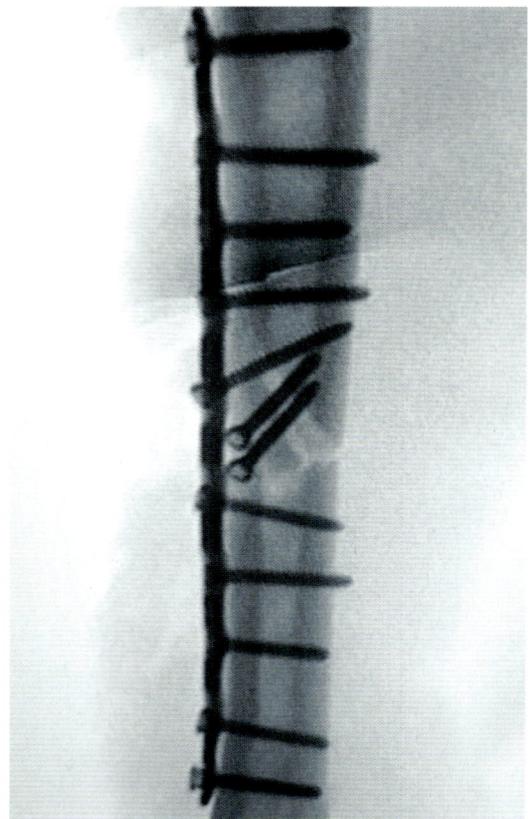

you have a chance to ride in MotoGP again the next weekend... Well, you know.

The fact that the plate broke on the Monday turned out to be a blessing in disguise. My flight to the Czech Republic was booked for the Wednesday. If my arm had held out for another two days, I would have got on my bike at the Brno Grand Prix. And my arm definitely wouldn't have withstood that strain. I would most likely have crashed badly that race weekend, and on one of the fastest tracks on the calendar. So at least that didn't happen and yet my nightmare had only just begun. Now they had to bolt my arm together again. It was time for operation number two.

This time, unfortunately, there was a problem with a bone fragment that had to be replaced with foreign material, a kind of bone cement that promptly got inflamed. Those were long, very painful days. There was no question of a comeback. A third operation was needed to get

↑
Video evidence: it was the front wheel – not the seat – that split Marc's career in two. As it did to his right upper arm.

→
Trying to get his swollen elbow to work: ice bath at the Misano test, 2022.

my totally inflamed arm back in shape. Part of the bone was replaced by a piece from my pelvis. An artery from my knee was also transplanted into my arm. The doctors were worried whether all this would actually work as it should in an ideal world. The worst-case scenario would be having to fix my arm with screws externally using a frame. The forecast was for at least six weeks in hospital, and a rehabilitation period of one-and-a-half years. That made me very cautious, because there was, after all, a not inconsiderable risk that this whole process would damage my radial nerve and I would have to deal with long-term limitations. Fortunately, this third operation, carried out at the Hospital Ruber Internacional in Madrid by Drs Samuel Antuña, Ignacio Roger de Oña, Juan de Miguel Sáenz, Aitor Ibarzabal and Andrea García Villanueva, went very well, technically, and yet I was unlucky again. My newly restored arm had been put back together somewhat crooked.

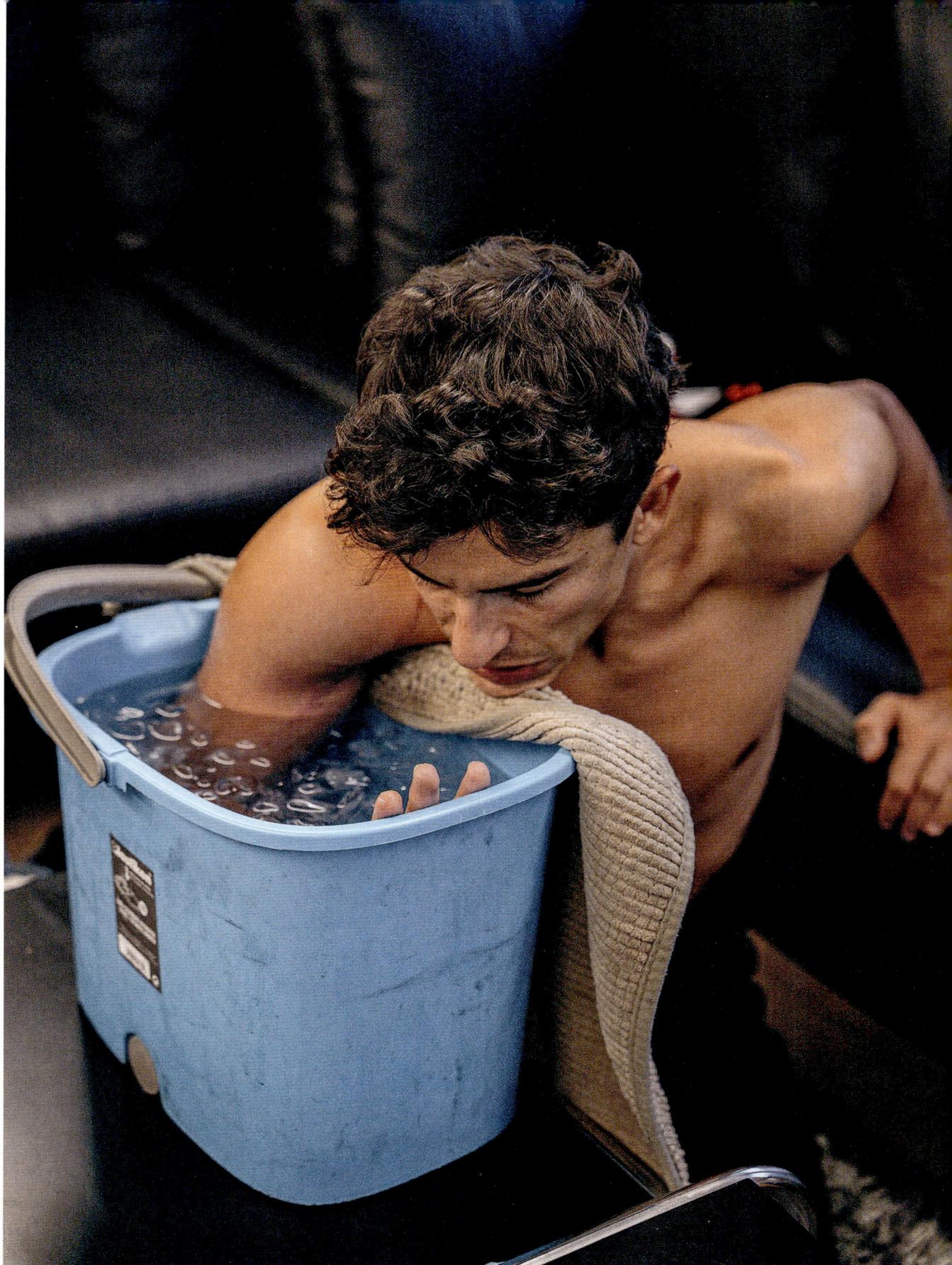

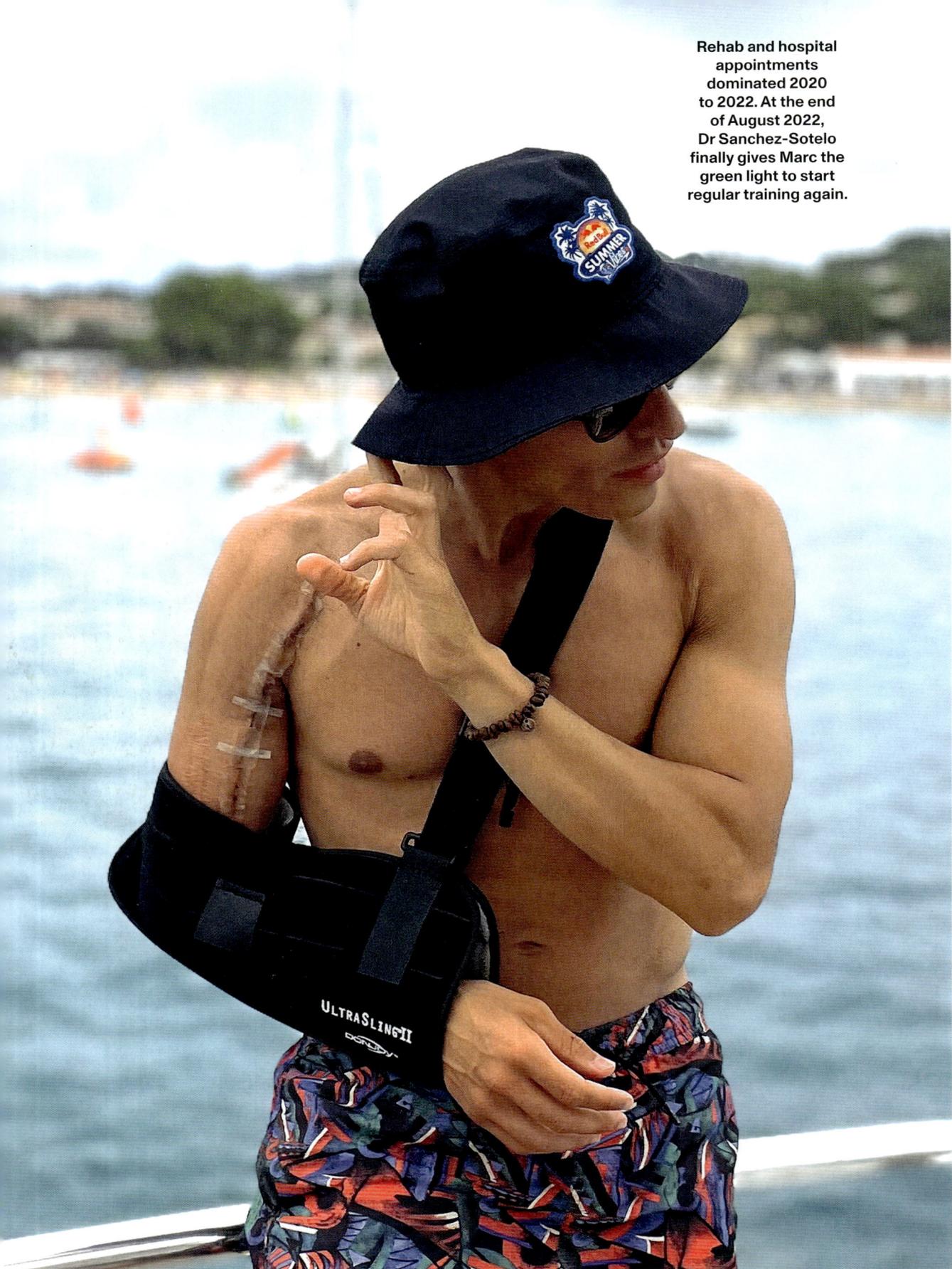

Rehab and hospital appointments dominated 2020 to 2022. At the end of August 2022, Dr Sanchez-Sotelo finally gives Marc the green light to start regular training again.

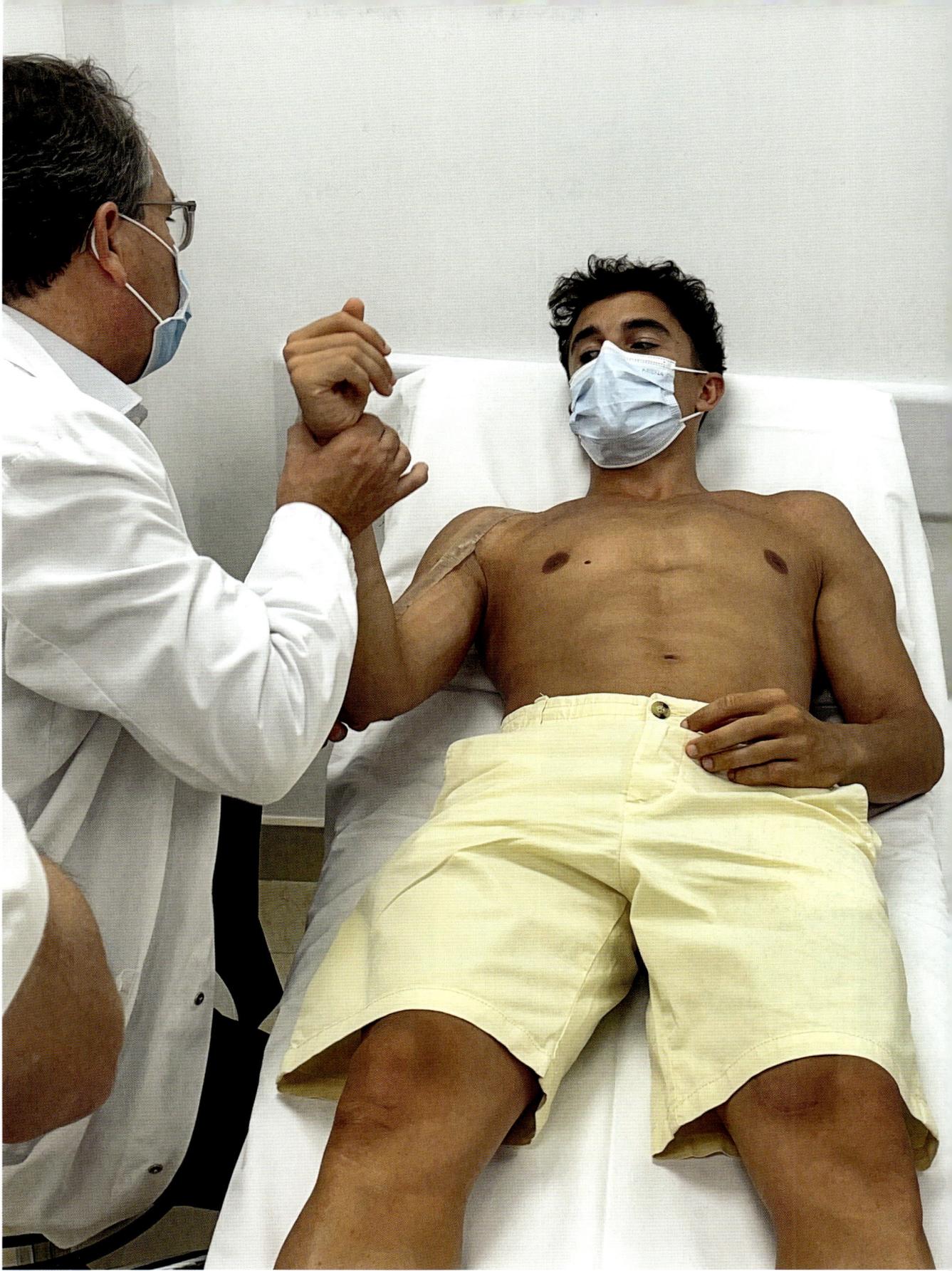

How could that happen, one might be forgiven for asking, angrily, but it was simply because the inside of my upper arm was so damaged by infection that the doctors didn't have the correct points of reference. I had also had shoulder surgery at the end of 2019, so my upper body was still slightly off from that too. The doctors did everything they could under the circumstances, but I reached a point early on in my rehab where I wasn't getting any better. At first they tried to comfort me, told me to be patient. I hadn't trained for almost a year as it was. Then, things didn't just stop improving. They got worse. I still rode in MotoGP but I was way off my normal form. The pain got worse and worse. I had to find out what was wrong. I couldn't carry on like that in the long term. I finally got an explanation. My upper arm must have got twisted. Through 10°, maybe 15°, the doctors estimated, though 15° would be a lot. A twenty-degree rotation would basically render you incapable of conducting your day-to-day life. In my case, the arm had rotated a full 34°! No wonder I could barely ride in MotoGP with it.

At least we now knew where the problem was. I consulted the physician Dr Joaquin Sanchez-Sotelo of the Mayo Clinic in Rochester, Minnesota, through my specialists in Spain. Dr Sanchez-Sotelo didn't know me or what I did for a living when he said that you can't even clean windows with an upper arm twisted through 34°. I told him I rode motorbikes, but pretty miserably at the moment. I had to try to compensate for my upper arm healing with this deformation with shoulder movements but, firstly, that only worked to a limited extent and secondly, it would lead to other problems, especially on the bike. It wasn't just that my arm was twisted, I was also sitting in a crooked and unnatural position. The shoulder was the first thing that started hurting because it was overcompensating so much. That pain soon then spread throughout the arm. If you look

at photos of me from back then now, you can even see through my leathers that my position is unnatural.

In the US, they severed my humerus and rotated it outwards back into its original position. The mechanical problem which had limited my mobility and that, obviously, no amount of physiotherapy was going to cure, was now resolved. The improvement in function was noticeable immediately. If I'd wanted to drink a glass of water beforehand, I had to stretch out my entire arm. It was the same thing with eating. My mechanics really noticed it of an evening. No one wanted to sit on my right anymore because they knew they'd get my elbow in their face! I only realised how warped and screwed up the whole thing was by getting feedback from others, because if the hands are basically where they are meant to be, you don't notice how far off the rest of the arm is.

But having my arm put back together mechanically didn't spell the end of my problems. Because I hadn't been able to move my arm correctly for almost two years altogether, some muscles had well and truly perished. Rehab usually takes three months after that kind of operation. Then, the muscles should be back to their former glory. Not in my case! I could race again, but if I'm honest, it still wasn't going the way I wanted it to, because some muscle parts just didn't work the way they were supposed to.

"My character changes depending on whether I can ride a motorbike or not. I need the adrenaline. Desperately."

Let's put this in perspective somewhat. When Marc made his comeback at the 2022 Aragon Grand Prix after a three-month break in which he had missed six races, he was immediately faster than his team-mate Pol Espargaró. By the start of the race, his rivals had all realised that the old fighter Márquez was back.

He positioned himself well and, while coming out of the third turn, tried to close in on Enea Bastianini and Aleix Espargaró, who had just touched each other. Marc caught a small slide as he accelerated, but it caught Fabio Quartararo, who was glued to his rear wheel, off-guard and lifted him into the air spectacularly. Four corners later, Marc came into contact with Honda brand colleague Takaaki Nakagami, whereupon he had to park up his damaged bike. Not the comeback you want, but in the very next race, in Japan, no less, in front of tens of thousands of Honda fans, Marc had his RC213V in pole position. The next highlight sees him back on the podium with a second-place finish in Australia. It goes without saying that, despite his physical limitations, Marc was the fastest Honda rider in the field.

My main task for the winter of 2022/23 was, with my physiotherapist, to bring back to life as best I could those parts of my muscles which had virtually died. A good physio and a motivated athlete can make a big difference through hard work in that area. I am very pleased with the way things stand as of the start of the 2023 season, but I know that there is more to come. I can still improve the function in my right arm. I believe that my body as it is will let me move a MotoGP bike well and quickly. But my goal is to be able to move my bike better and faster than everyone else. Much faster. What I aspire to is to make a difference as a rider again. That feeling did come back in the last few races of 2022, but my benchmark is the Marc of 2019, when all the other Hondas in the race were at least 15 seconds behind me. That's where I want to get back to.

To get back to where I was, outperforming all my opponents with my riding, I need to be able to bring my riding style to the track, and that style is very physical. I am all too aware that my right arm has been operated on four times and will probably never work as well as my left one, but I want to get as close to that as I can.

My character changes depending on whether I can ride a motorbike or not. I need the adrenaline. Desperately. If I don't get it, like in the winter of 2022/23, when I gave my arm all the time in the world to heal completely and made sure just to get it back to where it had been, I become completely unbearable. It ended up with my brother, Álex, telling me to go out and find a girlfriend, or do something else to keep myself busy, because I was unbearable. I was like a caged tiger.

Your willingness to take risks is different depending on whether you're 20 or 30. But my willingness to take maximum risk, if I have to, remains unchanged. Now I think about things more precisely when I take it to the max. I used to think my body was made for racing. Now I say if I don't look after my body, I won't be able to race. It's a small but crucial difference. Risk management is new to the Marc Márquez system. Is it really necessary to take as much risk in the first free practice session as in qualifying? In the past, I treated every outing on the bike the same: all in. Now I'm fine with 12th place in the first free practice. That wouldn't be the case in a race, of course. There, even third wouldn't be good enough.

My instinct is to attack! I have to learn to rein myself in, which I can say easily here and now without a helmet on my head or a bike under me. To date, I have wanted to win every race of my career. Every single one. Win or lose. Nothing in between. I am now so at peace with myself that it's OK not to win every time as long as I'm getting closer to the main goal, which, of course, remains utterly unchanged: winning the world championship. They say you don't have to win every battle to win the war. That's how I'm trying to do things now.

No one knows how my career will develop after these two tough years and my nearly retiring. If I were to become world champion again, it would be by far the most valuable title of my career. So far everything has been sweet. A few crashes, but everything has been relaxed, been easy. I've got over double vision. The rest – the minor operations, the injuries – is all part of being a MotoGP professional.

Last year was the first time I mentioned possibly retiring to my father and my friend, José Luis Martínez. The bad thing was that the passion was still there, but there was a risk my suffering would get worse. The idea of not being able to stop voluntarily, but to be forced to retire due to pain while the fire for racing was still blazing brightly within me, was tearing my heart out. To have got out of the slump and perhaps make it back to the top… That would make every new world title so much more meaningful than all the other eight I've won so far.

I don't know what that means to my fans or to MotoGP fans who haven't supported me in the past. Perhaps my life of suffering will bring me a little closer to them. Every life has its low points and they may now identify more of themselves in me, see that I'm just a normal person and not the superman everything comes easily to or perhaps the one who steals victory from their favourite riders all the time. I am aware of the fortunate situation I am in, and basically was still aware of that during these two years, which were all about my arm function and career. If I were to retire today, I would have no money worries and a life ahead of me. I don't want to trade places with a single-parent father who has just lost his job. He's worse off than I am.

But I have suffered. Maybe people will see that and respect me more, as a person like they are, not just as a dominant racer. I've had a lot of time to think in the last couple of years, about my past too. My life was like a rocket. I only ever lifted off, flew, ever faster, ever higher, up towards the light. It was a wonderful trip, but I thought it was normal. My injury helped me realise that my life was the exception, that reality is completely different. I've understood a lot of things. My friends notice that I've changed too. In the past, when I called, their first question was, "Hi Marc, what do you need, what can I do for you?" Now we just talk and I ask them, "Hi, I just wanted to know how you are." This is new to me, and it feels good to be more social. My life isn't now solely about bikes, about performance, about improvement. You can do other things too, just for the sake of it.

Every good heroic story needs a crisis, a low point, but this isn't a heroic story. It's my life. What happens next is still to be written. I could have another big crash and go through the whole ordeal again, because my passion for motorbikes is so huge. Maybe everything will be as simple and fantastically successful as it was up until 2019 or completely different. No one knows. My goal is to win and fight for podium finishes again. That would mean success. My dream is to be world champion again. And for that, I will continue to give it my all for as long as I am as passionate about racing as I have been all my life. My all.

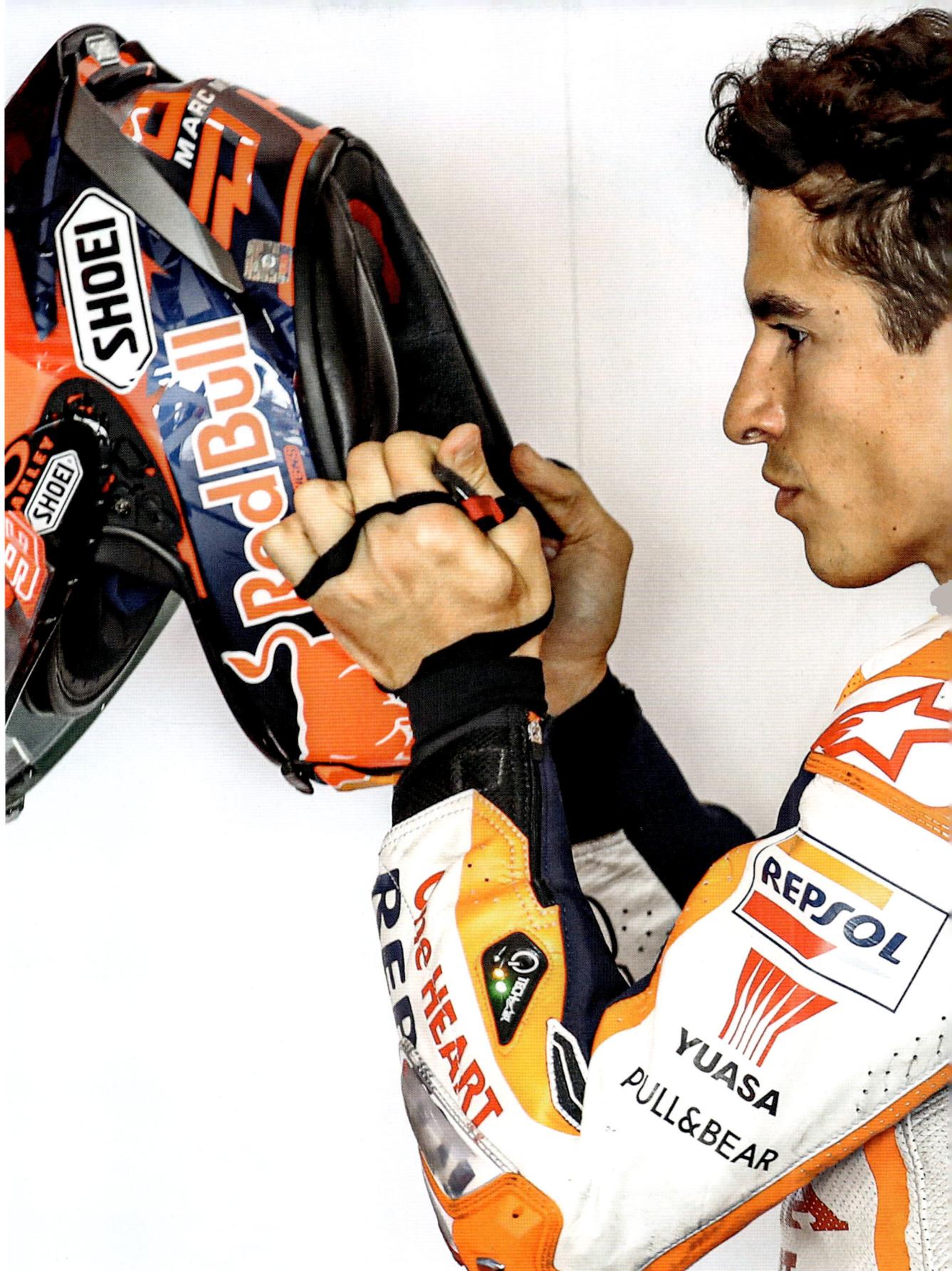

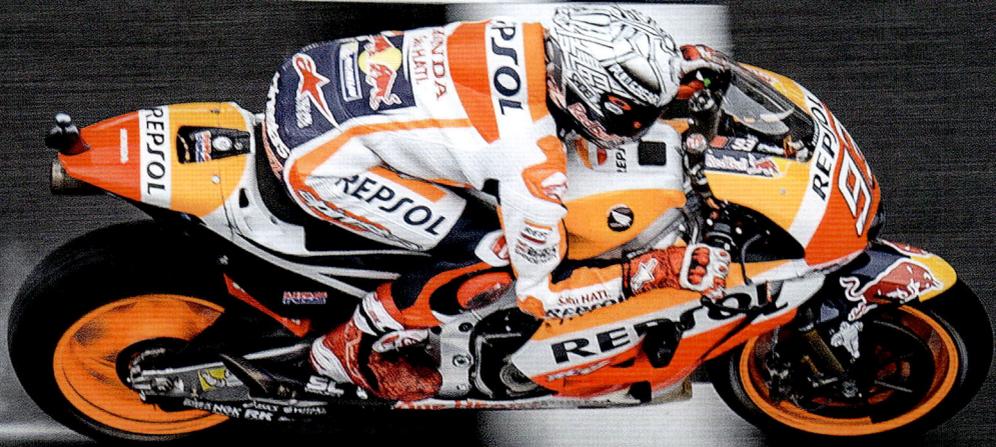

Curve 8

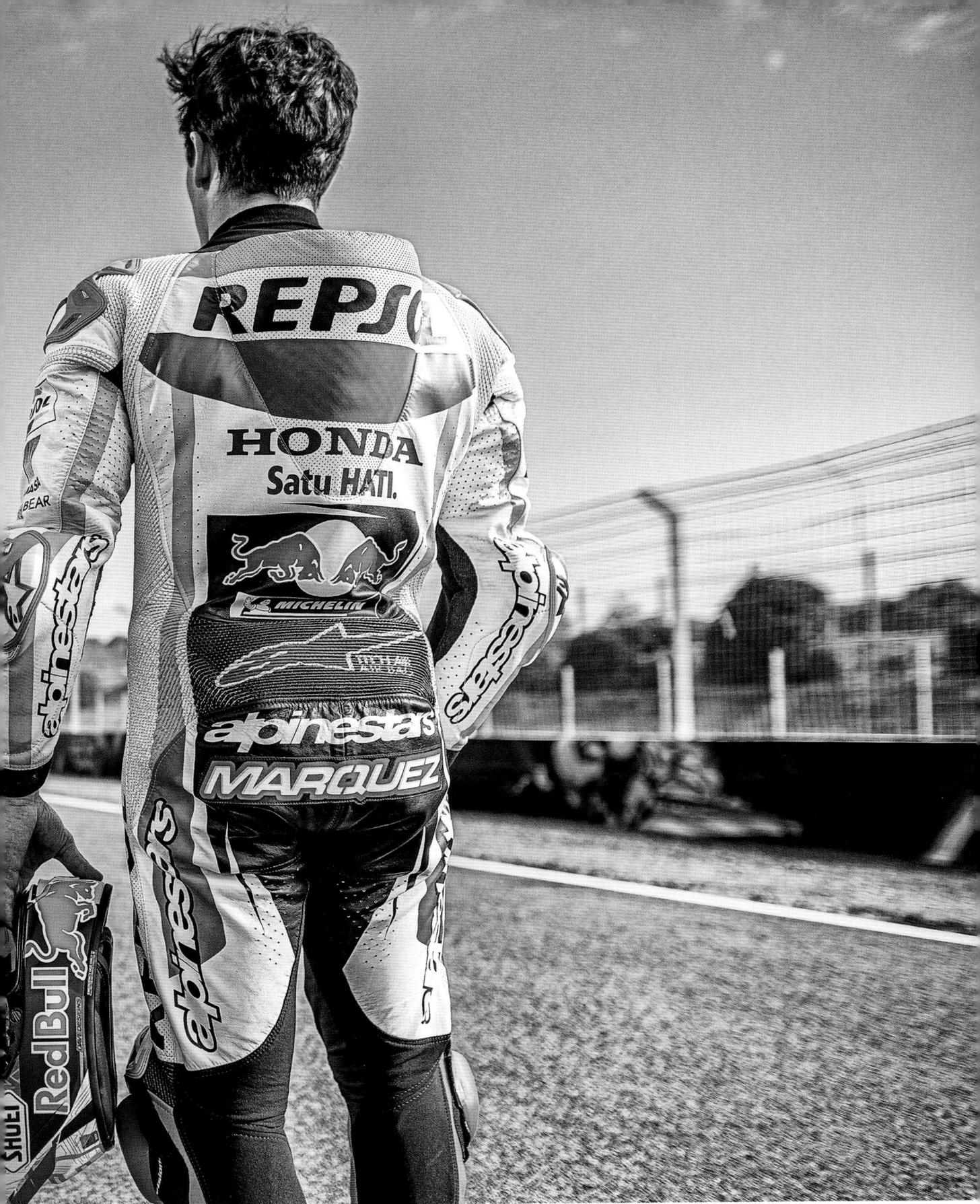

All motorbike
world champions
of the premier class

Year	Rider	Bike
1949	Leslie Graham, GBR	A.J.S.
1950	Umberto Masetti, ITA	Gilera
1951	Geoff Duke, GBR	Norton
1952	Umberto Masetti, ITA	Gilera
1953	Geoff Duke, GBR	Gilera
1954	Geoff Duke, GBR	Gilera
1955	Geoff Duke, GBR	Gilera
1956	John Surtees, GBR	MV Agusta
1957	Libero Liberati, ITA	Gilera
1958	John Surtees, GBR	MV Agusta
1959	John Surtees, GBR	MV Agusta
1960	John Surtees, GBR	MV Agusta
1961	Gary Hocking, ZWE	MV Agusta
1962	Mike Hailwood, GBR	MV Agusta
1963	Mike Hailwood, GBR	MV Agusta
1964	Mike Hailwood, GBR	MV Agusta
1965	Mike Hailwood, GBR	MV Agusta
1966	Giacomo Agostini, ITA	MV Agusta
1967	Giacomo Agostini, ITA	MV Agusta
1968	Giacomo Agostini, ITA	MV Agusta
1969	Giacomo Agostini, ITA	MV Agusta
1970	Giacomo Agostini, ITA	MV Agusta
1971	Giacomo Agostini, ITA	MV Agusta
1972	Giacomo Agostini, ITA	MV Agusta
1973	Phil Read, GBR	MV Agusta
1974	Phil Read, GBR	MV Agusta
1975	Giacomo Agostini, ITA	Yamaha
1976	Barry Sheene, GBR	Suzuki
1977	Barry Sheene, GBR	Suzuki
1978	Kenny Roberts, USA	Yamaha
1979	Kenny Roberts, USA	Yamaha
1980	Kenny Roberts, USA	Yamaha
1981	Marco Lucchinelli, ITA	Suzuki
1982	Franco Uncini, ITA	Suzuki
1983	Freddie Spencer, USA	Honda
1984	Eddie Lawson, USA	Yamaha

500cc two-stroke

Year	Rider	Bike
1985	Freddie Spencer, USA	Honda
1986	Eddie Lawson, USA	Yamaha
1987	Wayne Gardner, AUS	Honda
1988	Eddie Lawson, USA	Yamaha
1989	Eddie Lawson, USA	Yamaha
1990	Wayne Rainey, USA	Yamaha
1991	Wayne Rainey, USA	Yamaha
1992	Wayne Rainey, USA	Yamaha
1993	Kevin Schwantz, USA	Suzuki
1994	Mick Doohan, AUS	Honda
1995	Mick Doohan, AUS	Honda
1996	Mick Doohan, AUS	Honda
1997	Mick Doohan, AUS	Honda
1998	Mick Doohan, AUS	Honda
1999	Àlex Crivillé, ESP	Honda
2000	Kenny Roberts Jr, USA	Suzuki
2001	Valentino Rossi, ITA	Honda

MotoGP

2002	Valentino Rossi, ITA	Honda
2003	Valentino Rossi, ITA	Honda
2004	Valentino Rossi, ITA	Yamaha
2005	Valentino Rossi, ITA	Yamaha
2006	Nicky Hayden, USA	Honda
2007	Casey Stoner, AUS	Ducati
2008	Valentino Rossi, ITA	Yamaha
2009	Valentino Rossi, ITA	Yamaha
2010	Jorge Lorenzo, ESP	Yamaha
2011	Casey Stoner, AUS	Honda
2012	Jorge Lorenzo, ESP	Yamaha
2013	Marc Márquez, ESP	Honda
2014	Marc Márquez, ESP	Honda
2015	Jorge Lorenzo, ESP	Yamaha
2016	Marc Márquez, ESP	Honda
2017	Marc Márquez, ESP	Honda
2018	Marc Márquez, ESP	Honda
2019	Marc Márquez, ESP	Honda
2020	Joan Mir, ESP	Suzuki
2021	Fabio Quartararo, FRA	Yamaha
2022	Francesco Bagnaia, ITA	Ducati

Marc Márquez
All his wins

2010 125cc

Mugello, ITA
Silverstone, GBR
Assen, NED
Barcelona, ESP
Sachsenring, GER
Misano, SMR
Motegi, JAP
Sepang, MAL
Phillip Island, AUS
Estoril, POR

World Champion

2011 Moto2

Le Mans, FRA
Assen, NED
Mugello, ITA
Sachsenring, GER
Indianapolis, USA
Misano, SMR
Aragón, ESP

2012 Moto2

Losail, QAT
Estoril, POR
Assen, NED
Sachsenring, GER
Indianapolis, USA
Brno, ZCE
Misano, SMR
Motegi, JAP
Valencia, ESP

World Champion

2013 MotoGP

Austin, USA
Sachsenring, GER
Laguna Seca, USA
Indianapolis, USA
Brno, CZE
Aragón, ESP

World Champion

2014 MotoGP

Losail, QAT
Austin, USA
Termas de Río Hondo, ARG
Jerez, ESP
Le Mans, FRA
Mugello, ITA
Barcelona, ESP
Assen, NED
Sachsenring, GER
Indianapolis, USA
Silverstone, GBR
Sepang, MAL
Valencia, ESP

World Champion

2015 MotoGP

Austin, USA
Sachsenring, GER
Indianapolis, USA
Misano, SMR
Phillip Island, AUS

2016 MotoGP

Termas de Río Hondo, ARG
Austin, USA
Sachsenring, GER
Aragón, ESP
Motegi, JAP

World Champion

2017 MotoGP

Austin, USA
Sachsenring, GER
Brno, CZE
Misano, SMR
Aragón, ESP
Phillip Island, AUS

World Champion

2018 MotoGP

Austin, USA
Jerez, ESP
Le Mans, FRA
Assen, NED
Sachsenring, GER
Aragón, ESP
Buri Ram, THA
Motegi, JAP
Sepang, MAL

World Champion

2019 MotoGP

Termas de Río Hondo, ARG
Jerez, ESP
Le Mans, FRA
Barcelona, ESP
Sachsenring, GER
Brno, CZE
Misano, SMR
Aragón, ESP
Buri Ram, THA
Motegi, JAP
Phillip Island, AUS
Valencia, ESP

World Champion

2021 MotoGP

Sachsenring, GER
Austin, USA
Misano, SMR

Being Marc Márquez
This Is How I Win My Race

By Marc Márquez

Written by
Werner Jessner

Translation by
Desmond Tumulty

Concept by
Werner Jessner & Christoph Loidl

Edited by
Benevento Publishing

Editorial Management by
Sophia Angerer

Photo Editor:
Georg Kukuvec

Design by
wir sind artisten

Typefaces:
Monument Grotesk by Dinamo Typefaces,
Ivar Text by Letters from Sweden

Printed by Finidr, Czech Republic
Made in Europe

Published by gestalten, Berlin 2023
ISBN 978-3-96704-106-4

© for the English and Spanish editions
Die Gestalten Verlag GmbH & Co. KG,
Berlin 2023

© 2023 Pantauro by Benevento Publishing
Salzburg – München, a brand of
Red Bull Media House GmbH,
Wals near Salzburg

Imprint

Bibliographic information published by
the Deutsche Nationalbibliothek. The Deutsche
Nationalbibliothek lists this publication in the
Deutsche Nationalbibliografie; detailed biblio-
graphic data is available online at www.dnb.de

This book was printed on paper certified
according to the standards of the FSC®.

FSC
www.fsc.org
MIX
Paper | Supporting
responsible forestry
FSC® C014138

Picture credits:
Cover and back cover image:
Gold & Goose/Red Bull Content Pool
Inside: p. 4/5, 16, 30 (bottom), 76 (bottom), 77, 110,
128, 146/147, 149, 152/153, 204, 205 (2):
Gold&Goose; 6/7, 54/55, 74/75, 82/83, 88, 101,
130/131, 194/195 (Mauro Talamonti): Honda HRC;
8/9: imago images/Icon SMI; 14/15, 17, 22/23,
34/35: IMAGO/CordonPress, 18/19, 24, 90/91:
Samo Vidic/Red Bull Content Pool; 26/27: imago
images/Jan Huebner; 30 (top), 45 (2), 162/163,
200 (bottom): imago images/Cordon Press/
Miguelez Sports; 38: GettyImages/Christian
Pondella; 41, 44 (top), 52/53, 68/69, 116/117, 161,
164/165, 178/179, 180, 215, 216/217: Gold & Goose/
Red Bull Content Pool; 44, 64/65 (bottom), 114/115:
GettyImages/Mirco Lazzari; 12/13, 46/47, 155, 175
(bottom): Gepa pictures; 48/49: Márquez Family
archive/Alejandro Ceresuela; 59: imago/Agencia
EFE; 60/61, 182: imago images/ZUMA Wire; 67:
imago images/East News; 70/71, 87 (top): imago
images/PanoramiC; 76 (top), 158/159: imago
images/Motorsport Images; 80, 150/151: imago/
Gribaudi/ImagePhoto; 86: Shutterstock/Rainer
Herhaus; 87 (bottom): Christian Pondella/Red Bull
Content Pool; 92/93, 186/187: imago images/
ZUMA Press; 96/97, 136/137, 196/197: Alejandro
Ceresuela; 102, 103, 120/121, 209: The Crown
Creators; 106/107, 122/123, 126, 127: Márquez
Family archive; 108, 109 (top): Samuel Aranda;
109 (bottom), 142/143, 203: AFP via Getty Images;
113: Jaime Martínez Recasens; 134/135: Fundació
Pasqual Maragall; 140/141: NurPhoto via Getty
Images; 168/169: Sebastian Marko/Red Bull
Content Pool; 170: Jaime De Diego/Red Bull
Content Pool; 171 (2): Markus Berger/Red Bull
Content Pool; 174: Oscar Carrascosa/Red Bull
Content Pool; 175 (top): Matthias Heschl/Red Bull
Content Pool; 177, 190/191: imago images/Action
Plus; 181, 184/185, 188/189: imago sportfotodienst;
200 (top): Mondraker/Iván Marruecos; 201:
Javier Echevarria/Red Bull Content Pool; 207:
MARCELO DEL POZO/REUTERS/picturedesk.
com; 208 (left): Instagram @marcmarquez93;
208 (right): Dorna; 210, 211: MM93 Team; 218/219:
Sebas Romero/Red Bull Content Pool

Illustrations by Carina Lindmeier

MM93

marcmarquez93.com